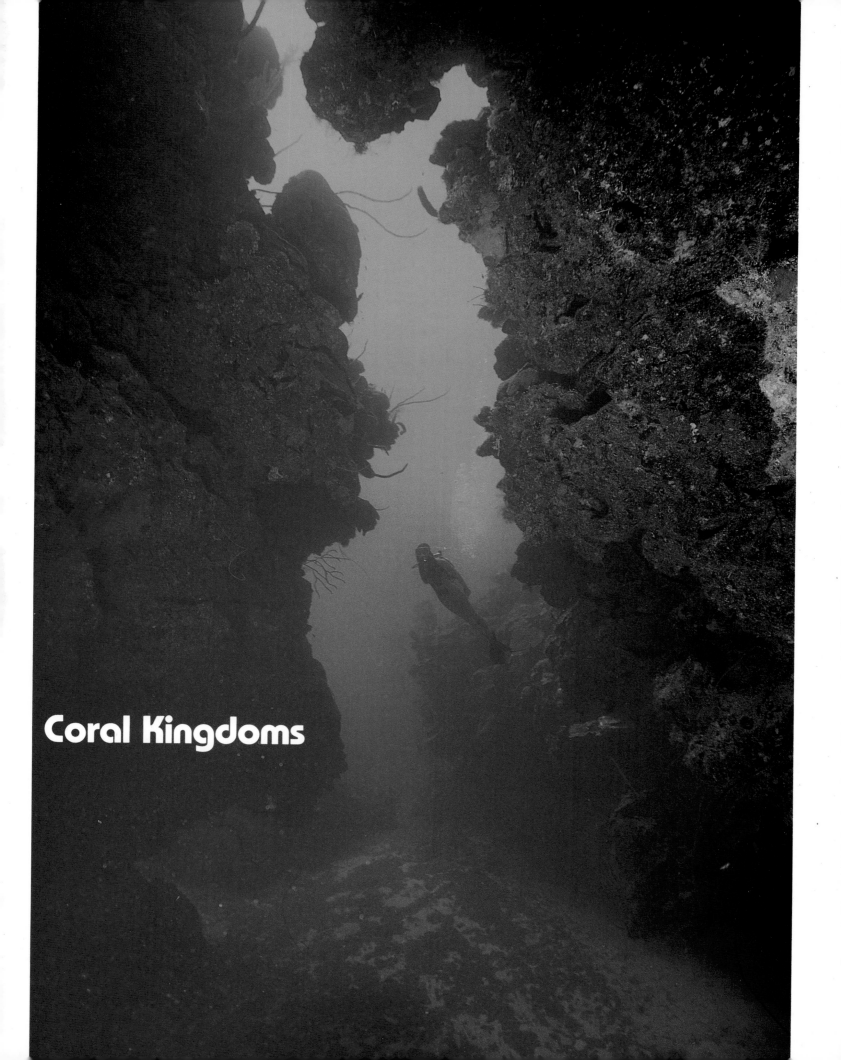

Coral Kingdoms

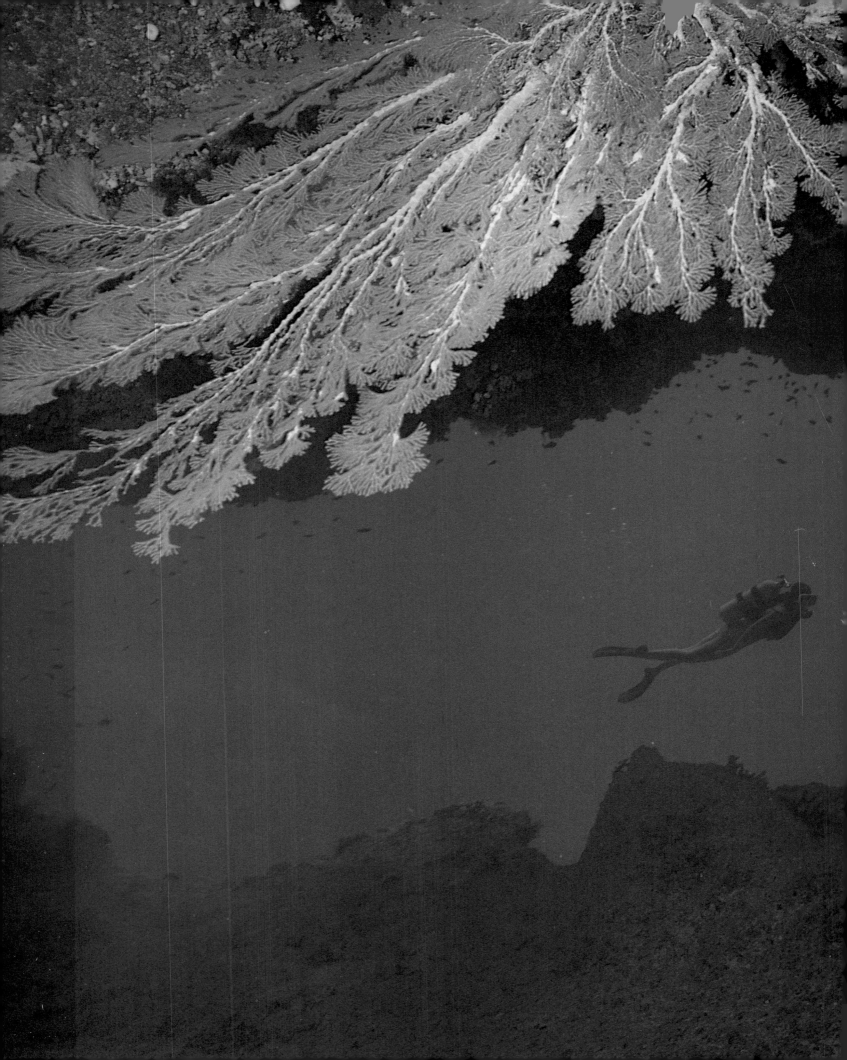

CORAL KINGDOMS

By Carl Roessler

Abradale Press •

Harry N. Abrams, Inc., Publishers, New York

For Jessica,
with my love and gratitude

Project Director: Barbara Lyons
Editor: Sharon AvRutick
Designer: Carol Robson

Library of Congress Cataloging-in-Publication Data

Roessler, Carl, 1933—
 Coral kingdoms / by Carl Roessler.
 p. 216 cm. 227 × 292
 ISBN 0-8109-8095-9
 1. Coral reef biology. 2. Corals. 3. Coral reefs and islands.
4. Coral reef biology—Pictorial works. 5. Corals—Pictorial works.
6. Coral reefs and islands—Pictorial works. 7. Scuba diving.
8. Skin diving. I. Title.
[QH95.8.R63 1990]
574.5'26367—dc20 89-28054
 CIP

Illustrations copyright © 1986 Carl Roessler

Page 1
The immense reef architecture of Grand Cayman overwhelms the visitor.

Pages 2, 3
Swimming outside a vast arch in Fiji, a human seems tiny compared to the immense architecture.

Page 5
One of diving's greatest thrills is to soar through the stone heart of a colossal reef (The Tunnel, Grand Cayman).

Pages 6, 7
Schools of fairy basslets (*Anthias*) hover above a coral mass in the Maldives.

Page 8
In the deep, cold waters off Cabo San Lucas, we find hand-sized coral colonies whose rich colors seem out of place in the surrounding darkness.

Page 10
In the muted twilight of a deep reef, a soft coral colony (*Dendronephthya*) seems to glow under our lights (Ponape, Micronesia).

Page 11
A crinoid climbs a soft coral to insert itself into the food stream.

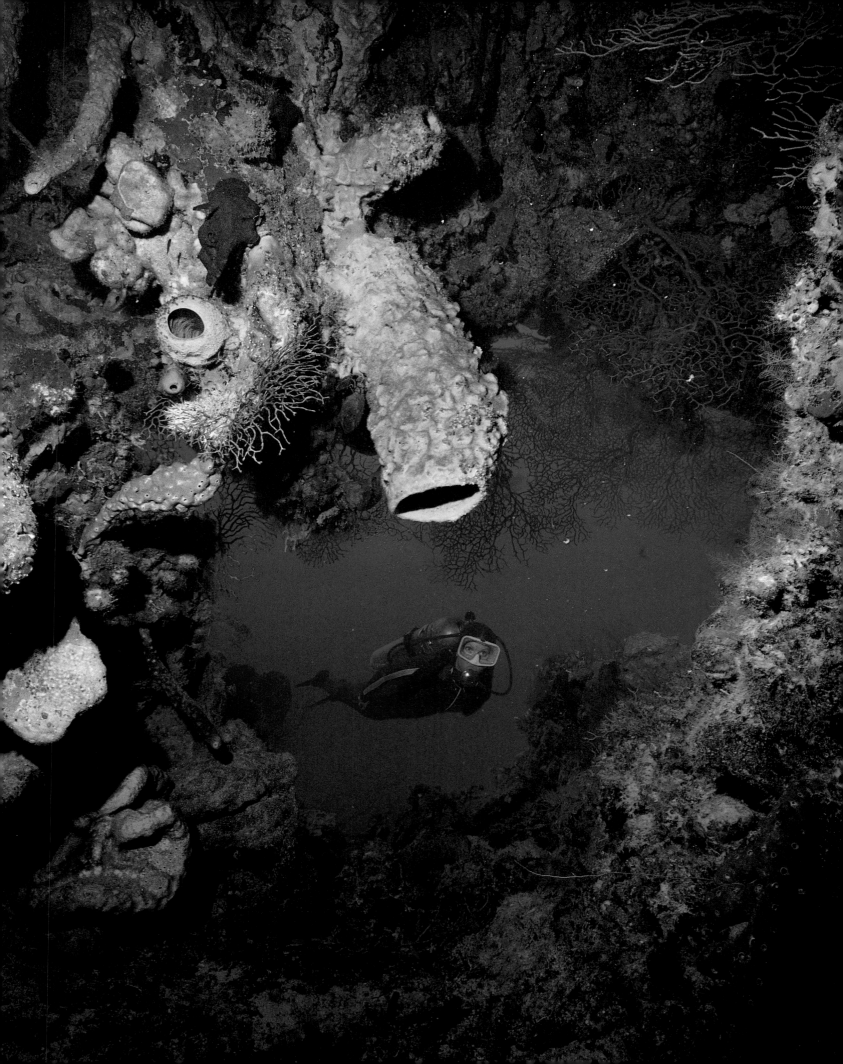

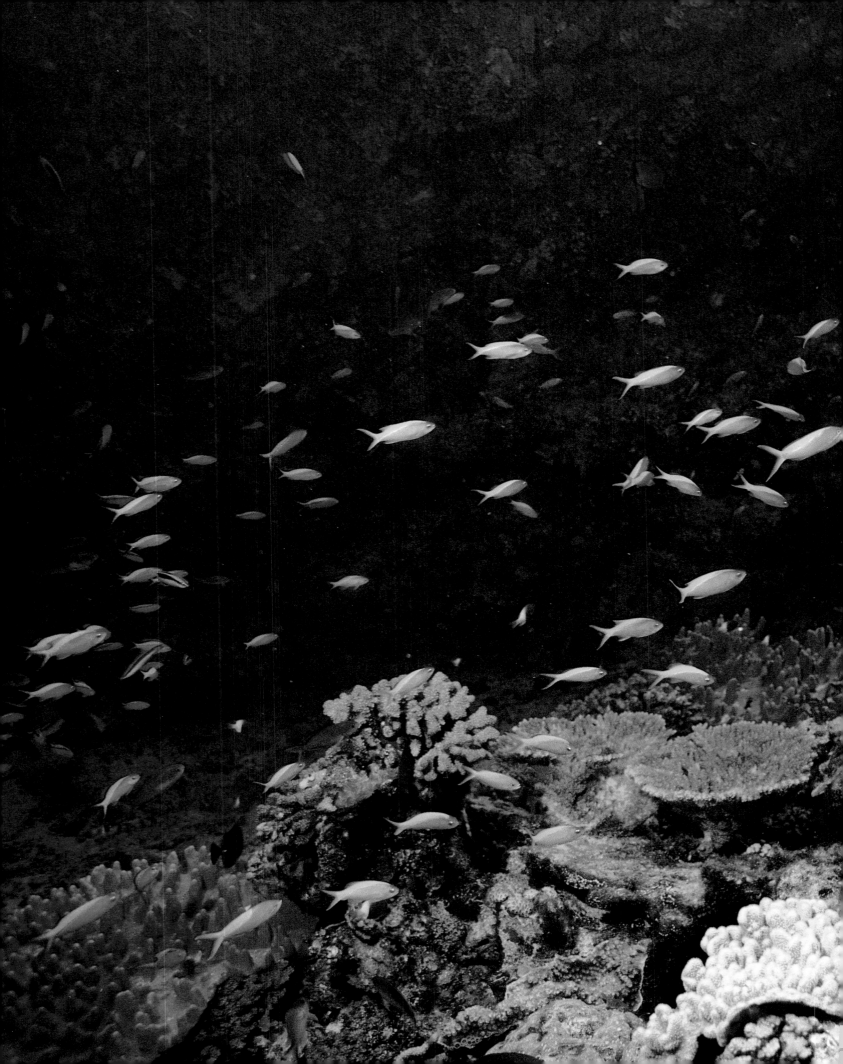

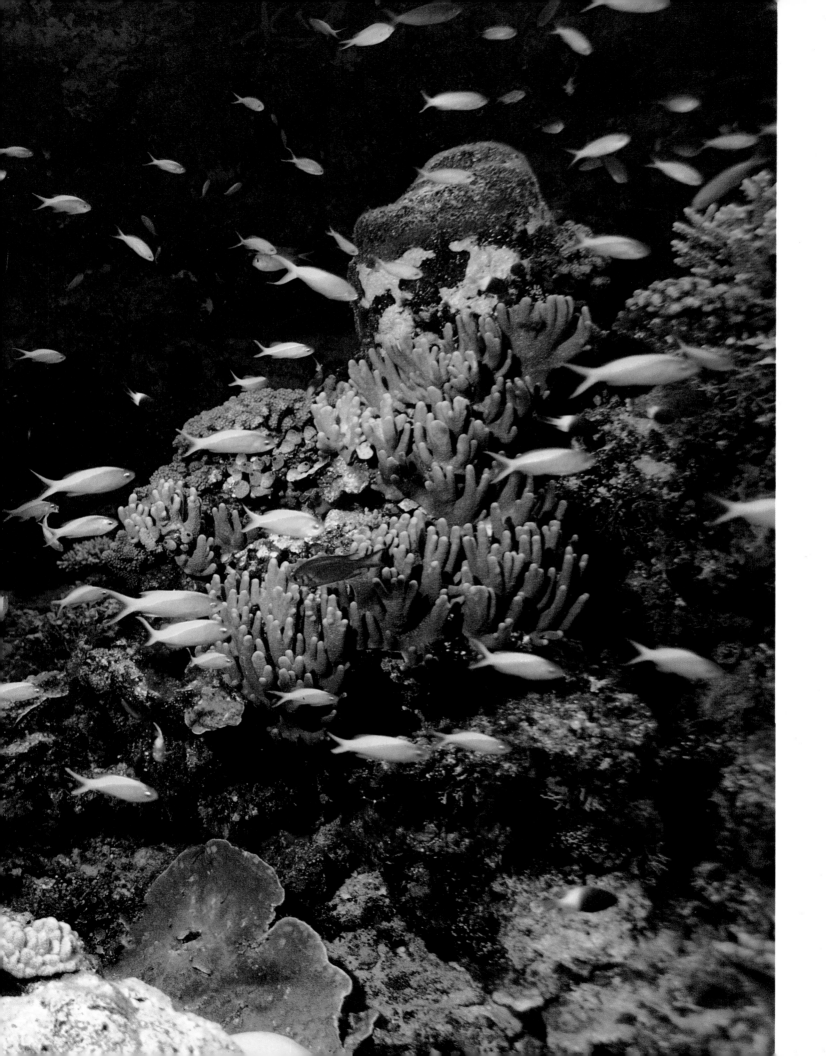

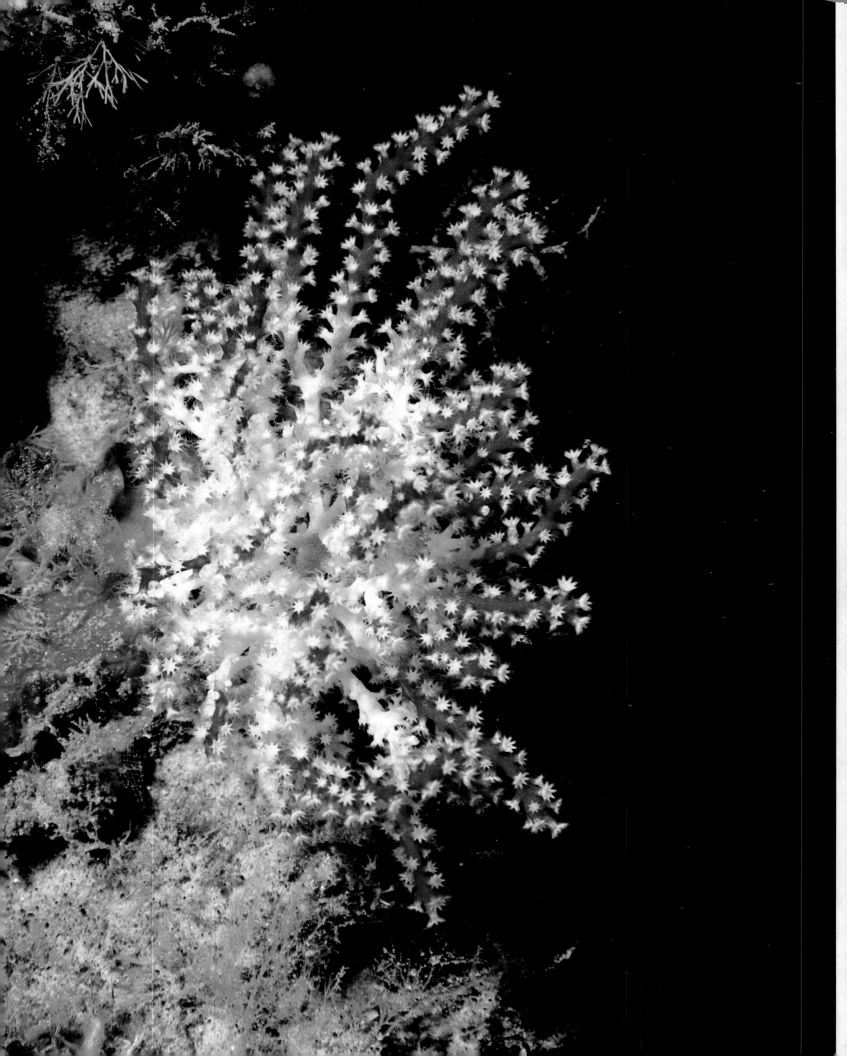

Contents

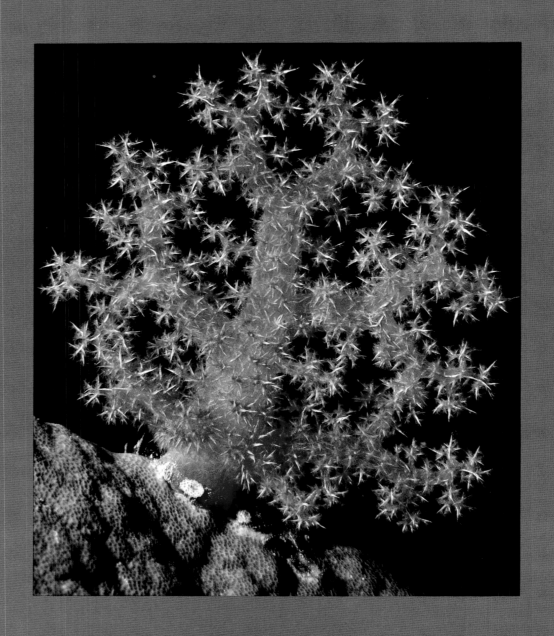

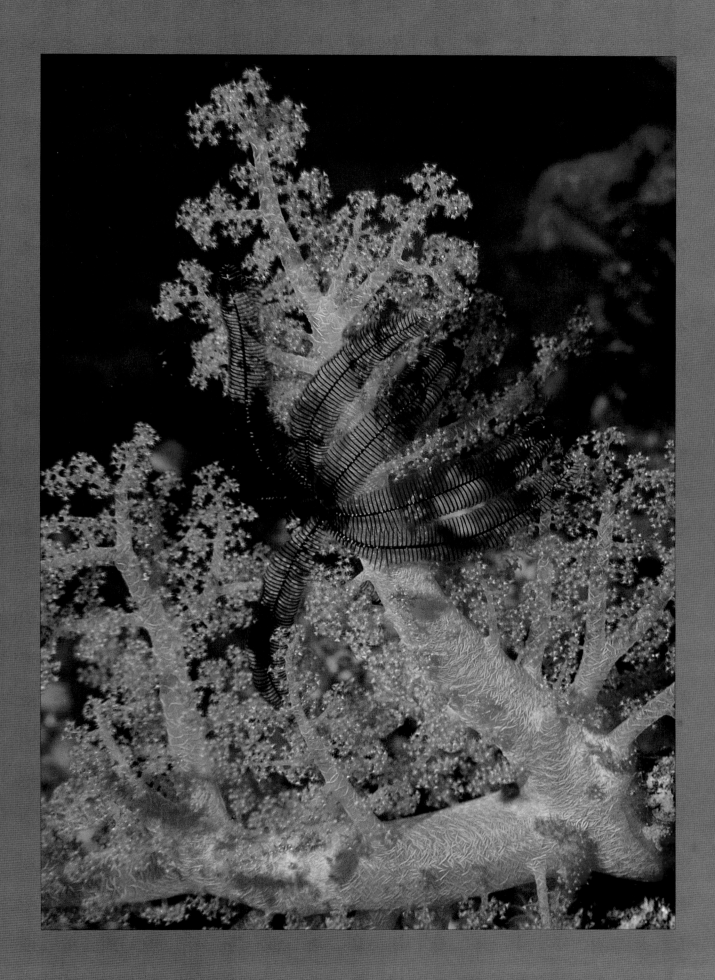

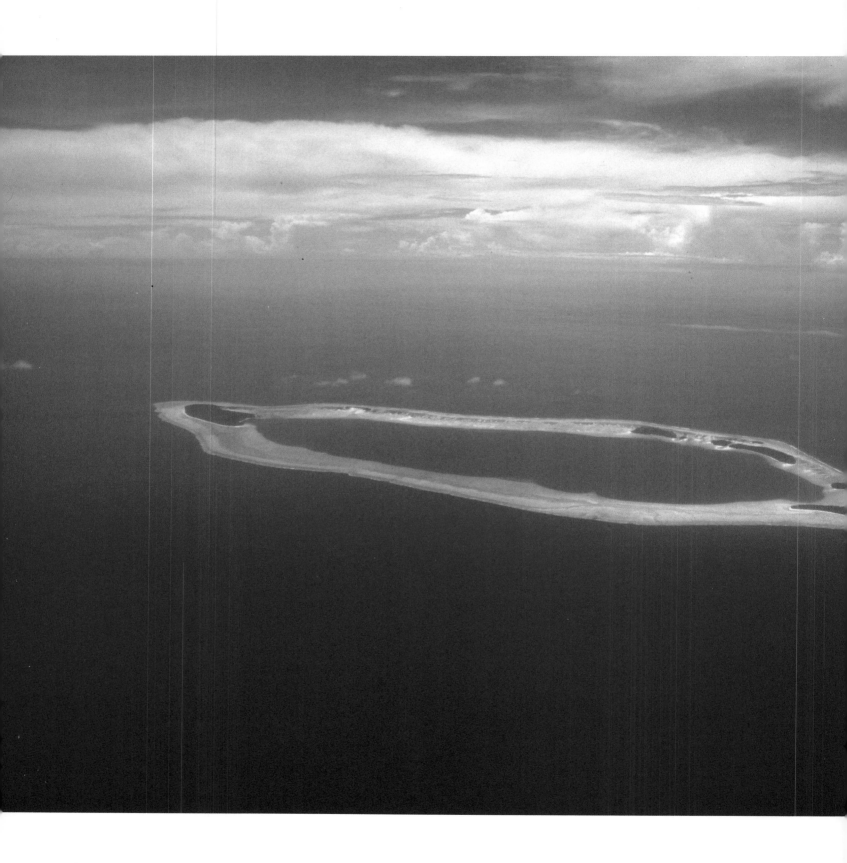

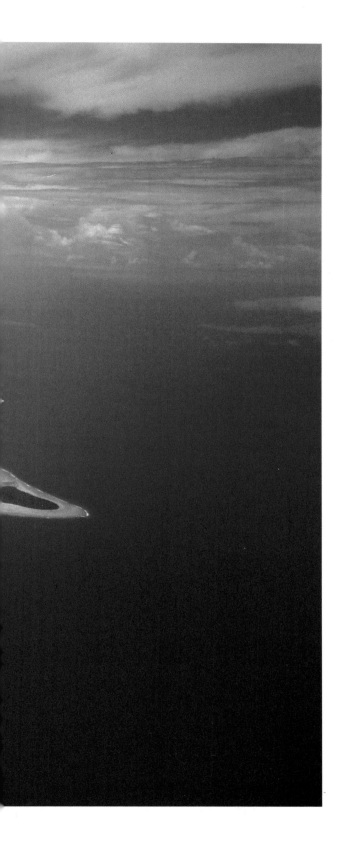

Pakin Atoll, a circular ring of coral marking the grave of a seamount that slowly sank. This subsidence is due to the interaction of moving tectonic plates (Micronesia).

The surface of the sea is calm and unruffled. The sky is blue, and warm breezes play across the water, evoking perpetual summer. The water is extraordinarily clear, so that patches of bright sunlight dapple and flash across the undersea terrain.

Dominating the scene is a coral reef, a vast stony citadel rising from depths beyond our vision to reach near the glinting surface. This fortress is irregular, its architecture seeming haphazard; there are crevices and caverns, terraces and shaded clefts, and the outer walls are festooned with a panoply of intricate and colorful decorations. Most of these look like plants, but are not. They have intricate arms radiating from central stems, and their surfaces are a tapestry of flower-like petals. Some are large and gaudily colored in rose, yellow, or violet. Others are minute, clothed in modest tans or olives, their complexity fully perceived only if seen from mere inches away.

Here and there among the plantlike decorations move small animals of various kinds. Unhurriedly they browse or forage, very like terrestrial garden snails or earthworms.

In the clear waters about the massive rampart dance thousands of gaily hued fish, darting here and there to pluck nearly invisible tidbits from the passing water. Beyond them and the walls near which they hover is the empty electric blue of the open tropical sea.

Once our eyes and minds have digested the intricacy, the color, and the variety of this reef panorama, we feel touched by essential tranquility. It is as if this scene were frozen in time. Unchanged, unchanging, the reef seems a haven of stability and peace in a world of tumult. Somehow, we instinctively feel it has always been thus. For eons before us and after us, the sea is the sea, and beauty dwells in the kingdoms of coral.

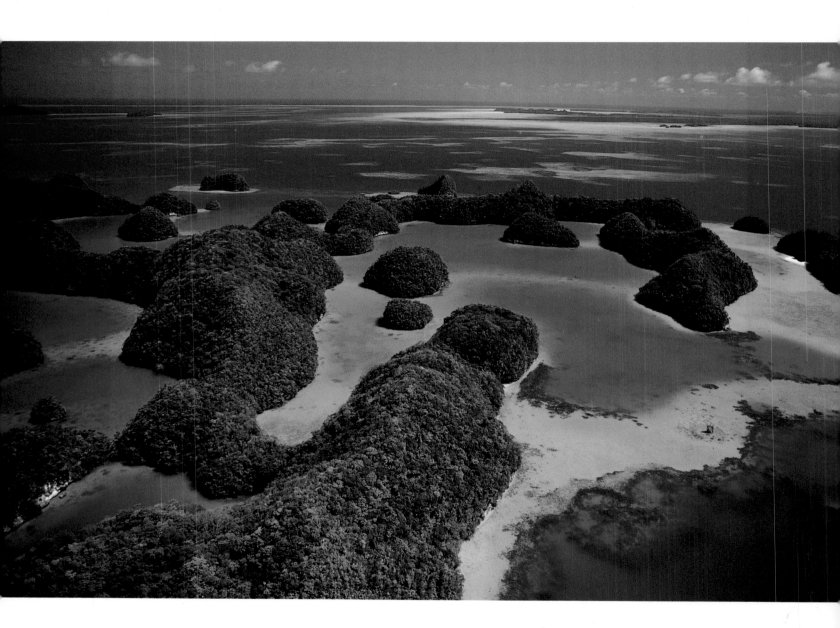

An aerial view of Palau, Micronesia, on a rare clear day.

Introduction

A Tapestry of Time and Change

The foregoing is an evocation of the coral kingdoms, worlds existing just beneath the surface of tropical seas. These kingdoms occupy broad spans of ocean, separated from each other by various boundaries. Some, such as the Indian Ocean, encompass entire seas, while others, such as the South Pacific, are subdivisions of much larger areas.

The boundaries of some coral kingdoms are physical, the edges of great continents or island chains. Others, their borders invisible to our eyes but nonetheless real, are individual elements of a worldwide system of immense ocean currents. In some cases the boundaries we use are arbitrary, reflecting climate, weather, culture, or even accessibility.

As we visit the great coral kingdoms in this volume, we will find certain characteristics that define each of them. It is, for example, impossible to mistake a Caribbean reef for one from the Philippines, for there are exquisite hallmark species that are limited to one coral kingdom or another. Indeed, we shall even find differences in some species from one quadrant to another of any area we describe. On the other hand, certain constants of heredity, form, and behavior are universal throughout all coral kingdoms, and some ocean-wandering species are found everywhere we will explore.

These similarities and differences are inevitable when viewed against the backdrop of geological and biological history in these regions; everything we see in our explorations is but one stage in a continuous, planet-wide process that has been underway for millions of years. Indeed, what we ob-serve today is merely one moment in that continuum of change. The mood of immutable stability evoked at the beginning of this book is true only for a given instant, for although the process of change is slow, it is constantly at work. Since the intricate societies and environments we observe in our sub-sea forays are the unavoidable evolutionary result of only recently understood forces, it is vital to appreciate at least the main elements of that long historic context before we begin our trip.

Scholars have been speculating about the sea and its life throughout the centuries, and many cultures have drawn their very existence from the sea. Our relationship with it, however, has often had contradictory aspects; while we have looked to it for nourishment, transport, and inspiration, our actions have often threatened its health. We have fished it relentlessly, erected breakwaters that disrupt its flow, dynamited reefs for boat passages, and used it as a dump for mountains of refuse. There are those who have felt that we will destroy the sea before we understand it.

Fortunately, however, the long years of speculation and study are now yielding profound insights into geology and biology that have altered our entire perception of the earth, its oceans, and their life. They are also leading to a fuller understanding of the role we must all play in the future of the sea. In many senses we are privileged to be observing the coral kingdoms now, at this precise moment in the earth's history.

Continents Adrift

One crucial insight into the history of the coral kingdoms has been tapping at science's shoulder for centuries. In 1620 Sir Francis Bacon suggested that the continents of the Western Hemisphere had once been joined to Europe and Africa. The same observation was made later by other scientists, including, in 1858, Antonio Snider. By the end of the nineteenth century Edward Suess postulated the existence of an ancient single continent he called Gondwanaland. In the first decade of the twentieth century, F. B. Taylor and Alfred Wegener even suggested mechanisms by which whole continents could move enormous distances.

These speculations met stiff resistance from other equally eminent scientists who insisted that the earth's crust and mantle were too rigid to permit such violent movement without enormous quantities of energy being expended. As they found no evidence for such expenditures, they dismissed the entire theory.

The argument raged. In the 1930s it was suggested that the necessary energy came from convection currents in the molten rock of the earth's mantle. In the early sixties Harry Hammond Hess and Robert Sinclair Dietz proposed that the midocean rifts and ridges were created by the rising currents of molten rock, which filtered through seams in the crust and then spread out across the ocean floor.

It was not until 1966 that this and other research on magnetic fields in seafloor rocks culminated in a widely accepted and relatively uniform theory of continental drift. The pace of research quickened. Computer-graphic studies showed how the present continents fit exactly into a gigantic megacontinent called Pangaea, which existed some two hundred to three hundred million years ago. The theory of plate tectonics explains how before Pangaea broke up, what are now the western limits of North Africa nestled against the eastern seaboard of the present-day United States; what is now Brazil pressed firmly against the midsection of the current African continent.

Then, two hundred million years ago, Pangaea broke laterally into two supercontinents, Laurasia and Gondwanaland. Gondwanaland, the larger, included what are now Africa, India, South America, Australia, New Zealand, and Antarctica. Laurasia included North America, Greenland, Iceland, Europe, and the rest of Asia. Laurasia and Gondwanaland subsequently broke into today's continents, which have since migrated to their present positions.

Our modern understanding of the breakup of Pangaea has consequences that have invaded every sphere of earth science. In biology, for example, it has long been known from the fossil record that there have been four major collapses of reef life since the Precambrian era six hundred million years ago.

Various theories concerning these collapses of reef life have been advanced, including one that posits enormous asteroids occasionally striking the earth. The proponents of this theory suggest that such an explosive collision created clouds of dust that blotted out the sun. The resulting darkness, which may have lasted more than a year, snuffed out light-dependent (photosynthesizing) plant life. This, in turn, caused the extinction of many species higher in the food chain. The scientists feel that after one hundred and thirty million years of dominance, the mighty dinosaurs should not have been swept away except by an external cataclysm of enormous magnitude.

By contrast, other scientists will point out that historic movements of lithospheric plates (those that form the earth's crust) caused catastrophic climate changes; there is no need, in the view of tectonic theoreticians, for an asteroid collision to explain the disaster. For example, they tell us that the Mediterranean Sea completely dried up eleven million years ago when the Mediterranean and European plates came together; core samples of the seafloor do show thick layers of what was once desert. Surely, the evaporation of the sea was a cataclysm for the marine life that depended on it.

Today, geologists find fossil palm trees in Canada, Argentina, Central Europe, New Zealand, and Siberia. Their presence is mute testimony to a tropical climate that was both worldwide and stable for millions of years, supporting the rise of enormous and highly varied reef communities. Extensive shallow seas covered regions of Pangaea. Great reefs flourished more than sixty-five million years ago in what is now Texas and New Mexico, North Africa, Central Europe, and Southern China.

At several points in history the effects of continental drift apparently turned hostile to extant life forms. As part of the seafloor spreading that drove continental movement, the waters grew deeper; huge landmasses emerged and the shallow coral seas that had overlain them drained into the deepening ocean basins. Deep cold-water currents from the poles began to underflow other tropical seas. The movement of continental masses now impeded the worldwide flow of tidal waters and created massive currents. Both terrestrial and marine climates changed. Researchers have shown that

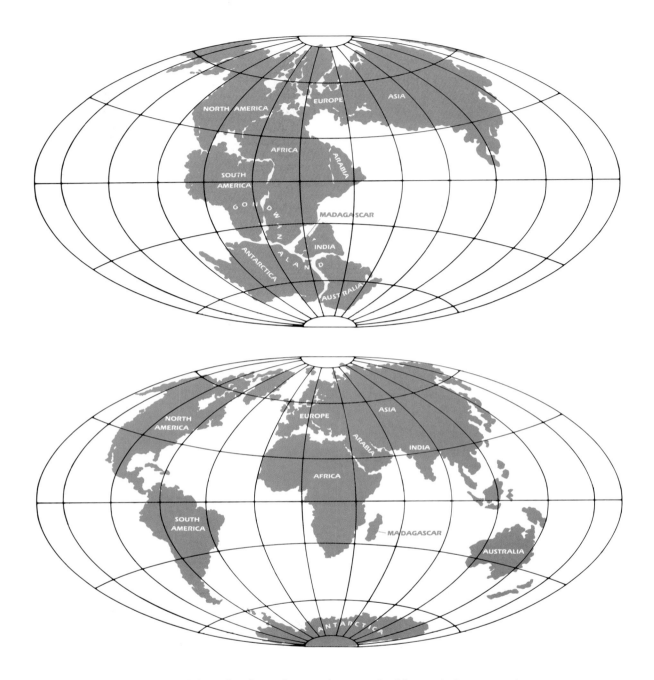

Scientists believe that the modern continents evolved from a single supercontinent, Pangaea, over the past 150 million years. (See upper map.) The lower map depicts the continents as they are today. In both maps the distortion of the continents is a result of the projection employed.

the temperature of deep-ocean water has dropped from 57°F. during the Cretaceous period (seventy-five million years ago) to only 37°F. today. Surface water temperatures during the same time have dropped from a high of 75°F. to today's 59°F.

Tropical weather, which once prevailed across much of the earth's surface, is now limited to an equatorial band extending from 30° North to 30° South. Compared to the immense tropical seas of two hundred million years ago, the coral kingdoms of today are shrinking enclaves kept alive by equatorial currents.

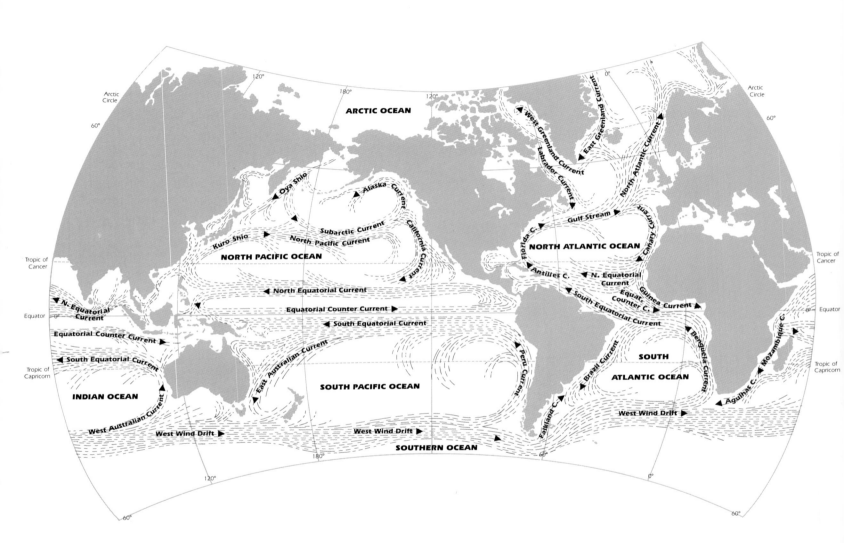

The map above depicts the surface currents of the world today.

Oceans in Motion—The Worldwide System of Currents

The continuing effects of plate tectonics influence both general climate and day-to-day weather in the coral kingdoms today. A fundamental consequence of the movement of the continents was to deflect and obstruct planetary ocean circulation. Before the breakup of Pangaea there was a single continent and a single sea. The movements of currents in that sea were unobstructed and hence quite slow and regular. As the continents separated, the forces behind the currents propelled the water around the new obstructions. This more complex circulatory system generated much faster currents in some areas, diverting polar water to tropical regions, which led to more powerful weather systems. The seas evolved local weather; there could be violent storms in one sea even as another on the opposite side of a continental obstruction might be enjoying calm. The result is an incredibly complex mosaic of moving seawater that directly shapes the coral kingdoms. Among the apparent anomalies directly attributable to these oceanic currents are the presence of penguins on the equatorial Galápagos Islands and of palm trees in Cornwall in southern England.

In a planetary ocean unobstructed by any landmasses, currents would follow a simple pattern. The rotation of the earth and the sun's uneven heating of its surface would create a global wind system. Along the equator and again near the poles, the trade winds would move westward, and in the northern and southern mid-latitudes, eastward. These winds would transfer some of their energy to the water through friction, creating a westerly surface current in the equatorial regions and an easterly flow in the mid-latitudes.

All of this also holds true for a planet that has landmasses dividing up the seas. As the continents obstruct the free-flowing currents, immense circular patterns called gyres are produced in major seas. These are further complicated by the Coriolis force, which deflects the currents to the right in the Northern Hemisphere and to the left in the Southern Hemisphere.

For example, below the equator in the Pacific Ocean, a colossal current moves westward. This south equatorial current, baked by the sun, creates a tropical sea that is deflected southward by the rotation of the earth as it reaches the vicinity of Australia. The continental obstruction continues the southward deflection, resulting in a south-flowing stream known as the Australian Current.

By the time the tropical Australian Current reaches the latitude of Sydney, it is being deflected eastward by the West Wind Drift, or Antarctic Circumpolar Current. This is the world's only major unobstructed oceanic current, circling Antarctica and largely sweeping past the southernmost tips of South America and Africa. It is not swift (perhaps one knot at the surface), but is estimated to carry two hundred million tons of water past a given point every second. That staggering volume represents 150 times the combined flow of all the earth's rivers. The atmospheric forces unleashed and affected by this staggering volume of cold water in motion have earned this violent region near 40° south latitude its not-so-affectionate nickname, The Roaring Forties.

When the West Wind Drift nears the tip of South America, a relatively small portion of its eastward flow is diverted northward by the intruding continental mass. This north-flowing Antarctic water, the Humboldt Current, supports one of the world's most productive fisheries, producing some 20 percent of the world's annual fish harvest. The Humboldt is an example of an eastern boundary current (a current that flows from the poles toward the equator along the eastern boundary of a sea). The eastern boundary currents are generally cold, of relatively low salinity, and rich in nutrients. Even at the equator, where the flow is again deflected westward, the Humboldt is cold and rich; the presence of penguins on the equatorial Galápagos Islands is consistent with the character and effects of a major eastern boundary current. By contrast, the western boundary currents such as the Australia Current are generally warm, clear, saline, and less rich in nutrients.

This spiral system of South Pacific currents has counterparts in the North Pacific, the North and South Atlantic, and the Indian Ocean. With few exceptions the prevailing climates of the coral kingdoms are direct products of equatorial and western boundary currents. Were it not for the circulation provided by the subtropical gyres the coral kingdoms as we know them simply could not exist.

Marine Life through History

Having set the stage for the emergence of the coral kingdoms, we now meet the players who have moved upon that stage through history.

The association of plants and animals in the tropical waters of the world is the most complex of all ocean ecological systems and is the oldest major ecosystem on earth. The oldest of all types of reefs is the simplest; in Precambrian times (more than six hundred million years ago) limestone-secreting algae produced extensive accumulations of distinctively laminated limestone called stromatolites. The microscopic organisms that built the stromatolites have not survived, but were apparently similar to certain types of blue-green algae found today.

Six hundred million years ago, during the Cambrian period, the stromatolites were joined by the archeocyathids, stony spongelike animals that grew in thickets and explosively populated the warm seas. Despite their proliferation these first reef-building animals were snuffed out sixty million years later in the first of the four major disasters to overtake historical marine fauna. Another sixty million years went by, with only the stromatolites still producing their characteristic tabular limestone formations.

In the middle Ordovician period, four hundred and eighty million years ago, fossil evidence depicts a renewed, more complex association between reef-building plants and animals. The stromatolites were joined by coralline red algae, by stromatoporoids (stony sponges), by bryozoans, and, most importantly, by certain stony coelenterates—the first corals.

One hundred and thirty million years of successful propagation were not enough to ward off the second great collapse, in which the reef community underwent a dramatic retrenchment. Only scarce and greatly impoverished reef communities survived a thirteen-million-year hiatus, after which once again marine life began a tropics-wide resurgence. Stromatolites, bryozoans, brachiopods, and some new arrivals—calcareous green algae, calcareous sponges, and crinoids (a group of echinoderms)—exploded into thousands of species that filled the worldwide shallow seas.

Then, two hundred and twenty-five million years ago, a third collapse occurred in which half the known taxonomic families on earth suffered extinction. Fossil reefs are unknown anywhere on earth for the first ten million years of the Mesozoic era. The catastrophe is generally linked to at least a brief draining of the shallow tropical seas, probably as a result of the gradual deepening of ocean trenches as continental masses moved. There may also be a causal relationship with Antarctic ice sheets and associated climatological changes, which had begun earlier, in the Permian period.

There ensued another stable interval of one hundred and thirty million years in which reef life once again spread and flourished. This time there arose an important new group of corals, the scleractinians. During the Cretaceous period (one hundred and forty to one hundred and sixty million years ago), there were about one hundred genera of scleractinians in the tongue of the Tethys Sea that became our modern Mediterranean Sea; sponges, sea urchins, foraminifera, and various mollusks proliferated. The present Atlantic Ocean was forming, presenting a widening deepwater barrier to the migration of reef organisms. For the first time significant differences between reef communities in the Old and New worlds became apparent. An extraordinary evolutionary development also took place: the rudists, previously obscure bivalve mollusks, exploded into such prominence that they challenged the corals as dominant reef animals.

At the end of the Cretaceous period (sixty-five million years ago) there occurred the best known of the four great collapses of earth life. On the landmasses the entire 115 genera of dinosaurs were extinguished. The calamity in the seas was equally devastating; nearly one-third of all families were eliminated, including the rudists and two-thirds of the extant coral species.

What happened? As described earlier, plate tectonics and paleoclimatology now propose that the moving continents and deepening seas had two devastating effects. In the late Cretaceous perhaps two-thirds of today's landmasses were submerged beneath shallow, warm seas bathed in sunlight and gentle tropical breezes. It appears that during this time, there was nothing like the powerful winds and strong ocean currents of today. However, as the continents moved, deepening ocean basins drained away the shallow seas, pow-

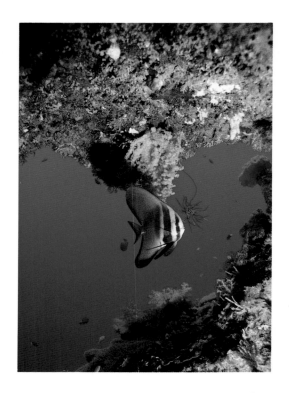

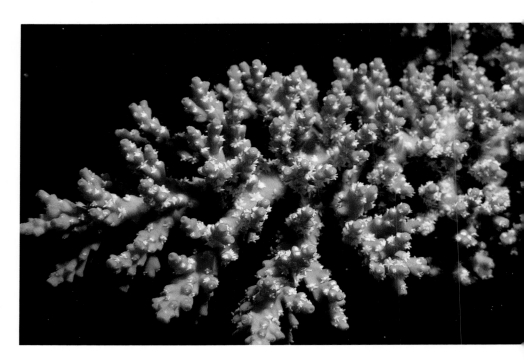

A batfish (*Platax teira*) hovers in a coral cave (Palau).

A cluster of the coral *Acropora varibilis*, found off the Great Barrier Reef and the oceanic reefs of the Coral Sea (Australia).

erful currents churned between the newly separated land-masses, and the emerging continents caused dislocations in the benign climate. The seas grew colder, seasonal variations became harsh. Such massive changes in climate sealed the

This commonly encountered squirrelfish (*Holocentrus rufus*) was found in Belize.

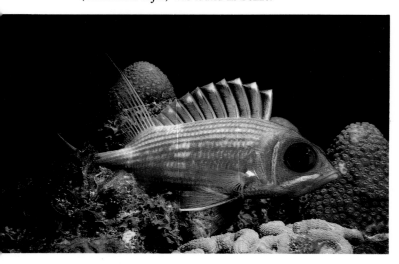

fate of the dinosaurs as thoroughly as the encroachment of a comet. Eons of unchanging tropical climate had ill equipped them or the foliage they consumed for anything like winter. Even today's more adaptive reef-building corals can survive only in a temperature range of 70°F. to 85°F. Severe changes in the temperature or salinity of their water world quickly kills them off.

Only a few species survived the calamities now seen as turning points in biological history. So we see a stark pattern recurring over the history of the seas: incredibly long periods of benign and stable conditions followed by abrupt change. Precisely because long periods of climatic stability place no premium on genetic adaptability, the mortality rate during the ensuing periods of change is very high.

During our own era, the Cenozoic, the processes of change have continued. The deepening seas have become steadily colder, partly due to the development of the Antarctic ice cap fifteen to twenty million years ago. Seasonal variations have become more severe, and the tropical seas have inexorably contracted. The seas are now filled with the most adaptive survivors.

Corals and the Evolution of the Modern Reef Community

A coral reef is a complex, highly stratified ecosystem. Its closest terrestrial counterpart is the tropical rain forest. Both are dependent on sunlight, and they use it in much the same way: the sunlight filters down through successive strata, and at each level we find particular organisms whose needs match the available light, shelter, and food supply.

The key to the coral reef is the coral polyp. It is a common belief that a reef consists of a rigid framework of coral limestone skeletons, but, in reality, more than 90 percent of the reef mass consists of sandy detritus (much of it the skeletal matter of dead marine organisms other than corals) converted into limestone and bonded together by the coralline plants and animals anchored to its surface.

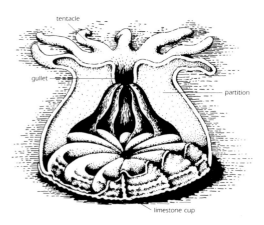

A schematic diagram of a stony coral polyp.

There are two principal food bases for the reef. Algae play much the same role as the plant life on shore, being consumed by herbivores. Floating microscopic plants and animals—zooplankton and phytoplankton—are caught from the passing currents and consumed by tentacled reef-dwellers.

There are other important relationships between plant and animal life on the reefs. For example, within the coral polyps' own tissue reside microscopic one-celled plants called zooxanthellae. It had long been known that the zooxanthellae are nourished by the coral polyps' nitrogenous wastes and that the symbiosis between them adds oxygen to the surrounding water. It was also known experimentally that the zooxanthellae promote the production of calcium by the polyps. The corals—by their very structure considered tentacled carnivores—capture small crustaceans and larvae for their food.

In 1974 experiments revealed that coral growth and the deposition of limestone continues at near-normal levels even in water from which all food has been filtered. Thus the corals and zooxanthellae were shown to have evolved a highly adaptive relationship in which together they thrive on food-filled currents, on sunlight, or on a combination of both. The critical value of sunlight to these symbionts is the key to the asteroid-collision theory mentioned earlier. Obviously, depriving these types of reef inhabitants of needed sunlight would have catastrophic consequences.

These marvelous symbionts have created monuments of immense size; some reefs are mountainous structures that may include masses of coralline limestone hundreds of feet thick. Generation after generation of coral polyps extend their tubular limestone cups with daily deposits of calcium carbonate. Recent research on fossil corals has even used their daily growth rings as paleontological clocks. Their daily and seasonal growth rings have been used to verify astronomical calculations that suggest that during Devonian times the earth year was 400 days long; the lowly corals have become an important and accurate witness to the celestial mechanics of earth's history.

Today's reefs, then, whether in the Caribbean, the Red Sea, or the Pacific, have come to exist by a common process. Free-floating coral and other marine larvae are carried far from their reef of origin on vast oceanic currents. Because of their short life spans and because these circular ocean flows, or gyres, pass the subpolar latitudes, many larvae fail to survive their journey, becoming food for other planktonic organisms or falling to the deep-ocean floor. But those that do survive eventually reach shallow water and take up residence. Some organisms, including the corals, build limestone bases and take permanent root.

With their daily deposits of limestone, the corals extend the cups in which they live. Aggregations of these gradually lengthening limestone cups become coral heads; some are domelike and dense, and others are intricately and fragilely branched. Over the years the coral heads grow and combine in massive reefs that provide shelter and nourishment for countless invertebrate and fish species, while slowly building ever more massive reef structures.

This marvelously intricate reef community is the current version of a remarkable evolutionary parade. The predecessors of today's marine species negotiated an evolutionary maze; the results we enjoy today are but one frame of a long movie whose later chapters we do not know.

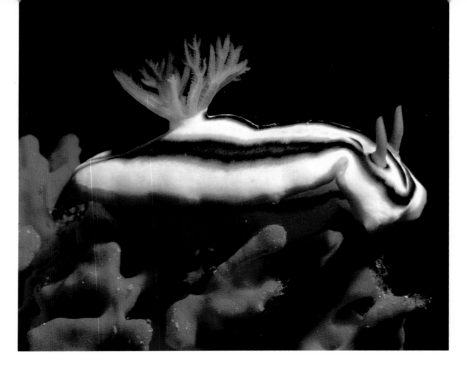

This nudibranch or shell-less snail (*Chromodoris quadricolor*) browses on the algal coating of a red sponge in the Philippines.

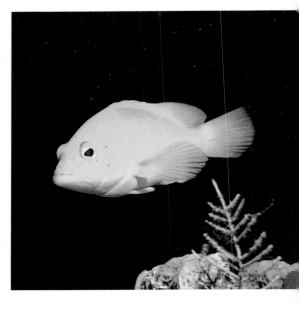

One of the most beautiful of Caribbean fish, the golden coney (*Cephalopholis fulva*).

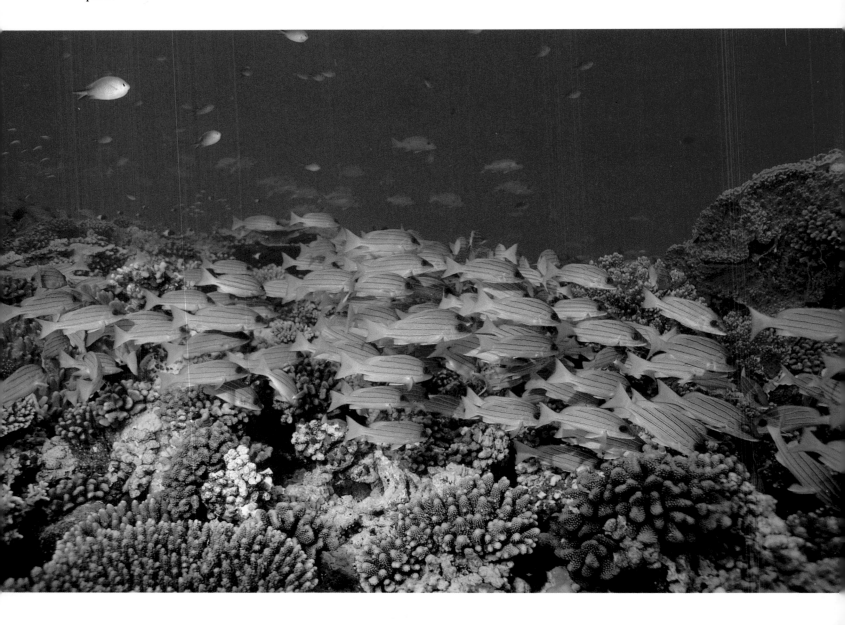

The Reef Society

We shall wander the coral kingdoms freely. We will see how they fundamentally resemble each other and yet how different each can be. We shall meet the citizens of the reefs—corals, other invertebrates, reef fish, and the pelagic species, those great wanderers of the open sea between the reefs. It is my hope that this encounter with the complex coral reef society may enlist the reader in the cause of saving it; for, at the end of our journey we shall see that it is man who poses the gravest threat to this vastly older society. If this volume helps to enlist you in this cause, the wonders we see here may survive to be viewed by future generations.

One of the most rewarding aspects of exploring tropical seas is the chance to observe the day-to-day encounters between members of this society. Throughout our journey we shall observe phenomena that illustrate the fundamental forces driving the reef society. I'd like to mention a few here by way of introduction, then describe and illustrate them in later chapters. These phenomena are the daily (and nightly) routine of the reef citizens, but they provide human visitors the thrill of discovery with each dive on a tropical reef.

Predation is one of the principal activities divers may observe on coral reefs. It occurs as frequently and as universally in marine society as in a jungle. Coral polyps, starfish, crinoids, and other tentacled feeders use their intricate arms to capture food from the passing currents. Invertebrates browse on algae; small fish eat tiny crustaceans; octopuses eat mollusks; large fish eat small fish.

Another critical aspect of undersea society that we can witness by diving near coral reefs is the use of color. Sharks and rays, for example, are shaded so that they blend into the monotone open water. Flounders, groupers, octopuses, and others have evolved astonishing abilities to alter their body color to fit the different backgrounds against which they move.

Other uses of body coloration are not well understood.

Some small reef fish, known as "poster-colored" fish, are adorned in particularly bright hues. It has been speculated that brilliant coloration in certain reef species is linked to aggressive territorial behavior. Recently, scientists have challenged this theory, citing the most territorial and aggressive of all reef fish—the damselfish—and its drab coloration. The question of poster-coloration remains open.

We will see a wide range of activity in the coral kingdoms, a kaleidoscope of exciting and intimate encounters with the members of an endlessly variegated society. If there is any important observation I might offer before we begin our journey it is this: all of these remarkable sights are available to even the most novice visitor to the undersea world. Most new divers tend at first to view the reef in toto. The great expanses of coral gardens, the sheer walls dropping off into deep water, the clouds of fish, the blue arena of the open sea beyond the limestone ramparts—all seem to blend together.

With more dives, however, one's powers of observation, one's focus, becomes more refined. This is the key to actually seeing the functioning of the reef community: let your eyes do the work—it is that large, noisy body we carry around that disturbs and intimidates the small reef creatures.

In this book we shall encounter hundreds of species of marine animals. In trying to identify them we discover that local names may vary widely for the same animal. For example, the lionfish is also known in various parts of the world as firefish, turkeyfish, chickenfish, and butterfly cod. Because of this imprecision in nomenclature, we are forced to use both Latin and English names to identify each species. Some people, hearing biologists use the Latin names, suspect that it is to flaunt erudition or impress nonscientists. The real reason taxonomy is so critical in the biological sciences is that it imposes discipline on discourse. It provides a language two people from different parts of the world can speak to know instantly they are discussing the same species.

Now it is time to go on our own personal excursion to encounter the reef world.

◄ In shallow coral gardens at the edge of the open Indian Ocean, schools of grunts (*Lutjanus kasmira*) drift above the reef.

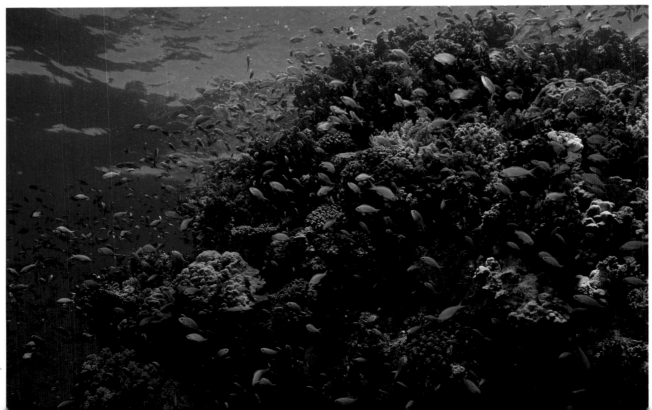

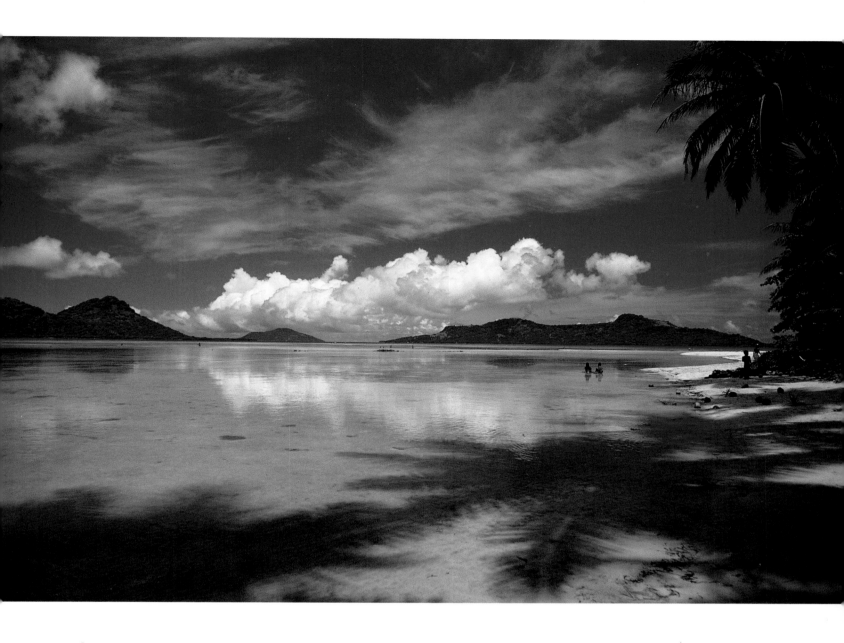

▲ Some of the sixty-four Japanese ships and 250 aircraft sunk in an American World War II attack lie beneath this bucolic scene in Truk Lagoon, Micronesia.

▼ Natives hunt shellfish along the margins of the beautifully still Lagon D'Erakor, Vanuatu, while the ocean batters the protective outer reef in the background.

◄ Shallow reef with school of orange fairy basslets (*Anthias squammipinnus*) in the Red Sea.

A grouper, discovered at night, decides ► whether to flee.

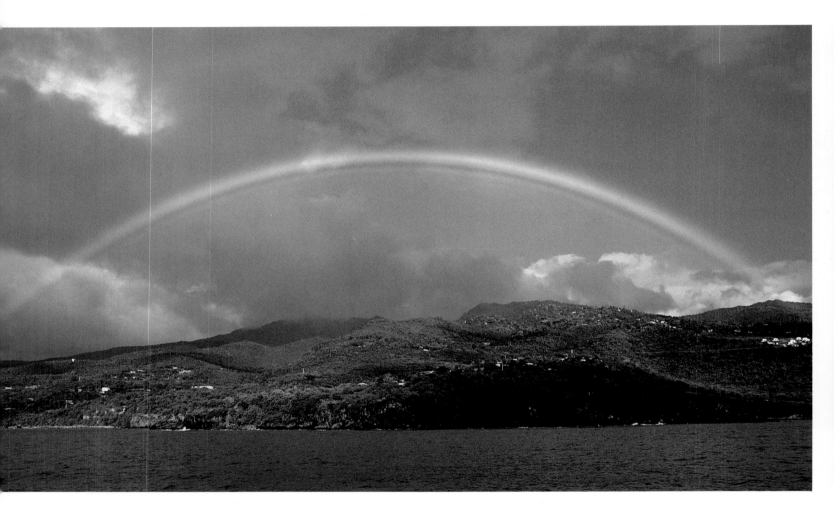

A rainbow arches across the sky above
the verdant hills of Guadeloupe.

Chapter One
The Caribbean
A GARDEN OF ISLANDS

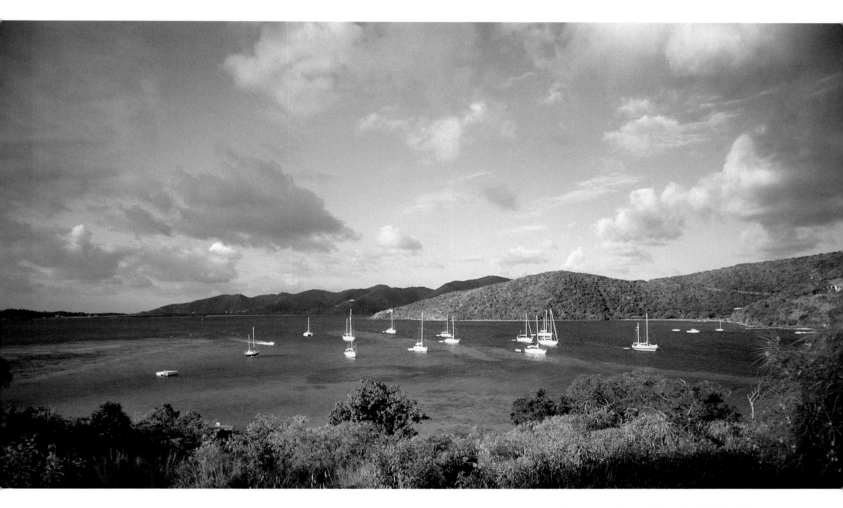

Boats at anchor off Tortola, British Virgin Islands.

A pair of striped grunts stage a mock battle (Cayman Islands).

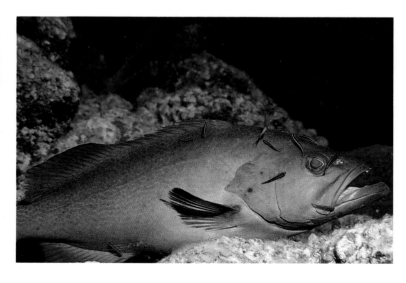

A young yellowmouth grouper (*Mycteroperca interstitialis*) is swarmed over by nine cleaning gobies (*Gobiosoma*) and a juvenile Spanish hogfish (*Bodianus rufus*).

In some ways the most isolated and unusual of all the coral kingdoms lies just off America's shores. At one time in the history of the Caribbean, it lay deep in Pangaea, almost at the heart of the mega-continent. As the continent slowly moved, the deep Atlantic opened to the east. What are now North and South America drifted apart, and this gem of a sea was formed. Its western boundary for much of its history has been the land bridge between North and South America. During prior epochs there were long periods in which this barrier was inundated, changes in water levels and landmasses causing the oceans to rise above their shores. It was during those eras that species were massively interchanged between the two seas.

This land bridge—by its political name, Central America—has been geographically much the same for the past one and a half million years. It is a complete barrier to the widespread migration or interchange of marine species between the Caribbean and the Pacific. (A small breach in the barrier was caused by the construction of the Panama Canal, and there are certain Pacific fish, invertebrates, and corals that have apparently been brought to southern Caribbean islands on the hulls of ships. For most species, however, the separation has been complete.)

This separation has caused Caribbean species to evolve in parallel but separate paths from their Pacific relatives. It is out of this history that the Caribbean's unique coral reef fauna has arisen. The two seas, for example, share families of marine creatures that clearly had common ancestors. Caribbean butterflyfish, angelfish, eels, and many others are morphologically very similar to their Pacific relatives.

While many families and genera from other seas are represented here, some are entirely lacking. Neither sea snakes (Hydrophiidae) nor the crown-of-thorns starfish (*Acanthaster*), two important Pacific species, are found in the Caribbean. The lack of crown-of-thorns starfish, an important predator on Pacific corals, may have caused an evolutionary divergence between Caribbean and Pacific corals. Many Pacific corals are dense and squat, while Caribbean corals tend toward delicately branching structures. In part this could be because Caribbean corals have never known the overwhelming attack of the crown-of-thorns, the effect of which we'll see in later chapters.

◀ On the huge coral precipice off Grand Turk Island, a diver is dwarfed in the distance (Turks and Caicos).

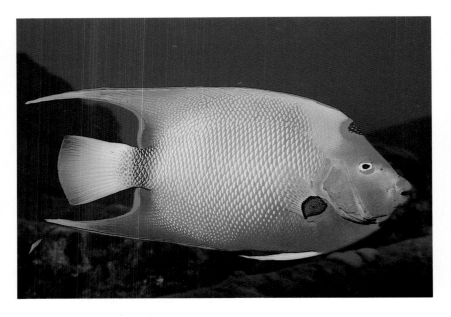

One of the gaudiest of Caribbean fish is the queen angelfish (*Holacanthus ciliarus*) (Grand Cayman).

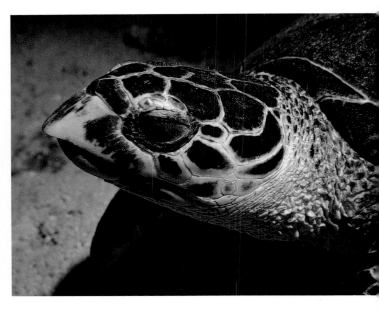

The head of the hawksbill turtle (*Eretmochelys imbricata*) found in Roatan.

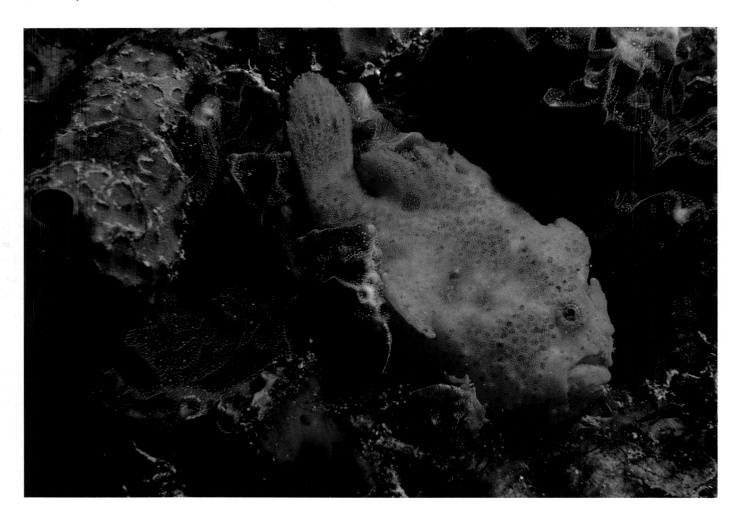

The unusual orange frogfish (*Antennarius multiocellatus*) uses a lure on its forehead to attract small fish, which it instantly engulfs.

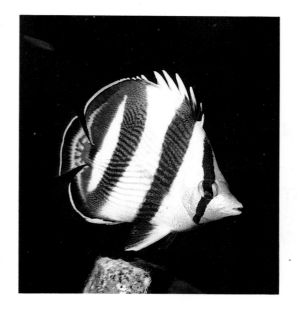

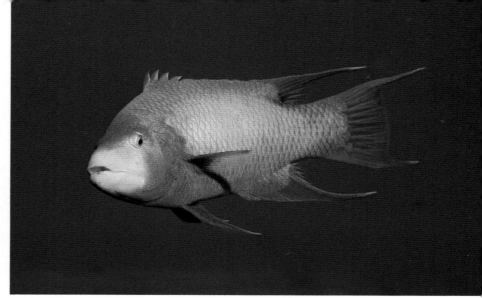

Those genera that are represented here have evolved to be superficially rather different from their Pacific relatives. The Caribbean butterflyfish, for example, tend to be smaller and less bold in coloration and pattern than their Pacific counterparts. Indeed, most Caribbean inshore marine species are different in color from Pacific equivalents, and a noticeable number are somewhat smaller.

The location of the Caribbean at the western edge of a major ocean defines its currents as the western boundary type. As northern equatorial currents flow toward the west in the central Atlantic, they are diverted northward by the shores of Brazil and the Guyanas, eddy through the tropical Caribbean, and resume their powerful flow northward as the Gulf Stream.

Today's placid Caribbean waters tell us nothing of their turbulent geophysical or political history. The breakup of Pangaea and the forces then unleashed are nearly beyond our imagining; in like manner, the catastrophic years of pillaging that began there in the early 1500s are hard for us to comprehend. Ruthless explorers—Portuguese, Dutch, Spanish, French, and English—obliterated entire native cultures in their plundering quest for every sort of booty from gold to spicewood to human souls for the Church. The fabled ruins we can visit today in Mexico, Guatemala, and Peru bear witness to the magnificent societies that existed before the European conquest.

The scourge of European exploration fell heavily upon tropical island cultures throughout the coral kingdoms we shall visit. The nature of the process itself—adventurers setting out across vast, unknown seas in modest, even primitive, sailing vessels—tended to concentrate their exploration in the relatively benign tropics. The islands the explorers found tended to be peopled with undeveloped Indian tribes for whom war usually meant ritual rather than violence;

many of the tribes lived in isolation even from each other and were not aggressive, by the very nature of their island-based lives. Many native societies that were not ravaged by the guns and forced labor of the conquerors were decimated by unfamiliar maladies. The Europeans not only wiped out the long-established cultures they encountered; they also profoundly affected certain of the coral kingdoms through the overharvesting of turtles, *bêche-de-mer* (sea cucumbers), *Tridacna* clams (in the Pacific), sea lions, whales, and other species prized as food or in manufacture.

For modern-day tourist-explorers of the Caribbean the scars of these conquests are no longer visible. If one is fortunate enough to explore in a boat, away from the rows of hotels thrown up in the past decades, the pristine isolation of that long-ago past can be sensed. On many occasions I've sat on the deck of a dive boat and imagined the scene as it must have been five hundred years ago; the deserted shore of some palm-clad island would indeed have looked the same then as it does today. Entering the water enhances this intellectual teleportation, for on the reefs I search out, the marine world has not visibly changed at all. These reefs looked just like this when the Caribs and the Arawaks stood on those hot, sandy beaches fearing the winged canoes of the light-skinned invaders.

Biologically, the Caribbean is unique among the coral kingdoms, its inshore marine fauna a roster of endemic species (that is, species found only there). As we travel from one Caribbean island group to another, however, we see that the evolutionary process is ever at work. At first glance the fauna seems uniform throughout and foreign to that of other seas. In time we learn that there is significant variation by area as well as strong ties to the parent stock; while the ties to the Pacific fauna are easily accepted, there are often surprising variations from one quadrant of this small sea to another.

This banded butterflyfish (*Chaetodon* ▲ *striatus*) eyes the camera as it searches out its next meal.

▲ The dramatic Spanish hogfish (*Bodianus rufus*) photographed at Grand Cayman.

The Bahamas

While not Caribbean islands per se, due to their location on the Atlantic side of Florida, the Bahamas' position in the path of the Gulf Stream blesses them with balmy Caribbean-type weather for much of the year. The Gulf Stream also seeds their reefs with a stock of Caribbean marine species. As a result, these most northerly of the "Caribbean" islands strongly resemble their cousins to the south, at least during the summer half of the year.

The Bahamas are low-lying islands, most sitting no more than a few feet above sea level and featuring lush stands of regal palm trees that rise behind beaches of hot, white sand. Even from the window of a jet at thirty thousand feet, one can see irregular reef lines offshore from the narrow lines of beach, engulfed aquamarine haloes ending abruptly in the intense blue of deep water. The reefs are populated with enormous numbers of dark-hued gorgonian sea whips (*Gorgonacea*), and in shallow water impressive stands of elkhorn coral (*Acropora palmata*) and staghorn coral (*Acropora cervicornis*) provide shelter for colorful fish and invertebrates in an encyclopedic range of colors.

The single largest undersea attraction in the Bahamas is a colossal chasm known as the Tongue of the Ocean, lying between New Providence and Andros islands. The walls of this abyssal deep opened between two tectonic plates plunge vertically nearly thirteen thousand feet; they have hosted numerous attempts at world deep-diving records. For divers there is a special mystique about walls such as these. Soaring outward beyond the reef edge we see the precipice plunging beneath us; then there is nothing but the empty electric blue of inner space. Surely this sensation is closely related to that of mountaineering or flying—tales by aficionados utilize many of the same descriptors of awe and immensity.

There are few times in a diver's career when he or she feels more remote from civilization than in the color-sapped twilight of this deep wall. Here there is the clear sensation of being beyond humanity's reach, for better or worse. Not only can you not be reached by voice or telephone; you have gone beyond where you could be saved if trouble struck. It is at times like these that the appearance of a large shark could tip the balance between life and death.

Rising again toward the realm of the sun we re-enter the busy world of the coral shallows. While such Caribbean stalwarts as tiger groupers (*Mycteroperca tigris*) and Nassau groupers (*Epinephelus striatus*), queen angelfish (*Holacanthus ciliaris*), and four-eyed butterflyfish (*Chaetodon capistratus*) populate these reefs, there are interesting local variations. For example, the blue angelfish (*Holacanthus bermudensis*) is found on these northern reefs, but is seldom found farther south. Also in the Bahamas and Florida Keys, one can find huge schools of French grunts (*Haemulon flavolineatum*) and porkfish (*Anisotremus virginicus*), species that tend to be found as solitary individuals in the Caribbean proper.

The Turks and Caicos Islands

South and east of the final Bahamian islands lies a charming and scenic group of coral strands known as the Turks and Caicos Islands. These fascinating islands seem too isolated and somnolent to support much commerce; still, when one arrives at the airport it is amid a flood of imported electronics, clothing, and household goods. Since fishermen are usually not so well off, the visitor quickly concludes that these islands could be perfect outposts for smugglers.

Whatever the nature of the local economy, the diving here is both easy and exciting. As at other Caribbean sites these islands have broad, sandy flats lying off the beach. A quarter-mile or so from shore, a huge barrier of coral reef rising from the sand heralds the drop-off into deep water. This immense wall of coral is penetrated by tunnels and caves, with vast furrows running from its crest to depths of more than two hundred feet. During February and March humpback whales migrate through the deep channel between the Turks and the Caicos groups. Other fascinating sightings here have included a young manta ray that swam with us for hours in chest-deep water off a deserted beach.

These unsullied islands are so new to the dive-travel industry that I only established a dive cruiser here in 1983. I expect to send many divers here over years to come, to make their own discoveries in these bucolic islands.

The Virgin Islands

Due east from Puerto Rico, the Virgin Islands have been blessed with attributes that have led to a spectacular growth of tourism. Dozens of hotels, frequent flights, and American ownership have made them a mecca for Americans seeking the nearby tropics.

The topography of the region has made it one of the most popular sailing areas in the world. Dozens of islands provide calm lees and bays to host the most inexperienced sailor. The same topography that provides great sailing, however, tends to weaken the quality of the diving. In general, in all the coral kingdoms we shall see that clear-water reefs usually require immediately adjacent ocean deeps; the tides and currents of open-ocean water sweep away particulate matter generated by reefs and their often-associated landmasses. Conversely, scattered islands on a shallow platform of seafloor anywhere in the world tend to create reduced visibility or less abundant marine growth or both. An area like the Virgin Islands (and, as we shall see later, the Great Barrier Reef of Australia) represents large, complex baffles through which tidal water ceaselessly churns; the open-ocean water gets no chance to flush away such visibility-affecting matter as rain runoff, stirred-up sand, and the detritus of reef decay. This can be seen most clearly in some Pacific lagoons where incoming tides mean crystal-clear water, while outgoing tides often reduce visibility in the same sites to as little as forty lateral feet.

The Virgin Islands do boast three unusual undersea attractions, two of them, interestingly enough, man-made. Off Salt Island in the British Virgin Islands is the wreck of the steam-packet *Rhone*, which foundered and was broken during a fierce hurricane on October 29, 1867. The stern section lies in shallow water, the propeller a mere dozen feet below the surface. The bow lies some distance away in ninety feet of water, a great mute shadow evoking the terror of its death.

As often happens (curiously enough, in areas of otherwise unimpressive marine growth) a shipwreck may occasion the formation of a spectacularly rich marine community. In shallow sections of the wreck, for example, schools of goatfish (*Pseudupeneus*), grunts (*Haemulon*), and squirrelfish (*Holocen-*

trus) hover in twisted metal caverns. They evidently see no difference between a coral crevice and one made of metal as protection from predators. On the deeper sections of the *Rhone*, large colonies of nocturnal corals cover the shadowed metal, while in the darkened interior of the bow two enormous jewfish (*Epinephelus itajara*) hover. When divers approach one end the jewfish drift out the opposite side and lazily cross the open sandy bottom to alternate hiding places, only to return to their great metal cavern when the divers have left.

A quite different undersea experience in the Virgin Islands occurs at the pier at Frederiksted on Saint Croix. Here in the bright sunlight we see a forest of wooden pilings, seemingly barren and even hostile to marine life. To our surprise, when the sun goes down a near-magical transformation takes place. Entering the dark water armed with powerful hand lights, we spy unusual and exotic marine creatures seldom seen on the nearby reefs thronging this great wooden forest. Seahorses cling with their prehensile tails to colorful finger sponges; arrow crabs (*Stenorhynchus*) prowl, on the lookout for tiny crustaceans to eat. On the open bottom the human visitor finds pufferfish (*Sphaeroides*) buried up to their eyes in the white sand, and batfish (*Ogcocephalus*) and spotted drums (*Equetus punctatus*), usually very shy, moving about in plain view. Sleeping goatfish (*Pseudupeneus*) in their brilliant nocturnal colors, and even wandering moray eels, are everywhere.

It is a community that eschews the normal "sheltering thicket" form of coral reef, yet its members seem to thrive. This may be because many of the predators that prowl coral reefs are not comfortable in this completely revealing environment. They usually strike from ambush out of a complex, concealing background, which is lacking here. Perhaps as a consequence of this, we see very few predators at the Frederiksted pier.

The third noteworthy feature of the undersea Virgin Islands is the colossal labyrinth of tall elkhorn corals off the coast of tiny Buck Island that has been the first glimpse of the undersea world for many thousands of scuba divers. Identifying plaques have been placed amid the coral, as the area has been designated an underwater national park. The scene is a remarkably beautiful tapestry of living corals a mere few

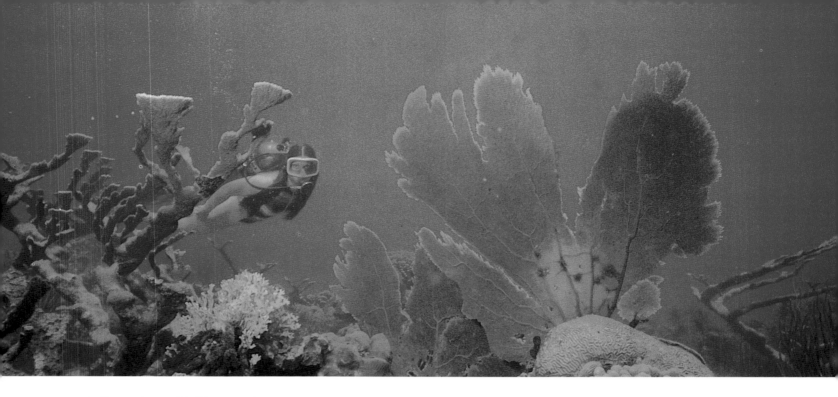

A diver swims amid elkhorn corals and gorgonian fans on a shallow reef in the Virgin Islands.

Schools of fish seek refuge in the artificial shelter offered by the wrecked *Rhone* (British Virgin Islands).

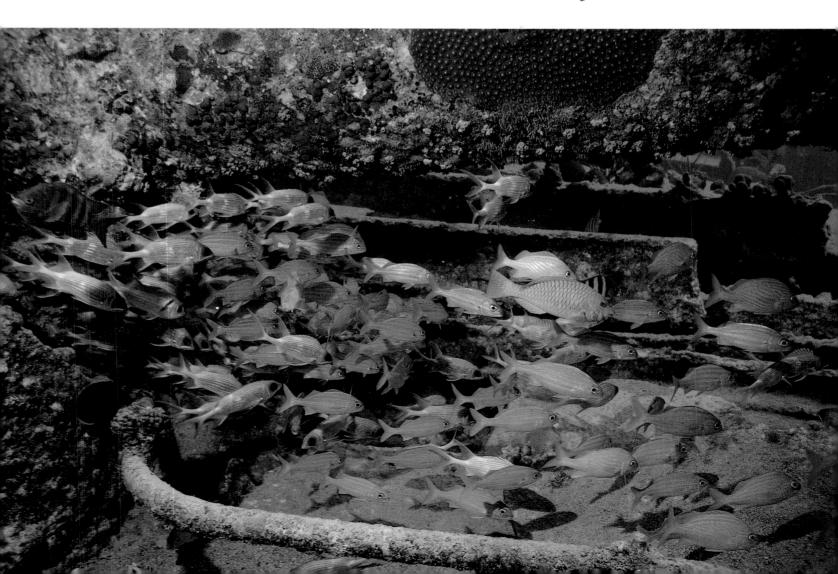

feet from the surface. Visitors using snorkels and floating on the surface can sample the wonder of the living reef at close range; many of these novices have moved on into scuba diving and full-fledged underwater exploration.

Guadeloupe, Dominica, Martinique, Saba, Saint Lucia

The coral reefs in the eastern Caribbean are influenced by the cool waters of the Atlantic Ocean. Since corals' temperature tolerance is quite limited, cool water generally means weak reef development. For this reason the islands of the eastern Caribbean have had a poor reputation among divers.

Occasionally, however, in traveling the world beneath the sea, one will find an unexpected gem, a place of great beauty in a region of otherwise weak development. On islands such as Guadeloupe and Dominica we find examples of unusual boundary conditions: coral growth is quite inhibited on the eastern (Atlantic) coasts, while a few miles away on the western (Caribbean) coasts, corals and their associated marine life form isolated communities profuse enough to challenge the very best in the Caribbean.

Another phenomenon that is found in these isolated zones could be linked to the localization of profuse marine life. On Guadeloupe we find the massive volcano Soufrière, and, off the coast of nearby Pigeon Island, vents of volcanic hot water rise from the reef. Immediately adjacent to these vents coral growth is suppressed by the high temperature of the escaping hot water, which creates a gully or hole in the coral beds. All around the gully, however, the marine growth is

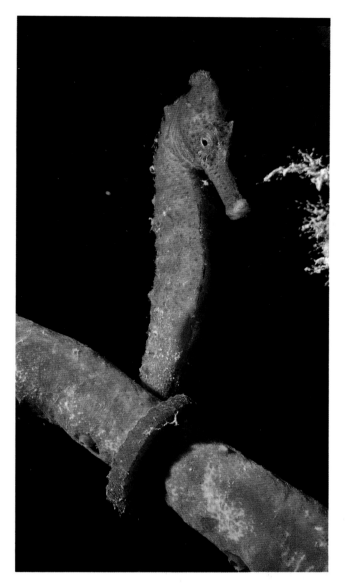

On a piling of the pier at Frederiksted, Saint Croix, a sea horse (*Hippocampus reidi*) clings with its prehensile tail to a finger sponge.

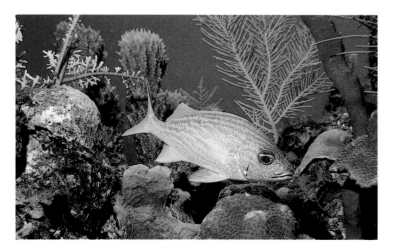

Amid a reef-top scene of corals, gorgonians, and sponges, a French grunt (*Haemulon flavolineatum*) spots a human intruder.

A male princess parrotfish (*Scarus*) sweeps above gorgonians bent over by a current.

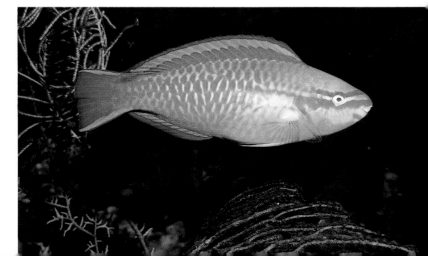

especially impressive. In fact, the vents seem to be integral forces in the life of these reefs. Reliable observers even describe large groupers hovering above the vents, floating on the jets of steam-heated water as if lounging in a hot tub.

Not far from one vent are some prodigious colonies of large tube sponges. One species features three-foot-tall purple tubes frosted with snowcap-like white, which creates an effect I've seen nowhere else in the Caribbean. The fish life in these areas of rich development is also truly impressive. I've had large porgies (*Calamus*), normally shy fish, hover next to me like pesky dogs, looking for a handout of sea urchins. Another aggressive beggar is the hogfish (*Lachnolaimus maximus*), like the porgy, normally quite reticent. Schools of yellowtail snappers (*Ocyurus chrysurus*) and several species of wrasses also plague any diver who brings a bag of fish scraps or extracts a sea urchin for feeding.

The irregular pattern of reef development extends all through the eastern Caribbean from Saba to the Grenadines. The diving is generally poor, due to the proximity of cool Atlantic water, but there are isolated outbreaks of splendid reef development. While these enclaves are difficult to find, the encounters they offer with the reef inhabitants are choice and rewarding experiences.

The ABCs and Adjacent Islands

Off the Venezuelan coast northwest of Caracas is a series of seamount islands, underwater mountains, in deep, clear water whose marine life is prolific and dramatic. Held for generations by the descendants of Dutch explorers, the islands of Aruba, Bonaire, and Curaçao (the Netherlands Antilles or the ABCs) have developed unevenly. Aruba and Curaçao have large refineries, substantial human populations, and heavy tanker traffic, which have severely affected the marine life along certain portions of their coasts. Tiny Klein Curaçao to the south and Bonaire to the east have escaped much of this development, to the benefit of their marine societies. Further east, the island groups of Islas de Aves and Los Roques are completely uninhabited; these remote

islands are jealously guarded by Venezuela, for they are important fishing grounds as well as potential staging points for guerrilla infiltrations. Diving expeditions in the Aves have been pounced upon by machine-gun–toting Venezuelan marines; to dive here have your papers in order.

The reef life on the slopes of the ABCs is quite beautiful, particularly in the zone from the surface to perhaps fifty-foot depths. In this sunlit region coral growth and the inevitable processes of reef decay have produced magnificent coral-filled shallows in narrow bands along the coasts. The floor of these gently sloping shallows is composed of coarse white sand; scattered everywhere are structures of the massive building coral *Montastrea annularis* as well as fluted colonies of the fire coral *Millepora alcicornis*. In some areas the larger coral bastions rise twenty feet above the sand, creating coral cities honeycombed with tunnels, passageways, and crevices that provide shelter for extraordinary populations of reef fish. The protection offered by the reefs of these islands is especially advantageous to such serranids (groupers) as the coney (*Cephalopholis fulva*), the graysby (*Petrometopon cruentatum*), the tiger grouper (*Mycteroperca tigris*), and the Nassau grouper (*Epinephelus striatus*). Sadly, over the decades since World War II, legions of spearfishermen have relentlessly hunted the larger grouper species without understanding the effects of their undersea depredations.

While the pressure from fishing has occurred all over the world, it has special meaning for me here. I lived in and dived these islands for three years, joined in the political education process that led to laws protecting the marine life, and suffered the pangs of diving comparatively empty reefs that once had thronged with the most vibrant of the sea's creatures. Of the three islands Bonaire alone has subsequently—in 1979—made its reefs a marine park.

Ironically, it was the spearers' attempt to kill only big groupers that ultimately led to the fishes' annihilation here. What the hunters didn't know was that in many species of groupers the only fish capable of breeding are mature individuals that have undergone sex reversals. My spearing friends often left the smaller groupers alone on the mistaken assumption that by leaving *any* population they assured a plentiful future for the species. The mature, breeding individuals were thus soon wiped out without having a chance to

reproduce. Soon the spearers were prowling grouper-free reefs, shooting eight-inch squirrelfish and soldierfish to sate their hunting drive. (I use the words "hunting drive" advisedly because there is often such a powerful force among natives learning to dive tropical reefs. A young porter in a hotel recently saw my equipment in an elevator and told me he had snorkeled for the very first time the prior weekend. I asked whether he looked forward to diving with an air tank and camera. "Oh no, sir," he said. "Those equipments are very expensive here. I'm going to get a big speargun." And so it goes.)

I have taken the lessons of the Antillean reefs with me all over the world: the breeding and living patterns of target species must be studied and understood before hunting exterminates them. This is as true in massive commercial harvesting of shrimp, tuna, and other food fish as it is in spearing groupers, snappers, and hogfish on tropical reefs. We are allowing the buffalo hunts of the 1800s to be re-enacted in our seas, to our shame; as the stock of these species dwindle, it could also be to our peril.

It is sometimes hard, when sitting on a boat looking out over the brilliant, sun-drenched reefs, to believe that anything could eradicate that incredible beauty. I remember the amazed response from local political leaders when biologists urged outlawing spearing, coral collecting, and unselective trapping in the Netherlands Antilles. They saw the sea as brimful of fish and incapable of being overharvested. They then, of course, had to face the rather less pleasant truth: particularly in tropical seas, the open ocean waters are quite barren. Biomass, the life upon which we in turn live, is concentrated in narrow and fragile bands along the coasts. These narrow bands are those areas in which two conditions are met: a substrate upon which the corals can take root must exist and the water must be shallow enough for sunlight to penetrate.

Here we encounter one of the major differences between Caribbean and Pacific reefs. As we shall see in later chapters, there are free-standing reefs in the Pacific with no land nearby. Some of these reefs have a characteristic circular shape and are known as atolls. They are formed by a process called subsidence, in which seamount islands slowly sink as the tectonic plates upon which they rest slide beneath adja-

cent plates; this slow sinking enables their surrounding coral colonies to continue their vertical growth toward the surface. In time, the central island sinks completely, and the characteristic coral atoll with its empty inner lagoon is left. One hundred years ago, Charles Darwin postulated sinking islands as the necessary ingredient to produce atolls, long before tectonic theory provided the underlying mechanism for the subsidence he visualized.

In the Caribbean the seamounts are not located on the sinking edge of tectonic plates; as a consequence there is a dearth of atolls here. With few exceptions the reefs are of the fringing type, immediately adjacent to land, and for this reason they are more likely to have neighboring native populations engaged in netting, spearing, hand-lining, and otherwise harvesting their life.

The physical characteristics of Caribbean reefs and islands are more a consequence of rather sudden water-level changes during ice ages than they are of long, slow tectonic change. On Bonaire and Curaçao there are three distinct bands of erosion visible today that were caused by former sea levels. One is nearly 140 feet below today's sea level, while another is almost one hundred feet above the sparkling surface upon which we sail.

Cartagena, Colombia

Diving conditions near continental landmasses are normally affected by river runoff, which severely limits visibility. One fascinating example of this phenomenon is encountered when diving near Boca Chica and the Islas Rosario (Rosary Islands) off the coast of Cartagena. Fresh silt-laden river water overruns denser seawater; the result is a layer of seemingly impenetrable murk overlying the clear seawater. I've often stepped gingerly out of a dive boat with full equipment, knowing that the bottom was only a few feet below, but being unable to see it.

After penetrating the silt zone one breaks out into relatively clear, but dark, water. The sunlight is almost completely screened, and we swim about in eerie half-light. Soon we see differences from other, clear-water, Caribbean areas.

The porkfish (*Anisotremus virginicus*) occurs in vast schools in the Florida Keys, but only as solitary individuals in the Caribbean proper (Lighthouse Reef, Belize).

A small member of the grouper family, the indigo hamlet (*Hypoplectrus indigo*).

The well-known Nassau grouper (*Epinephelus striatus*).

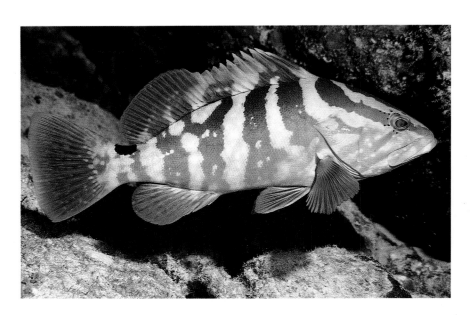

The shy taillight filefish (*Cantherhines pullus*) bolts into a coral crevice and raises its trigger when frightened. With the trigger locked in place, the fish cannot be pulled from its shelter (Bonaire).

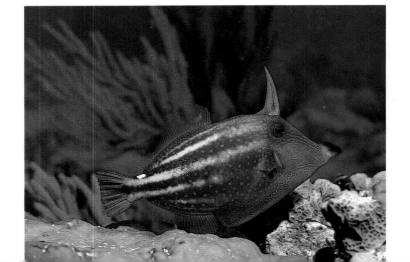

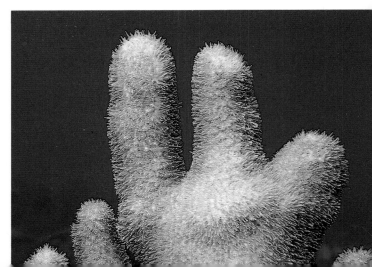

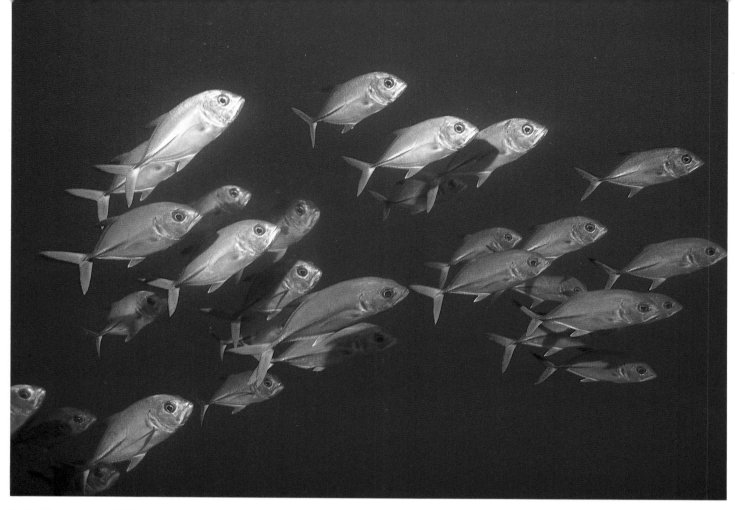

In the blue waters off Lighthouse Reef in Belize a school of horse-eyed jacks (*Caranx latus*) sweeps in to investigate human intruders.

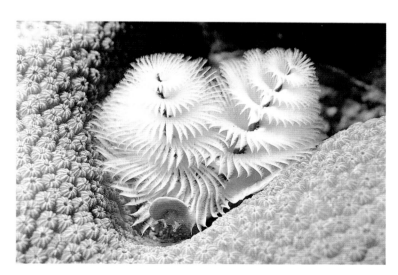

One of the two major types of worms to inhabit Caribbean reefs, sabellid worms (*Sabella*) construct a tube of mucus and sand to hide their bodies.

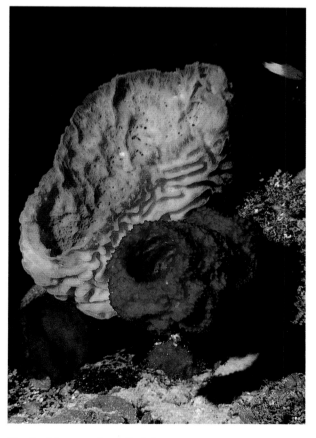

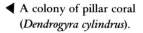 A colony of pillar coral (*Dendrogyra cylindrus*).

On Caribbean reefs we find that sponges of different species live in close proximity (Belize).

The fish life and coral development are affected by frequent blocking of the nurturing sunlight, though in some shallow areas enough light penetrates to produce coral beds of great beauty. There are thick carpets of delicately branched coral, which break if accidentally touched. Here and there huge craters signal the activity of dynamite-fishing; in Cartagena there are many one-armed cigarette-vendors whose former occupation is all too obvious. Further offshore, some ten miles from the coast, islands in clearer ocean water have more profuse corals, which support a denser reef population.

Bay Islands of Honduras

Roatán, Guanaja, and Utila lie off the coast of Honduras, far enough from the mainland to have been spared the problem of freshwater runoff. Surrounded by narrow bands of reef, then abrupt, plunging drop-offs into deep water, Roatán is a perfect example of the vulnerability of Caribbean reefs. It would not take a large population of fishermen to sweep clean reefs that are so narrow and so shallow.

Along some stretches of the southern coast there are drop-offs that plunge vertically nine hundred feet. This type of diving is extraordinarily dramatic by its very topography; when the precipice is festooned with colorful and exotic marine life, it defines an example of the world's great diving. Again and again as we travel the coral kingdoms, we shall find these open-water precipices combining clear water with rich reef communities and larger pelagic animals such as rays, jacks, tuna, and sharks. This is not to say that great reef development or world-class diving *requires* a deep-water precipice; there are spectacular exceptions such as the famous pinnacles in the Coral Sea off Australia, which we shall explore later. To my mind, these magnificent exceptions tend only to prove the rule.

The Bay Islands' marine fauna closely resembles that of Belize to the north, with some exceptions that bring to mind my earlier observation: a knowledgeable diver dropped onto a Caribbean reef has a reasonable chance of identifying the locale by the local fauna. The presence of enormous stands of pillar coral (*Dendrogyra cylindrus*), large numbers of black-cap basslets (*Gramma melacara*) at depths of 150 feet or more, and tall, graceful azure vase sponges perched out over the abyss here speak specifically of the Bay Islands.

Belize

One of the largely unspoiled wonders of the Caribbean is Lighthouse Reef, some sixty miles out to sea from the coast of Belize (formerly British Honduras). My visits to these exquisitely rich gardens of coral and fish are always tinged with sadness, because I realize that riches like those of Belize were once everywhere in the Caribbean. This realization is not merely my own personal reaction; it is a distillation of stories heard from hundreds of old-time fishermen and spearmen. There are men in their forties and fifties today who, as teenagers, speared off the upper Florida Keys when they were rich and clear, men in their thirties who knew Curaçao, Cozumel, Cayman, and other islands when they swarmed with big reef predators such as groupers and snappers.

Today, at Lighthouse Reef, one feels transported back in time, for on these reefs the big groupers still roam. Lighthouse Reef is a flat-topped seamount surrounded by miles of coral-flecked sandy shallows lying ten to twenty feet deep. Its flanks are sheer, so that clear open-ocean water flushes the sand and debris from the shallows and produces generally clear conditions for diving. During tidal outflows there are zones of particulate concentration that discolor the waters of the western rim. Ironically, the richest fish life gathers during these periods of low visibility because along with the discoloration come concentrated areas of good feeding. For the photographer the seeming cosmic injustice of this situation brings good-humored frustration: if only the big fish would gather in *clear* water. While clear water is great for photography, one soon learns that it has a much lower nutrient density.

With one spectacular exception diving at Lighthouse Reef takes place along the western rim or crest of the reef. Prevailing easterly winds provide for leeward, calm conditions during much of the year. Miles of coral-dotted sand shallows abruptly give way to a coral-lined precipice. The shallows

merely end, and the plunging wall drops away from the level of the sand without any vertical coral structures to mark the transition. This drop-off is decorated with profuse stands of gorgonian sea whips, black corals, sponges of many colors, and lush populations of tropical reef fish ranging from small grunts (*Haemulon*) and goatfish (*Pseudupeneus*) to gaily colored butterflyfish (*Chaetodon*) and angelfish (*Pomacanthus*).

That description, however, could apply to dozens of Caribbean reefs. What distinguishes this superb preserve is precisely those species that have been exterminated on other reefs: curious Nassau groupers (*Epinephelus striatus*), tiger groupers (*Mycteroperca tigris*), yellowfin groupers (*Mycteroperca venenosa*), yellowmouth groupers (*Mycteroperca interstitialis*), hogfish (*Lachnolaimus maximus*), cubera snappers (*Lutjanus cyanopterus*), and others. When a massive hogfish swims right up to you, you realize you've never seen enough of these superb animals before to understand their name; suddenly you see that large adults develop a distinctive hoglike snout.

The hogfish (or roosterfish, because of its long first three dorsal spines) is slow-moving, reasonably curious, and—to its peril—a delicious fish. This last characteristic has on many reefs brought this spectacular fish to the brink of eradication. On the sunny Belizean reefs, however, it is common to see a half-dozen or more of these placid, alert browsers on every dive. Like many other fish we shall meet in our travels, the hogfish has the ability to change color to blend into its background. Over clean sand it turns nearly white; in the shadows it flushes a deep pink to red. In the color-filtered twilight of the mid-depth reef, these red shades look deep gray to black.

Seeing so many groupers brings other truths to mind. In the wild a grouper instinctively goes to ground when a predator enters its range. Reputedly intelligent, the groupers often retreat to a coral shelter whose entries are simply too small for a threatening shark or jack to enter. When I lived in the tropics I learned diving from some highly efficient spearmen who used the fishes' defenses against them; when a grouper went to ground and hovered in its lair curiously eyeing the intruder outside (a strategy that has protected it and its ancestors from eons worth of sharks), the hunters would simply shoot through the openings.

What was clear from this experience was the entirely new dimension of threat people bring to the reef community. Their persistence in scouring the same accessible reefs again and again, their killing for commercial tonnage rather than for only their own consumption, and, finally, their foreign methods of attack doom any community they target.

These dark thoughts clamor at the mind on a balmy day off Lighthouse Reef. It becomes clear that only the relative inaccessibility of this coral community has saved it until now. The comparative impoverishment of Belize has prevented its fishermen from using modern techniques and equipment this far offshore. That could, of course, change, but for the moment the magic of the past lingers.

One day not long ago we anchored off a particular effluent pass on the western rim. In the late afternoon sun we wandered amid gardens—hothouses—of coral. Suddenly, out of the gloom a seven-foot manta ray appeared. These gentle giants fly like gigantic butterflies through the water with their huge mouths held open. In a manner similar to that of baleen whales, they strain tiny shrimp and plankton from the water they ingest, nourishing their huge bulks with the tiniest of the sea's creatures. Rays are elasmobranchs, having cartilaginous rather than bony skeletons, like sharks. Mantas have been reported with wingspans of twenty feet or more, weighing several tons. Yet they are the most inoffensive of creatures, burdened for centuries with the name "devilfish" by fishermen ignorant of their true nature.

After a brief but exciting encounter with us that day, the ray faded into the gloom. The next morning, bright and early, we entered the water in hopes of seeing our friend once again. During the next four hours first one, then another, then a third, and finally four of these mind-bending apparitions came to join us. In brightly lit, gradually clearing water, they circled us, soared over us, performed acrobatic loops, and obviously studied us with curiosity. Their charming nature seemed most apparent when after an entire morning the four swam in unison away from us out over the drop-off into open blue water. We followed to the precipice, but were reluctant to venture out over the deep blue. As we watched our huge friends fade into the distance, we were surprised to see them wheel and return to us for a final few minutes of what to this day seems like play, the fun and games of an exotic interspecies playground.

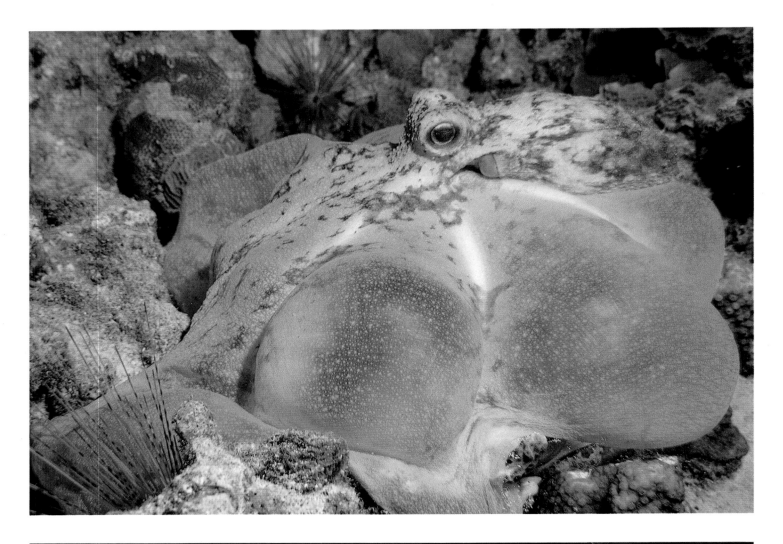

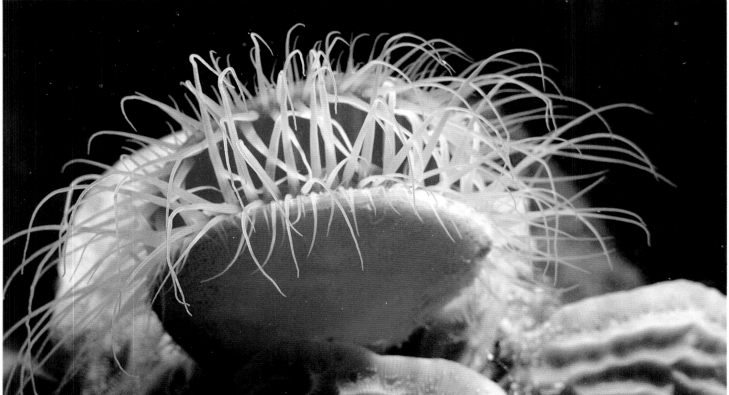

The file shell (*Lima*) inhabits crevices
in coral heads to protect itself from
predators.

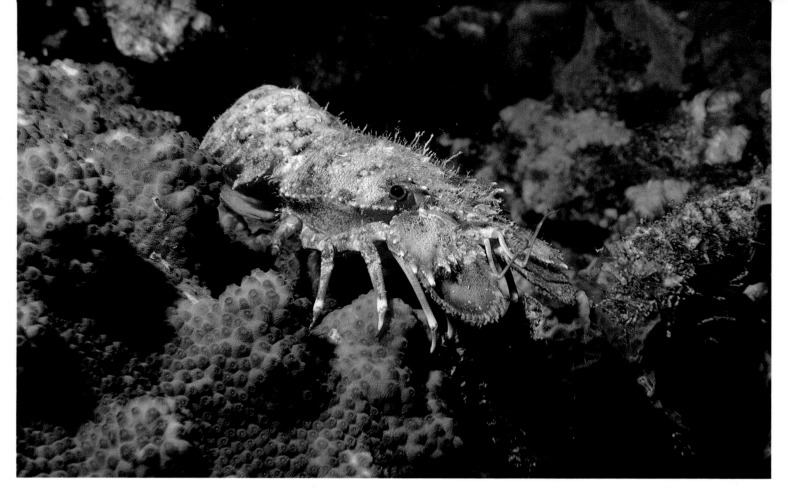

◀ An octopus, photographed at night, flares its skin to appear larger. This iridescent green color is seen almost exclusively after dark (Grand Cayman).

▲ This nocturnal creature is known as the elegant slipper lobster (*Scyllarides nodifer*) (Grand Cayman).

▼ A pair of barbershop shrimp (*Stenopus hispidus*) struts on the rough surface of a giant barrel sponge (Grand Cayman).

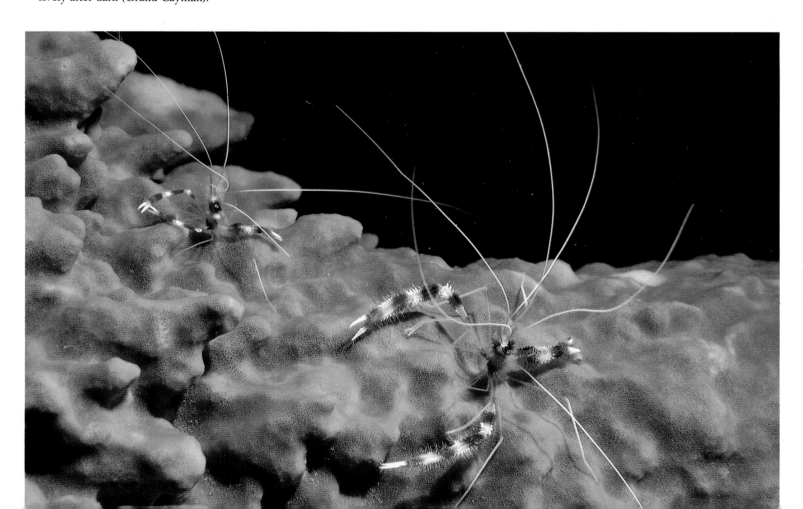

The arms of a brittle starfish (*Ophiothrix*) are visible on a colorful tube sponge (Grand Cayman).

A one-inch-long triple-fin blenny (*Enneanectes jordani*) is almost invisible on a blood-red sponge (Cayman).

Cozumel, Mexico

Two hundred miles north of Lighthouse Reef is an equally massive coral edifice with a totally different modern history. At the southern end of Cozumel Island, off the coast of Mexico's Yucatán peninsula, a massive reef rampart plunges some thirteen hundred feet to the floor of the Yucatán channel. For perhaps two miles this great coral fortress, called Palancar, soars from the depths, replete with crenellated turrets, honeycombs of passageways through the reef mass, and vast canyons of sand occasionally breaking through the coral bastions.

At one time forests of black coral grew here, and giant sea bass, big groupers and snappers, barracuda, and sharks enliv-

ened everyday encounters for early undersea observers. This reef, however, never had the protective barrier of a sixty-mile crossing to protect it. It is a mere mile offshore from a well-developed island with daily airline service, hotels, dive boats, and tourists in profusion. In the sixties Cozumel became a mecca for underwater hunters and black-coral collectors. They came by the hundreds, ripping out ten-foot black-coral trees to make pieces of one-inch-long jewelry and killing the curious groupers with huge spears at point-blank range.

As a result the contrast between Palancar Reef off Cozumel and Lighthouse Reef off Belize could not be more profound. Since the origins of these reef structures are very similar, the profundity of that contrast should speak powerfully of the damage that can occur in a mere twenty years. In the past few years there has been a serious effort to reverse the decline of what in the sixties was *the* dream reef, and there have been gratifying signs that Palancar's reef community can recover if completely protected. It may take another human generation, but that is a mere instant in the life of a mature reef. It would be a triumph of human good sense if Palancar could return to its lost glory in our time.

The Cayman Islands

East of Cozumel and due south of Cuba lie the Cayman Islands, where the lessons of Cozumel have not been lost. The Caymans soar from abyssal depths of fifteen thousand feet—at the edge of a tectonic plate along Grand Cayman's south coast—to glittering aquamarine coral shallows. Some twenty years ago the reef life here would have matched that of Lighthouse Reef or Cozumel's Palancar as they were at that time.

Something striking happened in the Caymans. After some damage had been done to the reef, local entrepreneurs banded together in the seventies to promote laws against spearing and coral collecting. As a result the explosive building boom in hotels has not been accompanied by a disastrous decline in reef life. True, the normal wear and tear on a reef even by well-intentioned divers is noticeable in many frequently dived sites; flippers kicking sand over corals and hands grasping (however briefly) for locomotion do inflict damage. Still, the reefs are remarkably well preserved considering their proximity to such a commercially developed tourist center.

In fact, the reefs of Grand Cayman show some interesting patterns from which we can anticipate future problems in reef ecology. For example, Grand Cayman has a roughly square base, with prodigious reef development on its three long sides—its north, west, and south coasts. The principal hotel development has been on the usually sheltered west coast, where condominiums and hotels line what is called Seven-Mile Beach.

Most tourist divers are taken to sites within a mile or two of this area so the dive operator can dive his customers, promptly return them for lunch, and refill his tanks for an afternoon trip. This means that the wear and tear of thousands of divers is essentially limited to the western coast and its associated reefs, and the north and south coasts are spared. These shores thus offer the pristine and exciting diving one seeks, but they are rarely visited. I've spent weeks working the north coast and never spotted another dive boat.

What happens, however, if the dive operators acquire faster vessels or in some other way increase their access to the north and south coasts? Then these reefs would inevitably decline, if only from unavoidable wear and tear.

For now the north coast of Grand Cayman and the similar northern wall of Little Cayman feature spectacular adventure in the sea. On a single dive on Grand Cayman's north wall not long ago, I enjoyed a hammerhead shark, two eagle rays, three large stingrays partially buried in the sand, and a shoal of eighty silver tarpon. All of this lay at the crest of a precipice that plunges at least four thousand feet. It is this type of dive that helps define what a world-class diving area really is. It is thrills and excitement and awe and wonder at what undamaged nature normally provides.

In the Caymans there are more colors and types of sponges than anywhere else in the world. Soaring down the plunging reef walls, one sees gigantic barrel sponges large enough to hide a diver, blood-red tube sponges, orange tube sponges, and other bursts of gaudy color. There seems no reason for these intense colors in an environment from which most color has been filtered. Seawater disperses light so effectively that in depths greater than thirty feet, blue is overwhelmingly predominant. In this azure world blood-red sponges appear gray-black and canary-yellow specimens, a dull off-white. Only in a beam of artificial light are the true colors revealed.

Why these spectacular colors in a monochrome world? What purpose can they serve? Until a diver intrudes with powerful beams of light, a sponge may have lived dozens or hundreds of years in Stygian gloom. Is the color meaningless, a coincidence of diet like the pink of a flamingo? Or is there some purpose we've never fathomed?

Our travels in the Caribbean have shown us an enclosed sea whose fauna is ever threatened by development. In a few areas we can still see how it was before the numbers of fish and coral being harvested increased, before people dynamited lagoon walls to construct marinas, and even before there was a constituency to protest such actions.

As we move on about the world, these symbols of warning will come to mind again when we visit unspoiled areas these pressures have not yet reached. One persistent realization we shall face is that the number—and safety—of such reefs is slowly dwindling.

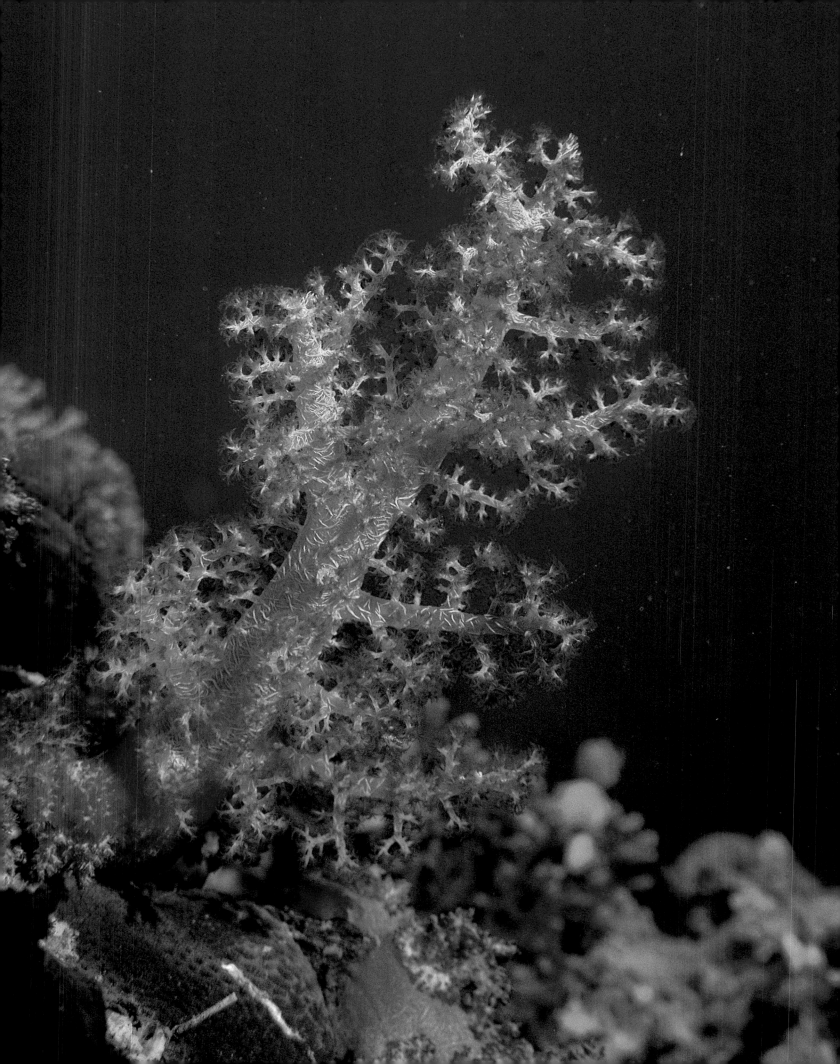

Chapter Two
The Red Sea
WHERE THE ETERNAL DESERT ENDS

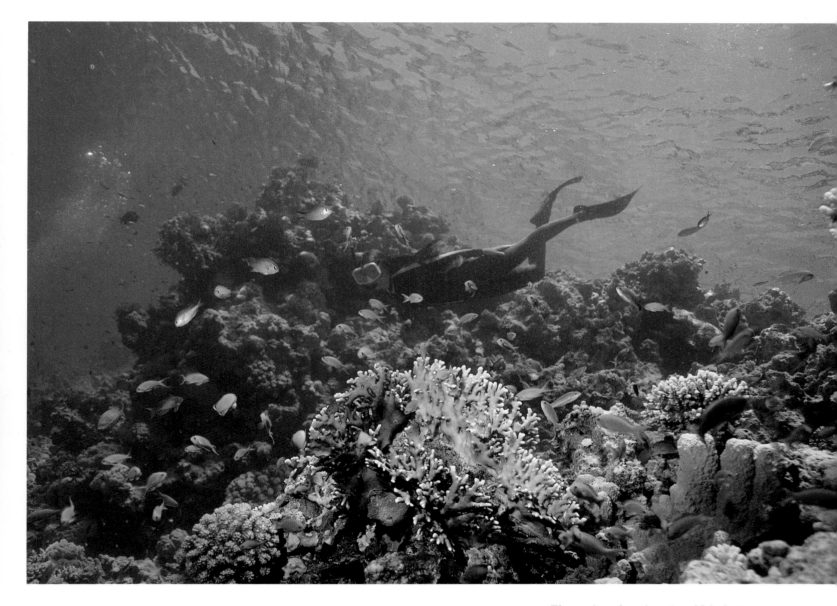

The garden of corals and reef fish that is
Jackson Reef.

◀ There are few creatures in the sea with
the fragile loveliness of these water-
inflated coral colonies.

The shoreline of Ras um Sidd, where the
barrenness of the desert meets the explo-
sive growth of the coral reef.

This coral kingdom lies in the most incongruous location
of any we visit, surrounded as it is on all sides by heat-blasted
rock and endless seas of sand. Indeed, as one flies over the
horizon-to-horizon desert of the turbulent Middle East, the
last sight one would expect to see is a deep, crystal-blue sea.

Tectonic history quickly identifies the Red Sea as a rift, or
crack, between slowly shifting continental plates. A system
of deep cleavages runs north-south from the Mediterranean
to the Indian Ocean, separating Africa from Eurasia with
this water-filled trench two thousand feet deep. A second

rift, creating the Dead Sea and the Gulf of Aqaba, joins the
first at the tip of the Sinai Desert. It is at this junction that a
number of truly world-class dive sites are found.

Modern history has placed one of its great dramas in this
arena, for bordering these deep, clear waters are Egypt, the
Sudan, Israel, Jordan, Saudi Arabia, and the Yemens. There
are vistas here of stark, violent visual poetry, but in the rush
of headline news about the mortal religious and political
conflicts among these and neighboring states their compel-
ling physical beauty is often completely overlooked.

A sheer drop-off to 2,000 feet lies ▶
a few feet from the coast near Ras
Muhammad.

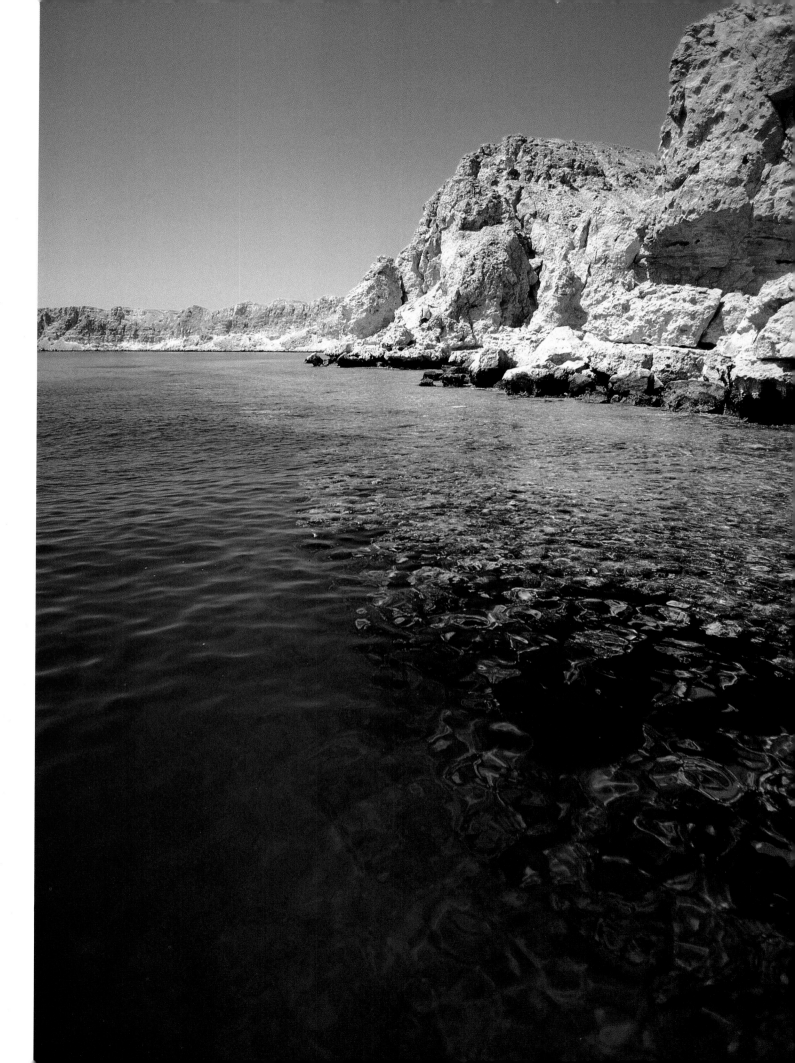

The so-called crocodilefish (*Cociella cro-codilis*) lies motionless on the sand await-ing its prey.

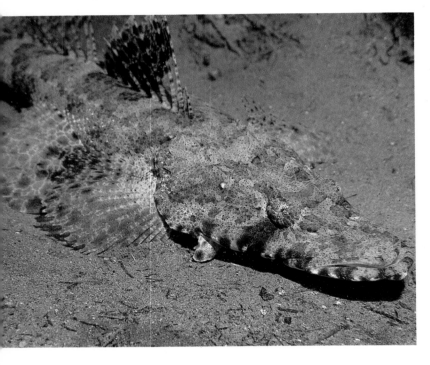

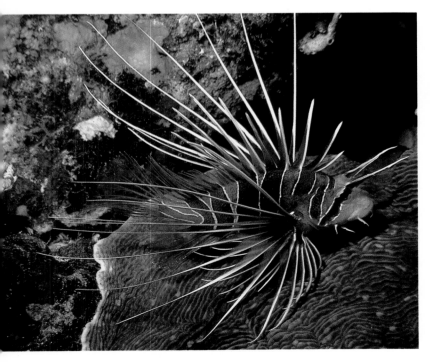

The lionfish (*Pterois radiata*).

Southern Jordan

My adventures in the Middle East started in the mid-sev-enties when I began bringing groups of divers to southern Jordan, diving along the short Gulf coast Jordan shares with its vast, empty neighbor, Saudi Arabia. At that time the coast was undeveloped, its shore sweeping quickly to the foothills of soaring mountains, immense ramparts of sandstone rearing against the blue sky. When the ever-changing light of the afternoon sun played upon these sandstone peaks, they offered a new mood every moment. At noon they were a scenic backdrop to water-skiers and wind-surfers along the beach, but as the shadows lengthened they became somber hulks in shades of roan and violet.

In those days we boarded native fishing boats in tiny Aqaba with an obligatory Jordanian soldier for company. Along the few coastal heights camouflaged military outposts sheltered other soldiers who watched in desultory fashion as we prepared to explore the gleaming coral gardens below. The waters of the Gulf are clear but cold in the spring as northerly winds move warm surface water southward, bring-ing cold bottom water up from the deep trench. This made it necessary for us to don rubber wet suits in the desert heat before we could dive.

Once we were underwater, the panorama of life more than justified our brief discomfort. Plateaus of intricate hard corals dotted with tall sculptured formations culminated in broad table corals in whose shadows forests of *Dendro-nephthya* soft corals bloomed. About each of these forma-tions hundreds or thousands of orange fairy basslets (*Anthias squammipinnus*) darted and flashed in the sunlight. In the sand valleys between the coral formations lay two-foot-long flatheads known as crocodilefish (*Cociella crocodilis*) and staring scorpionfish (*Scorpaenopsis*). On one notable occasion I observed two of these fearsome-looking scorpionfish en-gage in a swift battle that ended with the mouth of one locked on the head of the other. Along the perimeter of the coral fields, brightly colored nudibranchs browsed on ruby-red finger sponges, decorative crinoids climbed up on the oc-casional exposed soft coral, and huge black-coral trees grew at the relatively shallow depth of sixty to eighty feet.

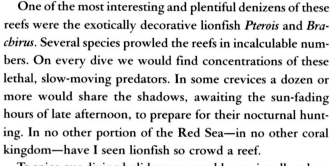

The largest of the great Nabatean tombs, El Deir, rises high atop the mountain stronghold of Petra.

One of the most interesting and plentiful denizens of these reefs were the exotically decorative lionfish *Pterois* and *Brachirus*. Several species prowled the reefs in incalculable numbers. On every dive we would find concentrations of these lethal, slow-moving predators. In some crevices a dozen or more would share the shadows, awaiting the sun-fading hours of late afternoon, to prepare for their nocturnal hunting. In no other portion of the Red Sea—in no other coral kingdom—have I seen lionfish so crowd a reef.

To spice our diving holidays we would occasionally take a day off to visit Petra. This desert stronghold was, in ancient times, the impregnable fortress of the Nabatean civilization. Twenty-three hundred years ago the Nabateans ruled the caravan routes from the East, secure in a fourteen-square-mile valley completely surrounded by thousand-foot-tall sandstone mountains. The only entrance to the valley was El Siq, a colossal crack in the mountains so narrow that potential raiders were forced to pass through in single file and be systematically annihilated. Within Petra, the "rose-red city half as old as time," the Nabateans carved gigantic polished tombs into the very heart of the sandstone cliffs. Today these perfectly preserved edifices echo the grandeur and power of the marauder kings so enticingly that many Israelis have been ambushed and killed trying surreptitiously to see them. Petra was totally lost to civilization for five hundred years until its rediscovery in the 1830s; since then Bedouin raiders have killed hundreds of would-be visitors. Now the area is administered by the Jordanian government as a national treasure.

The coral gardens of the Jordanian coast were rich and rewarding in the seventies, but the shadow of development has slowly spread over them. As Jordan's only direct access to the sea, the coral coast has necessarily become the site of ship-repair facilities, huge loading docks for phosphates mined in the desert, and military storage areas. The building and associated coral damage slowly blighted much of the marine life along stretches of what was, to begin with, a very limited coastline.

At the entrance to the lost city of Petra the spectacular tomb known as the Treasury shows the remarkable ability of Nabatean craftsmen.

At the Tip of the Sinai

Meanwhile, diving facilities were being developed one hundred miles south, where the Gulf meets the Red Sea, on the Israeli-occupied tip of the Sinai Peninsula. There, the desert plunges far out to sea on a spectacular peninsula along whose coast the coral development is awesome and, between 1972 and 1982, was protected as an informal preserve. The Israelis' occupation was a boon for the marine wildlife of these waters; the larger species of edible fish had for years been in danger of extermination by European spearers who had long since swept the Mediterranean coasts nearly clean of fish. The Israelis instituted foresighted regulations outlawing spearing, coral collecting, and even line-fishing. As a consequence, when diving was introduced in the region, an enchanted wonderland of unthreatened, hence easy to approach, marine species was made available.

In these waters the desert's edge is at the crest of a sudden precipice that plunges to deep water. The coral gardens are accordingly quite steep, or, along lengthy stretches of coast, completely vertical. This produces classic diving, for one may be watching small fish on the wall and turn to find a large pelagic wanderer passing by.

The reefs are particularly well populated with *Millepora dichotoma* (fire coral), often found in huge clusters. These colonies frequently cap structures built by more compact, heavier coral species, producing spires that project above the reef slope. In some areas entire walls are lined with fire-coral colonies.

The great precipice, punctuated by caverns, fissures, and ledges, and dotted here and there with coral heads, plays host to a panorama of invertebrate and fish life only rarely surpassed in the world. Schools of brilliant golden goatfish swarm over the coral landscape. There are resplendent butterflyfish in their mated pairs pausing now and then to pick a dainty coral morsel. Among these are the orange-tailed butterflyfish (*Chaetodon chrysurus*) and the foot-long butterflyfish (*Anisochaetodon lineatus*). The star of the local butterflyfish show, however, has to be the canary-yellow lemon butterflyfish (*Chaetodon semilarvatus*), which occurs only here. Hovering serenely under a table coral or drifting

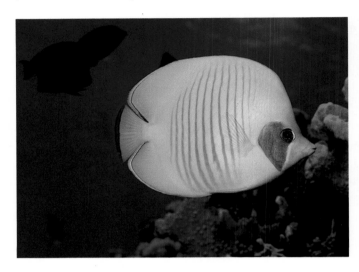

The exquisite butterflyfish (*Chaetodon semilarvatus.*)

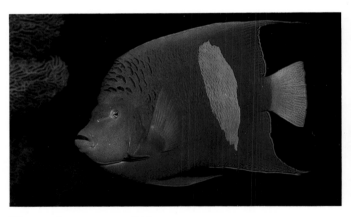

The rare large map angelfish (*Pomacanthus maculosus*).

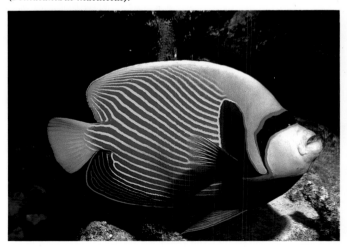

The emperor angelfish (*Pomacanthus imperator*).

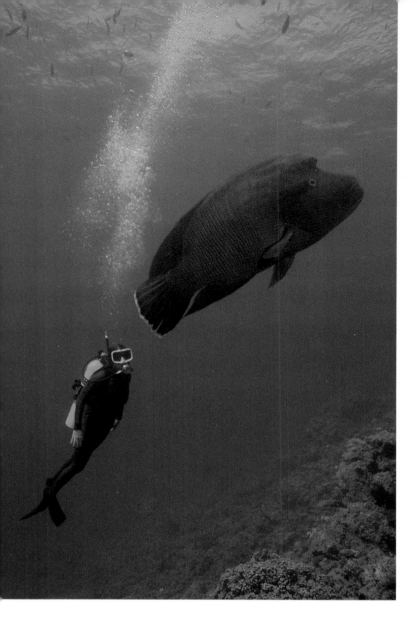

Near Ras Muhammad an enormous Napoleon wrasse (*Cheilinus undulatus*) dwarfs the diver.

slowly along the reef crest, these bursts of living sunlight lure underwater photographers as few other subjects can.

Not to be outdone, the Red Sea angelfish offer their own color show. The king angelfish (*Pygoplites diacanthus*) darts in and out of coral crevices, often sharing a shelter with its larger cousin, the emperor angelfish (*Pomacanthus imperator*). It is another endemic species, however, the map angelfish (*Pomacanthus maculosus*), that draws humans from far across the reef. Several individuals in frequently dived sites are quite bold, swimming right up to the divers as if in hopes of a handout.

Handouts are also foremost in the mind of the largest tame fish in the area. At Ras Muhammad, the final limit of the Sinai, a six-foot-long Napoleon wrasse (*Cheilinus undulatus*), the largest of the wrasse family, has been fed fish scraps often enough to make it a pest. One day I carried a plastic bag of fish scraps into the water in hopes of feeding a map angelfish that frequents the same reef span. From out of the distance the behemoth appeared, swimming directly toward me. Delighted, I raised my camera to take its portrait, the forgotten bag of scraps in my left hand. In came the wrasse, and as it filled the world before me, I took its picture. Suddenly I found that it had inhaled the bag of scraps whole! With a lofty flick of its massive tail, it churned away, pausing moments later to spit out the empty bag.

Sometimes other extraordinary citizens of these lavish reefs escape notice because they lie still in hopes of being overlooked. One of these, the blue-spotted ray (*Taeniura limma*), can be found under coral projections. I've seen these most colorful of rays in three feet of water and on deep slopes 150 feet deep or more. Normally very shy, these graceful creatures can occasionally be coaxed out for an encounter with human visitors.

Lizardfish (*Synodus variegatus*), scorpionfish (*Scorpaenopsis*), and anglerfish (*Antennarius*) are also difficult to see on the busy reef. These camouflaged predators remain stock-still until unwary small fish swim too close. Then, faster than the eye can follow, they snatch their meal. The crocodilefish use the same technique, with even their eyes camouflaged by obscuring tissue. Each of these fish blends so well with its surroundings that it simply becomes a part of its context. I've often nearly placed my hand on one without seeing it; in the

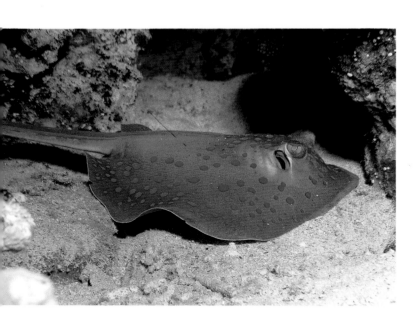

The spotted ray (*Taeniura limma*).

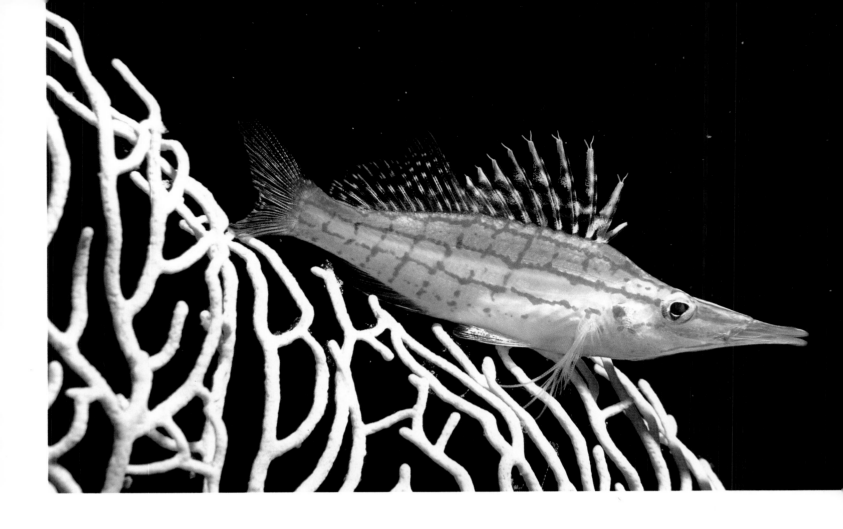
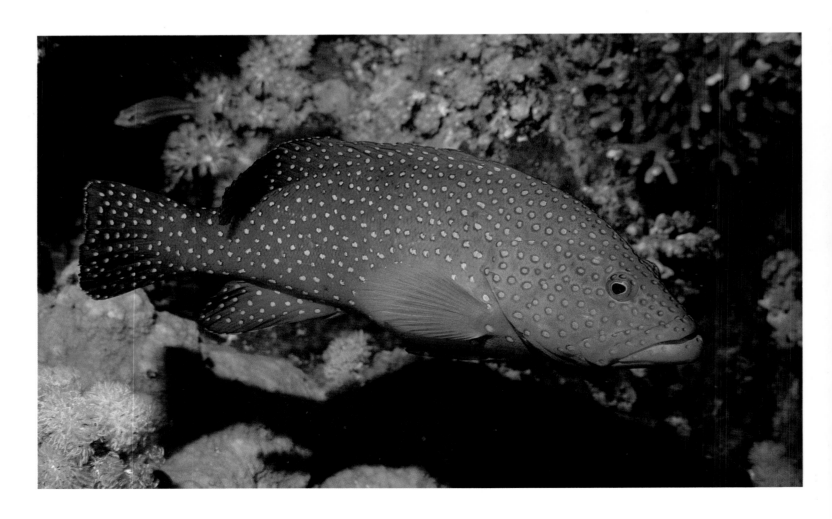

Against the crosshatched pattern of a gorgonian, the tartan camouflage of *Oxycirrhites typus* is extremely effective.

case of the scorpionfish or its deadly relative the stonefish, venomous dorsal spines would have made this mistake a painful experience.

Venomous spines are also a spectacular feature of the lionfish. Looking at these ebulliently decorated fishes, it is hard to imagine how they can ever approach their prey. It was on a night dive in the Red Sea when I began to understand their technique. As my lights illuminated sections of reef, I saw fields of hundreds upon hundreds of crinoids (feather starfish) with their delicate arms spread for feeding on microscopic plankton. Looking more closely I abruptly realized that scattered among the nocturnal crinoids were motionless lionfish. Their huge fanlike pectoral fins erect, the lionfish waited, looking precisely like the harmless feather starfish. Whenever a small fish passed before them in the darkness, they darted forward with one sweep of those huge fins. In this specialized environment the lionfishes' gaudy plumes are uniquely appropriate camouflage.

Another motionless hunter blends into its chosen background by virtue of crosshatched coloration. The tartan hawkfish (*Oxycirrhites typus*) sits amid the plaid pattern formed by the arms of large gorgonian sea fans. Only when disturbed by an approaching diver does this tiny hunter betray its presence by flicking to another perch on the sea fan. Since these sea fans can be of immense size, often approaching ten feet in span, the tiny hawkfish is afforded a gigantic tartan tapestry into which to blend.

Divers visiting these Red Sea reefs find an unusual topographical feature repeated again and again: the shoreline-hugging reef structures grow practically to the surface. All along the shallowest portions are sizable caves and crevices filled with copper sweepers (*Pempheris*) and incomprehensible numbers of silvery anchovies and cardinalfish. Moving in unison, like a living curtain, these swarms of tiny fish form gracefully shimmering patterns against the blazing blue of the sunlit surface waters. By moving, or even by waving one's hand, a diver can tear holes in the curtain or even wave it aside completely. Remain motionless and hold your breath, and the sparkling silver wall closes once again.

Not only are there caverns in the shallow water, but in the twilight of the deeper reef beyond 150 feet loom huge caves formed by lower ice-age sea levels. Around the rims of these

darkling caverns are large specimens of the soft coral *Dendronephthya*, which is not found in most shallower sections of the reef. There is one amazing exception to this general observation; at the site known as the Temple, magnificent concentrations of these water-inflated coral colonies abound in depths of twenty to forty feet.

The Temple is a huge coral complex in a sand-bottomed bay. The bases of its several towers are at depths of thirty to sixty feet, and the main structure culminates in a flat top a mere foot or two beneath the surface. Around the towers a host of marine species has gathered in easily accessible terrain. During the day the shallow waters at the crest of the uppermost level of coral absolutely shimmer with schools of darting orange fairy basslets. Lionfish and groupers lurk in its crevices, and both the emperor angelfish and map angelfish are represented here by nearly tame individuals. Huge Napoleon wrasses occasionally pass, while in a special little grotto far from the main structure a colony of two lemon butterflyfish, two bannerfish (*Heniochus*), a sassy triggerfish (*Balistapus undulatus*), and a lunar-tailed grouper (*Variola louti*) congregate as if in a performer's greenroom.

It is by night, however, that the Temple provides its most impressive pageantry. Around the crests of the pinnacles, forests of crinoids act as unwitting decoys for hunting lionfish, and basket starfish (*Astroboa nuda*) fan their great-armed spans across the dark waters. We have found literally dozens of the hand-sized nudibranchs known as sea hares here, in patterns of burgundy and white. Here and there the powerful night lights reveal the blazing red of that most famous of nudibranchs, the Spanish dancer (*Hexabranchus sanguineus*). When the dancer is at rest it is just another pretty face, a brilliant crimson nudibranch with a matching gill cluster. It is when this soft-bodied coquette is carried into open water and dropped, however, that it earns its exotic name, undulating in a swimming motion that puts many a terrestrial fandango to shame.

Strait of Tiran

Several miles from the Temple there lies the channel at the mouth of the Gulf of Aqaba known as the Strait of Tiran. Through this narrow passage between the Sinai Desert and Saudi Arabia's Tiran Island, millions of gallons of tidal water

A grouper (*Cephalopholis miniatus*) curiously watches human visitors, even if it requires that it reveal itself to do so.

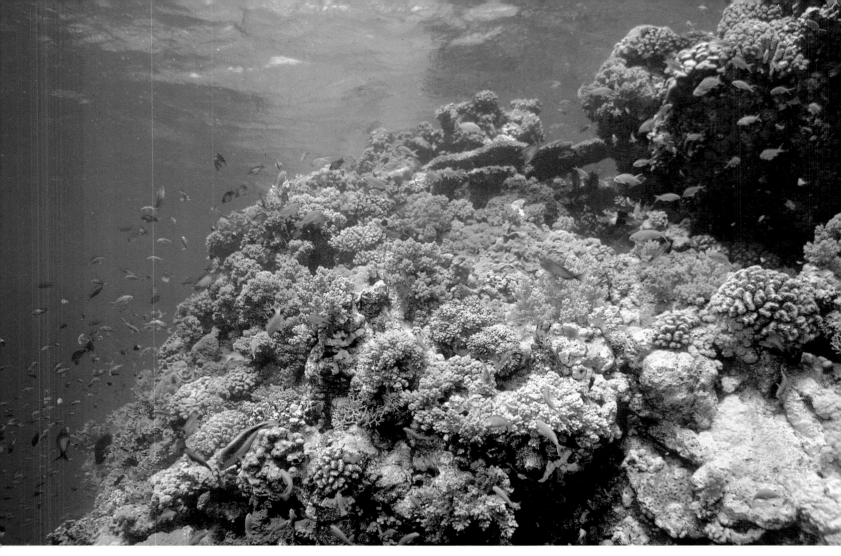

Jackson Reef's shallow wonderland.

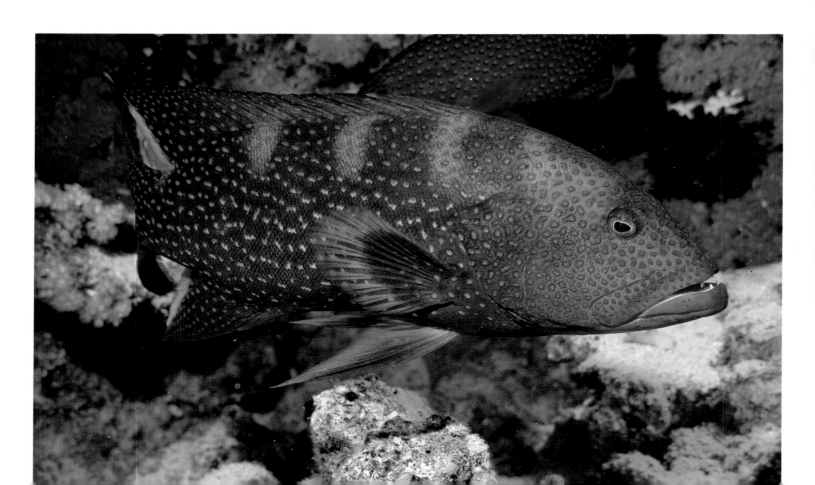

The Spanish dancer nudibranch (*Hexabranchus sanguineus*).

The grouper *Epinephelus fasciata* possesses a remarkable ability to change color.

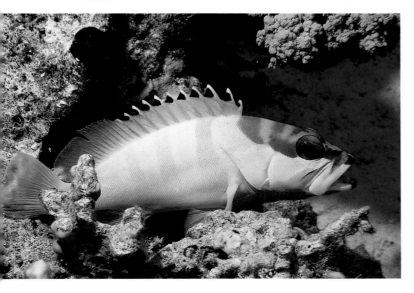

◀ This example of the highly varied grouper family, the lunar-tailed grouper (*Variola louti*), is shy, usually seen retiring into the shadows.

churn each day. In the center of the channel lie four reefs that caress the surface at low tide. The northernmost, a roughly circular structure shaped like a truncated mountain, is Jackson Reef. Powerful currents surge around three-quarters of Jackson's perimeter and a wrecked freighter lies stranded on its northern rim, but its southern arc is protected from either tidal assault. In this sheltered amphitheater grows an overwhelming profusion of corals, often so densely packed that each stony coral structure seems blanketed with gorgonians, soft corals, fire corals, crinoids, *Dendrophyllia* tree corals, and, it often seems, any other invertebrate found in the Red Sea. There are sandy valleys with motionless crocodilefish buried up to their eyes in sand, coral overhangs sheltering blue-spotted rays, and a flat plain whose floor is an almost unbroken carpet of fire corals over which hover great schools of filamented cornetfish (*Fistularia*) and lazy snappers.

There is also an abrupt drop-off on whose slopes one may encounter almost anything. One day we chanced upon a large sleeping green turtle (*Erethmochelis coriacea*); another time a six-foot giant jewfish (*Epinephelus itajara*) trundled up to us like some errant caboose and followed us about for an entire dive as if curious about our intrusion on its reef. Still another dive was enlivened by the sweeping passage of a dozen sleek hammerhead sharks. This type of excitement and beauty caused me to rate Jackson as one of the world's ten best reefs in a magazine article, even above its internationally famous neighbor Ras Muhammad to the south. In early 1980, about the same time as the article appeared, a five-thousand-ton freighter rammed Jackson's pristine reef dead center; when it was pulled off, it left a pulverized swath of coral fragments and depressing rubble.

Some months later I brought a group of divers to my favorite Red Sea reef, waxing eloquent over its haunting riches. My Israeli friends had neglected to tell me of the freighter incident, and I leaped blithely into the water to confront the complete catastrophe. In the very center of the reef, almost nothing was left alive. The brilliantly hued corals and their aura of dancing fish were gone, and in their place was a moonscape of bleached-white and dirty-gray fragments.

It is a living testament to the restocking powers of the sea that two years later much of the damage has been covered by a growing carpet of intense new life. Today, except for an unusual depression in the coral plain, there is little sign that the collision ever took place. At the moment when I saw the destruction, though, my heart sank for the future of all reefs everywhere. Any reef like Jackson, which lies astride a busy shipping lane, may suffer any number of accidents, from being rammed to being carpeted with bilge oil. While some nations—including the United States—exact severe penalties for ships flushing their oily waste, many other countries are neither particularly concerned about the practice nor equipped to prevent it.

One day I found that Israel is a nation that is deeply concerned about such pollution. Returning to port from a day of diving at Jackson in September, 1980, we spied a mile-long, oily smear on the glass-calm waters. Our radio report brought a swift speedboat with biologists and ecologists to assess the damage, and we subsequently learned that an investigation was immediately undertaken to identify the offending ship. The simple—and tragic—truth is that generations of ship captains have been unable to look beneath the sea to see the damage their anchors, their wastes, and their spilled fuel inflict on the marine ecosystem. The oceans have always seemed a dump of infinite capacity. Just as with terrestrial chemical and nuclear waste, however, the day of reckoning can be sensed in the near future.

Ras um Sidd

Along the Sinai coast near Ras um Sidd lie the remains of a more exotic shipwreck that took place several hundred years ago. At a depth of ninety to one hundred and twenty feet, near the foot of a sheer coral-walled coast, lie a huge anchor and a series of immense amphorae—final vestiges of a wooden-hulled ship whose timbers were eaten away centuries ago. The cargo can be found in tiny crevices near the amphorae: liquid mercury, so heavy it has never moved from where it landed.

It was near these amphorae that we received a detailed lesson in fish cleaning. The cleaning phenomenon is worldwide in scope and one of the most fascinating of all sights a human visitor may observe in the coral kingdoms. Tiny parasitic crustaceans infest all manner of vertebrates, from goatfish to parrotfish to large groupers to moray eels. Each must periodically seek relief, and certain small creatures have evolved to provide it. The cleaners are, quite simply, preying upon the tiny parasites. Several species have evolved to be cleaners: the barbershop shrimp (*Stenopus bispidus*), *Hippolysmata grabhami*, and other shrimp; the wrasse *Labroides dimidiatus*; several species of Caribbean gobies (*Gobiosoma*); and the juveniles of several species of angelfish and wrasses. One characteristic that they all share wherever they are found is a persistent pattern of striping. Indeed, this is so characteristic that cleaner juveniles of the Caribbean French and gray angelfish are striped, while in their adult phase (in which they cease to clean) the stripes disappear.

At the wreck one day a massive grouper (*Plectropoma maculatus*) apparently decided that the cleaning services it was receiving were far too valuable to interrupt for a mere human intruder. For several minutes it hovered above the coral while a cleaner wrasse (*Labroides dimidiatus*) picked tiny parasitic crustaceans from its body. Opening its fearsome mouth the grouper flexed its gills so that the wrasse could even explore its body cavity.

How can such a vulnerable fish—most cleaners can be easily eaten by the host—be enticed to roam freely inside the huge mouths of groupers? Obviously, some truce arrangement must be made, in which the parasite-plagued host agrees not to gulp down its cleaners. Each species has indeed evolved a set of easily recognized signals. Some, including bonnetmouths, fusiliers, jacks, and other schooling fish, approach what we call cleaning stations in small groups and hang motionless above the station with their mouths open. Parrotfish will often hover standing on their tails or in the equally unnatural head-down position. Goatfish change color, as will groupers, unicornfish, and others. Very large hosts such as moray eels will sweep into a cleaning station and hang motionless like automobiles waiting to be serviced. Sometimes a dozen or more cleaners will converge upon a single host, while on other occasions a huge moray eel will have but a single cleaner darting about its massive bulk. In some circumstances a host will cooperate by changing its body color in such a manner that the parasites skittering over its body are clearly visible—even to a diver.

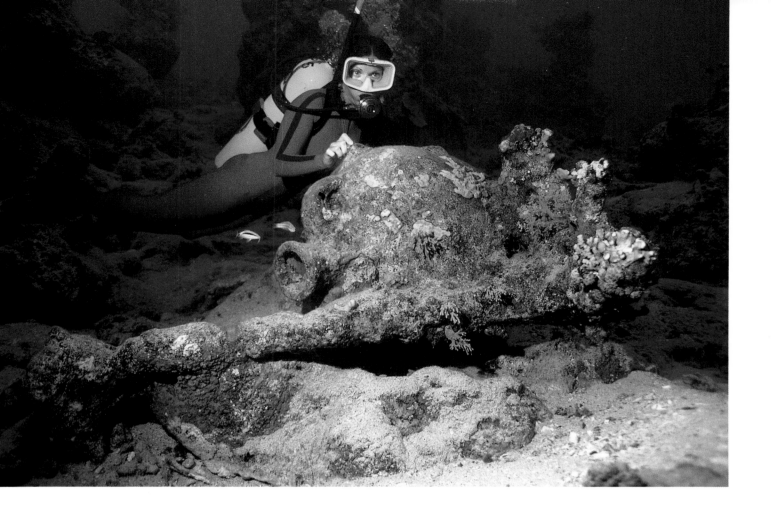

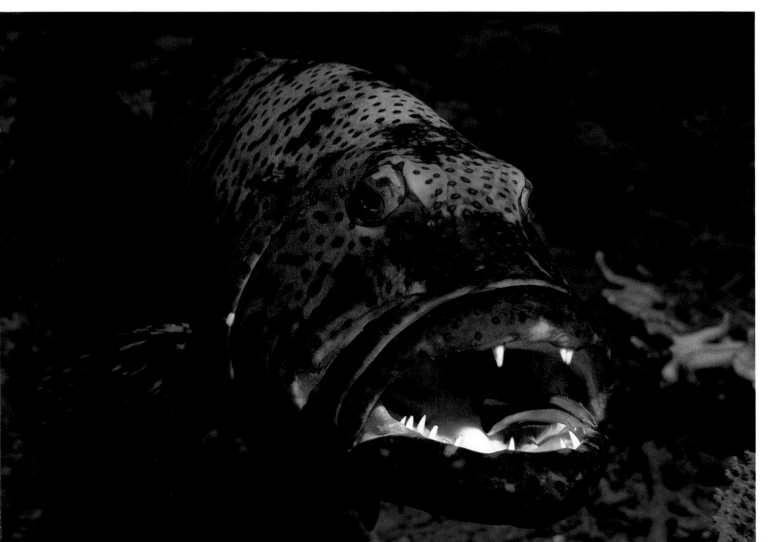

The butterflyfish *Chaetodon lineolatus* amid coral at night.

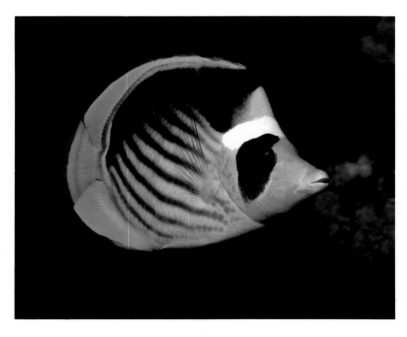

A curious masked butterflyfish (*Chaetodon fasciata*).

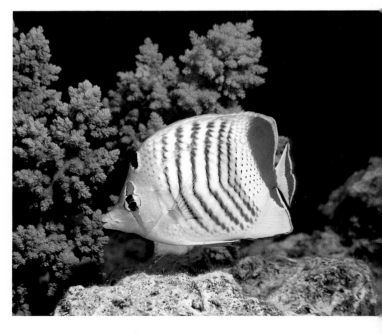

The orange-tailed butterflyfish (*Chaetodon chrysurus*).

Holocentrus spinifer is the largest of all squirrelfish.

A spiny pufferfish (*Chilomycteris*) inflates its body in open water above the reef.

Observing the cleaning ritual, one of the most intimate of all the sea's spectacles, is a thrilling experience. When a diver has become even barely skilled, he or she may settle down quietly on a placid reef in any of the coral kingdoms, and soon the cleaners will be at work on all sides.

It has been shown that the provision of cleaning services is a vital activity on the reef. Experiments in which isolated coral heads were artificially swept free of cleaners produced an epidemic of body lesions, ragged fins, and failing health among the hosts.

Ras Muhammad

At the very tip of the Sinai Desert is a sweeping, narrow peninsula with a crack down its center—known as Ras Muhammad—that has long been among the world's most famous dive sites. It is such an ingrained truth among divers that the best life is found where points of land jut out into deep water that I'm told that I once came out of anaesthesia in a hospital and proclaimed, "There's good diving down at the point!" and passed out again. The physical reason for life concentrating near a point is that water from intermixing currents, even different bodies of water, meets there.

Ras Muhammad, thrusting out into water nearly two thousand feet deep, is a classic example of this. Hanging in the crystal-clear water off the point, one may find enormous schools of barracuda, jacks, and snappers. One is tempted to swim far out into the empty blue (as I often have) to hover among them. The snappers will sometimes form a huge vertical column of literally thousands of ten- to twenty-pound individuals. A diver may swim out and circle this great stack; knowing that the water is two thousand feet deep beneath you concentrates the mind wonderfully, to paraphrase a famous aphorism. Divers have also encountered whale sharks, turtles, manta rays, and other pelagic species off the twin pinnacles at the tip of Ras Muhammad.

Many divers go to Ras Muhammad to see sharks, and it is true that these predators do roam there, usually at the one-hundred-foot level off both pinnacles. But to go to this enchanted place only to see sharks is to miss the point. The reason to go to Ras Muhammad is to see—everything.

Sweeping schools of tuna race through the pass between the coral towers, great herds of jacks prowl the sand flats behind the coral bastions, while huge triggerfish, crocodilefish, parrotfish, humphead wrasses, and hundreds of other exotic species crowd the small coral heads that dot the sandy bottom.

Meanwhile, the tops of the immense formations are another world of shallow-water species: clouds of orange fairy basslets, swift striped tangs, busy parrotfish, and butterflyfish play in the sun-bright coral playgrounds a few feet beneath the surface. In the shadows and tunnels at the base of the pinnacles, one finds nocturnal squirrelfish, bigeyes, sweepers, and moray eels. The large moray of these reefs is perhaps four feet in length and often is as heavy as a man's thigh, with a yellow-spotted pattern on its head that fades to a dirty off-white on its body. The first time one accidentally comes face to face with one of these huge heads one's heart pauses. There are also delicate, smaller white morays (*Gymnothorax grisea*), which will sometimes snake across the open sand from one hiding place to another, paying scant attention to intruding humans. In another section of Ras Muhammad the main reef walls are hollowed into large sun-filled caverns just beneath the surface. One may swim from one undersea chamber to another through schools of thousands of shimmering anchovies and sweepers.

In the end, though, it is the big animals that make Ras Muhammad so special. One plunges down the pinnacle wall to see the six-foot Napoleon wrasses, the schooling barracuda, the sharks, and great gatherings of batfish, manta rays, eagle rays, and big turtles. These deeper dives often require us to remain in the shallows for decompression upon our return, but the coral gardens near the surface are so rich as to make us welcome the stay.

Just as at Jackson Reef, the inevitable disaster happened at Ras Muhammad. In 1980 a freighter, the *Jolanda*, rammed the southern pinnacle, turned over, and sank with its bow projecting above the water atop the coral structure. For some months waste and debris, which spilled out of the dead hulk, discolored the famous dive waters. Rumors reached America that Ras Muhammad was ruined. Again, though, the cleansing and recuperative powers of such a site are marvelous to behold. Six months after the wreck took place we

dived it. Already the first marine growth was beginning to take hold. Today soft corals festoon the decks, and rays settle on the sand in the shadow of the projecting masts. In a generation the *Jolanda* could rival the greatest of the world-class man-made reefs.

The threats to Ras Muhammad go far beyond the effects of this sunken freighter. The end of the enlightened Israeli stewardship makes the entire Sinai an Egyptian domain. The implications of this change were made clear in the spring of 1980, when half of the Sinai (including Ras Muhammad) was returned by Israel to Egypt. In rapid-fire order three events occurred to blast the hitherto-protected waters. An Italian private yacht loaded with speargunners arrived and began hunting, a swarm of nearly one hundred Egyptian fishing boats came to fish the great shoals of snappers, and the Egyptian border guards used hand grenades to kill fish for food. Quick action by the Israeli and American governments to inform the Sadat government slowed the slaughter, but the message was clear: the ten-year period of conservation might be succeeded by a tragic devastation of the nearly tame citizens of these reefs. When fish are as tame as many of those in this prized quadrant of the Red Sea, there is no sport in hunting them.

Today's signs are not reassuring. During May 1984 I photographed a fleet of Egyptian fishing boats netting within the official marine park. Worse, several times while underwater I heard detonations of dynamite, the most devastating fishing technique of all. Could the Egyptian government let the great Sinai reefs be ruined? The answer appears to be yes. Only time will tell whether the Egyptian administration has the will to prevent the looming tragedy. Those of us who have sampled the sorcery of Ras Muhammad in the past can only hope that we will see the same wonders on future trips.

Beyond Ras Muhammad, in the Gulf of Suez, there is a long reef extension out from shore. The place is called Sha'ab Mahmud, and its victim was the British vessel *Dunraven*. A certain amount of mystery surrounds this wreck, for I'm told that the British Admiralty records place her nowhere near Suez at the time of her sinking. At Sha'ab Mahmud on a clear day the sun glistens on the sea and turns the shallow reefs a golden-emerald. When you drop anchor at just the right spot, you sit over a rounded slope near the

very end of the reef massif. The shallow reefs are lively with corals and fish, and as you swim down to about seventy feet you will be unprepared (no matter what you've heard) for the leviathan that suddenly blocks your path.

The ship lies upside down, the rudder and propellers pointing skyward as if in silent protest. Moving along the coral-studded keel, you arrive at an abrupt buckling of the hull, opening several gloomy galleries of darkness filled with a variety of schooling fish, groupers, lionfish, and others. To your left as you pass the twisted portion of the hull, the huge mainmast extends to the skeleton of a crow's nest in the silt-shrouded distance. The forward portion of the hull is crumpled and collapsed, culminating in a once-sharp prow that tore open on the reef and sits in the deep like some immense, ghostly flower. Hovering in the shadowy center of this tragic bloom are thousands of copper sweepers (*Pempheris*) and silver anchovies.

Everywhere on the great hull stony corals, the dark green tree coral *Dendrophyllia*, wire corals, and occasional soft corals are gradually making indistinct the straight lines that Nature never sculpts in the sea. Nature's sea is all curves, stars, rosettes, and complex flower-like designs; the harsh, long straight edge marks humans' unwitting intrusion. Given time, Nature covers and finally consumes these invasions of her realm.

For the moment, however, the sinister bulk of *Dunraven* provides a thrill very few divers have ever experienced. And it may be that with the volatile politics of the Middle East, this lost ship, now a reef, could once again pass from memory.

During all our Red Sea adventures we dive reef complexes and walls, only being enticed into swimming out of sight of the comforting bulk of the sheltering reef at Ras Muhammad. In the open cobalt-blue sea there is no place to hide if one encounters one of the large pelagic predators.

One day I was cruising from Ras um Sidd across the open sea to the distant hills of Ras Muhammad with a small group of visiting divers. The day was glorious, one of those cloudless days when you fully comprehend that the desert has left not a drop of moisture in the sky to form a cloud. We were a mile or two from any land when our boat lost headway, and there ensued one of those awful silences that informs every-

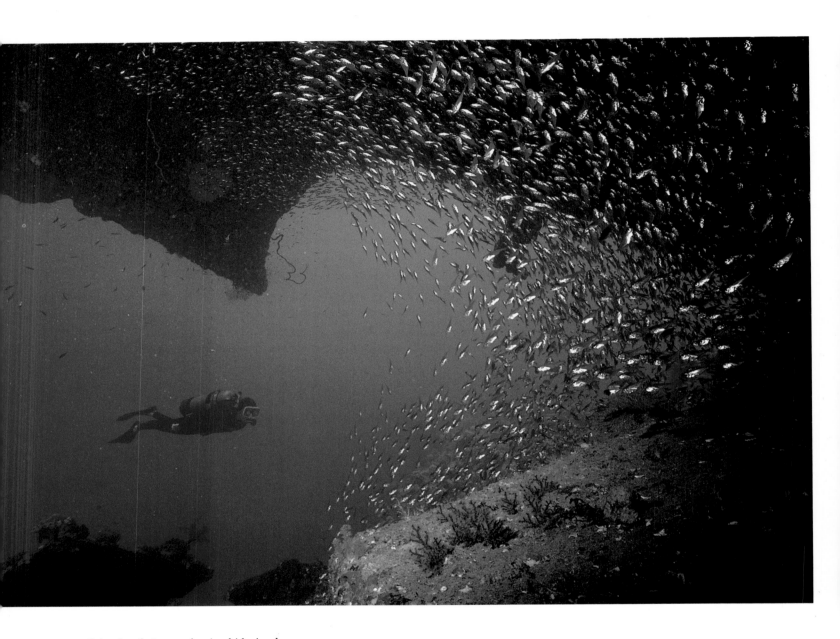

Schools of tiny anchovies hide in the
Dunraven wreck.

In the open sea there is nowhere to hide from the dangerously beautiful oceanic white-tipped shark (*Carcharhinus longimanus*).

We clambered into a small Zodiac inflatable boat so that we could put only our arms and cameras into the water, reducing our all-too-evident risk. The obliging white-tip moved slowly in and passed several times within a very few feet of us. At no time did it move swiftly or display any undue aggressiveness. So within minutes, clad in bathing suits, flippers, and masks, we were adrift in the open sea with one of its undisputed rulers.

Beneath us the water stretched into the depths, seeming as limitless as the sky above, but our drama was played out just under the surface. It should be said that white-tipped sharks follow schools of pilot whales and porpoises across the trackless open sea, preying on stragglers. The late Philippe Cousteau once wrote an evocative passage in which he described how he had drifted gradually away from his boat, as we now were, and realized that a white-tip had begun to close in.

Sure enough, as the distance from the boat grew, the long, slow circles became tighter, until after taking each photograph I had to bang the shark on the nose to get it to move away. We could see its slitted cat eyes following our every move, assessing us, gauging us, timing our progress. There was something of eerie concentration in those eyes that has haunted the sleep of mariners since they first ventured out upon the sea.

As the shark grew more interested and the bumps worked less well each time, we slowly retreated to the dive boat. After one particularly close pass I gave the shark's nose a sharp tap with my heavy camera. As it moved off we got out of the water quickly.

The engine started, and our encounter was over. As we began to pull away, the monarch resumed its slow prowl through its endless hunting space, watching, always watching, sensing any movement within its range.

The Red Sea has been graced with rich marine life and ideal conditions for observing it. In addition, it was favored with a ten-year age of security. I hope that amid the alarums of war and politics it may somehow not be forgotten that something precious lies off those sun-baked shores. Future generations deserve to see these treasures of nature, which must be allowed to thrive in peace.

one that the engine has broken down. After a few minutes the engineer cheerfully announced that he would have it all fixed in a half-hour. My local host and I looked at each other; what does one do with ten eager divers adrift in the open sea?

Our quiet panic was interrupted by a shout. One of our clients had spotted some kind of shark cruising nearby. We all rushed to the rail to see a magnificent oceanic white-tipped shark (*Carcharhinus longimanus*), one of the most beautiful and feared of the open-water sharks. Swimming in solitary majesty the shark slowly made a great circle about our motionless vessel. We could see a school of pilotfish attending the ocean monarch. The surface of the water was so still we could see it in every detail—cocoa-brown skin with gleaming white tips on its major fins, and its complement of pilotfish were striped in blue and white. As the shark made several close, lazy passes around us, I wanted desperately to photograph it, but how?

This parrotfish (*Scarus*) sweeps past a
cluster of fire corals.

On a bubble coral a tiny shrimp carries its eggs in its transparent body.

Shadowed crevices bloom with thickets
of crimson-and-yellow gorgonians.

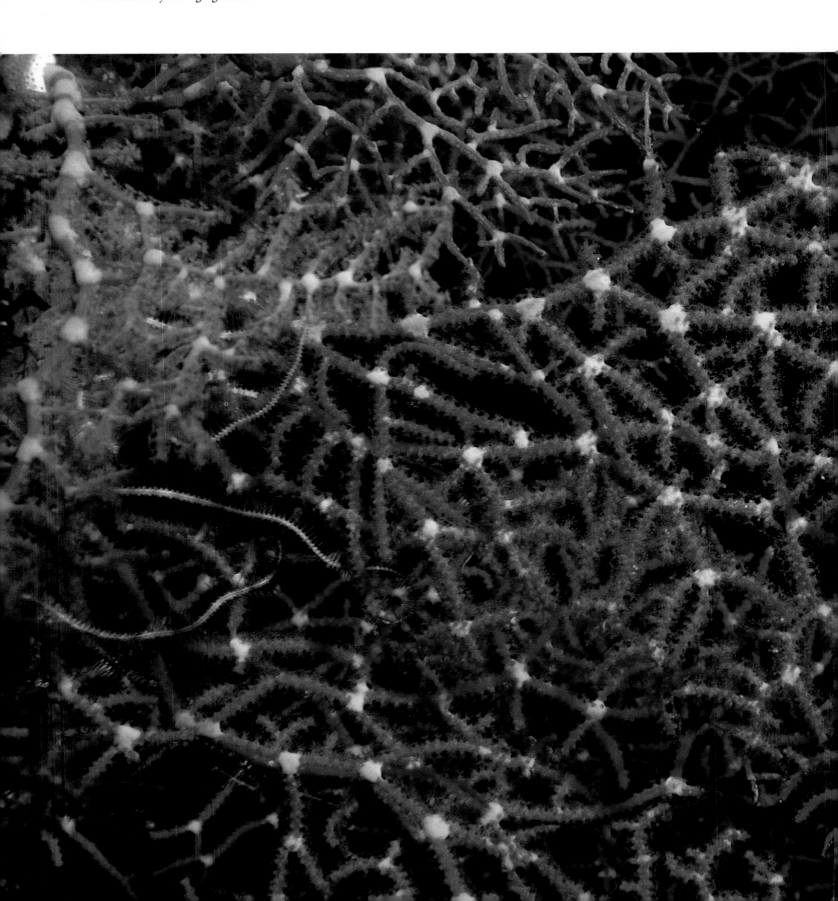

Chapter Three
The Indian Ocean
FAR SIDE OF THE WORLD

The Indian Ocean is bordered by such a kaleidoscopic variety of peoples and cultures they stagger the imagination: South Africa, Madagascar, Kenya, Oman, Iran, Pakistan, India, Sri Lanka, Bangladesh, Burma, Thailand, Malaysia, Indonesia, New Guinea, and western Australia. Within this great basin lies essentially empty sea, dotted here and there with tiny islands: the Comoros, Seychelles, Maldives, Similans, Laccadives, Andamans, and Nicobars (these last two in the Bay of Bengal). Some island groups, like the Comoros, have suffered recent political turmoil. Others, like the southern Seychelles, are so remote as to require ocean-going exploratory ships to reach them. Still others, such as the Nicobars and portions of the Andamans, are set aside as closed preserves to protect primitive tribes; to this day Sentinel Islanders, in the Andamans, greet visitors with slings and spears.

This is one of the many tiny islands that make up the coral kingdom of the Maldives.

The Maldives

The islands of the Maldives are exceptional in several ways. For a number of years the British maintained a major air base, called Gan, on Addu Atoll, the southernmost island in this five-hundred-mile-long chain. In 1976 the British closed Gan, and hundreds of trained Maldivian chefs, waiters, mechanics, and other skilled workers were suddenly without jobs. At the same time European tourism companies were financing the development of hotel and sports facilities here for their clients.

The results have been spectacular. Beach resorts sprang up on tiny atoll islands near the capital, Male, staffed with British-trained islanders from Gan. European travel firms (particularly those from Italy and Germany) sent waves of vacationers to enjoy the sun and beautiful beaches. Some of the resulting cultural juxtapositions are a bit odd; for my American diving groups the sight of topless or even naked Europeans cavorting amid the long-skirted, devoutly Islamic Moslem natives is incongruous in the extreme. The Maldivians are stoic through it all; the pay is good and the view, incomparable.

The physical beauty of the islands and the coral kingdom beneath the sparkling water make everything else here pale into insignificance. Topographically, the Maldives are a chain of nineteen enormous atolls upon whose shallow tops literally hundreds of tiny atolls have formed. Many of them, some only a half-mile in diameter, never reach the surface, but form gleaming aquamarine circles amid an ocean of deep blue.

Sitting on any of the small islands near Male, one looks out across blue water to scattered, tiny palm-clad islands at all points on the horizon. It looks as if one could sail a boat on a straight line to any of the visible islands, but woe betide those who attempt it. Dozens of reefs just beneath the surface lie in wait for the unwary sailor. The Maldivians do very little sailing at night; their characteristic triangle-sailed dhonis are safe in harbor by the time the sun sets.

For the undersea explorer the countless atolls here offer a seemingly infinite series of thronged aquariums filled with the gaudy, the exotic, and the unusual. Most diving takes place just outside the gaps in the atolls, called passes or chan-

nels, through which tidal waters flow in their daily cycle. There are so many passes that one is hard pressed to visit even those within an hour's boat ride of Male during any single visit to the islands.

The action on the reefs at the mouths of the passes often taxes one's assimilative powers. While the corals are of the strong, low-growing variety because of powerful tides and seasonal storms, they harbor a profusion of tropical reef fish. The open water above the coral shallows is constantly alive with clouds of fusiliers (*Caesio*), brilliant purple-and-yellow fairy basslets (*Anthias*), small blue tangs, and butterflyfish in formal black and white. Closer to the sheltering corals schools of grunts (*Lutjanus kasmira*) and sweetlips (*Gaterin diagrammus*) hover, aligned with their streamlined bodies facing precisely into the tidal flow.

Darting in and about the wary schooling species are pairs of dazzling butterflyfish (*Chaetodon trifasciatus*, *C. meyeri*, *C. ulietensis*, and *Forcipiger longirostris*). Their cousin *Chaetodon collare* is rather more timid, usually hovering in pairs under sheltering coral overhangs, though in the late afternoon schools of a dozen or more will rise to hang just a few feet from shelter. The angelfish are, if anything, more blatant than the butterflyfish in their coloration, with the king angelfish (*Pygoplites diacanthus*), the emperor angelfish (*Pomacanthus imperator*), the canary-yellow *Apolemichthys trimaculatus*, and the orange-masked *Euxiphipops xanthometopon* a symphony of intense hues against the complex coral backdrop.

A powder-blue surgeonfish (*Acanthurus leucosternon*) browses on algae and eyes the divers curiously as it busily makes its rounds, while in the deeper water over the drop-off the unicornfish (*Naso unicornis*) often surround the visitor so thoroughly that one cannot swim out of their school without inadvertently kicking a few. The curious unicorns don't seem to mind a bit, swarming about the divers like nearsighted grannies, often blotting out any sight of the reef beyond their close-packed circle.

Each of the hectic reef tops has at least one specimen of the large triggerfish *Balistoides viridens*, which performs a crucial function for the other fish. The first one I saw was at a corner of a reef pass, a spot known as Shark Point. I christened this two-foot-long triggerfish "Charlie the Wrecker"

Although it is the size of many butterflyfish, *Apolemichthys trimaculatus* is an angelfish.

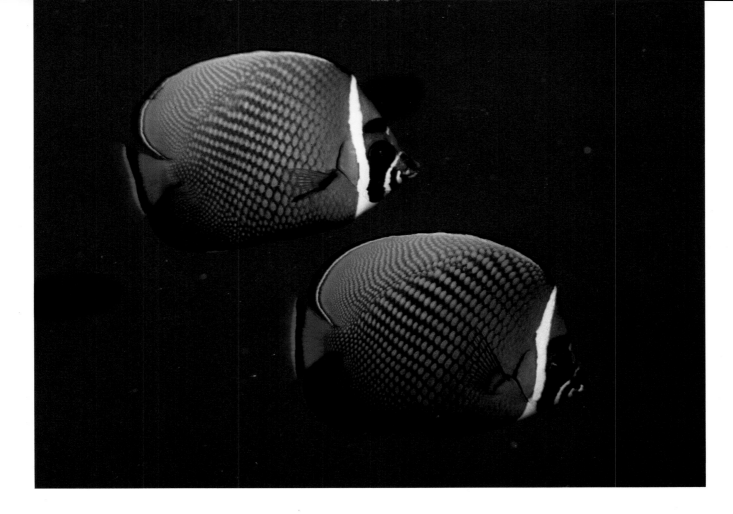

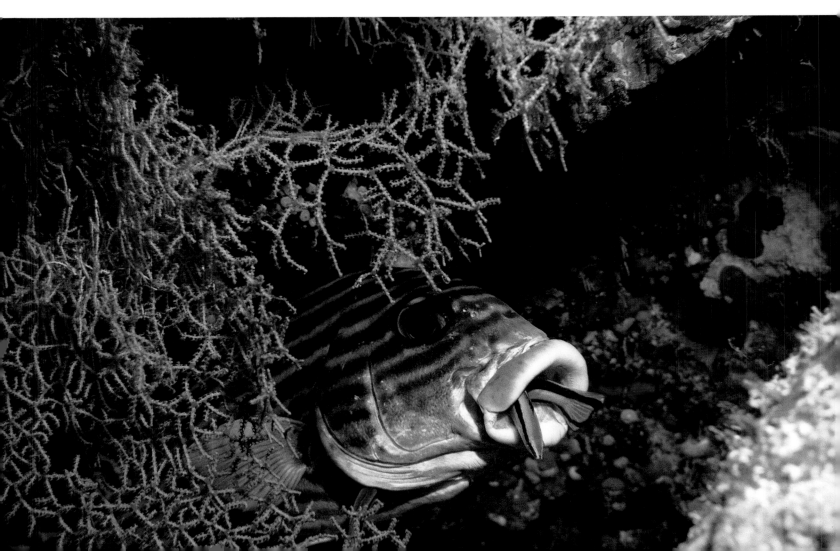

as I saw him lift large chunks of coral with his mouth to get at the delectable brittle starfish and small crustaceans living underneath. Of course, as Charlie pillaged the reef a host of curious and hungry fish followed his every move; butterflyfish, angelfish, small wrasses, parrotfish, surgeonfish, and Moorish idols swarmed about the huge triggerfish, snatching stray morsels and occasionally being buffeted off course by the wash of Charlie's huge pectorals.

The curious photographer in search of fish portraits soon tears a leaf from Charlie's effective book. Sure enough, turning over a small piece of coral brings a crowd of hungry fish that couldn't care less that the camera's huge eye is upon them. Even without such artifice one learns that the fish of these Maldivian reefs are remarkably tolerant of human intrusion. At one deeper pass on the eastern rim of Male Atoll, there lives a school of ten to twenty sweetlips (*Gaterin diagrammus*). Some of the school are invariably there, heads pointed unerringly into the tidal flow. Even when surrounded by divers, the sweetlips patiently hold their position. Usually there are one or two being cleaned by the wrasse *Labroides dimidiatus*. When approached closely the sweetlips closest to the intruder will move to the rear of the school, leaving their companions to face the camera, but the school will not leave until driven off, and even then the fish soon return. They've been there for years, as have so many of the fish we see in all our dives in the coral kingdoms. Those of us who have lived in the tropics get to know individual fish that will be in a particular area of reef for years, or until their career is ended in the reef's eternal hunt. In this engulfed jungle everyone stays close to the familiar shelters near home.

The upper reefs of the Maldivian atolls are so shallow that everything is blazingly visible, spotlighted by the intense equatorial sun shining through the clear water. There is, predictably, another entire spectrum of reef-dwellers that hunt by night and rest by day; for them such visibility and searing brightness is intolerable. Fortunately, these light-sensitive species have had made-to-order homes carved for them in the reef by the wave action of ancient, lower seas. The result is a series of long, shallow, undercut ledges at depths of fifteen to twenty-five feet. For the diver swimming just off the reef edge, there unfolds a dramatic two-tiered world. The upper stratum is gay and sunny, the lower world shadowed, indistinct. Approaching closely and aided by hand-held lights, the viewer of this second world is confronted with a new community as rich, complex, and colorful as the sunny gardens above.

Lining the darkened walls are endless carpets of the night-blooming coral *Astrangia*, accented here and there by bushy black coral (*Antipathes*) or by clusters of exquisitely delicate gorgonians whose nodes, or intersections, are different in color from their stems. Here and there the huge, frilled mouth of the scallop *Spondylus* gives a Cheshire-cat smile before snapping shut; on the scallops' heavy shells the *Astrangia* corals bloom without regard for the occasional motion of their mollusk host.

One sees enormous schools of nocturnal fish hovering amid all this invertebrate wealth, awaiting the departure of the sun: huge squirrelfish (*Holocentrus spinifer*), thousands of shy soldierfish (*Myripristis*), cardinalfish (*Apogon*), and shy bannerfish (*Heniochus*). The larger groupers hover here as well, as if knowing that their hunting technique—a swift strike from dark ambush—simply will not work in the sunny world above. They, like the sharks and barracuda, await the crepuscular period, that half-light of sunup and sundown when the unwary of the upper world are silhouetted against the lighter surface waters. Then death strikes swiftly from the darkness below.

Also sitting motionless amid the shadowed walls are formidable scorpionfish with their toxic dorsal spines, as well as the nocturnal lionfish (*Pterois*). Here and there a painted lobster (*Panulirus*) waves its long antennae, while often from the same crevice a large green moray eel (*Gymnothorax*) will emerge in order to sweep off to a deeper lair because of the divers' approach.

These great concentrations of life on the reefs just outside the passes contrast with the barrenness of the walls of the passes themselves. In some the water movement is so swift that the walls are scoured clean. In others sparse stands of hardy *Dendrophyllia* tree corals and occasional soft corals and anemones serve only to highlight the emptiness of the walls around them.

A sweetlip (*Gaterin diagrammus*) being cleaned by a wrasse.

The action in the passes is not for the small, the sedentary, or the slow. The reason divers occasionally seek out these swift-running waters is to glimpse the tigers and wolves of the sea, those swift predators who prey on small fish in open water. In the passes the tidal waters carry enormous amounts of plankton, coral larvae, and the pelagic stages of many reef species, so much that the water is quite turbid. Coral-reef–dwellers, from coral polyps themselves to groupers, have early life phases in which they are borne by the moving ocean currents until they find the proper conditions for establishing permanent residence. It is this process of disseminating the species that propagates and populates new reefs and accounts for the cornucopia in the passes.

The living chowder flowing through the passes attracts clouds of small plankton- and larva-eaters, such as flying fish and houndfish, which in their turn attract barracuda, mackerel, tuna, jacks, huge Napoleon wrasses, and several species of sharks. Here, in concentrated form, is the drama of the oceanic food chain in practice: small creatures thriving in vast numbers are eaten by larger fish, which in turn become the food for even larger predators. It is almost beyond our powers to understand this colossal hunt from the viewpoint of the protagonists. I have often watched the tiny baitfish (anchovies, silversides, and others) panic as swift houndfish, mackerel, or jacks make lightning passes at their massed schools. So frightened are the baitfish that they leap repeatedly out of the water, thrashing it to foam by their very numbers, only to fall back inevitably to the waiting predators.

Once at the outer corner of a pass I happened to be watching two schools of snappers (*Lutjanus*) milling socially a few feet above the coral. Suddenly, like a supersonic fighter plane, a fifty-pound turrum (*Caranx*) blasted in out of the blue, snatched a fish, and disappeared. The entire sortie could not have lasted two seconds; I was stunned at the devastating swiftness of the attack. There could be no defense against such a bullet-like strike.

To get some feeling for the power and speed of the water flowing through these passes, our small band of divers once took a drift dive, carried by currents along the edge of a pass in the clear water of an incoming tide. The water was moving at a relatively modest three knots or so, yet once we left our boat we seemed to rocket past the corals. As we swept along we silently came upon unprepared reef fish in much the same manner a shark or a turrum must; many reacted with sudden panicked flight to their coral shelters.

In the Maldives there is another unique way to make a very good estimate of the speed, power, and savage grace of reef sharks. Since 1978 a German diver, Herwarth Voightman, has been attempting to train a pack of gray reef sharks (*Carcharhinus amblyrhynchos*) by feeding them. Working with the sharks in the same place nearly every day, Voightman has managed to hand-feed them with a reasonable semblance of order. The pack circles, some individuals bolder than others, sweeping closer with every turn. Meanwhile, a miniature frenzy of small tangs, damselfish, groupers, and even remoras swims right up, aggressively snatching morsels from the fish carcass in Voightman's hand.

The sharks circle, slowly circle. They have survived two hundred and fifty million years in savage seas by being the ultimately cautious predator. Their slitted cat eyes watch as they lazily sweep closer.

Then, abruptly, one veers straight in, scattering the smaller fish. Its silver-gray body rushes in like some lethal projectile; at the last instant the shark raises its upper jaw and its head, and draws an opaque shield over its vulnerable eyes. It is a tableau I have seen many times; in my mind's eye I can still see that voracious last moment as if in some mad painting by Van Gogh, frozen vividly for all time.

I happened to dive with Voightman one day in 1981 when he returned to his beloved sharks after an absence of six weeks. As soon as the action began it was clear that things were not completely under control. The sharks' circling was swift, interspersed with bullet-like rushes in all directions. His absence had caused the pack to revert in part to its wild state, even after five years of daily work.

A characteristic of sharks in all seas is that they often bump before biting an unknown or unfamiliar target. The rough denticles in their snouts' skin scrape the target, precipitating a full attack if the taste of blood or oil is elicited. The bump is therefore a very aggressive act by the shark. In this day's wild melee a shark raced in and bumped Voightman right in the head, driving him from his accustomed spot near the sack of fish carcasses. The sharks were so agitated that we gave up the idea of feeding, and it was two days before

Herwarth Voightman's daughter Bine al-
lows a shark to feed from her mouth.

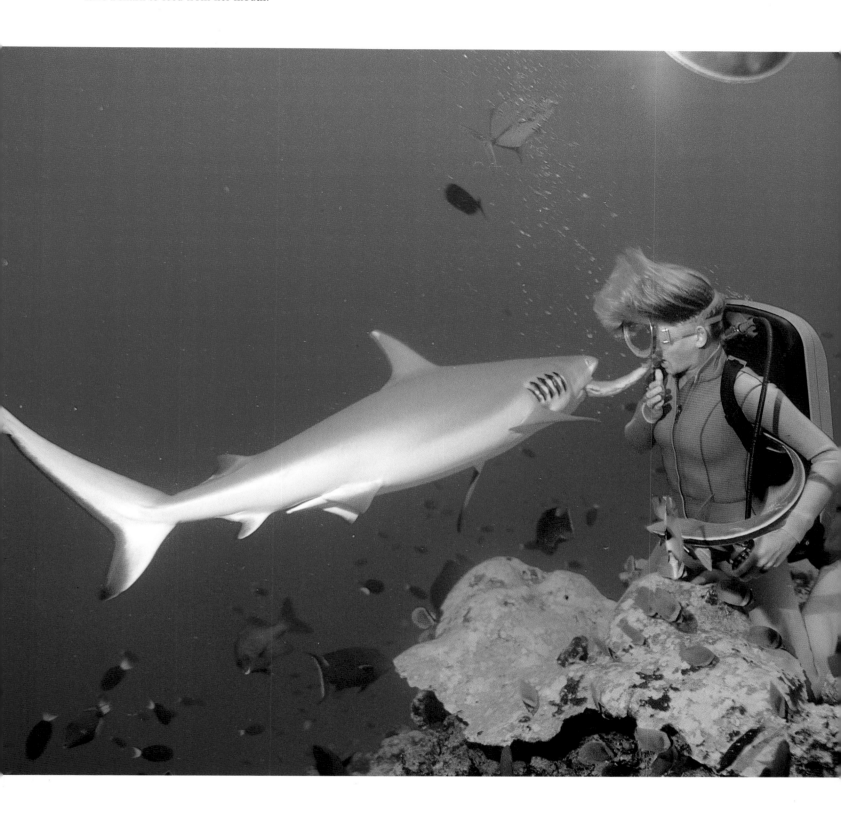

The king angelfish (*Pygoplites diacanthus*) is one of the most colorful of all reef-dwellers (Maldives).

Voightman could re-establish his normal routine. A pack of sharks, like a pack of dogs, can excite itself to quick ferocity. This rather stately version of a shark frenzy prods the imagination to mental images of what happens in the passes or the open sea when the sharks close in.

The reef itself is not a good hunting ground for sharks due to its inhabitants' habit of not straying far from shelter. Sharks are seen principally in open water, or far down the drop-off, in the eerie twilight of the deep reef. At Shark Point, when the current is running, I have prowled down the slope to see twenty sharks holding formation into the moving stream. Effortlessly, with hardly any visible movement, they congregated in a resting assemblage looking almost like a formation of well-armed aircraft. When I approached, one by one, they turned slightly away, and the current peeled them off like so many fighter planes, to disappear into the distance.

In the shallows far above, the fish life at Shark Point is among the most tolerant to human visitors that I have found anywhere in the coral kingdoms. In this arena of Charlie the Wrecker, the fish go on about their business with divers practically surrounding them.

One day I watched, fascinated, as several parrotfish pursued their endless attack upon the coral. Their huge horned beaks made clearly audible crunching sounds as they scraped chunks of coral to eat. Swirling around them was a huge assemblage of other fish browsing on the tidbits released by the parrotfishes' assault.

Parrotfish use their beaks to chip off and ingest the limestone coral skeleton itself. In their pharyngeal mills the limestone is crushed to fine sand, from which the parrotfish strains all manner of embedded nutrients such as coral polyps and algae. After this selective feeding the sand is excreted in huge streams.

I have often noticed that on all reefs around the world the visibility decreases as the day wears on. Watching these sand showers everywhere, I was tempted to speculate that the parrotfish (which sleep by night) may be in large measure the source of this gradual silting of the morning-clear reef waters. As I watched, fascinated, another train of thought started. Somewhere I had read and later quoted in my book *The Underwater Wilderness* (1977, New York: Chanticleer Press) a

statement by a forgotten source that a large parrotfish may excrete as much as a ton of sand in a year. Later a magazine editor called me to check my source for this estimate, and I confessed that I couldn't remember.

Here was a living laboratory. I picked out one of the larger parrotfish and watched it for perhaps twenty minutes. During this period the parrotfish would take several loud bites of coral, then leave its feeding area and swim twenty to fifty feet away before excreting a cloud of sand, which I roughly estimated to be perhaps a half-ounce. To my surprise this parrotfish (weighing no more than ten pounds) never waited more than two minutes before creating its streamer-like cloud of sand. Indeed, on some occasions the interval was no more than one minute. If this coral-chewing athlete carried on at that pace for a ten-hour day it would excrete some three to four hundred clouds. That could represent a weight of at least ten pounds in a single day, or more than thirty-six hundred pounds in a year. One can only marvel at the tremendous force a population of active parrotfish can be in converting reef mass to beach sand.

As I sat there with a half-dozen parrotfish filling the water around me with a sandy fog, I thought it small wonder that there were so many sandy island structures in the Maldives.

Two Maldivian fish species are so approachable as to deserve special mention. One is the orange-masked angelfish *Euxiphipops xanthometopon*. In other coral seas I have spotted these spectacularly caparisoned fish fifty feet away and had them turn tail and flee. Yet here a number of specimens of this species feeds without concern for the approach of my large camera.

Similarly, a number of the clown triggerfish *Balistoides conspicillum* have come within close range of the lens in a bold manner I have seen only once before. My impression after numerous dives with this boldly decorated triggerfish is that it is intelligent, alert, and suspicious. It appears to watch both the intruder's behavior and the fate of the small fish that approach more readily. Once interested, and particularly if convinced that there is a handout of food being offered, this quite-aggressive fish will cut right through the crowd and be first in line to feed. It is this kind of intimate moment that makes this region especially enticing for those of us whose hearts are always with the sea.

One of the most extravagantly colored angelfish is *Euxiphipops xanthometopon*.

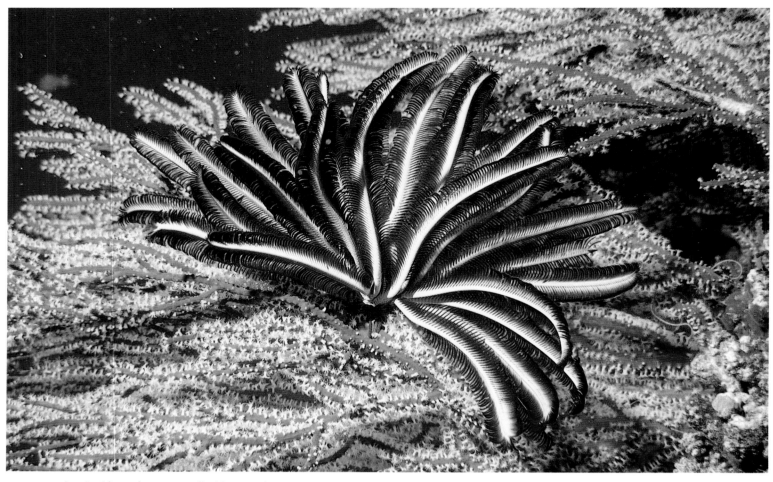

A crinoid perches atop a florid gorgonian.

This crinoid has closed after feeding.

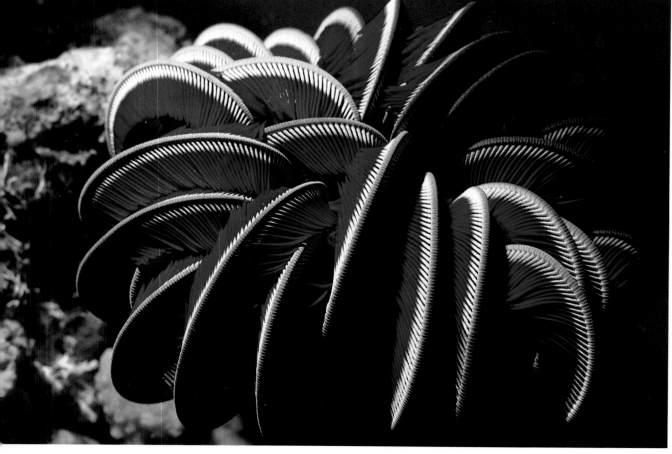

A bigeye (*Priacanthus*) hovers beneath the sheltering arms of elkhorn coral for protection.

The apparent willingness of reef fish to endure close contact with humans held true on at least a half-dozen completely different Maldivian reefs over a period of four years, and I suspect it applies throughout the entire atoll system. I believe this lack of fear exists because these reefs have not endured heavy line- or spearfishing.

The fact that these reefs are like jewels flung haphazardly across the sea adds to their allure. Sailing, one sees almost every hour a new line of tiny, palm-topped islands beckoning just on the horizon.

Our explorations here, while extensive, have merely touched one area in a colossal selection of reefs. So much of this land of a thousand atolls remains to be explored by divers that its wonderful reef fauna should delight generations to come.

I call this the "tin-snip" moray (*Gymnothorax breedeni*) for its distinctive head. On some sections of reef dozens of these eels won't allow a photographer to set down his hand without giving it a nip.

Sri Lanka

Four hundred miles east of the Maldives lies the ancient and majestic nation of Sri Lanka (formerly Ceylon). More than a thousand years ago the rulers of this fabled land built monumental cities, sublime temples, and massive engineering projects. To increase the production of rice, the staple food, the kings' engineers built vast agricultural water reservoirs, called tanks, which still stand today. These tanks were used for extensive irrigation, which allowed Sri Lanka to act as rice exporter to the entire Indian subcontinent, off whose southern tip it lies. This success and wealth led to jealousies, causing the island kingdom to be riven from within and without by civil strife and invading armies from India.

In time European seafarers—Portuguese, Dutch, and finally English—conquered the coastal regions. The English captured the inland capital, Kandy, in 1802 and held the island until 1948.

Sri Lanka has long been known for its abundant spices. There are beautiful valleys filled with nutmeg, pepper, cinnamon, clove, coca, and many others. One of these valleys, Hunas Falls, is one of my favorite resting-places in all the world. A high range of hills topped by a reflecting pool and tumbling waterfall overlook a peaceful valley in which everything one sees is a commercially harvested spice, even the long grasses (*Citronella*) along the roadside. Hundreds of miles of rolling hills are carpeted with tea plants, for Sri Lanka is one of the world's foremost tea exporters.

Today's visitor to Sri Lanka can marvel at ancient wonders. At Sigiriya the parricide god-king Kasyapa spent eighteen years building an impregnable castle on a six-hundred-foot sheer-sided pinnacle of stone; he feared the vengeance of his half-brother. Yet when the half-brother's army came, Kasyapa came down from his fortress to die on elephant-back. Today we enter Kasyapa's castle through the remains of a fifty-foot-tall stone lion whose paws alone remain on guard.

Or we may pause in wonder in a darkened temple in the ancient royal city of Polonnaruwa, where it is said the great stone Buddha there once had a colossal diamond mounted in its forehead. The entire temple structure is walled, save for a single window in the roof through which, it is said, sunlight and moonlight reflected from the diamond bathed all the other statues in sparkling light.

Undersea exploration in Sri Lanka has limitations imposed by its topography. As a large and partially mountainous landmass, it is blessed with meandering rivers; when these rivers reach the sea their prodigious silt outfall results in severe turbidity, and any diving off the eastern or western coasts must be done several miles offshore. There is a freighter wreck off Hikkaduwa, as well as some reefs off the eastern coast near the resort town of Trincomalee, but these do not provide the type of diving that would bear comparison with, say, the Maldivian reefs a few hundred miles away.

The famous British scientist (and genius of science fiction) Arthur C. Clarke lives in the capital, Colombo, and has dived much of the Sri Lankan coastline. His book *The Treasure of the Deep Reef* inspired me to try the very different adventures to be found off the southern coast of the island.

Southern Sri Lanka turned out to be nine or ten hours away by Land Rover with our scuba tanks loudly rattling about in the rear. The main attraction in this region is the large game preserve near Yala, a domain of water buffaloes, spotted deer, and a young bull elephant that sprayed our Land Rover with stones from six feet away. I soon discovered that I much preferred facing sharks and was much relieved when our guide hauled us out of there.

Near Yala, a small fishing village, dozens of unusual outrigger boats line the mile-long white sand beach. Loading one of these tippy craft with tanks, cameras, and other gear was an exercise in balance I'll never forget. Any camera that went over would have been lost for good. A mile offshore, beyond uncharted shallow reefs, we gingerly transferred our equipment to a larger boat for a ten-mile cruise to the Great Basses. The Basses are a series of shoaling reefs and rock formations in the open Indian Ocean. There is no protection here from tidal or oceanic currents, and the diving must be done with caution.

The area we explored had little coral. The bottom was composed of patches of cracked and broken rock. One mile-long uplifted rock face seemed sheared, as if by a giant hand. We went down the anchor rope through a roaring current, seeking refuge behind the line of upthrust rock, with the water rushing by over our heads.

Visitors climbing the massive staircases of the castle Sigiriya in Sri Lanka leave a level plain to visit the ruins upon the mountain.

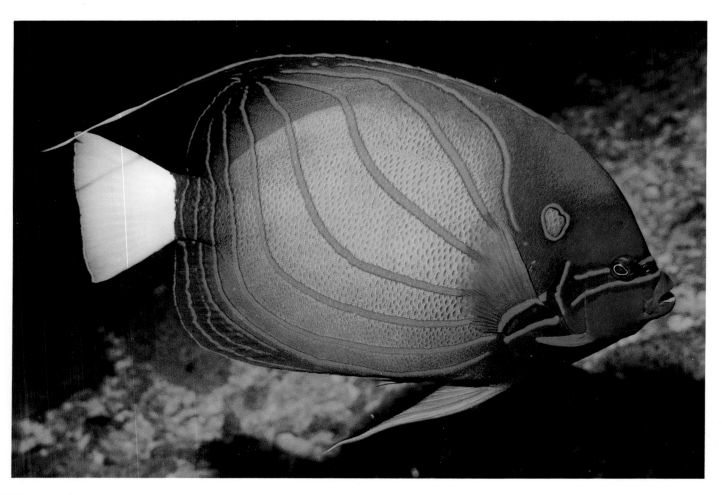

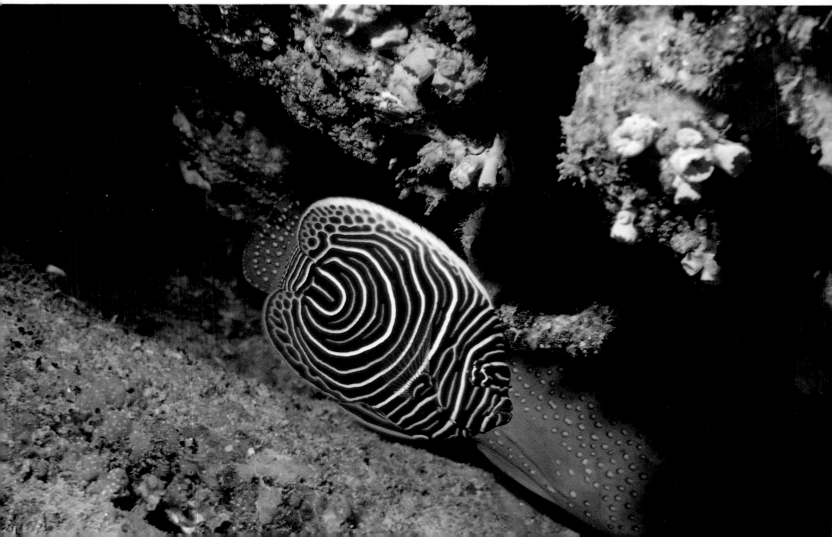

The angelfish *Pomacanthodes annularis* (shown here in adult and juvenile forms) is plentiful in Sri Lanka, but is unknown in the Maldives.

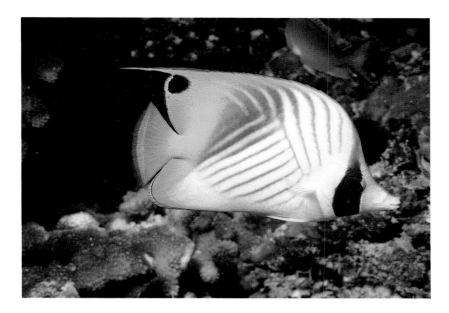

Color can mislead, as similarly patterned fish can be very different in other respects. The threadfin butterflyfish (*Chaetodon auriga*) is much smaller than the lined butterflyfish (*Anisochaetodon lineatus*). ▶

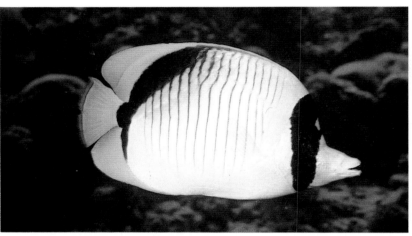

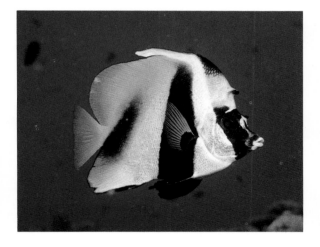

The shy *Heniochus monoceros* are often mistaken for butterflyfish.

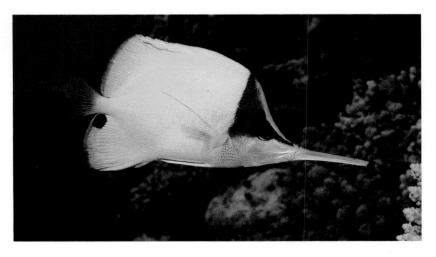

The longsnout butterflyfish seldom allows the photographer to approach this close. ▶

This color-accented butterflyfish is ▶ *Chaetodon zanzibarensis*.

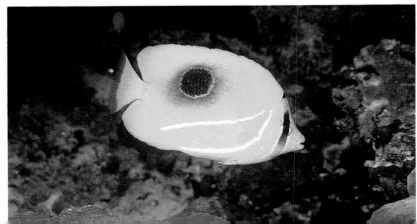

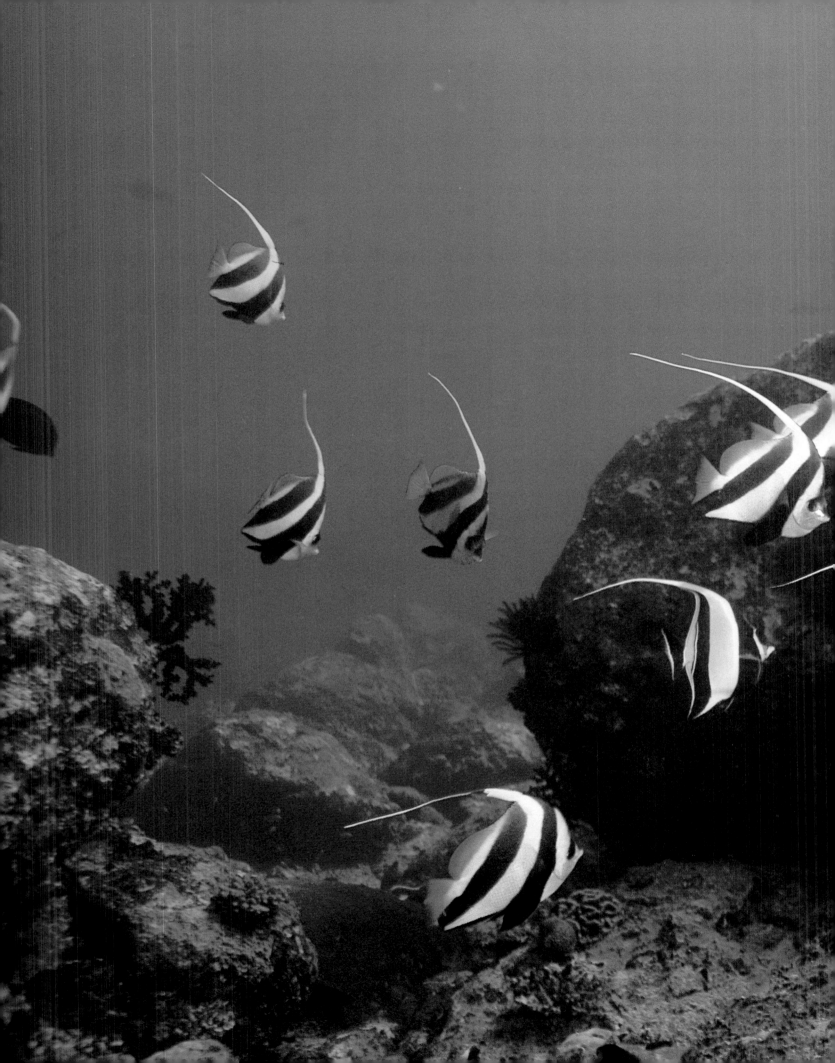

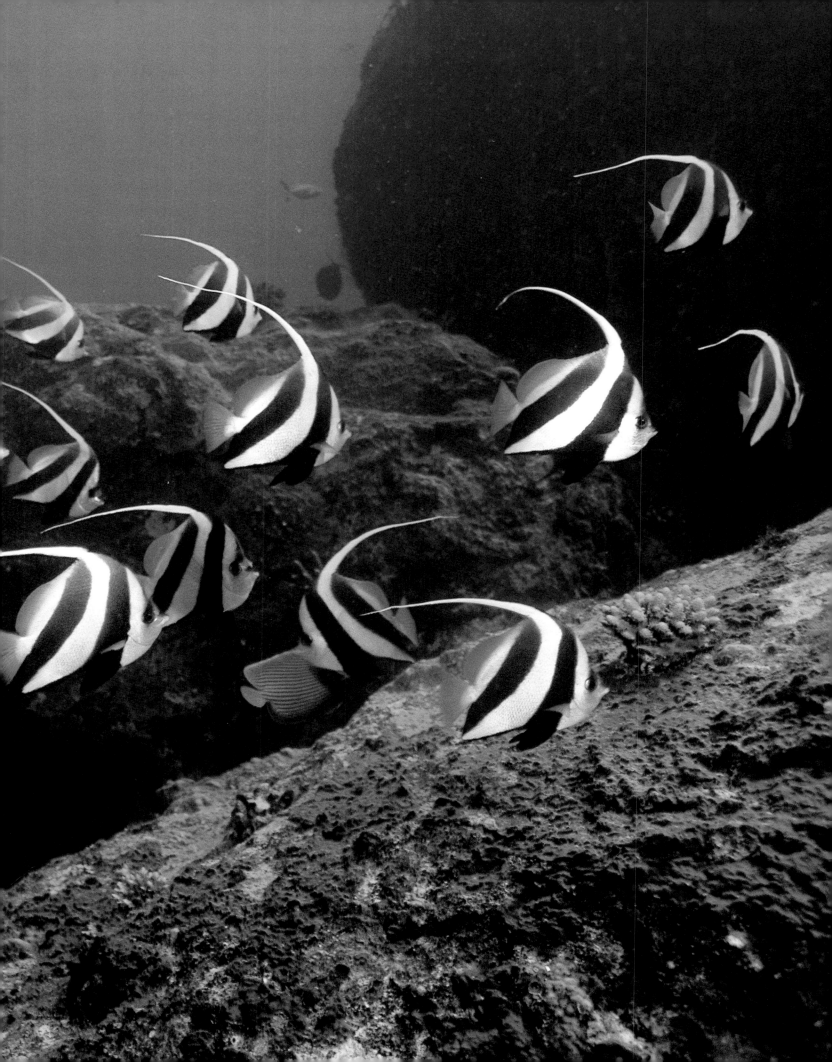

◄ Great schools of *Heniochus acuminatus* ►
wander the boulder-strewn valleys of the
Andaman Islands.

We were not the only ones seeking shelter from the current. As we moved along the cavern-pocked stone wall, we found a concentration of fish life like few I've seen in the coral kingdoms. There were enormous schools of jacks, snappers, fusiliers, grunts, and others forming constantly moving living whirlpools of densely packed fish. As we passed the caverns groupers ranging from eighty to two hundred pounds would bolt out.

While there were few corals, there were scattered tropical reef fish of rare beauty. To my surprise, several of these turned out to be startlingly different from any I had seen in the Maldives a mere four hundred miles away. Apparently, as we discovered in the Caribbean, different quadrants of the same open sea will develop local variants of common genera, though the extent of the differences surprised me. Most conspicuous among these new species was a graceful angelfish (*Pomacanthodes annularis*), which managed to keep its poise in the roiling waters as it snaked between boulders watching us. Its powder-blue stripes seemed to repeat in shy, slender groupers, several of which watched us cautiously from rocky crevices. There was even a new butterflyfish (*Chaetodon vagabundus*) apparently related to the right-angle butterflyfish (*Chaetodon auriga*), but much darker in color, melting into the shadows near which it hovered.

There are other areas of the Basses with greater coral development which my brief exploration did not reach, but the thrill of the dense shoals of fish always spices my memories of this land of ancient grandeur. These reefs and islands beyond the Sri Lankan horizon are the last coral outpost of the Indian subcontinent. At anchor here we look south across empty, deep-blue ocean waters that end only at Antarctica; below us along the rocky fissures, the dense shoals of fish are clearly visible from the surface. It is an unforgettable scene with which to end our journeys in Sri Lanka.

The Andaman Islands

Reaching the Andamans in 1982 was for me an odyssey of discovery across the midsection of India, an eye-opening panoply of experiences ranging from the sublime to the physically painful. Beginning in New Delhi, we were soon aware that the problems in this part of the world are of an order most westerners would find hard to comprehend. The key to the experience is India's well-publicized overpopulation, which intensifies any other problem (such as drought or flood) to immediate crisis proportions.

From New Delhi it is but a few hours by car to the fabled city of Jaipur. All of the buildings in the main section of this clean, prosperous city are pink, highlighted by the lovely Wind Palace. From Jaipur to Agra is another automobile ride of a few hours, to the site of what must be the world's most enduring token of love. Built by the devoted Shah Jahan as a mausoleum for his beloved empress, the Taj Mahal ranks with the best of any lifetime of famous monuments.

During our peregrinations across India we thought we had seen it all: overcrowding, poverty, and their painful ramifications. Our jumping-off place to the Andamans, however, was Calcutta, on the eastern coast facing the Bay of Bengal. There is nothing in a lifetime to prepare the first-time visitor for Calcutta. It is a vision of all of humanity's nightmares of the future encapsulated into agonized reality. The heat, the smoke from hundreds of belching smokestacks blotting out the sun, and the crowding constitute an overwhelming assault on the senses. It is the first place I have ever felt the physical pressure of millions of bodies as I walked the scorched mean streets. I could only wish that those who downplay the dangers of the world's race to procreate could spend a week in this most frightening of cities.

From teeming Calcutta we took off at dawn one morning for the six-hundred-mile flight to Port Blair, capital of the Andamans. These islands are a forward defense perimeter of the Indian government, lying as they do a mere hundred miles off the coast of Thailand. For this reason permits to visit the islands are hard to obtain, and few divers have ever been to the Andamans. We had been invited by the Indian government to evaluate the diving for future tourist development, so our permits were granted without delay. But no one could tell us what the diving would be like. One government official in New Delhi said that it was superb, but another in Madras said it wasn't very good. It was because of these contradictory reports that, as the jet finally circled the wooded hills, I looked diligently for signs of offshore reefs.

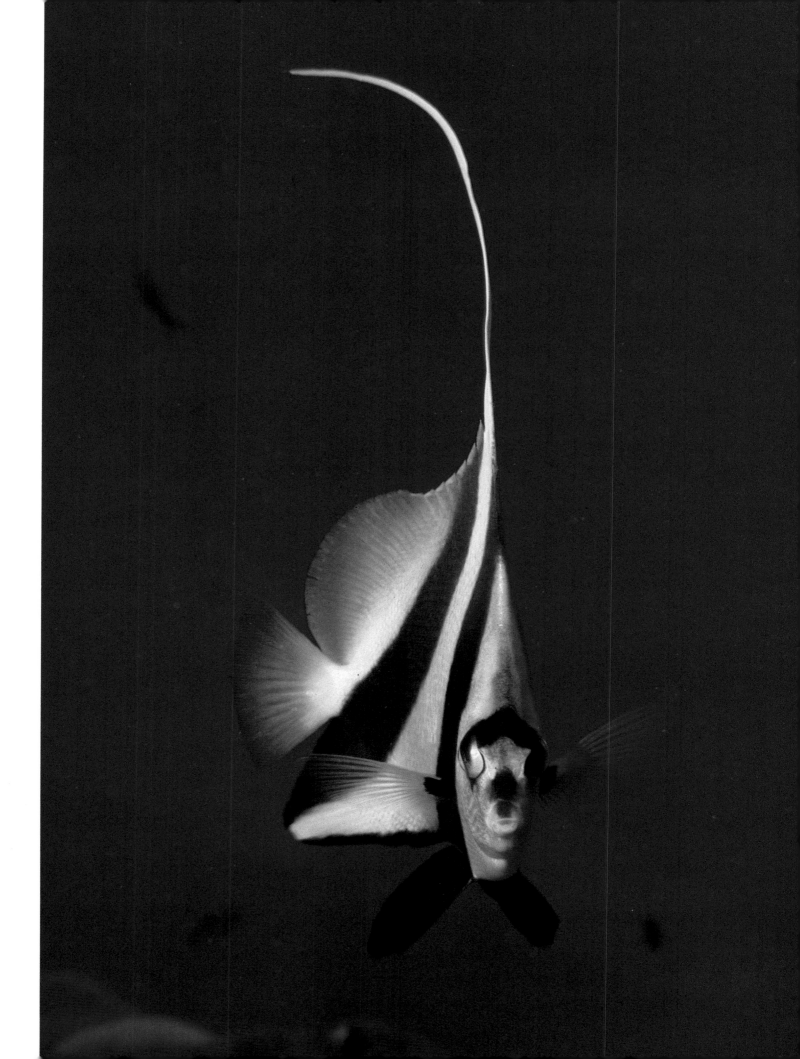

The clownfish *Amphiprion perideraion* ▶ looks out from a pink corridor of anemones (*Heteractis magnifica*).

The central islands of the Andamans are substantial; some are forty miles in length and several miles wide. With the generous annual rainfall, the hilly landmasses are heavily forested, and ambitious logging camps are in operation.

Another consequence of the heavy rainfall is muddy rivers, which empty into the sea and make the waters off Port Blair turbid. For this reason our diving was to take place some twenty miles south of the main island on rocky, isolated islets.

Accordingly, the next day's diving expedition began at 4:00 A.M. with an hour's ride down rutted corkscrew roads to reach the boat. Due to a severe lack of tourist facilities attributable to military restrictions on imports, the dive boat was a tugboat borrowed from a logging company. The crew was cheerful, much happier to be watching the crazy Americans than to be out hauling logs across the channel between the islands.

After three hours we arrived at Cinque Island, a high, forested ridge with coral reefs scattered nearby. During the limited season of good weather in February and March, Cinque and its sister islands escape both the monsoon weather and the current-borne turbidity from the larger islands to the north.

Leaping gratefully from the searing heat of the day into the clear, warm water, I saw that the island's steep, forested hillside continued downward in a plunging undersea wall spotted with scattered corals. Spiraling lower I found enormous boulders torn from the wall lying scattered on an abrupt bottom at one hundred feet. I immediately found that the fish swirling about the great boulders were old friends from the Maldives and Sri Lanka. Butterflyfish, angelfish, snappers, grunts, damselfish, small groupers, tangs, and surgeonfish darted everywhere. As I looked ahead I saw one unusual small surgeonfish (*Paracanthus hepatus*) occurring in remarkable numbers, but whenever I arrived they had disappeared. A moment's observation disclosed their hideouts. The relatively featureless stony bottom was honeycombed with tiny crevices, and the clouds of surgeonfish simply vanished into their holes, leaving not a trace, at my approach. As I explored the rocky midslope, I became aware of activity in the deeper water. Soaring downward I could make out a gigantic boulder, that had rolled down the slope and come to rest in 125 feet of water.

A medium-size parrotfish excretes sand in prodigious quantities, amounting to thousands of pounds a year.

This clownfish (*Amphiprion fuscocaudata*) ▶ barks loudly at our approach, a sound that is clearly audible.

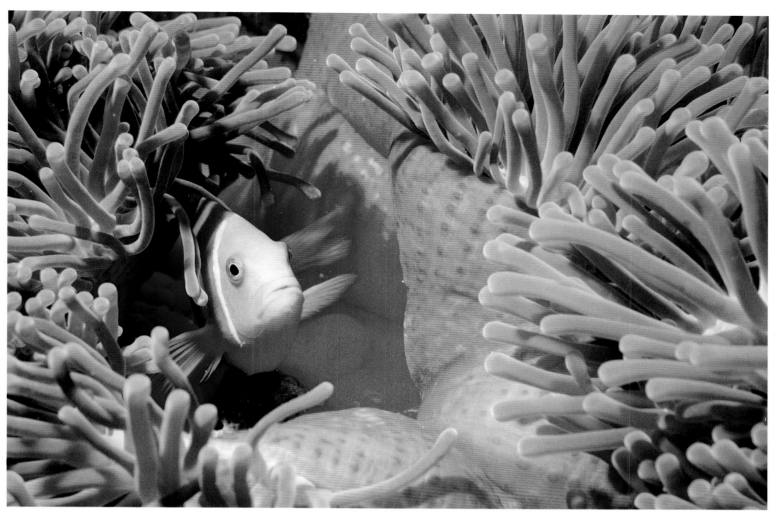

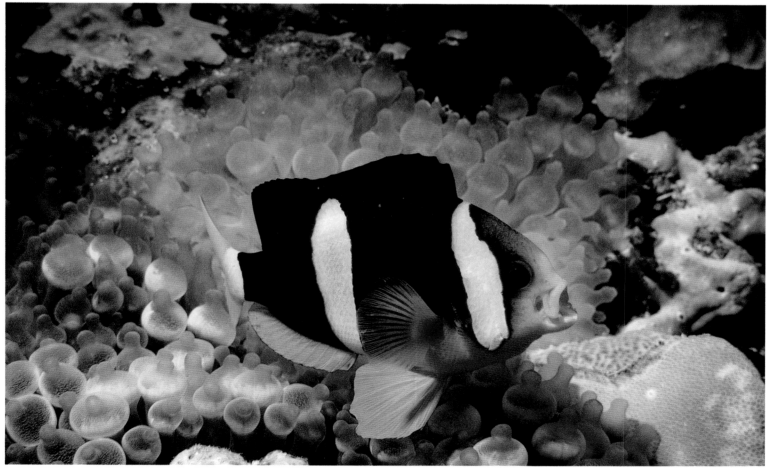

An octopus displays part of its repertoire of color and texture.

Anticipating this to be a natural gathering place for fish much as a sunken wreck would be, I watched out at the limit of visibility for signs of movement. The first denizens were two prowling sharks making a business-like sweep through the area. Then almost immediately a large school of the batfish *Platax* wandered by, each with one eye cocked suspiciously in my direction, but otherwise seeming unconcerned at my presence. About the base of the huge boulder big groupers moved like dark ghosts, visible mainly as fleeting silhouettes in half-lit passages.

This heavy boulder had indeed attracted an assemblage of marine life. As I slowly moved toward the lighter waters above, I could see gaily colored crinoids perched on isolated spurs of the rock. Tiny damselfish and butterflyfish enjoyed less competition than in shallower waters, eyeing the occasional school of passing fusiliers.

At about fifty feet I was abruptly surrounded by a large school of curious barracuda. This animal schools in the shallows during its youth, moving into deeper water as a solitary hunter during its adult life. In several parts of the world, however, I have seen large collections of what appeared to be adults schooling near the surface off major drop-offs. This is spectacularly true off Ras Muhammad in the Red Sea and only a little less so here in the Bay of Bengal. There was no apparent major precipice to deep water at Cinque, but the barracuda congregated anyway, watching with great round eyes this unusual apparition among them.

On another later dive I learned some of the factors that limit the Andamans' season. In the middle of a dive photographing reef fish at North Cinque Island, I looked up to see a wall of discolored, sediment-laden water moving inexorably upon me. The new water was cold and dank; I guessed that the huge tidal flow southward past the main islands had grown wide enough to split on the sharp end of North Cinque. Quickly we upped anchor and moved south where, an hour later, the wall of turbidity closed in once again.

Just south of the Andamans lie the Nicobar Islands, which are completely closed to outsiders to protect primitive tribes and are low atolls like the Maldives. The problems of siltation are less in these totally isolated islands. Perhaps in years to come some areas will open to underwater exploration.

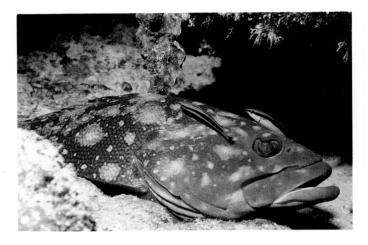

A large grouper lies in a deep crevice while two cleaner wrasses (*Labroides dimidiatus*) search its body for parasites.

A blue-spotted grouper (*Cephalopholis miniatus*) is ministered to by a cleaner shrimp (*Periclemenes*).

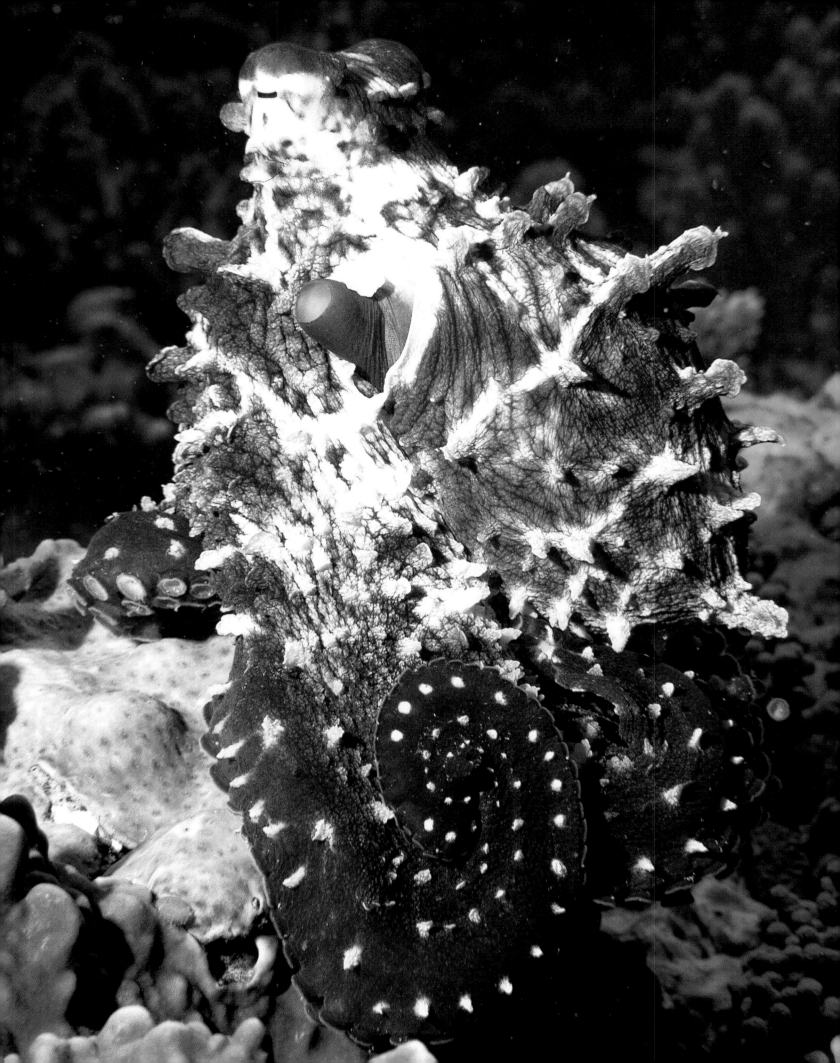

Rocky boulders and talcum-powder beaches are trademarks of the remote Similan Islands off Thailand.

Thailand—The Similan Islands

An overnight cruise to the northwest of Phuket in southern Thailand are the remote, rocky Similan Islands. As we anchor off the Similans, Burma is below the horizon to the north, and India lies far to the west. The mountains of the Thai mainland are indistinct shadows to the east. There is immediacy here in a night sky full of stars; the lights of Thai fishing boats glimmer in the distance. There is no hint of geopolitics or jungle warfare, though only a few hundred miles away the world rages on. This tiny chain of uninhabited volcanic islands has three distinctions, any one of which would make them worthwhile for divers to explore.

First, they have the finest talcum-powder sand beaches we have ever seen. These beaches are utterly private, for almost no one visits the Similans. There is a certain sybaritic triumph in claiming a half-mile of astonishingly white sand for one's own.

A second distinction for the Similans is the presence of crown-of-thorns starfish (*Acanthaster*) there in phantasmagoric colors. Iridescent pink, purple, and blue appear under our lights, and this otherwise-ugly creature becomes a highlight of our photographic efforts.

The third distinction is the most significant: a Jekyll-and-Hyde difference between sites on the eastern side of the chain from sites on the western side. The eastern shores look out upon rich, intricate beds of stony corals and countless millions of colorful reef fish. Indeed, peering out across the underseascape, we see what look like huge amorphous masses where we expect large coral heads. As we approach these masses, we discover them to be clouds of anchovies and silversides hovering in dense colonies about the large coral structures. Cruising sharks, schools of barracuda, and a hundred curious batfish complete the typical atmosphere of a tropical coral reef.

When we shift our activities to the western side of the islands, however, we seem to be in a totally different part of the world. The closest comparison is to Baja California, with immense volcanic boulders tumbling over one another in ponderous labyrinths. Upon these unyielding, barren surfaces passing currents have deposited brilliantly hued anemones, gorgonian fans, soft corals, scallops, and large numbers of reef fish. Sometimes, powerful currents sweep through these massive stone grottoes, forcing us to descend by handlines and seek refuge behind the shelter of the boulders. Butterflyfish, angelfish, and a cornucopia of other species share our shelter, none of us wandering into the swift flow but instead crowding in the still lee water.

Tame octopuses, large groupers, lionfish, grunts, and other reef-dwellers are all around us. Beyond them in the swift water, great shoals of iridescent fusiliers form a shimmering tapestry, effortlessly sweeping against the—to us—daunting current.

The Similans do, unfortunately, share one blight with some of the other great reefs of the world—dynamite fishing. Governments are powerless to protect such remote reefs as these; the dynamite fishermen only wait until no one is near to do their destruction. Here and there in the Similans, one sees pulverized rubble where healthy coral communities once flourished. A reef's recovery is measured in decades, making dynamite fishing extremely inefficient compared to nets or traps. Still, the explosive cult is spreading, destroying reefs at a profoundly alarming rate.

It is easy to imagine the marine life of places such as the Similans being snuffed out before anyone ever knows it is there.

In many ways, much of the Indian Ocean is a sea of the future. Development in the Maldives and Seychelles is only a few years old, and currently remote islands will become more accessible with the passage of time. The question, as everywhere in the coral kingdoms, is whether that accessibility will mark a beginning—or an ending.

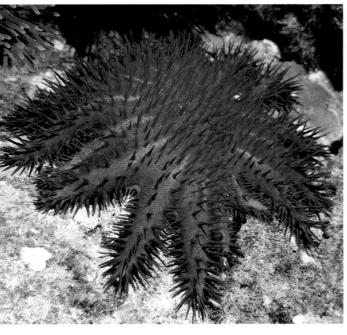

The crown-of-thorns starfish (*Acanthaster planci*) occurs in iridescent pinks and purples in the Andaman Sea between India and Thailand.

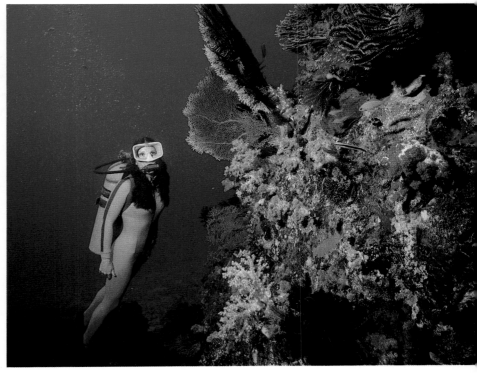

Typical coral formations on the western slopes of Thailand's Similan Islands.

At sunset a lone boat cleaves the sheltered waters between Palau's islands.

Chapter Four
Micronesia, the Philippines, and Papua New Guinea
AN INFINITUDE OF ISLANDS

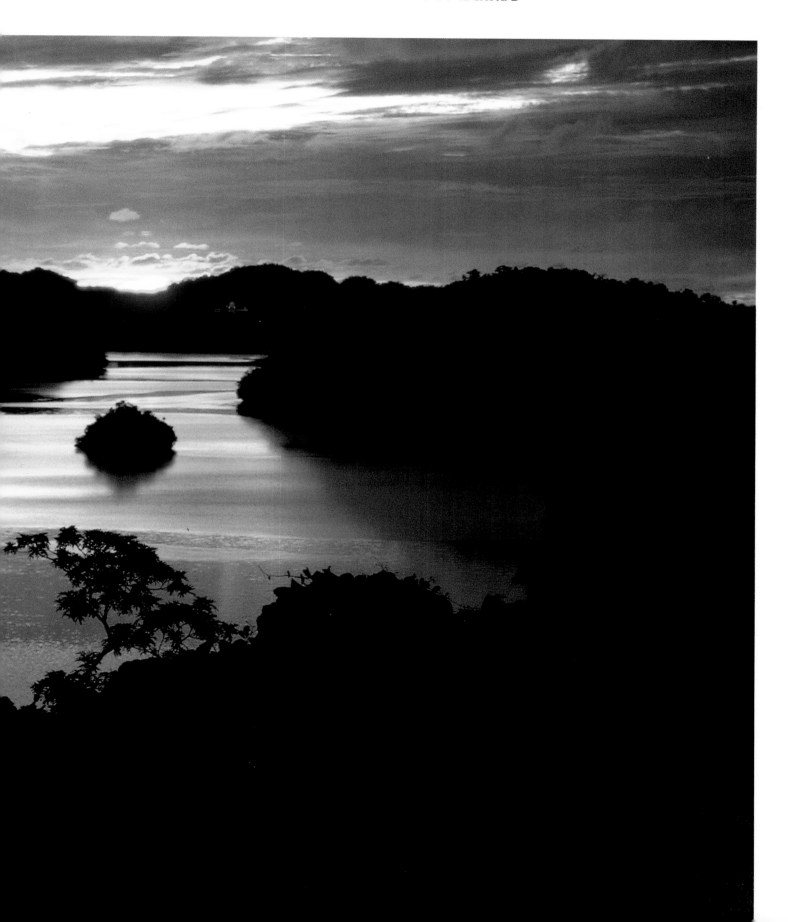

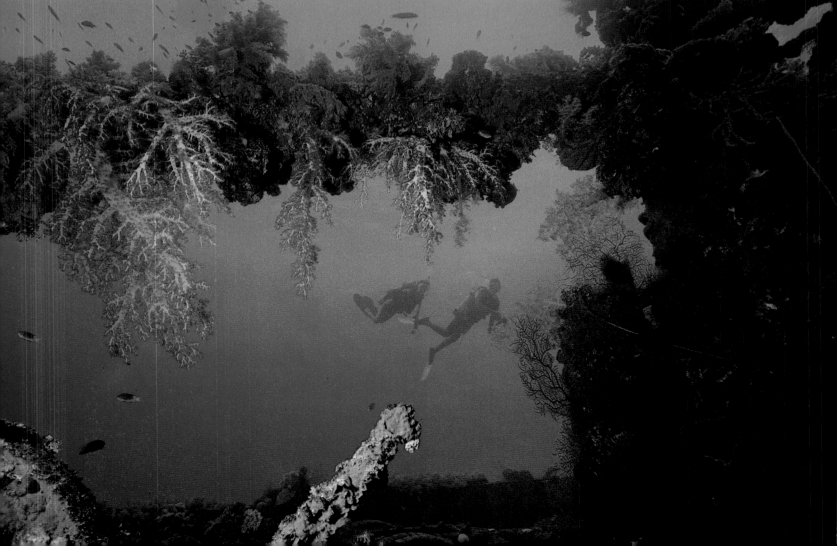

Palau's hundreds of islands are punctuated with peaceful sandy beaches.

On the slope of Apo Reef schools of butterflyfish (*Hemitaurichthys*) and fusiliers (*Caesio*) swarm in the plankton-rich waters.

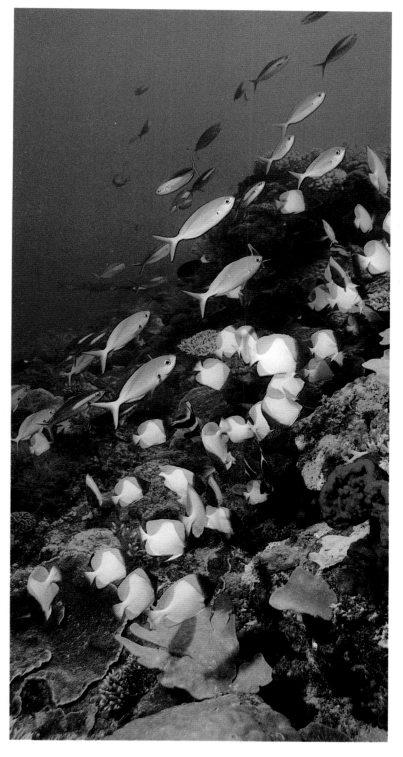

◀ Divers framed in coral and steel hover near the *Fujikawa Maru*, Truk Lagoon.

Across the central Pacific lies a span of seven thousand miles of open water dotted with clusters of tiny islands. As one's jet flies hour after hour over endless rippled blue ocean, one comes to respect the courage and determination of those explorers who traversed it in fragile sailing vessels.

Micronesia is comprised of twenty-one hundred small islands whose total landmass is substantially less than that of most American states. This amount of land is scattered over three million square miles of ocean (more or less the size of the United States), in a long band starting a bit west of Hawaii and extending to a point due south of Japan. Politically the Micronesian islands are organized in districts ranging from Palau and Yap in the west, to Truk and the Marianas in the center, to Ponape, Kusaie, and Majuro in the east.

Somehow when one says "three million square miles of ocean" it seems large but abstract, but it becomes very real when you sit in a cramped airplane seat for six hours to Hawaii, then drone on for fifteen air hours to reach Palau or Manila or Port Moresby. The nature of Pacific airline schedules is that these flights are often scheduled through the night. By the time you travel westward through eight or nine time zones (each extending the darkness by an hour) the night seems endless. The fortunate sleep; the author suffers.

The fact is, you don't miss much in the darkness. Flying the same route by daylight you see an eternity of blue water only rarely broken by tiny islands. When the islands are specks of tedium in a sea of monotony it is hard to appreciate just how many there are in the immense Pacific basin. Yet, in the Philippines alone over seven thousand islands crowd the Sulu and South China seas. Many hundreds more crowd the waters of New Guinea, the Solomons, Indonesia, and Malaysia.

From the time of the Spanish conquerors, all of these island groups have seen turmoil and conflict. Each has in its turn been a critical pawn in bids for national hegemony, and each has subsequently been devastated by modern war. Some, such as the southern Philippines, are still contested by insurgents.

In the vast equatorial Pacific basin these two groups of islands, Micronesia and the Philippines, offer a wealth of undersea adventure amid storybook settings. Several other areas there have not yet had enough underwater exploration to assess their potential.

Micronesia
Truk Lagoon

Nowhere in the coral kingdoms is the devastation of war more vividly portrayed than beneath the waters of Truk Lagoon. In 1944, during the height of World War II, the American Pacific command planned and consummated an all-out attack on the home base of Japan's Imperial Fourth Fleet. In one of those tiny accidents that can influence history, Japanese observers spotted an American reconnaissance plane two days before the intended strike. The Japanese immediately withdrew their capital ships, leaving behind some sixty-four supply ships, tankers, and submarines, with 250 aircraft. In two unbelievable days, February 17 and 18, 1944, all were destroyed except for three submarines spared only because American pilots knew that friendly subs had penetrated the lagoon to assist any downed pilots.

I've talked with Trukese natives who hid in the hills and watched this local götterdämmerung. When the American planes swooped in, most of the Japanese ships were caught at anchor. Very few managed to weigh anchor at all; those few that did were followed and destroyed. The airborne attack was so swift and murderous that there were almost no casualties among the attacking pilots. A pulverizing strike on Eten Island caught most of the fighters on the ground; they never even managed to take off. At least fifteen thousand Japanese personnel perished in the raid, which became known as the Japanese Pearl Harbor.

Today we sweep into Truk on a modern jet that roars in low over the water and enables us to see several wrecks from the air. We pass over Eten, where the fighter strip is now an incongruous rectangle of palm-tree green against the blue of the lagoon, and over Dublon, where the Japanese headquarters was obliterated. Around Dublon, Fefan, and Moen Islands this marine graveyard is today a balmy millpond punctuated with gentle green islands. Only here and there do the horrors of the raid reach the surface. Where they do, they are landmarks used to locate dive sites for undersea visitors.

Perhaps the most famous is the *Fujikawa Maru*, sitting upright with its two great masts groping above the surface like grotesque metal headstones. One of the most accessible of the world's large wrecks, it seems a ghostly setting for some cosmic play. The *Fuji*, as it is known, offers one incredible view after another to the undersea observer. Divers swimming through the great wreck are constantly surrounded by sculptures of booms, masts, cables, pipes, and other elements of the ship's structure. Perhaps most arresting is the great silhouetted cross formed by the foremast when the sun is directly behind it. Or there is the massive rear gun mount, or the forward gun, or the coral-and-sponge-festooned anchor chain, or a hundred others—from any angle any portion of this vast casualty graces the eye with vengeful and violent poetry.

The *Fuji*'s metal sculptures are not its only attraction. Here and there hanging from a cable or jutting from a spar five-foot-tall examples of the soft coral *Dendronephthya* can be found. When currents flow and at night, these colonies inflate to elevate the hundreds of individual polyps into the food-laden stream of passing water.

Truk is not the only home of these magnificent corals. They are found throughout the coral kingdoms of the Indo-Pacific and we shall encounter them widely in our travels. For some reason, however, certain of the grand metal reefs in Truk Lagoon seem to bear the largest soft corals I've seen. On the *Fuji*, and on her sister wrecks *Shinkoku Maru*, *Yamagiri Maru*, *Rio de Janeiro Maru*, and *Kyozumi Maru*, enormous yellow, rose, and violet specimens of *Dendronephthya* hang like the echoes of wind-blown pennants from masts whose real signals perished long ago.

In addition to the soft corals a mantle of other marine life adorns these metallic reefs—stony corals, gorgonians, polychaete worms, anemones with their symbiotic clownfish, wire corals decorated with chains of tiny white polyps. All around the invertebrate life attached to the wrecks, shoals of fish flutter in the still lagoon waters. These wrecks have been engulfed by the sea in every sense, their metal now a living, changing panorama of multi-hued life.

At night these vast marine gardens assume dimensions unseen by day. Nocturnal crinoids perch upon the soft corals, colonies of fiery-orange cup corals gleam in the divers' lights, and hunters of the darkness such as octopuses, eels, and lobsters prowl amid the sleeping fish, seeking unwary prey. In the coral kingdoms the hunt never ends.

Other wrecks, each with its own special atmosphere, throng the still waters. The *Dai Ni Nbo*'s deck gun is stalled a

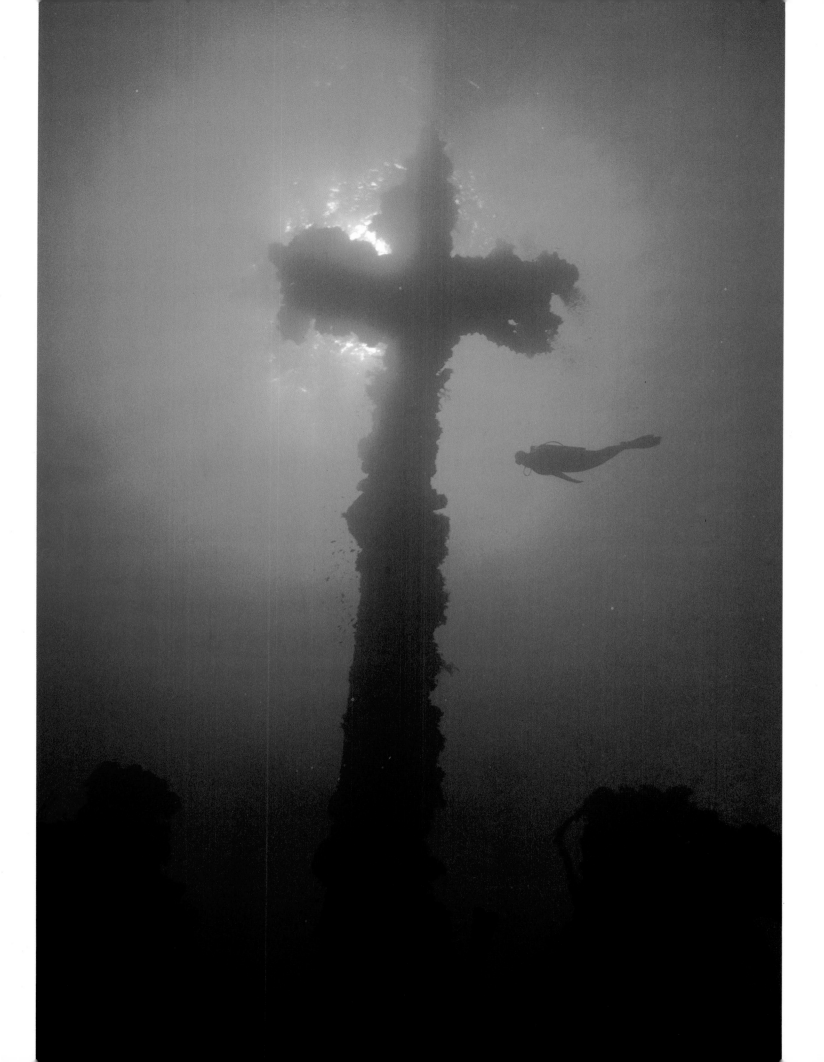

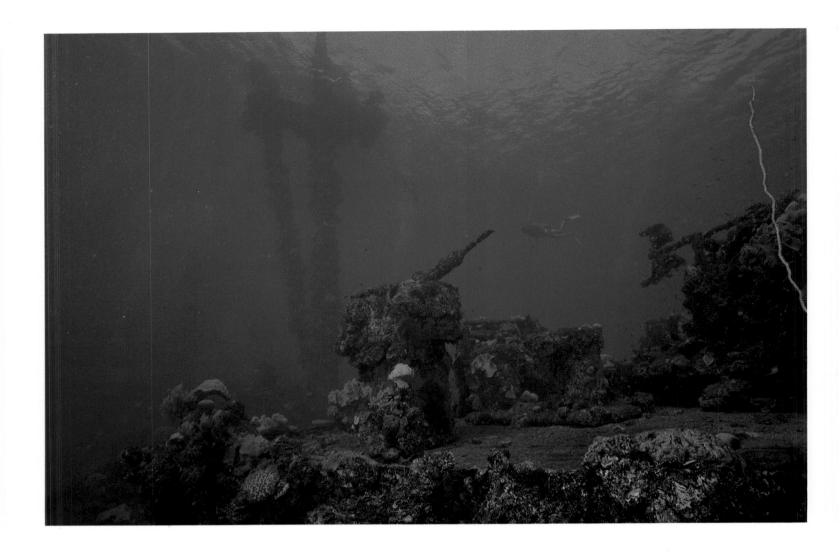

few feet beneath the surface; the *Sankisan*'s hold is filled with fifty-caliber ammunition; the submarine I-169 (the *Shinohara*) is a shattered shell from the explosions intended to help free her doomed crew; and in the silent, darkened hull of the *Kyozumi* lie the eighteen-inch shells used by the monstrous guns of the battleship *Yamamoto*.

There are some darkling wrecks that lie deeper than their dead compatriots. At the deep anchorage off Dublon the *Seiko Maru* sits upright one hundred and twenty feet beneath the surface, while at one hundred and fifty feet one may explore the decks of the *San Francisco Maru* with its pair of metal-treaded tanks, the armored vehicles doubly incongruous here in the deep, still waters. Farther out the *Amagi-san* lies totally shattered by an explosion that knocked the attacking American plane out of the sky. Which the assassin, which the victim?

Truk's thirty-mile-wide lagoon is surrounded by a reef wall pierced by passes through which tidal waters churn in their relentless daily cycle. These channels are the natural feeding grounds for large numbers of sharks; on occasional forays to these outer reefs I have found them both numerous and aggressive. Unlike most open-ocean reef walls, this area needs no fish-baiting to bring the sharks. As soon as we entered the clear blue water (a distinct contrast to the sixty-to-eighty-foot lateral visibility in the lagoon) some raced up at us from the deeps. Soon a half-dozen or more swift gray and black-tipped sharks were making curious and occasionally rushing passes to investigate us. I could discover no reason for their aggressive behavior, so unlike that on other Pacific reefs.

At day's end, looking out over the calm waters in the fading afterglow of an inferno sunset, I still find it hard to believe what I have seen here. Like the gaping mouths in Picasso's *Guernica*, the torn wrecks cry out silently, condemned to lie here in an endless quietus. They are fitting monuments to the days they commemorate. Somehow no statue or obelisk in a city square could evoke their end with the unspoken eloquence we find in this ghostly arena of past conflict.

◀ On rare occasions clear water enters Truk Lagoon, allowing us incredible views of the sunken Japanese wrecks. This is the *Sankisan Maru*.

The golden slingjaw (*Epibulus insidiator*) has extensible jaws that are nearly one-third of its body length.

Chaetodon kleinii, a delicate butterflyfish, browses amid reef life on the mast of the *Fujikawa Maru*.

On a shallow reef a brightly colored sea urchin (*Asthenosoma*) hides from the light.

Ponape

Ponape is a lost dream of an island some four hundred miles east of Truk, a kaleidoscope of lush images that flutter at the edges of the mind for months or years after one has left.

In the central hills the rainfall averages four hundred inches each year, while along the coast two hundred inches a year is common. This has rather mixed results. One surely positive consequence is a charming, thundering waterfall in the jungle, a place where tons of water cascading down a picturesque rocky defile tend to wash away the cares of civilization. Beyond the waterfall along the coast lie the ruins of an ancient city known as Nan Madol. Here, somewhere in Micronesia's shadowed past, a civilization of some consequence constructed more than one hundred city blocks of temples and other structures using enormous hexagonal basalt logs. These interleaved shafts form massive walls with predictably raised corners, evoking images of Chinese pagodas.

Surrounding Ponape at some distance is an outer fringing reef enclosing a sizable (and, to the local population, su-

premely important) lagoon. According to Darwin's theory of atoll development, Ponape is a subsiding volcanic island that will someday disappear from the center of its fringing protective reef. Indeed, flying west or east from Ponape one often soars above two extraordinary atolls, Pakin and Kwajalein. The latter is best known as the splashdown point for test missiles launched in California (they often take only seventeen minutes for the journey), a truth whose beauty is easy to miss as one lands at the spartan military facility at the southern end of the atoll.

Ponape has millions of years to go before its rain-soaked hills subside into its lagoon. Though the making of a long tomorrow's atoll seems certain, today we still see lofty hills misted with rain showers, and a mile-wide peaceful lagoon. For visitors flying in over the reef, all is brilliant in the sunshine: the splashing white of the ocean waves on the outer coral bastion, the deep green of the hills, the gleaming emerald and yellow reefs of the lagoon, the deep blue of the sea. In Ponape in the sun, colors are profoundly exciting.

While much of the outer reef structure shows only modest reef development, this is almost certainly a consequence of the severe weather and wave action along much of the pe-

▲ A native family leaves the main entrance
to the temple square at Nan Madol ruin.

rimeter. There are occasional sheltered enclaves of explosive growth. For about two miles along the northern shore, for example, the sun illuminates slender fields of table corals, an *Acropora* that has a central stem and flat top, resembling an ornate, round pedestal table. Most of the tables on Ponape's reefs are two to four feet in diameter; those in deeper water and others in other coral kingdoms can measure ten to twelve feet across.

Over the edge of the drop-off there are sheltered crevices filled with unusual purple hydrocorals (small, brittle branching corals) and delicate foot-tall soft corals in fantastic violets and pinks. The soft corals are not as large as those of Truk a few hundred miles away, but the colors are especially intense, almost as if in compensation.

The fish life is healthy and varied, with fluttering butterflyfish, color-splashed angelfish, swift wrasses, sweeping schools of fusiliers, and in deepwater counterpoint, masses of barracuda, occasional manta rays, and patroling sharks. These sharks are well behaved and for unknown reasons are not at all aggressive, as at Truk's outer wall.

Along certain portions of the reef perimeter the drop-off is nothing short of awesome. It plunges to a depth of three hundred feet at a steep angle, then falls away vertically to abyssal depths.

Ponape is the only place I have ever witnessed aggressive behavior by a barracuda (*Sphyraena barracuda*). It occurred during a scouting expedition during which a Ponapean dive guide and I were snorkeling along the outer limits of the reef to spot good potential areas for scuba diving. During one span that featured very narrow reef shallows and a vertical wall, we came face to face with a solitary barracuda. In my experience barracuda are not aggressive unless cornered, and so I was extremely surprised to see this one make a lightning pass at my companion. In his surprise at facing the animal he had backpedaled furiously, drawing an instinctive pass from the barracuda, which behaved much as a dog might under analogous circumstances. The barracuda, having unmistakably established its territorial rights, withdrew. My companion needed several pep talks back on the boat to resume his diving career.

Barracuda are well equipped for hunting fish in open water; they can be extremely swift in short bursts and have a formidable array of razor-sharp teeth. While they *look* fearsome, there are almost no authenticated accounts of aggres-

▲ This dreamlike waterfall lies in the palm jungle a mile from Ponape's deep reef.

sive behavior by barracuda toward humans unless the fish have been molested or cornered. As with sharks, most of the barracuda's reputation as a threat to divers is simply not supported by the facts.

After this highly unusual incident I have since made many dives on Ponape's placid reefs amid mind-numbing beauty, undisturbed by any such threat. Even at Ant Atoll, seven miles across open sea from Ponape and a place where the sharks are seen on every dive, my encounters with the marine denizens have been uniformly peaceful. Since the local natives feed the sharks, it's no surprise that they exhibit great curiosity. We're told that the children of Ant play with the sharks in shallow water, feeding them, riding them, and indulging in other local sports without ever incurring an injury. At Ant the sharks apparently take the place of local dogs, an interesting phenomenon of remote island life.

Palau

The Palauan islands are the farthest extremity of Micronesia for travelers from America, a prodigious odyssey of Pacific travel worth every minute of the trek. Flying in over the rounded green hills honeycombed with serpentine waterways, we recall that Palau encompasses approximately one hundred individual islands. The islands range from mushroom-shaped hillocks to the forty-mile-long mountained island called Babelthuap.

These islands are called the rock-garden islands for their unusual shape. Eons of weathering have broken the limestone into a life-supporting soil; thus, each rounded rock mound is smothered in a carpet of greenery. In addition, wave action has carved deep furrows at sea level. Especially in the smaller islands, the result is a characteristic mushroom shape that has come to symbolize this island community.

As we dive here it is hard to believe that we are due north of Darwin, Australia, and due south of western Japan. Only the remoteness and inaccessibility of these islands have kept their character Pacific rather than Asian. With different currents, winds, and tides, millions might be living here—as in the not-so-distant Philippine and Indonesian islands—rather than the sparse population we actually find.

Palau's complex islands and gigantic outer reef ramparts offer tremendously varied and complex diving. One absolutely fabled site, the Blue Hole, is a subterranean chamber at a depth of 110 feet that has four vertical shafts, or blue holes, soaring up through the solid reef to the brilliant sunlight far above. This huge, deep cavern opens directly onto the open sea. One dive I made there in April, 1984, was filled with spectacle. No less than four species of sharks patrolled the chamber, and as we hovered with them, four heavenly beams of sunlight blazed down through the shafts. The edges of the deep opening to the sea were lined with vast treelike black corals, past which the sharks cruised in their never-ending search for food.

Another natural formation near the Blue Hole is a large point, or projecting spur, of reef. Because this reef peninsula disturbs the smooth flow of ocean currents along the reef wall, strong currents and turbulence abound. The activity stirs up concentrations of plankton, and the waters are consequently filled with fish. Swift schools of horse-eyed jacks, tuna, sierra, and mackerel race by in the open blue water; whole great herds of snappers hug the wall as if in fear of the predators out in the blue. There are crevices filled with red-and-white gorgonian sea whips. Reef fish dart and swirl in contrast with their usual placid swimming. The entire area is a world unto itself. A diver, fighting the current, pulls his or her way from handhold to handhold, just for a chance to glimpse the concentration of fish life in this unusual scene.

There are other prodigious natural formations that in my diving experience are unique to Palau. At one point in the outer reef another undersea chamber opens at the same 110-foot level of the blue holes, clearly part of an ancient sea level's action. In this case, however, the chamber extends completely through the reef; nearby there is a large channel through the coral wall, so that the tunnel and the channel have formed a huge sub-sea column a diver can easily circumnavigate. Currents flowing through during tidal flows nourish plentiful sponges, gorgonians, crinoids, black corals, and hosts of bravura-colored fish that feed on plankton; among these darting splashes of color are damselfish, fusiliers, bonnetmouths, and diamond butterflyfish (*Hemitaurichthys*). These last fish occur by the thousands all along Palau's outer reef precipice, gaily darting to and fro above

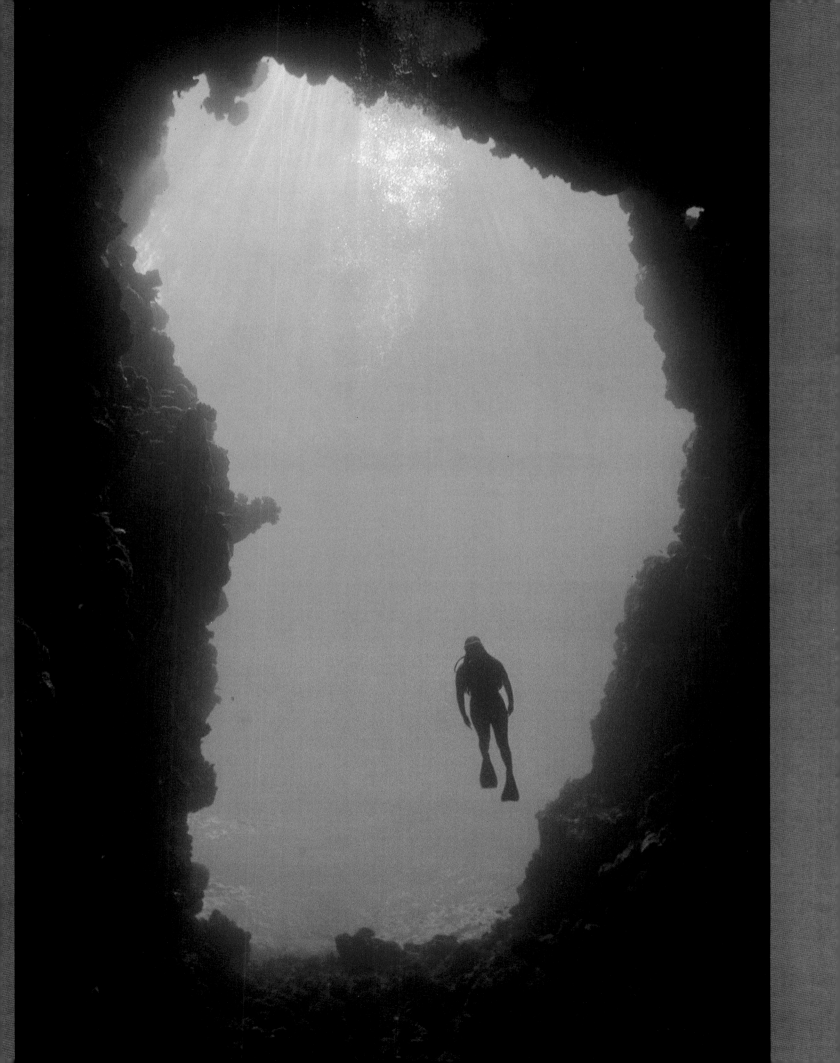

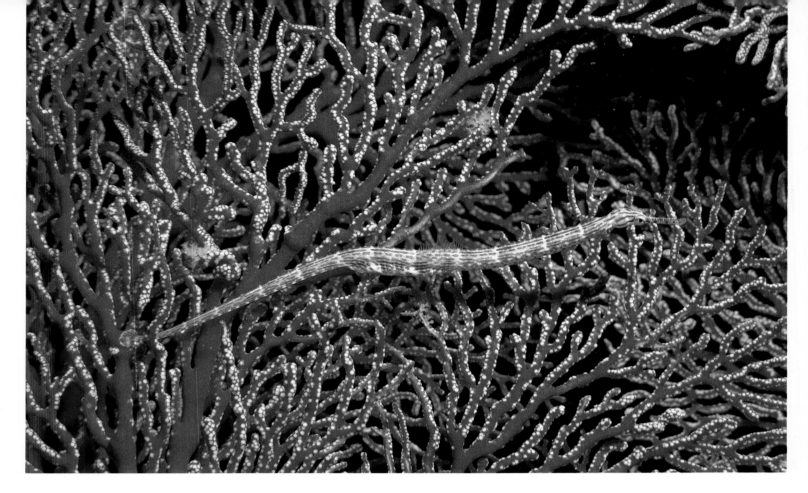

▲ This slender pipefish (*Corythoichthys*) seems to appear each afternoon around four o'clock on the red gorgonians of Palau.

The rare ghost pipefish (*Solenostomus paradoxus*) hides against the complex background of a gorgonian sea fan. ▼

A rainbow of coralline color. ▶

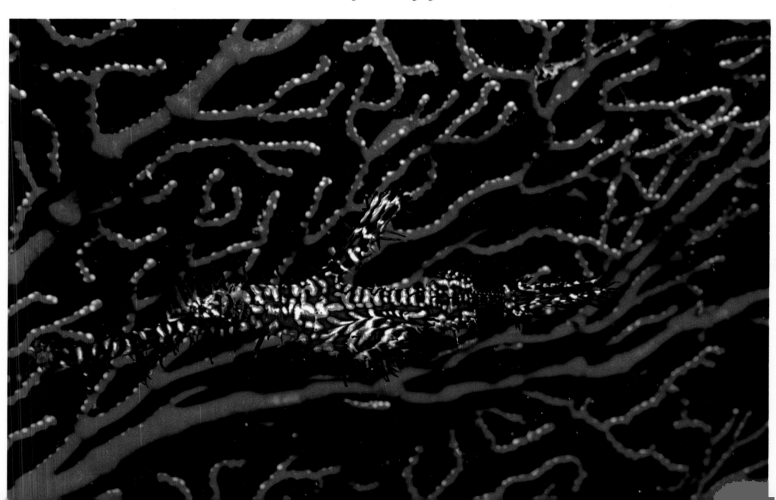

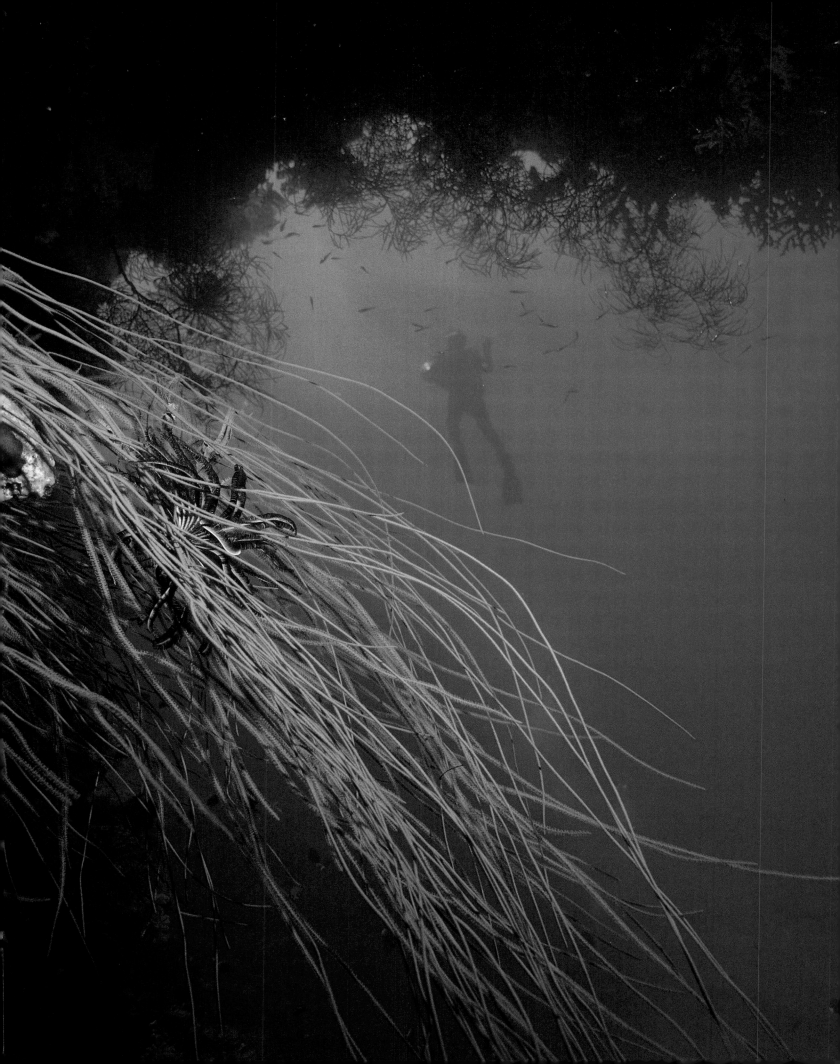

the abyss, seeming brighter than normal because of their contrast with the inky blue of the deeps behind them.

Another sea-carved wonder occurs just at sea level not far from Koror, the capital. Known as Chandelier Cave, this amazing formation is actually a sequence of four caverns, one after the other. Their main entrance is an unimpressive hole in a shallow reef just beneath the surface of a lagoon lined with overhanging greenery. One wonders how the doorway was ever found.

Not far inside one enters a Stygian darkness that at once rouses a soulful yearning for the sunlight. This yearning grows with every foot one moves into the darkness. The first cavern is filled with enormous white-capped stalagmites and stalactites that gleam in the beams of our lights. Those immense limestone constructions represent eons of dripping water slowly depositing limestone when these caverns were above water, during the lower sea level of an ice age. This first chamber is incompletely flooded; in certain sections the bubbles from our exhalations rise to crash into solid limestone, while elsewhere there is an air pocket above the surface.

After perhaps sixty to eighty feet, the floor of the cavern rises abruptly to a threshold twenty feet high. Traversing it in the still, clear water, we enter the second chamber. Now the darkness is total save for a faint distant hint of light from the entryway. Passing through this cavity we find it as large as the first. It, too, is filled with stalagmites and stalactites.

Another threshold, and we penetrate the third chamber, which is very like the first two (except for the psychological effect on a diver of being so deep within the mountainous island). At the end of the third chamber, we clamber up onto an exposed floor, doff our tanks, and crawl down a narrow passageway to the fourth and final cavern. Here, completely encased in rock, the last chamber broods through the ages in uninterrupted, eternal darkness.

Returning to the third cavern, we put on our tanks and re-enter the water. For the sheer joy of it we extinguish our dive lights to bathe in the totality of the darkness; people who install sensory deprivation chambers suddenly seem to have missed the whole point—*this* is what total darkness is about and it seems completely comfortable to us.

After our eyes become accustomed to the darkness we can distinguish, to our surprise, an ever-so-faint glow at the farthest limits of our vision. As we move slowly through the darkness toward the distant glow we see several soldierfish (*Myripristis*) silhouetted against the dim light, living out their lives in this eternal semi-darkness. Since this species eats by night, I suspect they leave the cavern each evening to feed on the outer reefs, but spend their days hovering here. Perhaps it is understandable as an evolutionary adaptation meant to insure serene shelter against the predators encountered on an open reef.

After leaving the cavern we find ourselves sitting once again in our small dive boat anchored outside the tree-shadowed doorway. We chat quietly, reliving the sensations of this marine spelunking, a contrast indeed to our normal career on sun-warmed reefs.

There are some unusual citizens out on the teeming Palauan reefs. For example, in the tide-riven passages between many of the small inner islands there are lush red gorgonian sea fans with white polyps. During the sunny part of the day, there appears to be no predation on these intensely hued coral colonies. At four o'clock every afternoon, however, each gorgonian seems to receive a visitor—a lovely and delicate fringed pipefish (*Corythoichthys*). Traveling about on my late-afternoon rounds I am sure to find a fresh pipefish with each gorgonian. There is a quite practical reason for my moving from one pipefish to another; my close-up photography tends, even when I'm very careful, to unnerve the pipefish to the point where they hide. When this happens I move on to the next one, for when I return to repeat the process several minutes later, each pipefish will have returned to its chosen gorgonian to resume its browsing.

There is another very rare pipefish that inhabits these delightful reefs. I found it in an odd way, and by purest accident. Diving one day at a depth of one hundred feet on a reef slope, I spotted a graphic black-and-white crinoid perched atop one of those plentiful red-and-white gorgonians. As I focused from three feet away, I noticed what I took to be a misshapen arm on the crinoid. Being rather severe about such things in my photographs, I reached out to pluck away the offending arm. To my thorough surprise it moved away from my grasping fingers, and I was elated suddenly to see

not one, but two, of the rare ghost pipefish (*Solenostomus paradoxus*). This bizarrely decorated fish is exceptional even among the seahorse-pipefish family. The seahorses are unusual in that the males carry the fertilized eggs in their pouches; the same pattern is found in most of the pipefish as well. That is, except for *Solenostomus*, in which it is the female who carries the eggs.

By similar accidents one finds other unusual reef-dwellers. Cruising above the coral crest on a steep drop-off one day, I looked down through the crystal water of an incoming tide to a small sandy channel 140 feet below. Lying in the channel like some dowager in a deck chair was a seven-foot zebra shark (*Stegastoma tigrinum*). As I soared slowly down until I was at the shark's depth, it appeared to track my flight with resigned, beady eyes. I lay down in the next channel and imitated it; the shark stirred, and I worried that it would leave.

At some point in this infinitely wearying process, the shark apparently decided that I meant no harm, and it simply settled in to stay. I crept in slow stages across the coral ridge that separated us and lay down right next to it. At the end of this twenty-minute-long procedure, I lay taking portraits of its face—a testimonial to the shark's trusting nature, or perhaps to its unwillingness to part with a good resting-place.

As readers who are divers will know, I paid for this long deep excursion with an extended decompression stop on the very shallow reef far above. I try not to abuse the rules of good practice in diving and don't mean in these accounts to encourage any such abuse. However, sometimes an encounter in deep water with an unusual creature does cause me to stay beyond the proper limits calculated for each depth. When this happens there is an excessive buildup of nitrogen bubbles in the bloodstream. Going directly to the surface would be like uncapping a bottle of carbonated soda; there would be a sudden, fizzing expansion of the bubbles. Expanded, they could not migrate back into the lungs to be expelled. The result would be decompression sickness—the bends—in which the bubbles obstruct the capillaries, causing great pain or even death.

By stopping for a while at a depth of ten feet, the bubbles are resorbed and expelled, and the danger is avoided. It can,

however, be boring after an exciting dive to wait around for ten minutes in empty shallow water far above the action.

The single most famous dive locale in Palau is Ngemelis Pass, a sheer-walled slash through the outer reef that plunges nine hundred vertical feet. The southern wall of the pass is a half-mile-long vertical precipice whose coral-sculptured top lies a mere three feet beneath the rippling surface. All along this sheer wall huge gorgonian fans hang over the deeps, and at depths of 120 to 150 feet large soft corals in vibrant colors throb in the near darkness.

In the pass sharks, barracuda, and large rays are common. On incoming tides the gin-clear open-ocean water provides superb visibility, and the feeling of incredible spaciousness has few parallels in the world.

On the north wall of the pass is an equally immense precipice. This side—not a straight wall—features angles and curves, with deep caverns slashing back into the coral structure. Schools of barracuda hang in the open blue water off the section known as Turtle Cove, and far down the wall sharks pass in near darkness. At the fifty-foot level there is a shallow cave with a batfish (*Platax teira*) hovering amid sprays of lush soft corals. This patient fish has endured my attentions with charming equanimity.

I've often found that, if approached properly, an animal in the wild remains still even when nearly touched. However, there are very few that will accept being handled without immediately leaving. Certain octopuses, cuttlefish, sea snakes, and very large groupers have proven exceptions to that rule, but even those animals will usually try to avoid actual contact. There are undoubtedly several reasons for this. For one, since many creatures in the coral kingdoms have skin or appendages equipped with venom—anemones, lionfish, cone shells, to name but a few—marine animals tend to keep their distance from everything they see. Another reason may well be the delicate nature of the animals' skin; any wound, however slight, can provoke an attack in a reef jungle that operates through unceasing predation.

These reefs of Palau feature astounding variety. There are dramatic outer walls, shallow gardens splashed with living color agleam in the sun, silty inner passes, caverns, and tunnels. There is one spot in the channel near Koror where there lives a four-foot-long *Tridacna* clam in an otherwise un-

Huge stalactites hang in the darkness of Chandelier Cave (Palau).

This zebra shark (*Stegastoma tigrinum*) let me lie down next to it in a sandy valley 140 feet deep.

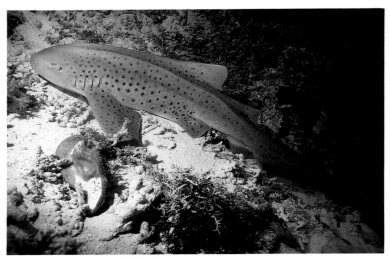

The mushroom coral (*Fungia*) is another burst of Palauan color.

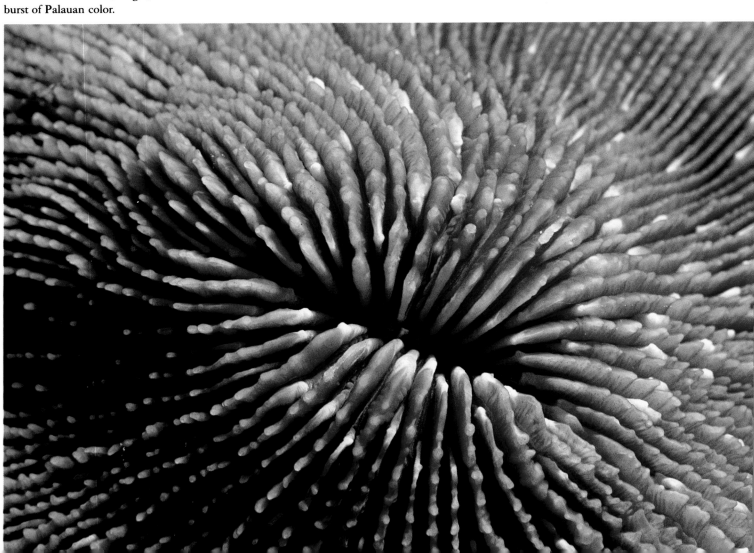

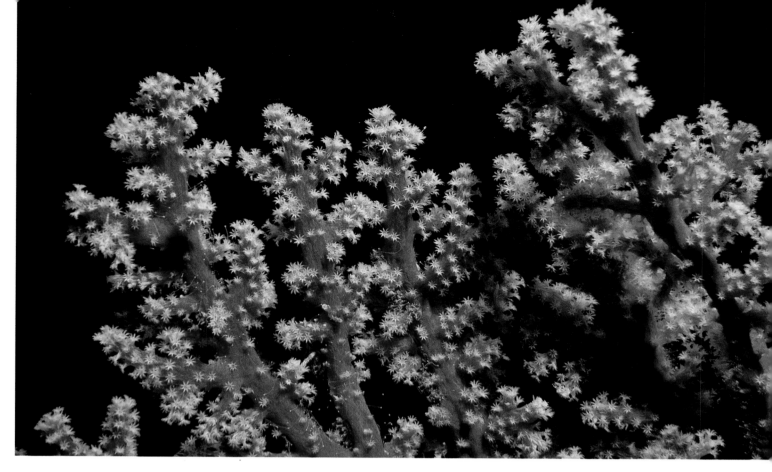

Gorgonians and soft corals splatter Palau's reef with brilliant color.

This nudibranch browses on coralline algae in shallow water.

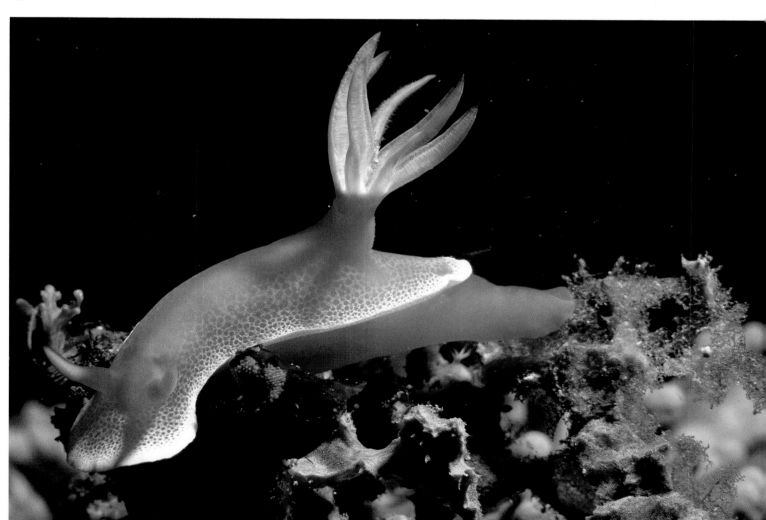

spectacular area. Most divers who have never seen a really large clam are nonplussed at their first sight of this one.

Near the clam, at the base of a coral wall, lives an odd couple indeed. A blind prawn shares a burrow with a striped seeing-eye goby. The goby keeps watch while the prawn dutifully maintains the burrow; like a miniature bulldozer the prawn pushes load after load of loose sand, loose stones, and other refuse out of the hole. The goby's guard duty seems quite systematic. When intruders are at a safe distance it sits a few inches from its post. As the intruders come nearer the goby returns to the burrow and stations itself outside, blocking the entrance with its tail. The prawn, encountering the tail from inside, stays below. Move slightly closer, and the goby disappears down the burrow like striped lightning. In one unusual situation on a different Palauan reef not only the shrimp and goby but also three slender blue gudgeons (*Ptereleotris*) all disappeared into the same burrow. That is togetherness.

These pairs of defensive symbionts are found on many Micronesian, Philippine, and Indian Ocean reefs, often on open sand or coral rubble bottoms where cover is scarce. Many divers instinctively seek out the rich coral complexities of a well-developed reef, but miss many of the sea's most interesting creatures, which shun the reef entirely and seek the subtle shelter of the open bottom where approaching predators have nowhere to hide.

The Philippines

Philippine reefs present us with an interplay of opposing forces, the outcome of which will determine the future of these seven thousand islands. As might be expected, there are many diving areas among so many islands. Surprisingly, the development of the reefs is very uneven. Certain newly protected areas are supremely well endowed, ranking easily among the world's finest. Visits to other reefs, however, painfully illustrate the pressures of a population of nearly fifty million. The fishing industry in the Philippines ranges from one man in his banca (outrigger canoe) to tremendously destructive factory boats whose carnage on the reefs is unforgivable. Steaming into the South China Sea near Busuanga, these ships carry as many as four hundred young

boys. The boys swim atop the water, each carrying a rock on a long string; forming a line, they pound the rocks on the corals below in a sweep that drives fish before the advancing rank into pre-placed nets. Thus, these reefs are not only denuded of fish without thought for leaving breeding stock, but the coral base is severely damaged in the process.

Another terribly destructive technique is dynamiting, now officially outlawed, but evident on all the reefs (including some of the most beautiful) as ugly pockets of blasted moonscape rubble amid the flourishing coral beds. So complete is the destruction wrought by these blasts that over the seven-year period that I have personally observed, nothing can be seen to grow in these barren craters.

To its credit, the Philippine government is attempting against long odds to change the techniques and attitudes of its fishermen. One dedicated marine biologist, Porfirio "Pir" Castañeda, is actively helping convince fishing villages to establish municipal marine preserves. The villagers themselves select the areas for these preserves, and the protected reefs act as gene banks to stock the remainder of the local fishing grounds. By making these municipal rather than national marine parks, the Philippines will avoid a problem that has severely damaged other marine parks all over the world—local resistance and poaching in parks that "foreign" wardens can never adequately protect. A local village protecting its own park is an entirely different matter. This is an experiment whose outcome could have profound implications for other parks, both marine and terrestrial, throughout the world.

Leaving aside these very real problems, the diving at the best of the Philippine reefs is splendidly alive, delightfully colorful, and filled with sorcery in motion that enchants the visiting diver.

Apo Reef, which has been established as a national park, is one of the finest. The dazzling shallow reef gardens surmount vertical walls that beckon the human visitor deeper to see new wonders. There are extravagant collections of large anemones with at least five species of clownfish in evidence—the tomato clownfish (*Amphiprion melanopus*); *A. bicinctus*, with its two distinctive stripes; *A. percula*, with its sweeping white patches on orange; the white-striped *A. perideraion*; and the skunk-striped clownfish *A. sandaricinos*.

The relationship between these remarkable symbionts is a source of endless fascination for visiting divers and scientists alike. The anemones are voracious predators, with chemically activated, spring-loaded stinging cells (cnidocytes) on their profuse tentacles. When the cnidocyte is activated, a poison-tipped dart called a nematocyst shoots out. Yet the clownfish blithely live amid this lethal tangle without harm. Their protection is a mucus on their skin, which operates at the molecular level to suppress the firing of the nematocysts. This protection may even be specific between particular anemones and particular clownfish. While I have seen a clownfish readily move among the tentacles of two or more anemones, most clownfish inhabit but one anemone for their entire lives. A clownfish taken from its anemone host and wiped clean of mucus is quickly devoured by the same anemone that may have hosted it for years.

During one recent incident on the reef at Malajon Island, south of Busuanga, I took a bag of fish scraps to feed to an anemone. My purpose was to see whether hand-feeding the host could cause it to withdraw its tentacles and temporarily dispossess its symbiont clownfish. Before I fed the anemone its tentacles stuck to my skin and presumably fired, though, as humans have thick skin, I could not feel it. After seizing several chunks of fish scraps, the anemone partially closed, and those tentacles that were not grasping the food no longer tried to capture my fingers. In Australia I once witnessed an anemone devour a fish whole. One's mental image of the anemone as flower-like changes quickly when you see one actually devouring a fish.

One consequence of keeping one's head buried in anemones or corals for photos is that one occasionally looks up from the small subject to see a very large animal consumed with curiosity at your efforts. In the Philippines the observer might well be a manta ray, for they are numerous and quite curious here, a source of awe, amazement, and utter delight. One day at Apo Reef after a week of daily sightings, four great rays converged on our dive boat in mid-afternoon. For several hours, in an exquisite duplication of the Caribbean encounter described earlier, the four rays swirled and looped about their human visitors in total, unconcerned play. This amazing display of confidence has not been repeated in later visits. I wonder what other encounter ended the rays' child-

like playing with humans? It is in hopes that all such magic not be snuffed out that I have appealed to the Philippine government (and several others in the coral kingdoms) urging that reefs such as Apo be diligently protected both as national treasures and as important economic resources (through tourism).

The undersea world of the Philippines is an exotic garden rife with such sublime encounters. One reef site is a favorite because of another close encounter. This one was not with a manta ray, but with that intelligent, amazingly talented cephalopod, the cuttlefish (*Sepia*). For three years we have returned to the same reef, and one or more practically tame cuttlefish have never failed to welcome us. A close relative of the octopus and squid, the cuttlefish shares much of its relatives' morphology and talents.

All three cephalopods are capable of mind-boggling quick-change color artistry. In the skin of the cephalopods are tiny sacs of variously colored pigments which, under control of the central nervous system, can contract to tiny dots or expand to discs. Thus the tones of these animals' skin mirrors their mental state as well as providing extemporaneous camouflage. For example, during one of our cuttlefish adventures a large jack (*Caranx sexfasciatus*) zoomed past threateningly as we photographed. The cuttlefish darted down between two coral heads, quickly changed color from dark brown to nearly white, raised bumps all over its skin, lifted two tentacles in front of its eyes, and seemed to cower. When the jack had swept out into the distant blue, our cuttlefish friend suddenly turned sassy, swaggering between us two large humans as if it owned the reef.

Unlike the octopus, whose extraordinarily fluid body contains no hard structures other than its jaws (flexible connecting rods anchor its musculature), the cuttlefish possesses a porous, light-weight cuttlebone. On beaches in the outer reaches of the Great Barrier Reef of Australia, thousands of cuttlebones bleach in the sun; in the Philippines we often saw them bobbing on the surface. These are the same cuttlebones familiar to many from their common use in birdcages.

One of the most moving experiences of my years under water was an enchanted two days on this same shallow reef with what seemed to be a family group of three cuttlefish. They swam about, and punctually, every three minutes, the

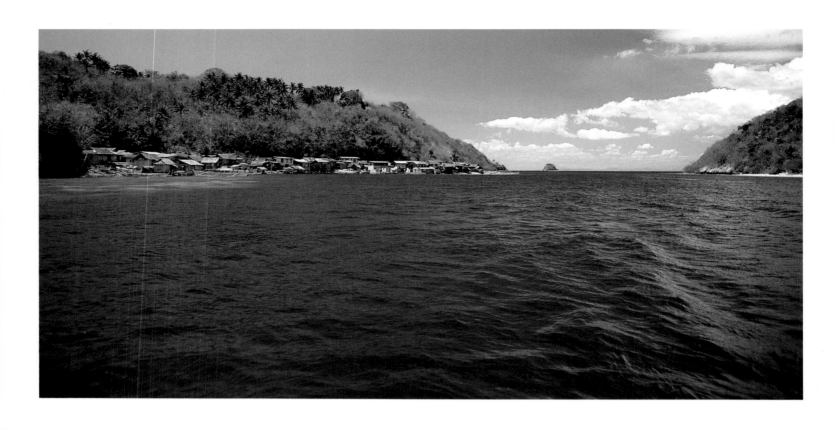

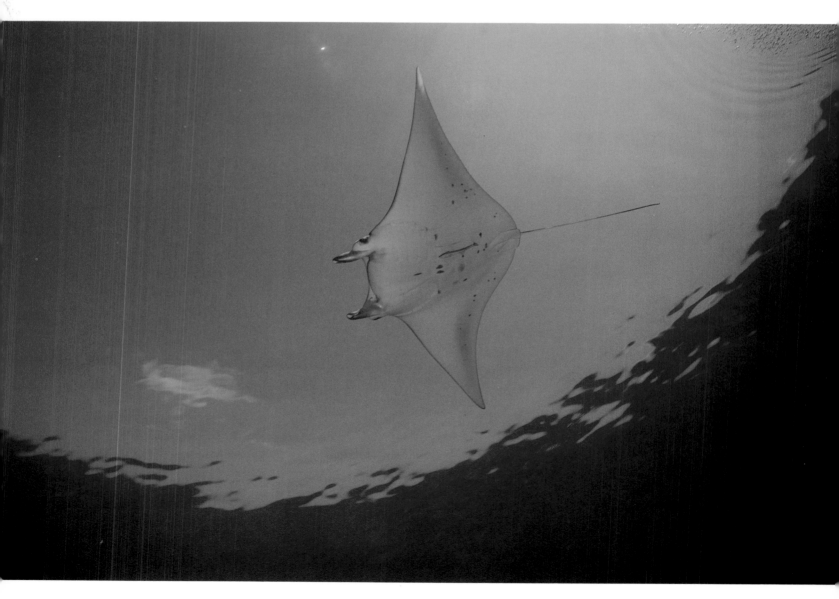

▼A small fishing village basks in the sun south of Manila, Philippines.

◀ A manta ray feeds along the eastern drop-off of Apo Reef, Philippines.

The skunk clownfish (*Amphiprion sandaricinos*).

A pair of tomato clownfish (*Amphiprion melanopus*).

group would return to the same coral head. While two hovered protectively, the third cuttlefish would slowly settle above the coral head with tentacles lowered. At a given instant the tentacles would extend convulsively, and a snow-white egg would be deposited amid the protective fingers of coral. Again and again the trio returned. It made no difference whether the coral repository was surrounded by eight or nine divers; the precise ritual continued on its eternally set schedule.

Two years after that first encounter we returned during the same season of the year. A single cuttlefish welcomed us, and soon we discovered a head of finger coral where what seemed like a hundred or more eggs had already been deposited. Its work done, the cuttlefish seemed content to socialize with us, but never strayed far from its precious cache.

There is another lonely reef in the Philippines where a colony of other—more lethal—"regulars" dwell. Hunter Reef is far from any type of land and never reaches closer to the surface than twenty feet. It was on a dead calm afternoon here that we met the sea snakes of the Philippines. While divers can usually observe sea snakes in Australia's Coral Sea, isolated colonies occur in other Indo-Pacific coral kingdoms. This is one, a gathering of twenty or more thick-bodied five-foot-long snakes, which makes Hunter unique in the Philippines. These unnerving snakes proved much less curious and friendly than those we'll meet in Australia; it could possibly be that our visit here coincided with spring mating season, while our visits to Australia are always in the fall.

Another dangerous species is sometimes found on these reefs—this one lethal to the coral itself. In 1981 I led a group of divers to the Philippines, only to discover an infestation of the crown-of-thorns starfish (*Acanthaster planci*) on one of my favorite coral gardens. This immense starfish, whose outbreaks of population are now known to occur at somewhat regular intervals, can devastate an entire reef in a few months. *Acanthaster* feeds by flooding a coral head with its digestive juices and then devouring the partially decomposed polyps. This process leaves a bleached-white limestone skeleton that is soon smothered by green algae.

In two days we removed over two hundred and fifty large starfish and buried them on the beach. Our determined action apparently broke the infestation, for we have found very few specimens there in the succeeding years.

One of the worries of traveling many thousands of miles from home is that of the weather. What can happen to your diving if a distant typhoon stirs up the water? On one Philippines adventure this happened, causing us to run for cover into a bay on Busuanga Island. We watched impenetrable rain showers pelt down while outside the bay ocean rollers kept us bottled up for a full day. As we chafed at missing the outer islands, we decided to dive a reef wall near the entrance of the bay.

What we discovered upon entering the water was a massive school of jellyfish, which seemed to be migrating out of the shallow lagoon toward deep water, passing our site. While the water was not pleasantly clear, the sight of huge jellyfish half the size of an oil barrel was an unexpected dividend. All kinds of jellyfish pulsed by us in the dark waters, turning our dreaded day of captivity into a rare opportunity to photograph these unusual creatures.

One of the special charms of the reefs here is that their structures usually reach to within a few feet of the surface, which makes them ideal for night dives. One night we enjoyed an evening's thrills at about the thirty-to-forty-foot level at the southern end of Apo Reef. Halfway through the dive we noticed odd lights to one side of us. Turning off our torches, we could see closely spaced pairs of streamlined green lights that proclaimed the presence of the flashlightfish *Photoblepharon palpebratus*. *Photoblepharon* and its Caribbean cousin *Kryptophanaron alfredi* were once thought exceedingly rare. As recently as 1982 two prestigious scientific institutions chartered one of our dive boats in the earliest expeditions to collect and display these exquisite little nocturnal fish.

Each of the flashlightfish has pouches under its eyes in which colonies of bioluminescent bacteria are nourished. The flashlightfish don't flash without the bacteria, and the bacteria thrive richly in the protective sacs mounted under the eyes of the fish. The mechanism of the pouches is well understood, though their uses are still being studied. *Photoblepharon* "blinks" its eyes by drawing opaque lids over them; *Kryptophanaron* extinguishes its pouches by physically

Face to face with a cuttlefish.

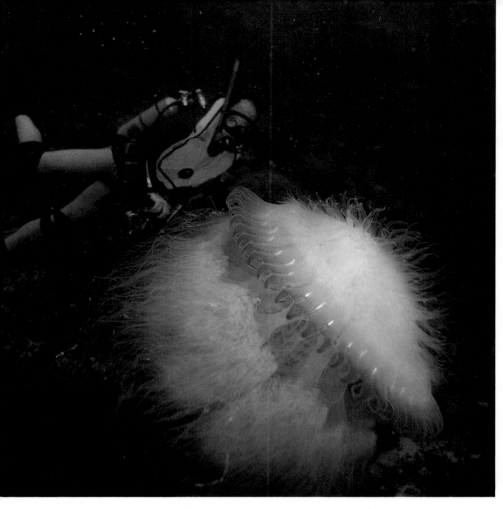

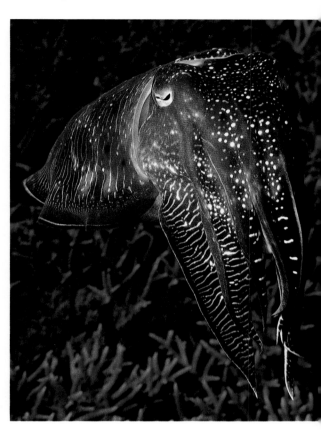

The cuttlefish is intelligent and curious. This one actually approached close enough to be touched.

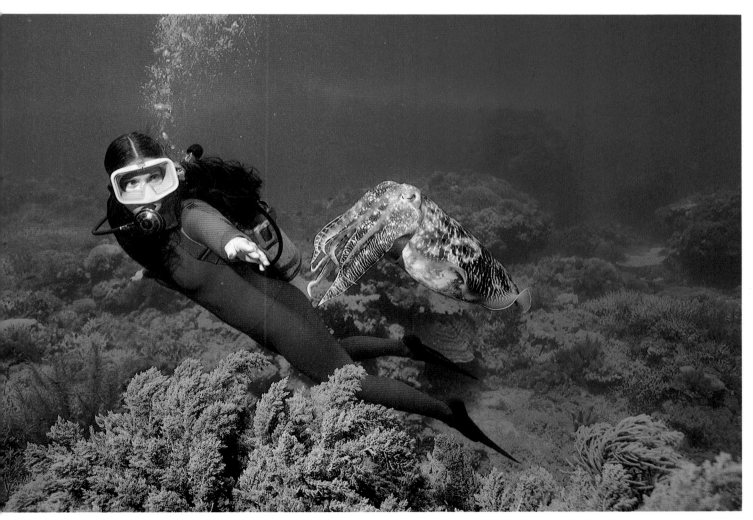

▲ Immense table corals gleam in shallow
water in the Philippines.

▼ Diver on wreck of an unidentified Japa-
nese fishing boat in the Philippines.

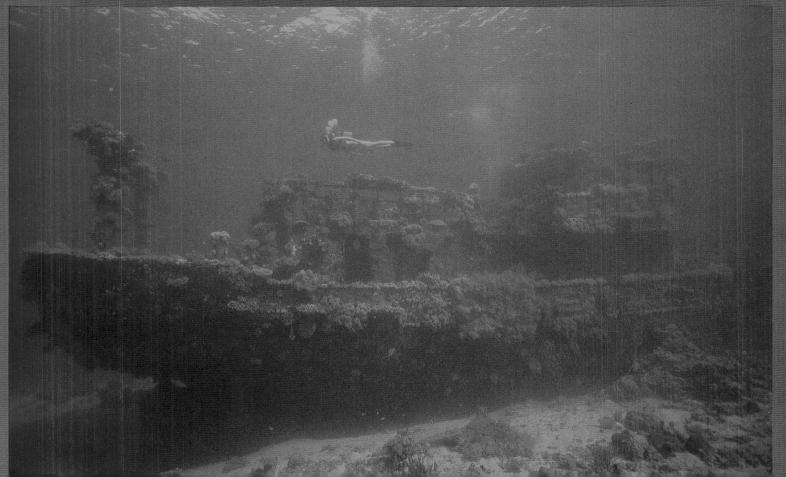

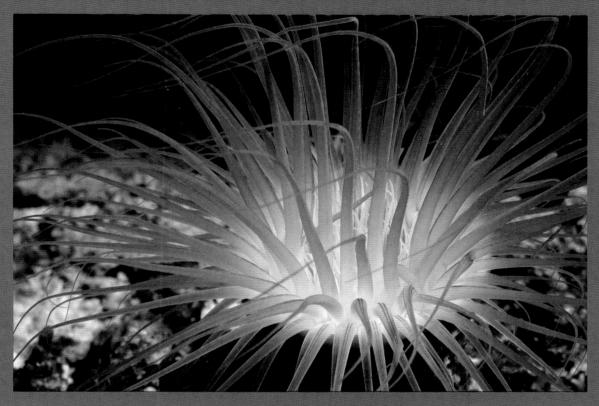

An iridescent cerianthid glows in the darkness of the deep reef.

A ribbon of nudibranch eggs.

◀ A cleaner wrasse prowls the body of a pufferfish (*Arothron citronella*).

Beneath a coral ledge a snorkel-nosed ▶ moray (*Rhinomuraena quaesita*) eyes the photographer with suspicion.

rotating them inward into darkened chambers behind each pouch.

In our dive the fish paired off into three couples. When we extinguished all lights the fish would swim in darting little passes, bustling to and fro a few feet above the corals. When we played our lights on them they would duck under the nearest table coral, apparently undisturbed by the rapid transition from darkness to brilliant light. By contrast, most reef fish freeze when abruptly lit. We turned out our lights again and could easily see where the fish were hiding; their pouches lit up their protective caverns beneath the table corals. After only a few minutes of restored darkness, they would emerge, despite our dark presence, to resume their

darting hunt. During our observation the pairs of *Photoblepharon* only rarely "blinked" their lights. I am led to conclude that—during this episode at least—the fish were using their lights both to maintain their pairings and to see to feed, rather than (as has been speculated) as a signaling device.

The very next morning I entered the water intent on photographing a particular coral head, which is festooned with a dozen beautiful soft corals. To my dismay the bright late-morning sun had caused the soft corals to close up for a few hours. Species of soft coral often cease feeding and deflate during periods of bright sunlight and no current.

Swallowing my frustration I headed out over the drop-off. My mood underwent a rather rapid transformation, for seventy feet below me a twelve-to-fourteen-foot manta ray slowly cruised by. Moving down the wall very gingerly, I settled on the sandy bottom above which it was hovering. Its large mouth was closed, so it was apparently relaxing between its normal feeding periods of early morning and mid-to-late afternoon. It was wary of me, moving away out of sight twice, only to return when I remained very still. I settled down behind a large gorgonian fan with only my head and camera showing. Perhaps it was the spectacle of a bubbling gorgonian (though I suspect the ray knew precisely what was going on), but this time it drifted in until its vast wings filled my universe. I blazed away, and my three companions perched on the wall above later said the manta dwarfed me, and that its wing tip passed right over my head.

It is episodes like these that in spring make a young man's fancy turn to thoughts of Philippine reefs.

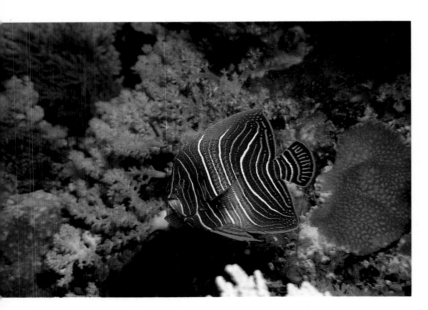

As a juvenile the angelfish *Pomacanthus semicirculatus* is striped.

Painted prawns live amid the spines of a ▶ poisonous sea urchin.

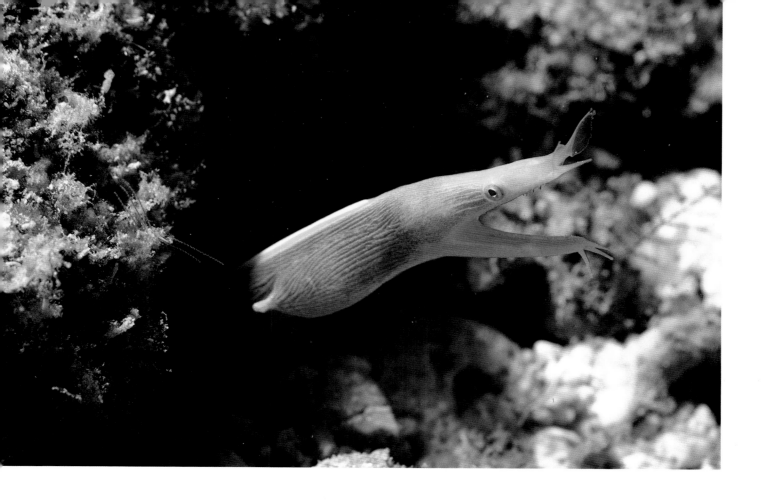
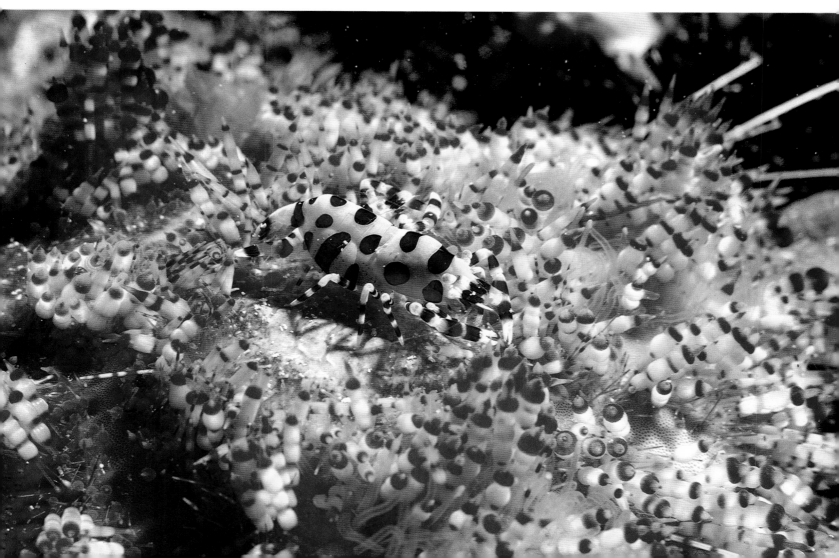

Papua New Guinea

This new Pacific nation is in the midst of profound and deep-seated change. Having recently achieved independence, Papua New Guinea faces replacing a long-standing Australian business and service community with one built by the native population. In many ways this transition has gone far more smoothly than outside observers ever anticipated, yet there are intractable problems of unemployment and unrest, particularly among the young, which could be the focal point of eventual danger.

Papua New Guinea occupies the eastern portion of the large island of New Guinea, while Irian Barat (part of Indonesia) occupies the west. Papua New Guinea has been known among industrialized nations mainly for the magnificent treasures of its primitive cultures. Many of these have been collected by unscrupulous outsiders for very little money. One extensive collection in Port Moresby, the capital, fills an entire museum, yet it was but a single shipment impounded at the airport. Huge carved crocodiles, local totems, drums, village artifacts, pottery masks of mud and shell, and many other priceless handicrafts there fill a morning's visitor with admiring wonder.

Much of this impressive art is produced in villages along the banks of the hundred-mile-long Sepik River. Papua New Guinea's villages have developed in such isolation from each other that fully 45 percent of all the world's languages—more than seven hundred—still exist there. During the twentieth century increasing interaction between villages and the use of native laborers in Australia has led to the widespread use of Pidgin English as the lingua franca.

Dozens of these villages along the Sepik are linked only by canoe, sleek, hollowed tree trunks usually decorated with a carved crocodile head on their prows. The natives are extraordinarily skilled in maneuvering these canoes, and on occasion foreign visitors will be surrounded by a swarm of these tiny vessels filled with shy natives offering beautiful craft items: slit gong drums, masks, lime sticks, and canes representing many hours of patient, skilled workmanship.

For divers, as for collectors of primitive art, Papua New Guinea is a treasure trove. Its waters are nearly unexplored, but initial forays have yielded exciting results. Off Port Moresby the reefs are modest in size and coral development, but I have encountered huge groupers that were practically tame and swarming schools of gaily colored reef fish. On one dive I was fortunate to encounter one of the world's least-known fish, the scorpionfish *Rhinopius aphanes*. This was only the third specimen of this gaudy but reclusive fish ever recorded.

Far to the north, in the Bismarck Sea and Milne Bay off the northern coast of Papua New Guinea, we find the clear-water big drop-off diving for which serious divers yearn. The Trobriand, Ninigo, and Hermit Islands have extraordinary if terribly remote reefs; off Egum, Iwa, and Kitava Islands beautiful shallow coral gardens suddenly plunge to open-ocean depths. Here we find schools of dog-tooth tuna, kingfish, barracuda, and jacks swirling in the sunlit shallows, while just over the drop-off numerous sharks eye the action from the concealing deeps. The coral gardens are splashed with the yellows and greens of crinoids and the bright orange of sponges; throngs of brightly hued butterflyfish, damselfish, and fairy basslets dance just above the protective thicket of coral.

Two unique qualities give power to Papua New Guinea's diving. One is the high proportion of totally unusual creatures on its reefs. For example, there are great colonies of black sponges that look like the gnarled and twisted roots of a great cypress; there are ten-foot-tall specimens of the green tree coral *Dendrophyllia*; there are four-foot-tall sponges whose body walls are paper-thin and gaudy yellow; there are deadly stonefish in unexpected colors such as purple or shocking pink.

The second aspect is more surprising: the quality of the reef sites is completely uneven. On my last trip through the Milne Bay–Bismarck Sea region I would encounter one reef that was the equal of any in the world, but the very next one would be mediocre to poor. More than anywhere else your choice of sites in Papua New Guinea will determine whether the reefs you see are fantastic or purely awful. I could see no inherent reason for this unevenness, for I was diving tiny seamount islands in a vast, empty sea. I recall certain dives as the most exciting of my career, and others as embarrassingly poor. In Papua New Guinea, you really need expert guidance to find the great reefs.

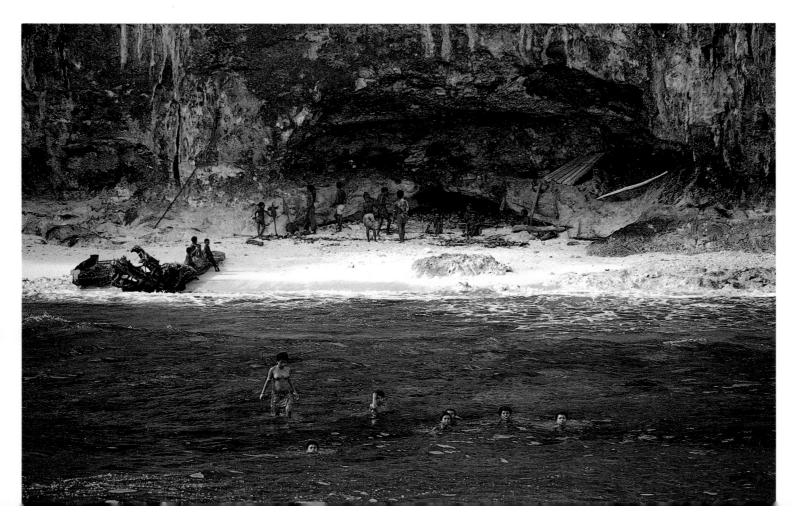

In open water a swimming royal Spanish dancer nudibranch (*Hexabranchus imperialis*) offers a stunning display.

Certain of these oceanic reefs are the only places I've ever dived where turtles scattered as our dive boat approached, or where I've seen beds of *Tridacna* clams where each specimen was five feet long and weighed several hundred pounds. The islands' reef fauna has been spared hunting by its remoteness and by the primitive nature of the fishing implements used by the natives, but it now faces a growing threat from poaching by pirate boats from Southeast Asia—a danger to which this new nation is ill-equipped to respond. Without major financing and a skilled naval force, I can imagine these reefs eventually being destroyed by poaching and overfishing, which would lead to imbalances in the food chain. This danger is difficult to detect in its early stages, and once the problems are visible, they may also be irreversible.

Many stories have been told of the sea-going crocodiles of Papua New Guinea (and also, rarely, of Palau). Those of Palau have largely been killed, but a substantial population does remain here. The crocodiles inhabit Papua New Guinea's great muddy rivers and their outflows, areas of great turbidity that offer them easy stalking. There have even been isolated instances of attacks on humans who were unwary enough to be repairing boat hulls or other equipment in murky water.

One night we went out hunting three hundred miles up the Sepik River and captured two immature crocodiles, one freshwater and one saltwater species. Bringing them aboard, our native guides showed us an incredible phenomenon: laying the crocodiles on their backs, our guides gently stroked their bellies, and the animals became totally catatonic. For perhaps a full minute after the stroking stopped, the crocodiles remained dormant. But they then erupted into lightning-like movement, sending guides and divers leaping for cover. One could say that this is a very useful technique for encounters with crocodiles, but it has its limitations.

It is to be stressed that the crocodiles are not found on the offshore reefs, and almost never in clear water. Divers have little chance of encountering a crocodile, and need have no concern that they will meet one on the reefs.

If the problems associated with autonomy are resolved without crisis, Papua New Guinea will surely develop as a strong tourist destination during the next decade. Now,

when one sits for eight hours waiting for a late airplane to Madang, on the north coast, one wonders if it really can be done. Problems such as these are epidemic, and are only a hint of how deeply change must run; it must be left to philosophers whether such changes should be imposed so quickly.

Meanwhile, the fabled primitive villages on the Sepik and the thronging life in the waters off little-known islands will lure adventurous undersea explorers. This emerging coral kingdom will soon join the Philippines and Micronesia among the best known and most sought after of all undersea destinations.

Papua New Guinea's sun, moon, and stars butterflyfish (*Euxiphipops navarchos*).

Rare, deadly stonefish (*Synanceia horrida*) come in such colors as pink and purple (Papua New Guinea). ▶

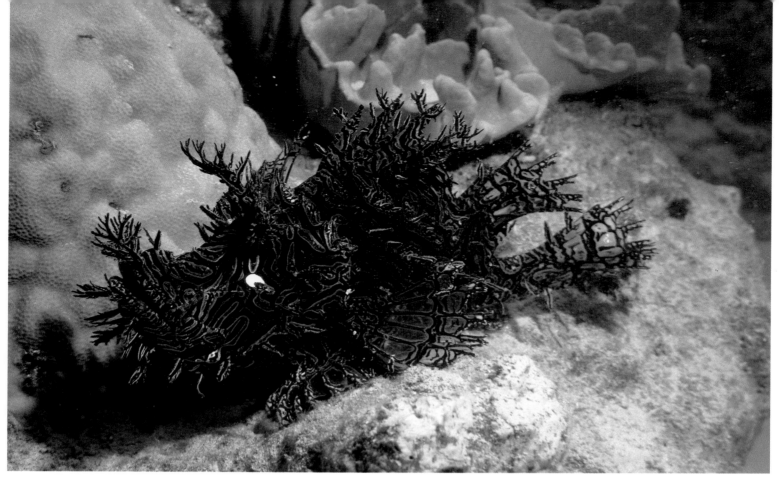

▲ The rare scorpionfish *Rhinopius aphanes*.

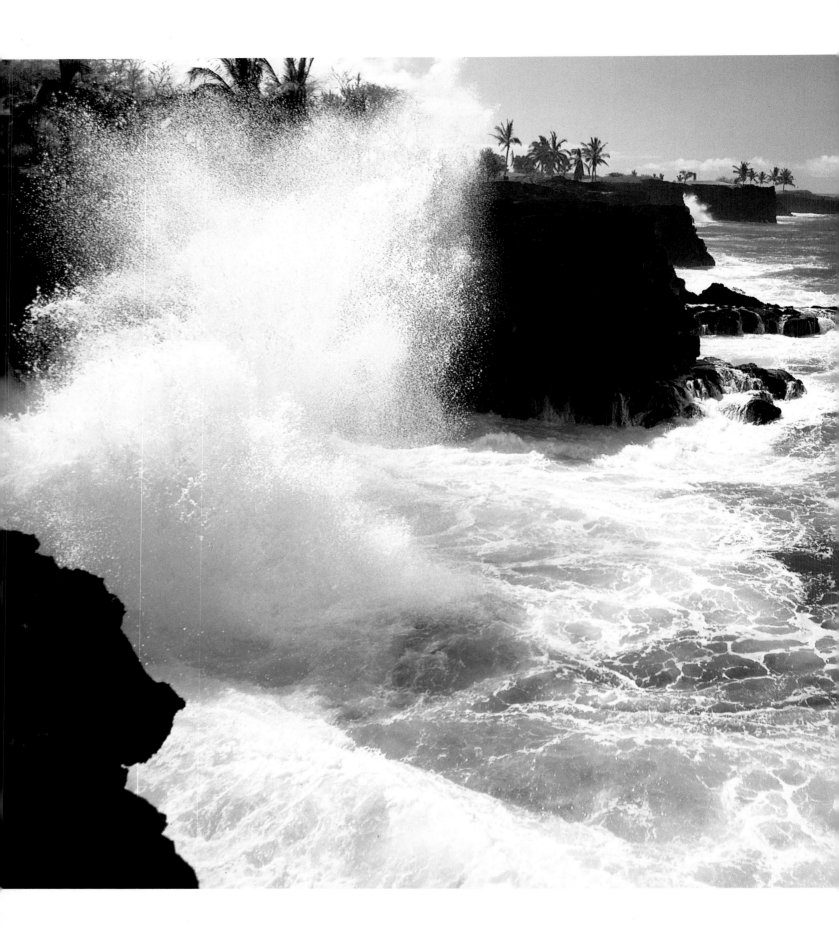

Chapter Five
The Galápagos,
Baja California, and Hawaii
THE EDGE OF THE TROPICS

In the eastern Pacific lie three unusual undersea zones. Their particular character is determined by their position in the vast system of Pacific surface currents, which endows them with features greatly different from those of other coral kingdoms.

Two of these areas, Baja California and the Galápagos, are near the western rim of the American continents; for at least part of each year, western boundary currents bathe their rocky bases in frigid water from polar latitudes. As a result, most of their fauna could not be more different from that of the tropical coral kingdoms. Yet, because occasional warm currents vie for dominance in these areas, we also do find typically tropical elements in the inshore marine fauna. It is the interplay between these very different fauna which makes these volcanic outposts so fascinating to us.

The questions raised by the third zone, Hawaii, are of a different nature. Portions of this region have become far from remote during our lifetimes, and the costs of their new-found accessibility are mounting. What happens there may presage the future of other coral kingdoms that today are only protected by their isolation.

Waves from a distant storm crash against the rocky Kona Coast of the big island of Hawaii.

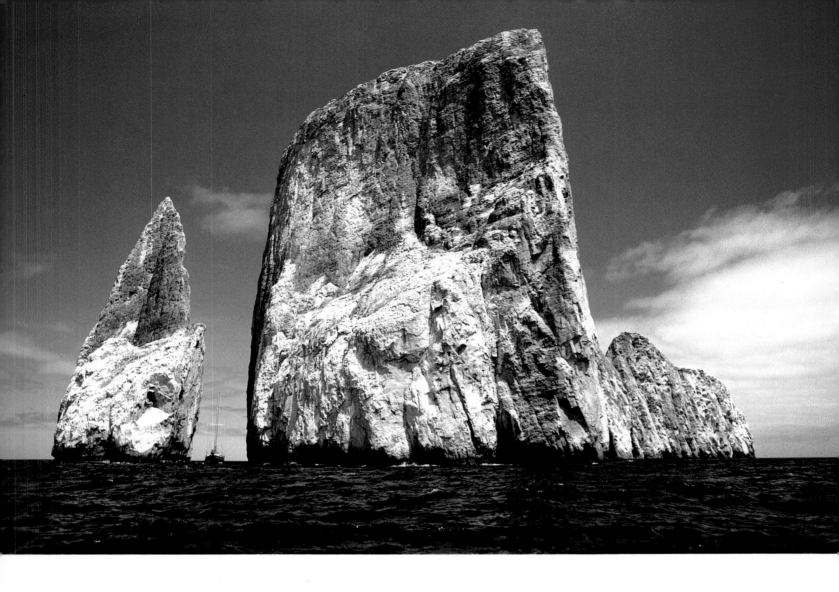

The Galápagos Islands

There are certain places on the face of this overused planet that exert an incalculable magic upon us. In almost all cases these are remote, pristine sanctuaries where the care-worn traveler may look upon the face of pre-human earth, where the beaches are not paved or boardwalked, where the animals do not flee when approached.

One of the most famous of these is a lonely, faraway group of volcanic islands six hundred miles due west of Ecuador along the equator. Since their accidental discovery in 1535 by Tomás de Berlanga, Bishop of Panamá (his ship was blown off course), they have been known as Las Islas Encantadas, or the Enchanted Islands. Their familiar name, Galápagos, commemorates their once-great population of terrestrial tortoises (*galápago* in old Spanish) and has become the official name of the island group.

The particular form of their enchantment arises from a geological and biological history that is unique in certain critical ways. Three to five million years ago these basaltic islands were born in the thunder, smoke, and flame of incendiary volcanic eruption. Where there had been only endless vistas of empty ocean, there was suddenly a scattered complex of truncated conical islands.

In the eons that followed, these totally barren islands became the accidental destination of a host of otherwise doomed long-distance travelers: plants; seabirds and small land birds; reptiles on ocean-borne debris; fish and invertebrate larvae carried vast distances by the surface currents.

Those terrestrial settlers whom fate brought to these islands found a peculiarly benign environment. There were no well-established predators or competitors to threaten or restrict them. Their only possible danger might have been a lack of food, but there was a sufficient amount of soil for plant growth on at least the larger islands. As a result species

Masked boobies huddle on the rocky ▶
pinnacles of Hood Island as wind-driven
waves assault the coast (Galápagos).

of tortoises, birds, snakes, and lizards developed here as they did nowhere else on earth. So complete was their freedom to adapt that certain of them vary significantly even from one island to another. For example, the tortoises' shells developed in shapes specific to feeding conditions on each island. Where food was easily reached the tortoises' necks are held down by a flat-rimmed shell. On islands where food grew on taller vegetation, their shells have exaggerated arches along the front so the tortoises can reach higher.

What was true on the rocky islands had its parallel in the cold waters that lapped at their bases. Inshore marine species, their larvae borne thousands of miles by the currents, were also deposited in a biological vacuum. Where there were no or few other species, these newcomers had no competitors and no predators, and enjoyed enormous evolutionary latitude. Had they landed on already stocked islands they might have simply perished at the hands of earlier-established species. Inbreeding in small colonies and adapt-

ing to the local undersea terrain and feeding conditions, they began to diverge from their faraway parent stock over the course of time. Fully 23 percent of the 223 inshore species of the fish in the Galápagos are endemic; they are found, in all the world's diversity, only here.

The principal current dominating the Galápagos is the Humboldt, a western boundary current sweeping from the Antarctic northward to the equator. It is the mighty Humboldt that has brought penguins to these basalt islands and has nurtured offshore populations of finback, gray, and killer whales, tuna, and other open-water species.

As the waters of the Humboldt flow northward they become one of the richest and most active feeding zones on the face of the earth. Yet, whether it is due to heavy predation, a low survival rate during the long sea journey, or difficulty in adapting upon arrival, we find that only 7 percent of Galápagos inshore marine species originated in Chile or Peru.

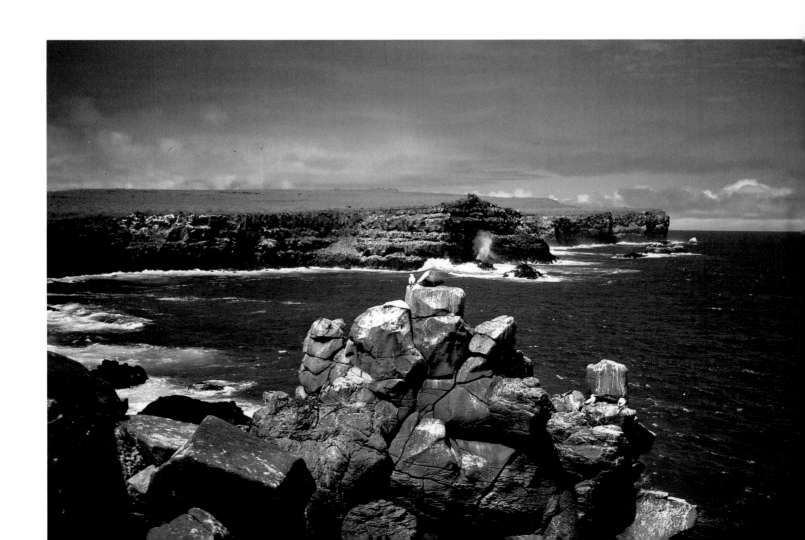

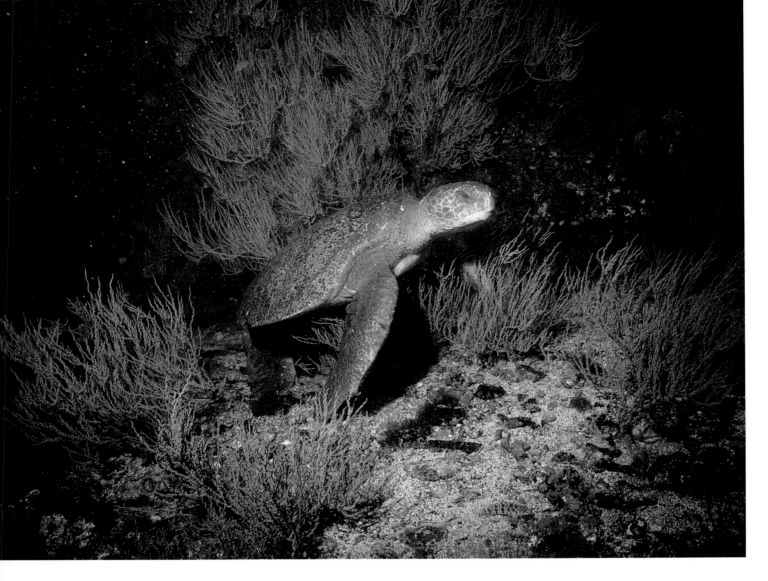

We found huge green turtles napping on some of our deeper dives in the Galápagos. They would usually allow us to approach quite closely before soaring off into the green depths.

Other currents vie with the Humboldt for hegemony here, despite what would seem to be dominance by that huge force. For example, a major warm-water current known as El Niño (recently known for its effect on weather) occurs irregularly, perhaps once every six years. The survival rate in this short-distance current is very high; some 54 percent of the inshore fish species in the Galápagos originated in Baja California or Central America and were brought here by this or a similar current.

While the Spanish originally discovered and explored the islands (and still have a sizable descendant population on San Cristóbal Island), English pirates held sway during the seventeenth century. For this reason all of the islands have both Spanish and English names. Travelers become accustomed to maps showing one island as either Santa Cruz or Indefatigable and another as Isabela or Albemarle.

In the 1800s whalers succeeded the pirates in using the Galápagos as a base. One result of their presence can still be felt today. The pirates and whalers discovered that the four-to-seven-foot tortoises could live for up to a year without food. Thousands were taken aboard ships to be stored on their backs in dark holds, then later slaughtered for fresh meat during the ships' yearlong voyages. The devastated population now stands at only forty-five hundred individuals, principally at huge Alcedo Crater on Isabela, with some of the original dozen species extinct and others represented by only a few survivors. The Charles Darwin Research Station on Santa Cruz raises and protects young tortoises in an attempt to give threatened species a chance to return from the brink of extinction. When there are so few survivors in a species, there is often the problem that they will fail to meet in the wild for breeding. The station's collecting activities assure that the remaining individuals will have access to each other.

A second and greater threat to the non-competitive endemic species came from animals such as cats, dogs, goats, and pigs (as well as ship-raiding rats) that accompanied sailors to these outposts and then became feral. These animals made disastrous inroads into the populations of both tortoises and birds. Searching out and destroying eggs or competing for vegetation to consume, the feral animals were far more efficient hunters than the gentle endemic popula-

tion. Suddenly the rules changed; in an environment that had placed no premium on efficiency, it was suddenly demanded without quarter.

A recent example of the calamitous effect of such newly introduced animals began in 1958, when three goats were purposely introduced onto one of the islands by Ecuadorian fishermen so that they would have goats to hunt and eat on later fishing expeditions. The goats bred wildly, soon threatening native species. When this incredible violation of the Galápagos' formal protected status became known, determined efforts began to eradicate the marauding goats. Fifteen thousand were killed, yet the goats simply could not be stamped out. Many still roam the interior, avoiding the hunters with relative ease.

Since goats can reach much higher than tortoises to forage, the goats' presence on the island meant slow starvation for the tortoises, which have had to be removed to the protection of the research station on Santa Cruz.

Amid the dark chapters of Galápagos history, one event and one personality stand out like a beacon. In 1835 twenty-six-year-old Charles Darwin explored the islands aboard the HMS *Beagle* as the assistant to the expedition's naturalist, Robert Fitzroy. Darwin was an astute observer and a penetrating and insightful thinker. He made careful observations of thirteen species of finches and realized that the same basic finch—a common ancestor—had evolved different types of beaks to accommodate the different feeding conditions it encountered in varying locales. If this evolutionary adaptation could occur among these isolated finches, he wondered, couldn't it have happened throughout biological history? Couldn't it even be the principal method of long-term survival among all of the life forms on a changing planet? If adapt or die is the rule of survival, then the eventual survivors would be those whose adaptations were most appropriate to their situation. The results of Darwin's long and thorough research were published in his epic *Origin of Species*, a landmark in the history of human understanding.

Today Darwin's islands retain their grandeur. Sailing across the open miles between the volcanic crests we marvel at the vistas that unfold before us: Fernandina Crater, its immense flanks dusky blue even in the midday sun; the great thousand-foot wall at Isabela; the hot black lava fields of

The lightly spotted yellow-tailed surgeonfish of the Galápagos, *Prionurus laticlavius*.

A diver is surrounded by a playful group ▶ of Galápagos sea lions.

An acrobatic sea lion (*Zalophus californianus galapagensis*) cavorts at close range.

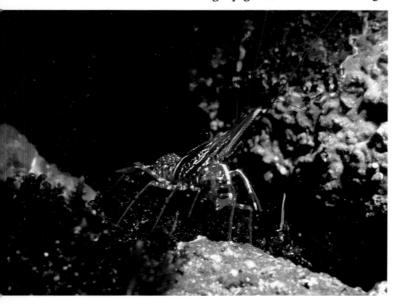

These brilliant shrimp are found in rocky crevices at all depths in the Galápagos.

Bartholomew with their fluid loops and whorls hardened as if to fingerprint time itself.

The underwater vistas of the Galápagos are harsh, abrupt, and amazingly varied. One general characteristic that holds throughout is that much of the best diving is in relatively shallow water. This means that nondivers who are comfortable snorkeling may share some of the undersea wonders at certain sites, depending, of course, on the weather-related water clarity.

One's first impression at many of the islands is that the water is filled with sea lions (*Zalophus californianus galapagensis*). Great herds of the gentle, fun-loving females thrash into the water at our approach. Throughout our Galápagos diving we have a constant impression that these females are with us for their own amusement. Racing about like bright-eyed puppies, they will whiz up to us and bark, as if asking us to play (or perhaps answering our noisy exhalations). They are everywhere, eternally in motion, our constant companions as we explore.

The huge males are another matter. The bulls don't seem to like their harems chasing off after every bubble-blowing apparition that happens by; they'll cruise back and forth at a distance, barking furiously. On one unforgettable occasion an enormous bull cost me several heartbeats when it roared in at top speed from the limit of visibility straight toward me. When it was about fifteen feet away, it launched itself into the air (and out of my sight) only to reappear with a roar a mere foot or two from my mask. As it passed beneath me I could feel the wash of its thunderous passage. I'm sure I thought something profound in that moment, but I have no idea what it was.

In general, the dive sites here are the immediate flanks of the rocky islands—scarred volcanic rock pitted with the holes of a burrowing species of thick-spined sea urchin. Between the urchin holes are countless thousands of shallow-water barnacles (*Balanus tintinnabulum*), overlain with vari-colored encrusting sponges. Some of these shallow walls are a riot of yellows, oranges, and reds, a nubbly living carpet of flaring hues. Also living near the surface are several species of short-tentacled anemones (notably *Anthopleuro dowii*), coating and softening the battered waterline. Skittering over the anemones are flag blennies, gobies, and, nestled here and there, a young scorpionfish.

A gaily colored hawkfish (*Cirrhitichthys* ▶ *oxycephalus*) perches amid a host of barnacles.

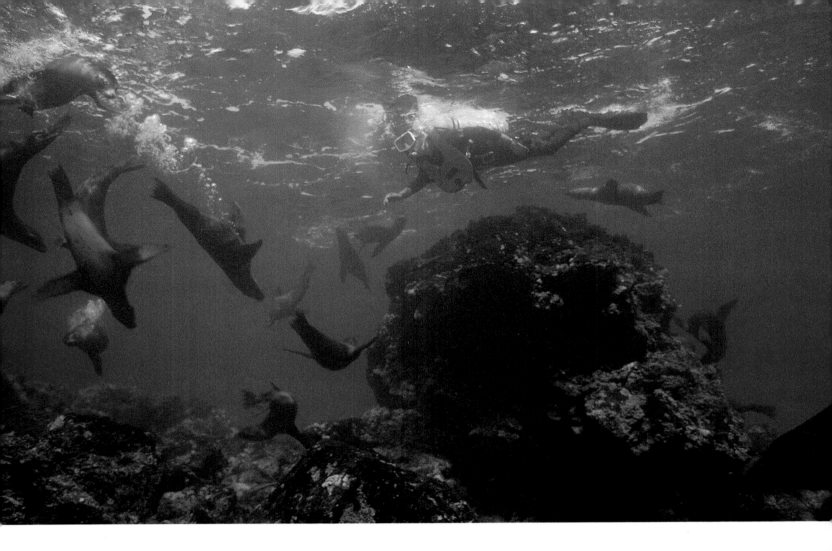

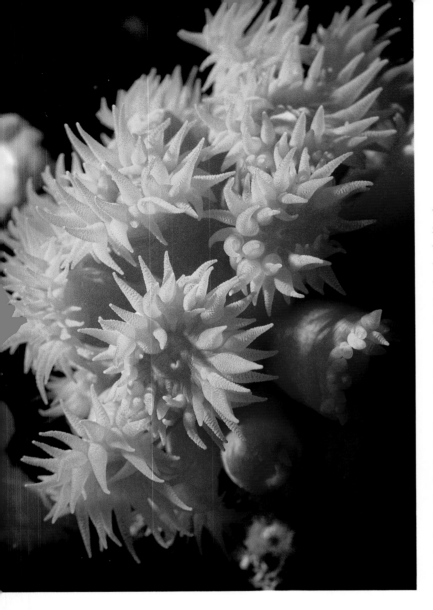

Here and there the lava rock is splattered
with night-blooming corals in small but
brilliant clusters (Galápagos).

One day I was searching such a wall for interesting life,
when I came upon two octopuses in rocky horizontal crev-
ices, one above the other. Though I attempted a non-
threatening approach, the octopuses seemed painfully aware
that the open rock face and shallow shelves offered little pro-
tection against this large, noisy intruder. What was most
touching was that despite their fear the two cephalopods
maintained constant tentacle-contact with each other. Even
when writhing in apparent agitation, each had at least one
tentacle extended to the other. It was a rare and touching
moment. After a while I stole away, feeling guilty for disturb-
ing them.

In addition to the burrowing sea urchins, barnacles, and
anemones, other colorful creatures punctuate the rocky faces
of the engulfed rock. There is a broad selection of large and
gaily hued starfish, clusters of orange night-blooming corals,
slipper lobsters, and small, darting blennies. In deeper water
one finds great bushy black-coral trees (*Antipathes galapagen-
sis*), whose polyps are a startling canary yellow, or on other
occasions finds oneself face to face with a six-foot green mo-
ray eel. These big morays (*Gymnothorax castaneus*) will lie
full-length in the open juncture of two rock planes, their en-
tire—and entirely impressive—bodies exposed to full view.
You can see divers almost tiptoe when they inadvertently
come upon these huge eels.

The scorpionfish (*Scorpaena mystes* and *S. bistrio*) here are
extraordinarily large compared to those of warmer seas,
looking like twenty-pound frilled dragons among the rocks.
Some manage to be nearly invisible in their camouflage
colors, with only their mirror-like eyes betraying their
immobile presence. These astonishingly homely fish are
clumsy, lurching in an ungainly way from one rocky perch to
another. Once settled they may remain motionless for hours,
waiting for the small fish that will eventually wander past.
Then, in an instant, the scorpionfish opens its enormous
maw so quickly that it sucks in its prey from inches away.
One gulp and it's over, the scorpionfish again completely
motionless, and the onlooker wondering whether he really
saw what he just saw.

In many areas of the world, divers find a trademark spe-
cies hovering just above the reef in large numbers. In the

A large scorpionfish (*Scorpaena bistrio*)
rests its frilled head amid the rocks, wait-
ing for unwary prey.

Red Sea countless thousands of orange fairy basslets shimmer above the coral line, while in Palau and the Philippines there are great numbers of the butterflyfish *Hemitaurichthys*. In the Galápagos immense shoals of creolefish (*Paranthias colonus*) in numbers beyond imagining form moving walls of white-spotted roan against the backdrop of the green depths. Swelling upward like some living musical crescendo, the living curtains of these fish blot out one's view of any other fish in the area. On several occasions I have been completely immersed in a big school of creolefish, only to have the curtain part to reveal a searingly beautiful golden grouper (*Mycteroperca olfax*) poised watching me from the nearby open water.

The golden groupers are one of many splashes of high-voltage color in a generally drab background. Looking at the electric gold of this fish one wonders why in this world of green darkness nature extends her palette to such singular limits. For another example consider the Panama horse conch (*Fasciolavia princeps*). This peaceful browser upon the algae coating the rocks is mantled in a rather drab shell and keeps its soft and vulnerable body hidden beneath that protective pillbox. Yet when one coaxes this reclusive mollusk partially out of its shell, its radiance is effulgent against the rock upon which it rests. Why its body of fire-engine red is spangled with spots of the purest cobalt blue, I cannot guess. The only time I've seen the finery exposed is when two of the conches are mating; the rest of the time the festive coloration is withdrawn beneath the shell, not visible to other eyes. Perhaps this gaudy plumage is simply for attracting a mate.

The reason for my intense interest is that other members of the animal kingdom use colors for very specific purposes. A male frigate bird will develop a large inflatable flame-red throat pouch during mating season. There is no missing its splash of living fire amid the greenery of the nesting ground. In the frigate bird's case the use of bright color is specific and instantly understandable: to attract a high-flying female. But when I see the horse conch I am plagued by the inescapable sense that I am missing something. What evolutionary nudge led down this path? Is there perhaps some reason that has come and gone, lost in the history of this now-resplendent animal?

The Panama horse conch (*Fasciolavia princeps*) reveals its unexpectedly effulgent coloring.

At a remote point of the northern coast of Isabela, the largest of the Galápagos Islands, there is an exciting cavern that is open to the air and leads far back, deep into the rock mass. Within the cavern is a gathering of reclusive young sharks, which scatter as our motorboat slowly glides into the dank, shimmering interior of the cave. The last time I dove at the mouth of the cave the weather was a little rough and the surface waters somewhat murky. No matter: we knew the rock walls were splashed with lavish photo subjects and eagerly donned our wet suits to explore.

I moved down the face of the wall, for often in these conditions the murky water is only a surface phenomenon, overlying clear, cold water. At about sixty feet the thermocline (temperature boundary) between the two water layers was as sharp as a knife. The deeper water had to be at least five to ten degrees colder and was exquisitely clear. Suddenly I could see the great boulders decorated with red-and-yellow sea fans that lie in the valley beneath the cavern and, beyond them, the sharp plunge to deep water.

Something moved. I turned quickly, to find two large ocean sunfish (*Mola mola*) hovering just beneath the layer of murk as if ready to retreat into it. They were six to eight feet in height, great vertical pancakes with saucer eyes. Some say that sunfish feed at depths of two thousand feet or more (though they have been observed eating jellyfish at mere eighty-foot depths), but regularly come to bask on the surface. The steely silver fish eyed me suspiciously, then began flapping their top and bottom fins in an ungainly waddle, swimming down into the clear depths beyond the final ledge. Twice more that day I dove down to the crystal water to find them there waiting, but they are tempting targets for predation, and hence are very cautious. I saw one some years ago with its lower fin bitten nearly off by the razor-saw teeth of a shark, so I understood their extreme reluctance to be approached.

A long night's cruising to the east of Isabela lies isolated Kicker Rock. At dawn one watches a tiny pinnacle interrupt the unbroken line of empty horizon near San Cristóbal Island. An hour passes; the pinnacle is somewhat larger, but oddly it still seems very far away. Soon the reason becomes apparent—Kicker is a gigantic snow-white tower erupting a thousand feet into the sun-filled morning, so tall that it al-ways seems closer than it is. The white is the residue of countless generations of seabirds such as the frigate birds we see wafting so high as to be mere specks against the flat blue vault of the sky. The nearer we approach, the higher the enormous spires seem to reach into the sky. Now we see clearly that an enormous needle of rock has split away from the main body of Kicker; later we'll sail our vessel through the deep shadows between them. Like some colossal citadel from a mythic past, Kicker Rock dominates the mind of the observer.

The diving around Kicker is as dramatic as the Matterhorn of rock towering vertically above. On one side the shadows are so dark that the hand lights we normally use to dive at night are required. Yet on the other side the vertical rock walls are agleam with flashing sunlight and splashes of varied color. The undersea terrain offers little cover, consisting mainly of enormous tumbled boulders. For this reason the marine life, from tiny brown skittering blennies (*Ophioblennius steindachneri*) to huge red-and-cream starfish, is easy to distinguish as we slowly explore. On my last visit I came, quite without warning, face-to-face with a huge green moray with its head held close to a rock ledge. Since it seemed reluctant to leave this particular ledge, I looked at it more closely. There was an entire colony of elaborately marked caridean shrimp engaged in cleaning the big eel. At my approach the moray pulled its body down among the rocks, but held its head near the cleaners as if loath to lose its place or priority with them. As I sat watching the moray, a graceful school of white-striped angelfish (*Holacanthus passer*) crowded in around me, as if trying to understand why I was crouched down among the rocks. These gaudy fish are also found in large numbers at another island of the Galápagos, far to the south of Kicker Rock at the Devil's Crown.

This formation is the jagged remains of a tiny volcanic vent off the coast of much larger Floreana Island. Looking much like a tattered black-spiked tiara from a distance, the island resolves when approached into a circular caldera of eroded basalt perhaps one hundred yards in diameter. Inside the jagged ring are sun-warmed shallow coral fields, while beneath the crown structure itself are honeycombed passages through which tidal currents thread their ceaseless way. On the sloping outer flanks of the Crown, gatherings of

fifty or more foot-long white-striped angelfish congregate in wheeling, curious schools. Occasional octopuses wind sinuously among the rocks, and now and then the ungainly bulk of a pufferfish rumbles across the underseascape.

One of the most noteworthy events at this volcanic formation was one I just managed to miss. We had finished a morning of diving at the Crown, pulled anchor, and were an hour or more under way to our next destination when the radio crackled excitedly. Our official naturalist appeared on deck somewhat crestfallen. Another vessel, he told us, had arrived at the Crown after our departure. While it sat at anchor its crew saw a pod of killer whales (*Orcinus orca*) set upon and slaughter a large manta ray right before their eyes, in a paroxysm of violence that had stunned the onlookers. Yet, as I pointed out to my group when they reacted similarly, in nature's realm this is not crime, but the natural order. This event differed from a butterflyfish plucking a coral polyp only in scale, in impressiveness. In both cases what we are seeing is one species preying upon another.

As we wander southward among the islands we find noteworthy contrasts with the volcanic outposts to the north. At Champion Island there is an area of substantial coral development, which in these generally cold waters comes as something of a surprise. The ever-present sea lions are also here in impressive numbers, shooting past like barking arrows. Indeed, here too, one is sometimes surrounded by a maelstrom of flashing pinniped bodies the moment one enters the water. Words often fail me in attempting to convey the effect of swimming with these sleek marine mammals. Up close they are all eyes, examining us closely, only to swoop away in a flashing arc to disappear in the roiling mass of their compatriots. Swimming with the sea lions one is sorely tempted to envy their carefree, graceful ways. Yet the dark waters behind us contain sharks and killer whales, both relentless predators upon the lovable pinnipeds. Any of these playful, wide-eyed acrobats could simply fail to return from its next fish-chasing swim.

Deeper down Champion's outer slopes we encountered an unusual cave-dwelling fish scientists have tagged with the whimsical appellation "wrasse-assed" bass (*Liopropoma fasciatum*). This remarkable fish has basslike characteristics in the front of its body and wrasse features in its nether parts.

The white-striped angelfish (*Holocanthus passer*).

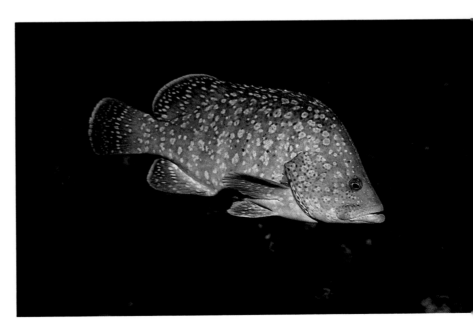

The marbled grouper *Dematolepis dermatolepis*.

Living deep in crevices, it is not often seen; indeed, it had never been spotted until the advent of scuba diving here. It is a particular thrill to see its brilliant red-and-gold body in the rocky darkness of Champion's deeper slopes.

In total contrast to the personal adornment of the wrasse-assed bass, the marine iguanas of these isolated islands are both drab and homely. There are two distinct colonies of these signature animals of the Galápagos. At Punta Espinosa on Fernandina in the north, the reptiles are black with white crests, while at Hood Island in the south the iguanas often display distinctive red bands on their sides. All share the same feeding behavior.

The iguanas remain motionless for hours on the black, sun-baked lava rocks. Occasionally, without warning, they will snort salt that their systems have isolated from ingested sea water from their nostrils; otherwise, they form vistas of sprawled, inert bodies almost indistinguishable from the dull background of lava rock. Then, as the tide reaches its ebb, a remarkable transformation takes place: one after another the immobile reptiles lurch to life. In an ungainly parade they awkwardly make their way to the water's edge and hurl themselves in.

Now occurs a second transformation. The jerky mime of their march across the rock is forgotten as they swim with fluid grace along the surface. Their heads held free of the water, their long tails lashing rhythmically, the iguanas fan out across the inshore shallows. At a given moment each iguana will dive down from the surface, attach itself with its claws to a rock, and munch contentedly on encrusted algae.

On their way to and from their nearby feeding grounds the iguanas occasionally suffer small indignities. I've seen sea lions playfully bat them around as if in sport. After a time, and as the tide rises, the reptiles return across the surface to the black lava rocks. Like a movie run in reverse, the two transformations occur again: the awkward, almost comical scramble onto and across the rocks and the lapse into frozen immobility. It's almost like the legend of the enchanted village Brigadoon, which comes to life each century, only to fall back into its long sleep after but a single day. Each time I leave the lava fields at Punta Espinosa with their burden of living statuary, I can't help but feel the illusion that the lizards will be frozen there until my return years later.

There is, along the coast of Bartholomew Island, an immense, slightly tipped pinnacle of rock that leans out over the water of a protected bay. On one occasion we were anchored there for a night dive and in preparation had attached a light to the base of the boarding ladder. As we suited up to dive, I looked over the side before clambering down the ladder. In the glow of the sunken light I saw dozens of just-hatched green turtles swarming by the ladder. This fortunate brood must have hatched in darkness and escaped the gauntlet of seabirds that thins their ranks by day. We brought forty or more up on deck in buckets. Like human infants they burst with energy, constantly paddling about. When it was time to return them to their odyssey of survival in the dark sea, it was with a twinge of regret that we let them go. Many of these youngsters would end up as quick tidbits for larger predators, and in the end only one or two might reach full adulthood. Those are the normal percentages for newly hatched turtles; it is a long-shot chance at best that one day one of these newborn will send its own tiny fledglings back to the sea.

The enchantment of the Galápagos is made up of dozens of unforgettable images: twelve thousand pairs of nesting albatross on Hood Island; basking eagle rays seen from the heights of Plaza Island; the perky walk of red-billed oyster-catchers darting along the shore; a pair of penguins sunbathing at the water's edge; a blue-footed booby shielding its chick from the harsh glare of the sun.

If any area of the world deserves a mantle of protective laws to create true sanctuary for its marine wildlife, it is certainly here. From the sea lions to the iguanas to the tiny red crabs of the foam-churning shore, the wonders of this evolutionary laboratory should be cherished for future visitors to share.

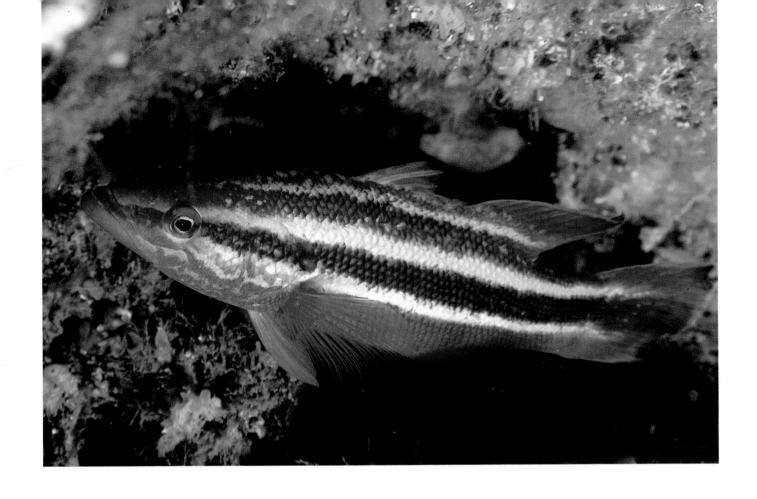

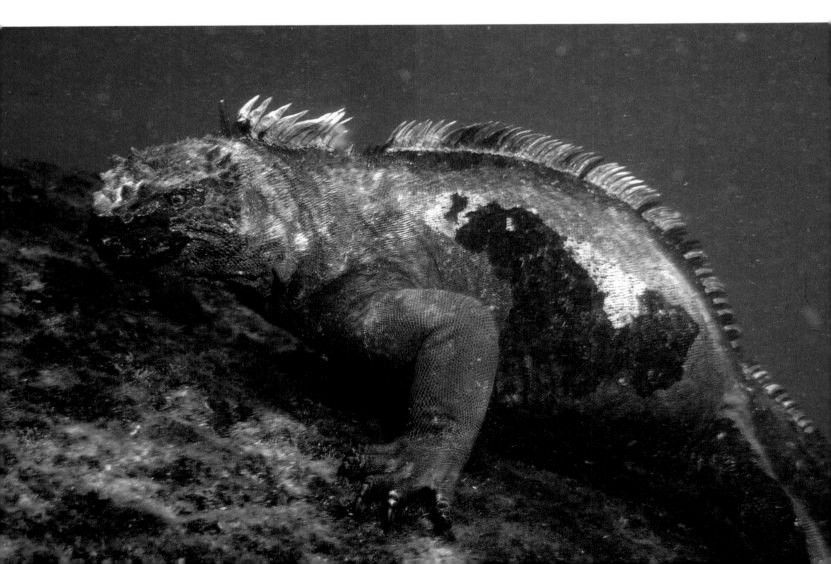

Baja California—The Sea of Cortez

Lying between the mainland of western Mexico and the long peninsula of Baja California, the Sea of Cortez was formed in a cataclysmic seismic event ten to fifteen million years ago. The San Andreas Fault suddenly opened a vast chasm, and the western coastline simply fell away, coming to rest twenty-five to 150 miles out from the mainland mass. Whole mountain ranges fell into this chasm, forming what are today isolated offshore islands. The Pacific Ocean roared in, creating—when it came to rest—a quiet, sheltered sea surrounded on three sides by substantial landmasses.

The Sea of Cortez was, at least until the invasion of massive fishing fleets, one of the richest isolated seas on the planet. Schools of countless thousands of tuna, porpoises, hammerhead sharks, and giant sea basses were common here. To this day divers in remote sites may still see gatherings of these species, but the fishing has taken its toll, changing the very nature of life in this sea. Now we'll hear from returning divers who weren't so fortunate that they saw relatively few fish during their trip. In the Sea of Cortez this is really disappointing, for there are no coral reef complexes and associated reef fish populations to substitute for sightings of big pelagic species.

Like the Galápagos the Sea of Cortez is influenced by cold western boundary currents, especially the southbound California Current. This enormous flow of nutrient-rich polar seawater lowers the water temperature and creates an inordinately rich and broad base for the open-water food chain. The cold water, however, also accounts for the distinct lack of building corals and their associated fish and invertebrate life.

Only occasional solitary or gorgonian corals survive here. There are no massive coral heads or actual reefs, as in the other tropical seas. Here, as in the Galápagos, volcanic boulders overgrown with colonies of algae and scattered invertebrates make up the undersea terrain. Unlike a coral reef complex, this rocky substrate will not support a large population of browsers.

The anomaly of the Sea of Cortez, then, is that it is lacking in large populations of coral-associated species, yet is especially rich in those open-water creatures that are part of the plankton-based food chain—at least until recent years.

In its own haunting way, Baja is beautiful. The land is stark and barren, but under a vault of blue sky or in the red light of sunset it is unforgettable. Hills of jagged stone stippled with scattered cacti are washed in russet and orange and mirrored in calm waters.

Beneath the surface we wander amid the tumbled volcanic statuary to see scattered cornetfish, small groupers, pufferfish, goatfish, wrasses, butterflyfish, and angelfish. Interestingly, we immediately recognize species that appear to be ancestral to those that evolved in the Galápagos. The flag cabrilla (*Epinephelus labriformis*) appears identical, as do the barberfish (*Heniochus nigrirostris*) and the white-striped angelfish (*Holacanthus passer*). On the other hand the yellow-tailed surgeonfish (*Prionurus punctatus*) has evolved in the more recent Galápagos into a nearly unspotted version known as *Prionurus laticlavius*.

In the southern reaches of the Sea of Cortez, the influence of the enormous Pacific tidal flows is evident. This is where, on isolated seamounts, encounters with hammerheads, manta rays, and even whale sharks are still reported. At the very tip of the Baja peninsula, a rocky arm of land juts south from Cabo San Lucas. Not far from the curving beach, the rocky structure falls away to a plunging wall. Sharp thermoclines lower the temperature from 83° F. at the surface to 70° F. or less at depths of one hundred feet. In the shallows hundreds of the slender cornetfish *Fistularia commersonii* hover, while along the rocky shoreline lazy sea lions (*Zalophus californianus*) loll in the noonday sun. This is another species with a direct descendant in the Galápagos, *Zalophus californianus galapagensis*.

It was in the warm waters above this dark precipice that I first saw manta rays do acrobatic loop-the-loops right out of the water. Flashing upward with their snow-white bellies to the sun, each cleaved the water like a springboard diver, making almost no splash upon re-entry. It was a dazzling aerobatic display and another one of many experiences with marine animals in the wild that leads the observer to insist that what he or she is seeing must be pure play.

A rocky island off Loreto, Baja California.

The most valuable benediction this special sea could receive would be limitations on the commercial fishing taking place here. Even such a favored concentration of life as this can be unbalanced and eventually destroyed by the unrestricted harvesting of particular species. I've heard recent reports that fishermen were even slaughtering the majestic manta rays that have drawn divers here. There would be left a sense of great and needless sin if these waters no longer echoed to the calls of their larger denizens; in the absence of busy, crowded coral reefs the resulting emptiness would be all the more profound.

Amid the massive boulders of Baja California curious sea lions investigate us.

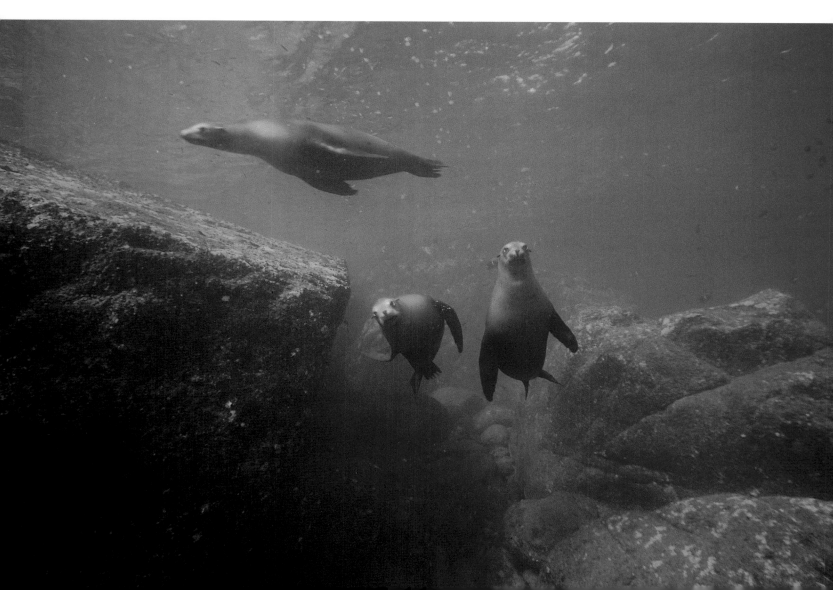

Seen at close range, the lemon butterfly-
fish of Hawaii (*Chaetodon miliaris*) is a
rich golden hue.

The ornamented butterflyfish
(*Chaetodon ornatissimus*).

An adolescent hogfish (*Bodianus diplo-taenia*) soars above barren rock (Baja California).

Amid the barren rock off the Baja peninsula, a small mutton grouper (*Alphestes afer*) sits, cautiously watching us and ready to bolt for cover in an instant.

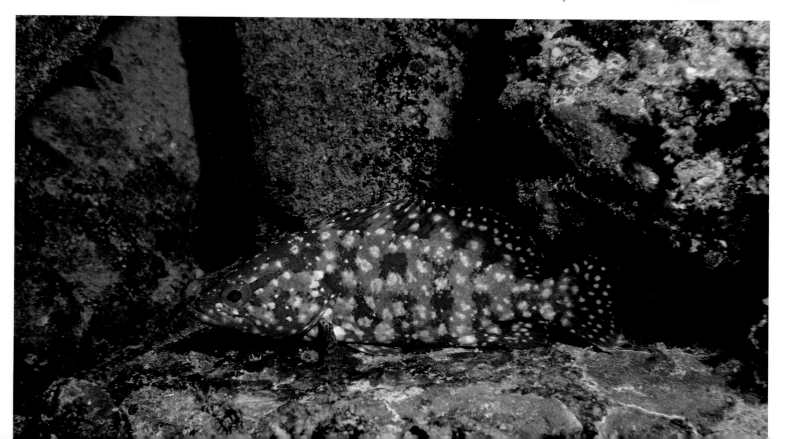

The Hawaiian Islands

The third of the regions that lie on the outer edges of the tropical Pacific is the group of volcanic peaks known collectively as Hawaii. The Hawaiian Island group comprises 120 islands and islets strung in a long chain across two hundred miles of open sea. Of these only six are permanently inhabited and are inundated with well over a million visitors each year.

The great sunken volcanoes that form these Hawaiian outposts rise thirty thousand feet above the seafloor. Were they not largely submerged they would be recognized as the tallest volcanoes on earth. Tectonic scientists posit that these volcanic towers were formed by a "hot spot" deep beneath the earth's mantle. As the immense Pacific plate moved slowly northwestward, the hot spot punched a series of holes through the mantle; lava poured through in such incredible volume that tall peaks of basalt accumulated. Each volcano in its turn then shifted off the hot spot, became dormant, and saw a new one rise to its southeast. As verification for this theory scientists point out that the Hawaiian Islands grow older and more eroded in direct sequence from southeast to northwest.

The volcanic source that raised the islands from this sea five to fifteen million years ago placed them in what is today a deprived biological position. The great surface currents of the North Pacific Gyre flow unceasingly in an immense circle around and past them, and these islands receive mere eddies from the final vestiges of the western boundary current that flows southward along the California coast. The surface currents that do reach the Hawaiian Islands are at the end of a long journey from their tropical origin; any warm-water larvae reaching here from the western Pacific have traveled past Japan and the subpolar Arctic on their way. For this reason it is understandable that there are relatively few new larvae introduced into these waters today. It is important to note that during past eons these currents may have varied significantly, offering the islands past periods of heavy seeding by the larvae of tropical species.

On a positive note, it is this awkward position relative to winds and currents that protected the Hawaiian Islands from European exploration for almost three hundred years after Columbus made his momentous voyage of discovery. The Europeans tended to sail westward just north and south of the equator, using the trade winds and the equatorial currents to speed their journey. For this reason Hawaii, which was probably first settled twelve hundred years ago by navigators from the Marquesas Islands, were left in unmolested isolation until Captain James Cook came upon them in 1778. Within one hundred years of Cook's discovery, three-quarters of the Hawaiian natives had perished from the cumulative effects of their exposure to western civilization.

The huge North Pacific Gyre that delayed Hawaii's discovery, also cast the shape of its marine fauna. From the islands' present position in the gyre's pattern, one might predict that they would have few corals or tropical fish species. Yet, while the corals themselves are indeed sparse, often limited to shallow, sunbaked bays, the tropical fish population is fairly rich. Sweeping above stunted finger corals are Moorish idols, Achilles tangs, several species of spectacular butterflyfish, angelfish, and many others.

The butterflyfish population is especially impressive, with twenty species from four genera represented. In certain areas, such as on the flanks of the tiny volcanic crater Molokini, schools of hundreds of the lemon butterflyfish *Chaetodon miliaris* swarm about divers in crystal-clear waters. In shallower zones life-pairs of golden-slashed (*C. ornatissimus*) and four-spot butterflyfish (*C. quadrimaculatus*) browse at leisure.

Amid the stubby corals hide a variety of colorful but vulnerable invertebrates. There are spiked shrimp with long, slender antennae, round-bodied crabs with protruding eyes, barbershop shrimp, slipper lobsters, and the color-splashed harlequin shrimp (*Hymenocera picta*) feeding on red starfish.

For many divers who have enjoyed the well-developed coral reefs of the Caribbean, their first trip to dive Hawaii can be a big disappointment. After all, where are the big coral heads swarming with parrotfish, wrasses, groupers, and snappers? It takes patience and a shift of mental set to enjoy diving in Hawaii. There are tunnels and arches formed by the lava and great sun-pierced caves at Lanai known as the Cathedrals. Now and then a manta ray or spotted eagle ray will soar past, or a barnacle-bedecked turtle will move on its placid way to feed on grassy algae in the shallows.

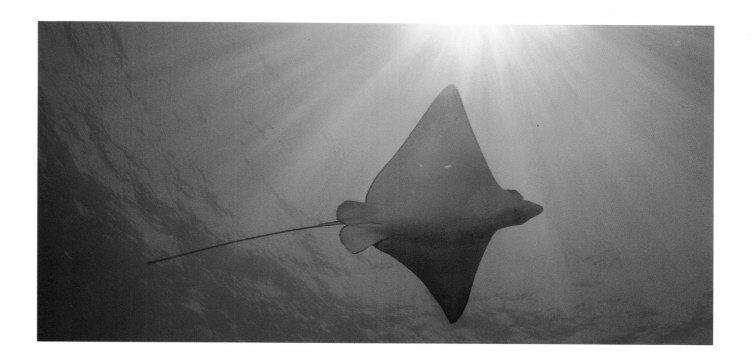

This spotted eagle ray purposely soared over me on its way to deep water, as if to say farewell.

Molokini Crater, one of Hawaii's most dramatic dive sites.

In the deep blue waters far offshore the early spring brings humpback, sperm, and pilot whales. Over-eager promoters boating tourists to see the whales have so harassed these grand migrants that such boating is now outlawed. Sometimes, however, a mere half-mile offshore from the palatial hotels, humpbacks will breach in thunderous splashes of water. I once sat with a friend in his hydrophone-equipped boat while he taped the long, introspective sound of a humpback somewhere in the vast blue ocean depth around us. It was a touching moment, a profound sharing of song both personal and universal.

Scientists believe that some of these songs may reach out over thousands of miles of open ocean, the great whales joining in an ocean-girdling chorale. This epiphany, which we may never truly comprehend, is one of the magnificent mysteries of the deep blue water that covers 70 percent of our planet. The whales long ago learned to raise their voices in communal song even as they wander trackless depths, separated by unimaginable distances, yet always together.

While Hawaii, the Sea of Cortez, and the enchanted Galápagos may indeed not be lush tropical undersea paradises, their marine life is unusual and highly rewarding for the serious observer. Here, where the ocean currents cool rather than warm, where pelagic larvae may have journeyed thousands of chilled miles, we can't help admiring the survivors. As we move on into the sun-warmed South Pacific we may wonder how the seemingly delicate creatures of those lively reefs could ever transmit their progeny so far, through such hazards.

Chapter Six
Fiji and French Polynesia
ISLANDS OF SPELLBINDING BEAUTY

◀ Sunset at Huahiné Island.

The enormous reef that encircles Bora-Bora has only one opening.

In the empty stretches of the vast south-central Pacific lies a coral kingdom whose far-flung islands are among the most beautifully scenic we find anywhere in our travels. These long-eroded peaks rise from ocean depths of clear blue water. Unlike their neighbors to the east, the islands here never face the intrusion of cold Arctic or Antarctic water. Their volcanic masses are surrounded with well-developed fringing coral reefs supporting a broad range of marine life. One, Bora-Bora, has even become a symbol of ultimate romantic islandhood; it was the mystical Bali Hai of the Broadway musical *South Pacific*.

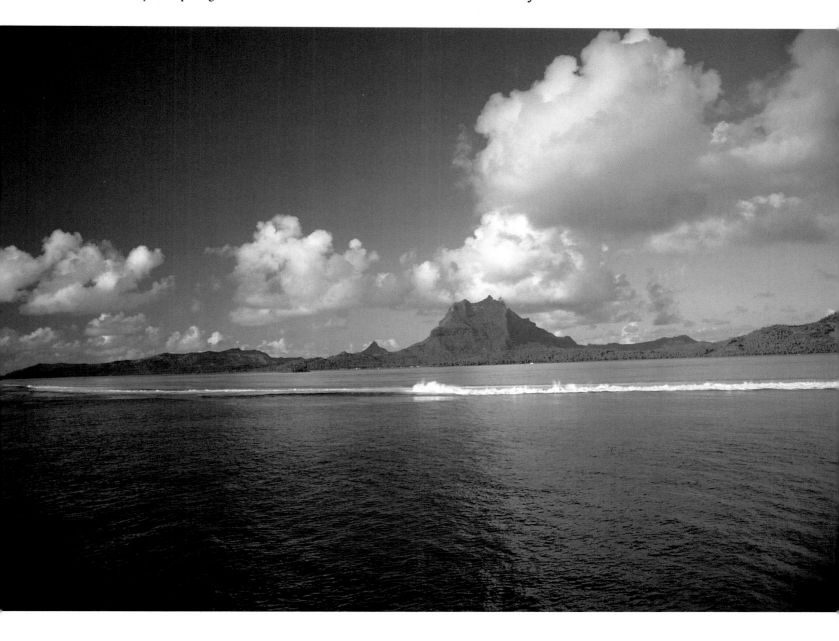

Rainbow Reef (in the background) during the stillness of low tide.

Fiji

One of the few island groups in all the world to avoid centuries of devastation by the Europeans, Fiji (or the Fiji Islands) was protected by a reputation for menacing reefs and even more menacing native warriors.

In 1643 the Dutch explorer Abel Tasman declared the Fijis (or "Vitis" as they are known locally) dangerous to navigation because of the shallow reef complexes associated with their more than eight hundred islands. Moreover, Tasman warned potential conquerors that the Fijians carried on internecine warfare that often ended in mass annihilation. His warning echoed out through the fleets, which certainly faced enough hardship in their far-reaching peregrinations without purposely inciting skilled native warriors. Captain William Bligh strongly repeated this caveat 150 years later, after a war canoe chased one of his longboats away. The result of such encounters was that until the early nineteenth century the Europeans managed no commerce—or conquest—in these islands.

In the early 1800s, however, the lure of sandalwood and sea cucumber (known as trepang or *bêche-de-mer*) caused courageous traders from Djakarta and Australia to assay relations with the Fijian tribes. By 1835 these early contacts resulted in members of the London Missionary Society settling here. In 1858 a British-backed tribal chieftain emerged as king of all the Fijis and sought annexation by Britain. The British demurred, not eager at that time to add to their collection of dependent island groups on the other side of the world.

A few years later when the American Civil War caused a sharp decline in cotton production, British merchants built cotton plantations in the Fijis. As they had in the American colonies, the plantations' needs for cheap labor led to slavery, here called "blackbirding." In the absence of any government control, it swiftly wreaked havoc on the populace. By 1874 blackbirding—along with the ravages caused by imported diseases and guns—had taken such a physical and social toll on the Fijians that the British agreed to annex the islands, gradually ending the slavery, the tribal wars, and eventually even the cannibalism there.

Today the Fijis rise majestically above vistas of blue sea, their mountaintops often wreathed in fluffy white clouds, their shallow inshore waters a symphony of aquamarine hues rimmed by gleaming white sandy beaches. The natives are big, square-jawed, and imposing. Even today one sees flickering reminders now and then of the fearful Tasman and Bligh reports in their deep-set eyes, yet for all their warlike

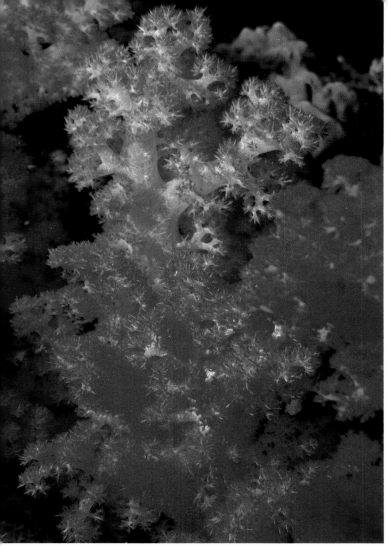

A varied assortment of soft corals (*Dendronephthya*).

appearance the Fijians are a wonderfully friendly and gentle people. On occasion I've dived with young native giants whose biceps were bigger than my thighs and whose smiles were brighter than the tropical sunshine.

Undersea life in the Fijis is so varied as to be misleading. In 1972 and 1975 I made visits to certain sections of reef that were so poor I came away wondering whether Fiji actually had any good diving. Indeed, one of these scouting trips could easily have led to tragedy when the poorly maintained boat I had chartered with which to explore the outer Yasawa Islands broke down. Fortunately, it failed near another vessel, which was able to take us in tow. Had the breakdown occurred on a different day, we would have been alone, drifting in the vast, empty sea. To this day one of the two friends who accompanied me on this exploratory trip can be reduced to inarticulate rage at the mere sight of anything Fijian.

Finally, in 1978 a close business associate who knew my feelings about my Fijian experiences told me about three specific areas. He had just returned from visiting a small island off the coast of the major northern island, Vanua Levu. What he described rekindled my interest, and a few months later I took a few diver clients by chartered twin-engine aircraft to explore these new reefs.

There could not have been a greater contrast to my earlier visits. As we circled above the reef line in our plane, we could see that the outer rampart of Vanua Levu curled and looped along the edge of the deep Somosomo Channel. The next day we saw at close range the startling beauty of the reefs below the clear blue water.

This area is known as Rainbow Reef. The name is particularly apt, for at the time of my visit Rainbow was a revelation of multi-colored soft corals. I'd never before witnessed such a dense carpet of these delicate bursts of radiance as along the edge of the precipice here. These soft corals were not huge, like their relatives at Truk Lagoon far to the northwest, but they tumbled over each other, sometimes in such profusion that one could not see the stony-coral substrate upon which they took root. Rose, yellow, pink, and every shade between seemed to clamor for notice. Fluttering in the currents they formed a living Kashmir rug of incomparable lushness and complexity.

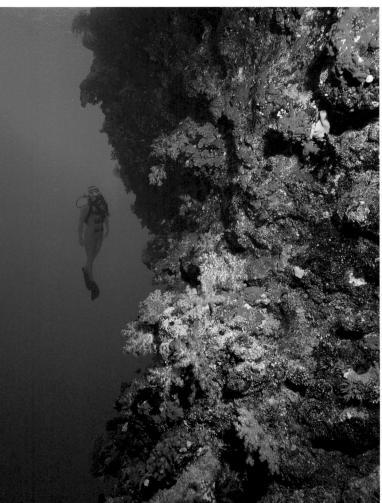

The Color Wall is carpeted with soft corals in a rainbow of hues (Fiji).

Strong currents swept along the outer reef, an important factor in the profusion of marine life here. To avoid being swept away after leaping into the current, we quickly dived down to perhaps fifty feet to get behind a large coral mass. In the shelter of the reef bastion, we were protected from the racing waters, yet could view the incredible wealth of life the swift-moving stream awakened.

At the crest of Rainbow Reef there is a huge stony coral formation that was covered with soft corals; a tunnel-like passage led beneath it. When the current was running, the force of the water was so strong that I had to pull myself hand over hand along this passage, trying not to damage my two big camera rigs in the process. The first time I ran this current-riven gauntlet I had some expressive—and unprintable—comments to make. (In fact, I do talk a great deal underwater, scolding uncooperative fish, complaining about currents or surge, cursing fiercely when a camera or strobe light fails to fire. Many of my clients have enjoyed a good laugh at my antics. My only defense, of course, is to inform them very seriously that my cameras would *never* work if I didn't constantly remind them who's boss.)

On the southern end of the crest formation—on the other side of the passage—I looked back and saw the huge rock face completely carpeted with rippling soft corals and small fish fluttering like tattered pennants in the fast-moving water. An interesting comparison in the hydrodynamics of fish and diver shapes occurred to me: most fish, even the smallest, are generally sleek and streamlined, and they can propel themselves through even a strong current with mere flicks of their pectoral fins. We divers, on the other hand, are great lumpy bulks with relatively little strength and enormous water resistance; if we don't get a firm hold on a coral projection the current will sweep us away.

From this vantage point in front of the great coral-coated rock one needed only to look ahead to see one of two major tunnels that pierce Rainbow Reef. The entry to the nearest was a large, rubble-strewn depression behind a long coral ledge. When the current was running it was a perfect hideaway and vantage point filled with still water. The open-water current swept by, yet one was protected within the rock womb of the reef mass. About the mouth of the tunnel were iridescent gorgonians fluttering in the moving water.

Clouds of small fish—damselfish, butterflyfish, angelfish, wrasses, and parrotfish—darted busily about. Seen against the carpet of blazing soft corals these flashes of constantly moving color had an incendiary quality that is impossible to capture on film. One shy butterflyfish (*Chaetodon rafflesi*) was particularly elusive because of its quick and random movements.

There is a deeper cave on the Rainbow Reef, carved by an ancient sea level, and perhaps sixty feet below the one I've just described. In the cave I found several small but beautifully plumed lionfish (*Pterois antennata*). One day I was on the reef wall up near the fifty-foot level where the tunnel exits. Looking down I saw an agitated gray shark making fast passes at something on the reef rampart. Quickly I realized that its target was the spastically jerking legs of one of my clients. This man was head-and-torso into the cave photographing lionfish, but his legs, fluttering in the current as he tried to maintain his position, were driving the shark to threatening heights of interest.

I hauled myself down the wall to get between the shark and the dancing legs. It is axiomatic in all my shark experience that, when faced with a determined human, a single shark will back down. There are, of course, exceptions (large sharks, sharks in a feeding frenzy), but generally one's best option is always to face down a six-foot gray shark as you would a neighbor's barking dog. Fortunately for my client the axiom proved accurate this day, and the shark soon raced off into the darkness.

On the same vertical precipice, beginning at a depth of ninety feet and continuing down to beyond 250 feet, is what we called the Great White Wall. On the sheer rock face, gleaming in the near-darkness of these depths, grows an extensive field of foot-tall ice-blue soft corals. The effect is similar to that of a glowing theater curtain over a perpetually dark stage. We sometimes let the current carry us along in a drift dive at a depth of 150 feet, so that we flew past the great living curtain, which stretches into the gloom above and below. It is an eerie sensation. The corals have somehow attained relative exclusivity here, competing en masse to prevent gorgonians, crinoids, and other reef-carpeting species from gaining any foothold in their midst.

The typical Fijian shallow coral gardens are among the world's most beautiful.

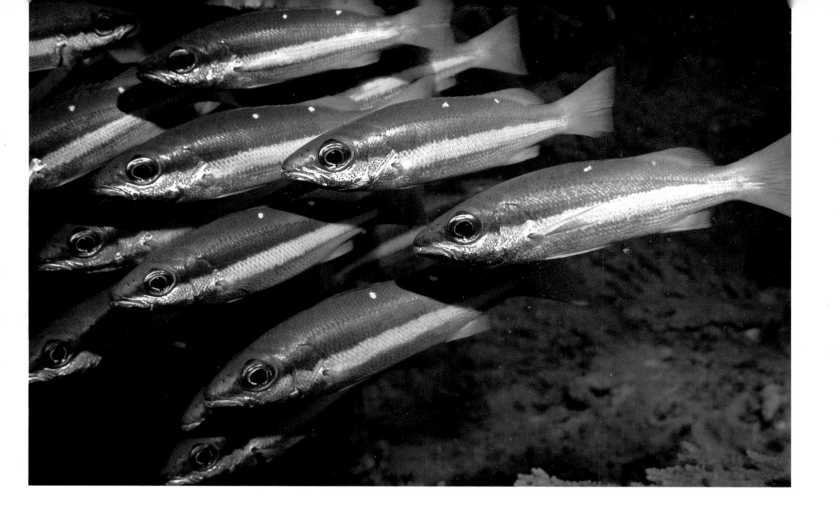

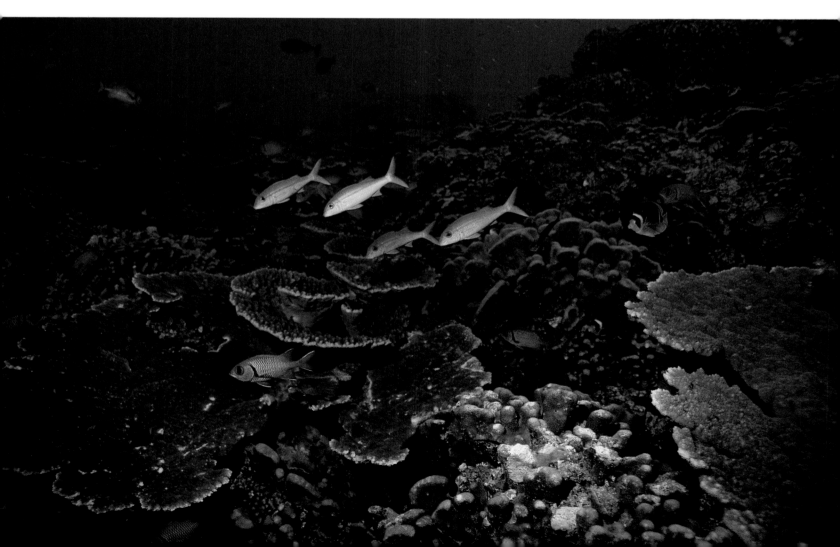

On a visit to Rainbow Reef in 1982 I was stunned to find many of the shallow corals completely devastated. From the surface to a depth of fifty feet, most of the stony corals and almost all of the soft corals were dead. I was confronted with a scene of utter, monochromatic desolation on one of my favorite reefs.

This time the destruction was not the work of man, but of the inexorable forces of nature: an earthquake, a cyclone, and an infestation of crown-of-thorns starfish had occurred in the space of a single year. The delicate reef corals hadn't had a chance against this combination of attacks.

From my Philippine experience I felt that the crown-of-thorns damage could have been avoided if the starfish had been immediately removed from the most precious sections of reef, but the local divers hadn't known what to do when the infestation began. By the time they learned to remove the starfish, it was too late to prevent the damage.

The ruin wrought by the earthquake and cyclone shows how mature reefs that have grown to within a few feet of the surface are peculiarly vulnerable to devastation by major weather disturbances. Waves of incredible power rear above the shallow reef corals, pounding them to rubble. In a clearly cyclical sequence these reefs are battered, and recover over a period of many years, only to eventually be devastated once again.

I must say, however, that it doesn't make the visitor any happier to realize that the damage is from natural causes, or that someday the reef will regenerate. Rainbow Reef's real beauty begins now only at the fifty-foot level. The Great White Wall is as beautiful as ever, and the caves are filled with life. The sharks patrol the shadowy depths, while the reef fish dart here and there looking for food. The coral is growing back slowly, splashes of color spreading across the barrenness. One day the shallow crest of this once-mighty reef will be as beautiful and color-drenched as ever; I only hope to see it once again as it was.

Off the town of Nadi on the big island of Viti Levu is a fringing reef twenty miles or more out to sea. Near the outer limits of the lagoon it forms we find a series of picturesque islands and—more interesting to us—scattered large coral formations that approach but do not reach the surface. This makes them very hard to find, and we have sometimes searched the area for a half-hour or more before finding some of these pinnacles of coral. As we shall also see in Australia's Coral Sea, this type of pinnacle formation in open water tends to concentrate reef life in profusion seldom found on fringing reefs.

These Fijian pinnacles prove this point. Their crests are a mere dozen feet beneath the surface, sunbaked like those earlier encountered in the Maldives. Upon dropping our anchor we can see quite a lot of detail even from above the gleaming surface. These mature reef tops are regularly battered by big waves during the monsoons and heated by the sun during the fair season, so the coral growth tends to be low and squat. The drop-off is another matter altogether: stony corals project everywhere, many draped with one or more color-splashed crinoids with graceful arms. Between the coral formations are hundreds of crevices, each of which seems to be sheltering a different type of fish. There are hundreds of bigeyes (*Priacanthus hamrur*), brilliant butterflyfish (*Chaetodon ephippium, C. ulietensis, C. rafflesi*), and frequent visits by the normally reticent blue angelfish (*Pomacanthus semicirculatus*). In the clear water just off the wall, huge schools of unicornfish (*Naso unicornis*) unconcernedly form a living cocoon about the divers.

At two different pinnacles we were favored with finding nests of octopuses. Encounters with these intelligent cephalopods are similar to those with their cousin, the cuttlefish: one senses a thoughtful and curious reaction to one's presence in both animals. Because of the unusual pigmentation system of the cephalopods, their thoughts seem to be mirrored on their skin. Waves of brown and white sweep their bodies, their eye and body movements alter depending upon the style of your approach. Their skin will abruptly turn coral-tan with raised bumps as they camouflage themselves—there is always something expressive going on. We humans are in a way used to this, for we alter our faces with the red flush of anger, the pallor of fear, the furrowed brow of concentration. Among the reef populace, however, most invertebrates show no change upon being approached except to withdraw their feeding tentacles. Fish betray nervousness through rapid eye movements, but their faces are otherwise impassive and incapable of expression.

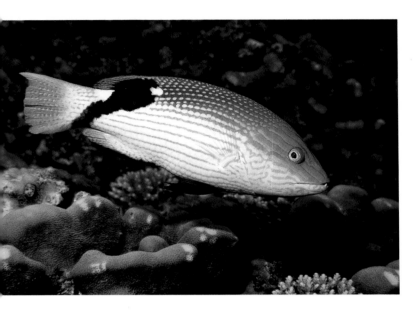

A large hogfish (*Bodianus hirsutus*) above
the low reef corals of Bora-Bora.

An octopus camouflages itself by color-
ing and raising bumps on its skin.

At night a huge, spiny pufferfish (*Diodon
holocanthus*) inflates to protect itself from
predation.

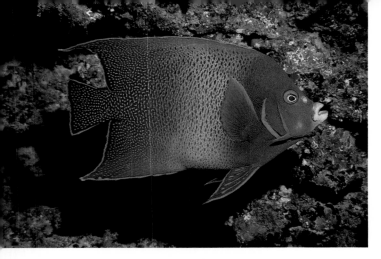

Blue angelfish (*Pomacanthus semicircula-tus*) seldom allow divers to take their picture.

A golden damselfish (*Amblyglyphododon aureus*) hangs above a drop-off to deep water.

A clownfish (*Amphiprion bicinctus*) guarding its eggs on the crest of the reef wall.

A nocturnal crinoid begins to curl its feeding arms at the first touch of our hand-held light (Fiji).

When found in pairs or larger groups, the octopuses' interactions heighten our impression of intelligence among these marvelous animals. Their fluid bodies ooze from crevice to crevice in shimmering plasmid grace, disappearing into impossibly small cracks only to appear on the other side. No matter how random each individual's movements may seem, the members of each pair rendezvous constantly and always seem aware of each other's precise location.

Night dives on these pinnacles off Viti Levu are a delight, for it is so easy to find one's way about—the straight precipice walls are like a road map upon which one cannot become lost. As we focus in on one animal after another we realize that the world of the nocturnal reef is a new dimension of experience for us. Our familiar daytime creatures (butterflyfish, angelfish, parrotfish, damselfish, and others) are bedded down in protective coral sanctuaries. Their places have been taken by entirely new families of fish, which we often saw hovering in dark crevices during the day: cardinalfish (*Apogon*), bigeyes (*Priacanthus*), soldierfish (*Myripristis*), and squirrelfish (*Holocentrus*). Many of these species have large eyes in proportion to their body size, apparently to enable them to see better in the low light conditions. Now and then our lights also capture a lobster (*Panulirus*) making its armored way through the darkened coral world. The lobster is preyed upon by so many of the larger reef denizens that it is always poised to disappear into a handy aperture in the coral.

One feature often overlooked by divers making their first forays into the water by night is the variety of crinoids, the delicate feather starfish. The hot-colored crinoids of the day are still in place, but have been joined by countless others in new colors and patterns that only emerge by night. These nocturnal crinoids are often barber-pole striped, and therefore must conceal themselves deep in the coral during the day. So sensitive are these delicate, many-armed creatures to light that even the low output of our hand torches interrupts their feeding. They writhe in great agitation in the beam we focus on them and immediately forsake their feeding perches to begin crawling toward shelter. We never find these light-shy creatures during the day, indicating how deeply into the coral honeycomb they must withdraw.

A female painted lobster (*Panulirus*) ▶ showing the claspers she uses when gravid to hold the eggs against her abdomen (Fiji).

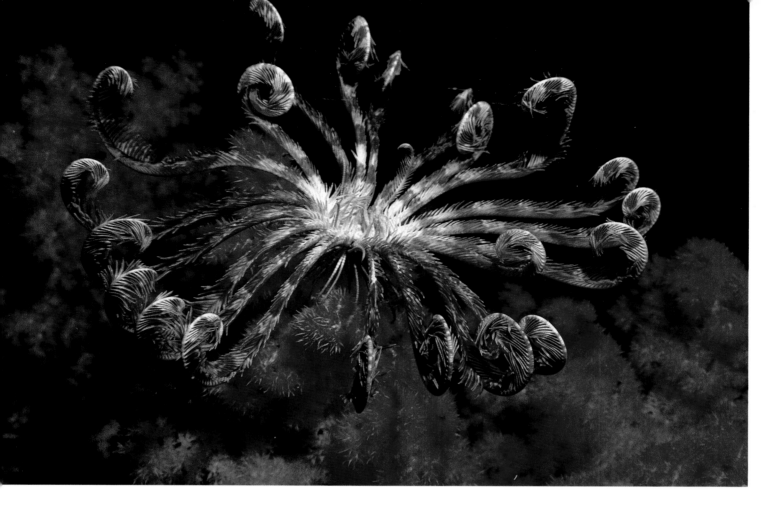

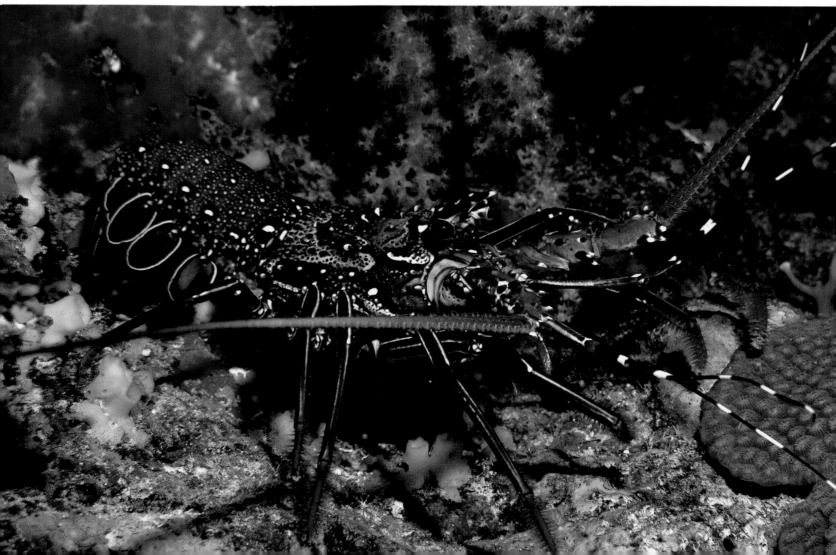

Thirty miles south from the major city of Suva lies Great Astrolabe Reef where the greatest of the Fijian reefs plunges majestically beneath the surface. On the marine charts this reef-and-island chain reaches toward the mainland like a grasping tentacle; for perhaps ten miles the northern extension of the reef forms a barrier to the wave action caused by the trade winds. For this reason we always find a lee here to explore Astrolabe's coral communities.

One's first impression upon entering the water is one of immense scale. Undersea parapets plunge from just beneath the surface to as much as six thousand feet, walls of coral that dwarf the human intruder. Some of these precipices, like the one I call the Color Wall, are carpeted with soft corals and gorgonians in a riotous tumble of colors, plunging to depths beyond our comprehension. When ocean currents sweep along these walls, the corals pulse with intense color, like some mad artist's prairie fire. Earthquakes have fissured these colossal coral masses so that Astrolabe's walls are labyrinths of huge cracks, passages, and winding corridors in which a diver may soon feel rather lost.

The waters that bathe Astrolabe's mighty coral bastions are warm and clear; with this visibility it is easy to see an eternal parade of passing marine life. Now and then a mature sea turtle glides by, head slightly raised as if carefully assessing the threat from the human observer. When wandering the great corridors through the coral mass one will encounter occasional reef white-tip sharks, schools of batfish (*Platax*), or a lumbering Napoleon wrasse (*Cheilinus undulatus*). A face-to-face encounter with a six-foot Napoleon is rather disturbing when each of you realizes that one must back down and retrace his path.

On several occasions I encountered the decorative banded sea snake (*Laticaudia colubrina*) in these coral passageways, serenely gliding just above the rocky surface looking for small cracks that might contain the tiny fish upon which it preys. Upon finding a human hand in its path, the snake does a visible double take, then flicks its forked tongue rapidly over the hand's surface. Its head and eyes are decorated with sweeping bars of creamy yellow, a gaiety of adornment that belies its armament: like its Philippine and Australian relatives, the banded sea snake is possessed of extremely po-

tent venom. While it is not aggressive in the least, the mere presence of such lethal equipment urges caution upon the human intruder.

At Usborne Pass tidal water flows through a quarter-mile gap in the reef wall, gathering pelagic predators such as sharks, jacks, barracuda, tuna, and several species of swift mackerel. Like passes elsewhere these are not particularly scenic; the swift-moving waters seem to scour the coral surface, with only isolated gorgonians and crinoids to offer a highlight of color in a monochromatic blue world. In the moving gloom of the tide, vague shapes in the distance materialize into schools of rainbow runners or swift jacks. They swoop into view, eye the human visitor curiously, then move off into the darkness once more.

Astrolabe's distance from Suva and a relative lack of dive boats have protected these reefs from the ravages of weekend divers. To dive here it is necessary to have a live-aboard vessel that can anchor overnight at any of a half-dozen small islands in Astrolabe's lagoon. It is also necessary to obtain permission from the village chiefs of the lagoon, an extremely touchy matter. Fijians still show that fierce independence of spirit that can lead to confrontation. These are their reefs, no doubt of that. Jealous of their fishing prerogatives, the islanders seldom permit outsiders to visit this very private domain.

The wealth we have seen here and in other remote areas such as Belize's Lighthouse Reef or the Red Sea's Jackson Reef exemplifies the natural reef state. When we go into the sea near population centers or resorts and encounter relatively impoverished marine life, we are often seeing the effects of human activity ranging from pollution to various forms of fishing. It is only in areas such as Astrolabe that we encounter the sea's largesse as it has been over eons.

When I am in a place such as Astrolabe, where the sun sets over low-lying, palm-silhouetted islands, I sense that I am apart from the modern world not only in space, but in time as well. There are no jet contrails in the empty, serene sky; there are no sounds of traffic. The world clock could have been turned back a hundred or a thousand years and I would never even realize it.

The yellow-lip sea snake (*Laticaudia colubrina*) of Fiji.

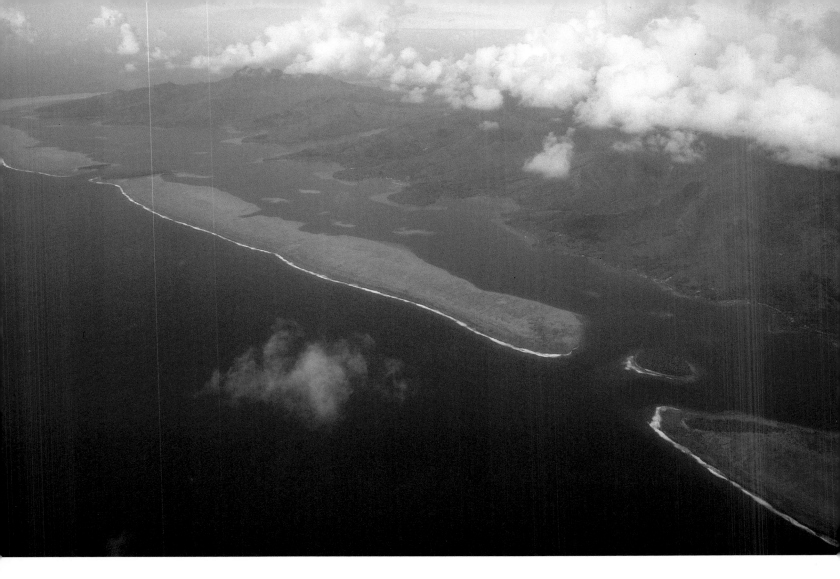

This aerial view shows the outer reef and passes of the large island of Mooréa.

The gentle calm of a reef motu, or small island, lures picnickers (Huahiné).

French Polynesia

This far-flung complex of coral reefs and volcanic islands is among the most romanticized in all the world. While thought of today as thoroughly French, French Polynesia was discovered by the English sea captain Samuel Wallis in 1767. The French explorer Louis de Bougainville claimed them for France a year later. Captain James Cook visited the islands in 1770, 1773, and 1777, and one of his lieutenants, the disciplinarian William Bligh, was overthrown here by history's most notorious mutiny in 1788.

Throughout the late eighteenth and early nineteenth centuries, the British and French contested the islands until the French finally seized them in 1843. In the following years the Polynesians, like most of the world's island peoples, were devastated by disease against which they had no immunity.

Today the islands are a color-drenched cliché of tropical beauty. In the Society Islands, the high, mountainous paradises most tourists see, there are lush, greenery-choked valleys and tall, cloud-wreathed peaks. The Society Islands include the large islands of Tahiti and Mooréa (the Windward Islands), and Huahiné, Raiatéa, Tahaa, and the ultimately enchanting Bora-Bora (the Leeward Islands). Other island groups here are the Tubuais, grassy islands rich in coconuts, taro, and coffee; the mountainous Marquesas, home of the original Hawaiians; and the Tuamotu Archipelago, a chain of huge atolls marking the sunken graves of ancient volcanoes.

◀ Deepwater gorgonians at the mouth of the tunnel at Rainbow Reef, Fiji.

An aggressive moray eel (*Gymnothorax favagineus*) (Tahaa, French Polynesia).

A blackbar soldierfish (*Myripristis*) hangs motionless in a crevice.

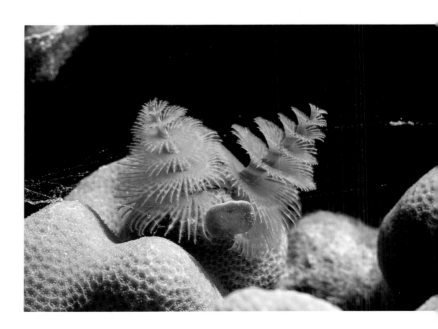

Mucus filaments drape the feeding arms of the serpulid worm (*Spirobranchus gigantius*).

The orange pufferfish
(*Arothron nigropunctatus*).

A golden goatfish (*Parupeneus cyclostomus*) showing the delicate barbels it uses to stir food from the sandy bottom (Vanua Levu, Fiji).

The undersea world of French Polynesia varies greatly. The coral growth on the fringing reefs of the high Windward Islands is dense but not terribly interesting to divers. The corals are extremely low-growing, often failing to reach an elevation of even one foot from the reef mass. Excessive freshwater runoff from the high mountains may explain this underdevelopment. In remaining squat the corals may be protecting themselves against violent waves during storms, and it is also possible that the island masses may block food-bearing currents from reaching these areas. Because the reefs are unimpressive, sailing and sight-seeing in the mountainous islands far surpass the diving in excitement. In fact, the best-developed coral colonies in the Society Islands are found in the quiet, sheltered lagoons where the corals' delicate branches are protected against breakage during rough weather.

In the Tuamotu Archipelago things are rather different. There are no central high mountains, merely empty lagoons in vast circular atolls. The highest points of land on the tiny atoll islands (called motus) are only six feet above the water's surface. The reef corals, while still low-growing, are far more massive, often forming huge tabular structures six to twelve feet in diameter. Here it seems likely that the coral's squat growth is in fact an evolutionary response to intermittent violent wave action; the food supply, plankton, is quite rich, and branching corals are found in the protected lagoons. Also, in the absence of central volcanic masses rain runoff is clearly not a major influence.

Interestingly, the fish life on these rather two-dimensional reefs is surprisingly dense. It seems that the low-growing coral thicket still offers good protection against predators, for swarms of Achilles tangs (*Acanthurus achilles*), masked butterflyfish (*Chaetodon lunula*), soldierfish (*Myripristis*), and parrotfish (*Scarus*) move across the sculptured terrain. The schools of tangs are so thoroughly unconcerned that they flock about us, as if totally tame.

The reef shallows here (as in the similarly formed Maldives) are quite narrow; from the exposed motus to the outer precipice may be a mere hundred feet. These long, narrow marine gardens are thus very close to deep water and

its wandering predators, and it is therefore no surprise that frequently during our dives a swift gray shark or huge manta ray will soar in from the deeps, encounter us, then almost casually disappear back into the immense blue of inner space.

The most famous marine features of the atoll called Rangiroa are its two passes, which allow the daily movement of colossal amounts of tidal water. We've often taken a speedboat into a pass, leaped with our equipment into the racing waters, and let the current carry us a mile or more. The deep channel bottom is scoured and barren, but is surprisingly punctuated here and there by low-growing coral heads. The rich fish life here tends to concentrate on the shallower side walls of these ever-turbulent passages.

The most impressive local characters are the resident sharks, which frequent the passes in enormous numbers. Two of my associates made extensive observations of this shark population in 1967 and estimated that as many as fifteen hundred gray sharks (*Carcharhinus amblyrhynchos*) would be in the pass at a given time. They array themselves against the sides of the coral chasm facing the current and merely hold their positions, a living wall of potential action. When divers sweep through at the several-knot pace of the tidal rip, the sharks do not attack, perhaps simply dismissing the humans as tidal flotsam. However, if one uses the scattered coral heads or crevices to anchor oneself, then spears one or more fish, the mood is altered radically. The grays become agitated, racing in short, rocket-like rushes toward the stimulus. Ten or more may charge in very quickly, posing an instant and mortal threat to the spearfisherman. One of my friends' standard jokes about diving here involves an imaginary machismo contest: each contestant spears a fish, stuffs the carcass in his trunks, and swims across the pass. Anyone who gets to the other side wins.

This is a coral kingdom of rare above-water beauty and selective undersea riches, a region that requires specific knowledge (or assistance) to experience its very real submarine treasures. When one does find those special enclaves of profuse life, they challenge the best in all the other kingdoms, and reward the knowledgeable explorer with wonders he or she may never have witnessed before.

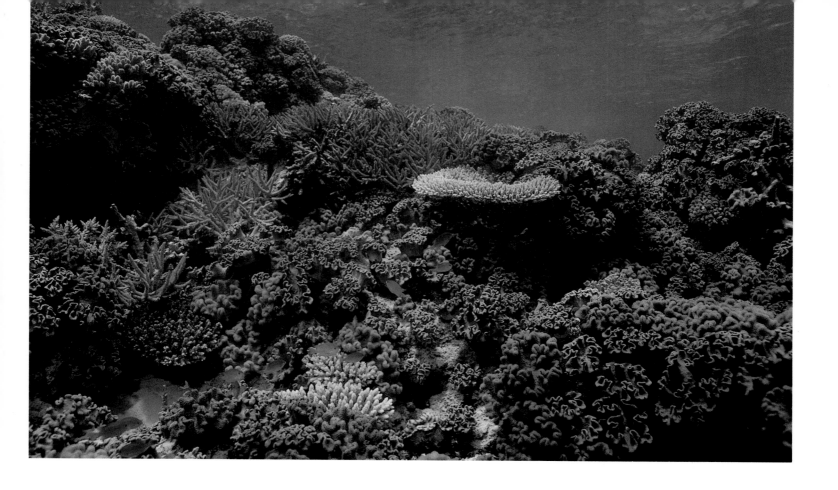

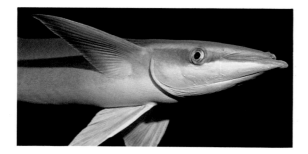

▲ This is an overview of a field of low-growing sturdy coral typical of the best Polynesian reefs (Rangiroa).

◀ A remora (*Echineus naucrates*) looks for a new host in open water near the drop-off (Rangiroa).

▼ A reef white-tip shark (*Triaenodon obesus*) prowls near the northern pass into Rangiroa Lagoon.

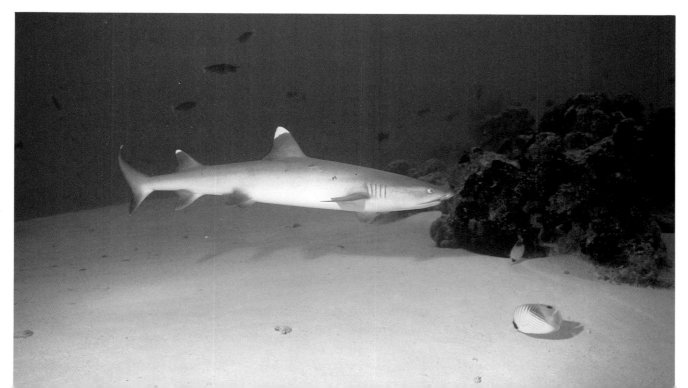

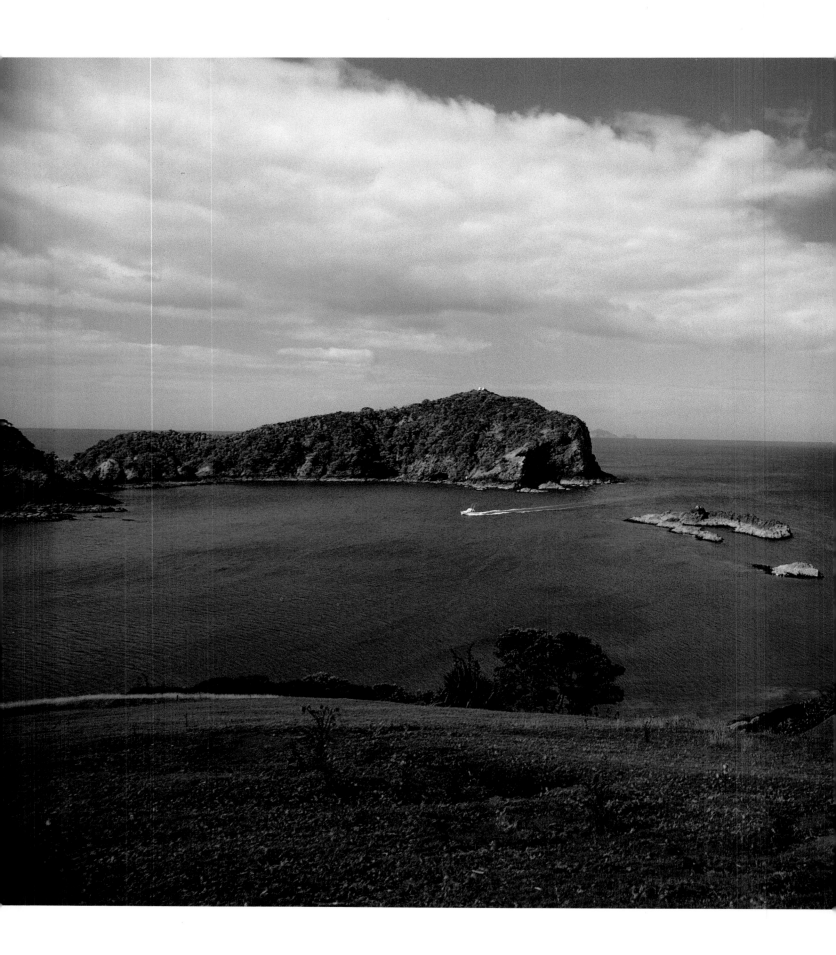

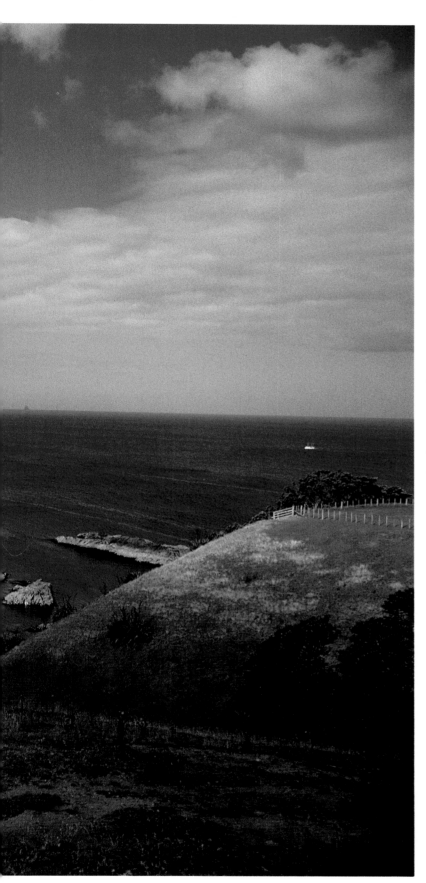

Chapter Seven
To the Limits of the Far Pacific

For our final adventures in the sea we journey to the farthest reaches of the immense Pacific basin. In this last great coral kingdom we discover that the seas still have some heady surprises to offer: marine communities in environments rather different from those we have seen before.

As I cross the oceans with modern ease, I experience conflicting sensations. While we have found ways to race across the seas, our island destinations are often as they were centuries ago, when adventurers such as Captain Cook first came upon them. For example, while Cook required two years to complete his voyage to Australia, I have made twelve trips there in only eight years. Yet, when I am anchored off a deserted reef in Australia's Coral Sea, it seems that Cook might have just left for all the region has changed.

A fishing boat enters one of the countless bays of the coast of New Zealand. The Poor Knights are on the horizon directly behind the promontory, and the Hen and Chickens are out of sight to the left.

New Zealand

Far to the south of the palm-festooned trademark Pacific islands lies New Zealand, a land more reminiscent of Europe. There are scenic rocky bays, rolling miles of sheep-and-cattle-dotted green pastures, and (on South Island) high mountain lakes and glaciers—hardly "Pacific island" scenery by any measure we've applied thus far. The reason is clear when we look at a map: New Zealand lies below 35° south latitude in the cold regions to the south of Australia's Sydney and Melbourne, south even of Tasmania. South Island in particular lies directly in the howling band of latitude known as the Roaring Forties. No palm trees here—Antarctica is just across the water.

Yet the final strands of the tropical Pacific's coral-bearing currents have left their mark here. As the great Australian Current follows its gyre southward and then eastward from the Australian continental barrier, the last vestiges of tropical-larvae–bearing water lap about the northern tip of New Zealand before being borne away by the West Wind Drift. It is here in the chilled waters off Whangerei and Tutukaka in northern New Zealand that we find a rich and colorful fauna composed of both tropical and temperate species scattered almost randomly amid the unyielding basalt rock walls.

Along the scenic eastern coast north of Auckland rolling high meadows abruptly plunge into the cold green sea. This eroded coastline is a picturesque and enchanting series of high headlands and bays, which are for much of the year beset by harsh weather. The underwater terrain along the coast consists of oddly uninspiring rocky hillocks scoured by wave and weather. As one stands on a high headland looking out to sea, one spies a series of lonely sentinel rock islands in the distance. When Captain Cook first came upon these remote, isolated rocky masses he named the northernmost group the Poor Knights. The island group south of the Knights could have only been given the name it bears today—the Hen and Chickens—for that is exactly what it resembles.

The waters about all these islands fairly boil with fish life. We have passed half-mile-long patches of churning water created by the action of countless schooling fish here. The upwelling of nutrient-laden deep water around the islands is due to their position on the edge of the continental shelf.

In the open sea between these remote outposts I have followed whales as they made breathing appearances at intervals as long as ten minutes. In these nutrient-rich waters the whales seemed to contentedly browse through great deep pastures of sea, ignoring our pathetic attempts to anticipate each appearance and position our boat for a closer look. You have never been totally ignored until one of these leviathans has ignored you.

The islands are two-hundred-feet-high sheer-walled masses of gray-black rock, garlanded at their peaks with intense but low-growing sturdy greenery, which softens the harsh spires. Several species of birds and shrubs are endemic here, the product of a biological isolation that in many ways mimics that of the far-off Galápagos. The Poor Knights, for example, host endemic tropical butterflyfish in water of a bone-chilling 50° F.

The tall cliffs have been carved by the relentless seas into wondrous sculptures. In the Poor Knights there are three rock arches through which we easily piloted our forty-two-foot dive boat; there was ample room for a much larger vessel. There is also a cave so large that we took the boat in and spent the night there to avoid expected bad weather. This vaulted cavern had to be at least eighty to one hundred feet high and two hundred feet across at the waterline.

Where the soaring volcanic rock faces plunge into the cold water an explosion of life occurs. Rolling meadows of waist-high bull kelp grow along many of the walls, the waves keeping the sinuous plants in constant motion. Parting the leafy tops of the kelp, we see the flexible stalks and holdfasts attached to the rock beneath. Marine life abounds on this sheltered rock; shy slipper lobsters, slithering moray eels of all sizes, shrimp, sea urchins, nudibranchs, and a host of other creatures carpet this ocean version of a forest floor. Canopied by the kelp fields, these wary creatures live out their lives sheltered from open-water predators.

Other rock walls are inexplicably free of kelp, the stony surfaces open to our view. Here burst clusters of strawberry corals and solitary cup corals in an intense rainbow of pulsing colors. Some are rose-red, others pink or violet, still others, canary yellow. Some of these corals shine in shallow

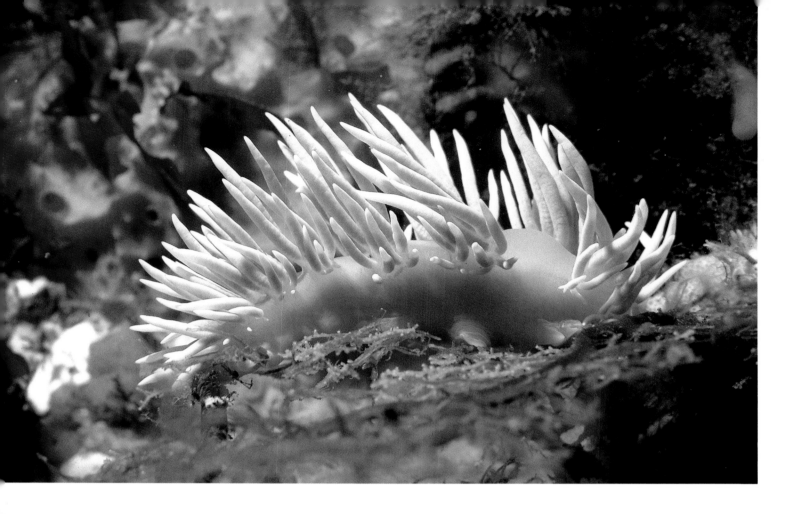

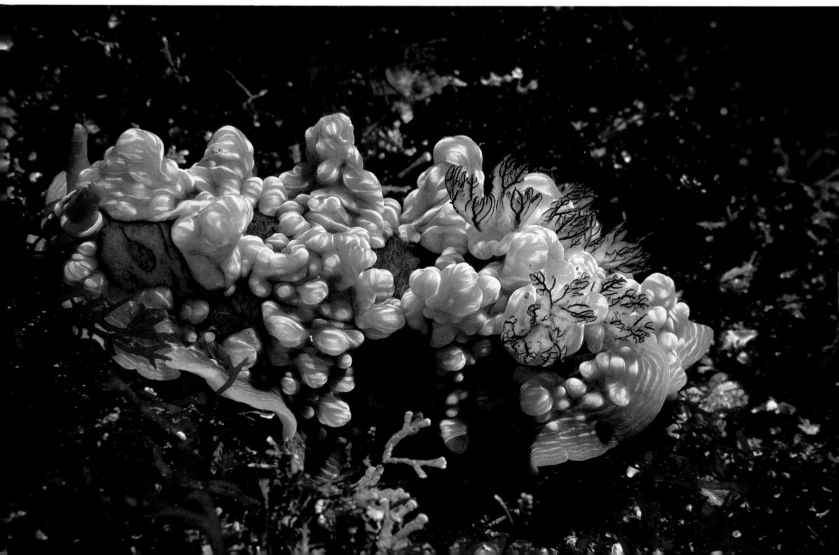

◀ These two scorpionfish (*Scorpaenodes cardinalis*) lie motionless awaiting unwary prey. The scarlet color phase may possibly be an adaptation to make the fish nearly invisible in the dark shadows where I found it. ▶

water of fifteen to twenty feet, while others bloom on deep, shadowed walls 120 feet or more from the surface.

In certain dark crevices the exploring diver will come face to face with the two-foot-long scorpionfish (*Scorpaenodes*) of New Zealand. These thoroughly imposing predators lie motionless as the stone around them, awaiting small, surge-tossed fish to swallow up. One species occurs in a brilliant scarlet, which looks black in the color-filtered water.

Moray eels occur in the open here more often than in any other coral kingdom I've explored. Unlike Caribbean morays, for example, usually seen with only their heads visible,

This brilliantly hued snapper (*Verreo oxycephalus*) is known locally as the pigfish. It is extremely curious and follows divers around, perhaps searching for the food we dislodge.

the eels here move along the angular planes of the algaed rock with utter unconcern. Sometimes two or three of these sinuous prowlers are visible in a small open area, busily searching for food or their next resting-place. At the approach of a group of divers, they will coil in preparation for attack and eye us coldly. These lightning-fast, well-armed eels would give a fierce account of themselves in any form of close-quarter combat.

On several occasions I've opened sea urchins to see whether the wrasses, pigfish, and other swirling fish would come to feed. Invariably, the fishes' frenzied dining is well in progress when a lightning bolt of moray eel appears from nowhere. The eel causes all the fish to scatter then buries its head in the urchin shell until it finishes eating the entire meal. Sometimes two or even three morays come together in such a feeding orgy. While they are extremely aggressive toward other species, they extend every courtesy to their own kind.

In open water mill unimaginable numbers of fish. Mullets and anchovies, groupers and wrasses swarm everywhere. The water is simply filled with masses, with schools, of fish. These schools form moving and shifting walls of bodies, and when your eyes pierce the nearest wall you see that there is another beyond it. Sometimes these thick schools of fish even pass through each other, individuals unerringly holding their proper places in their own formation.

Some of the species are gaily decorated, the equal in adornment of any tropical reef-dweller. One of these is the gaudy yellow-striped mado (*Atypichthys strigatus*), which is very active, swirling amid schools of pesky painted parrotfish (*Coris sandageri*). On deeper walls and crevices we discover the incomparable pink mau-mau (*Caprodon longimanus*), which morphologically appears to be a distant relative of the creolefish (*Paranthias*) of the eastern Pacific and Caribbean.

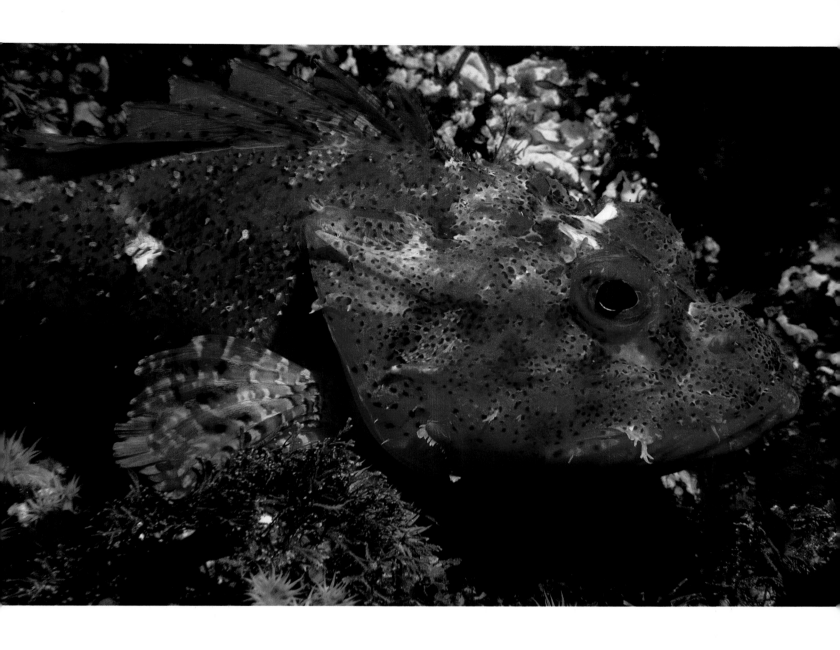

The curious mado (*Atypichthys strigatus*) swirls about us looking for tidbits.

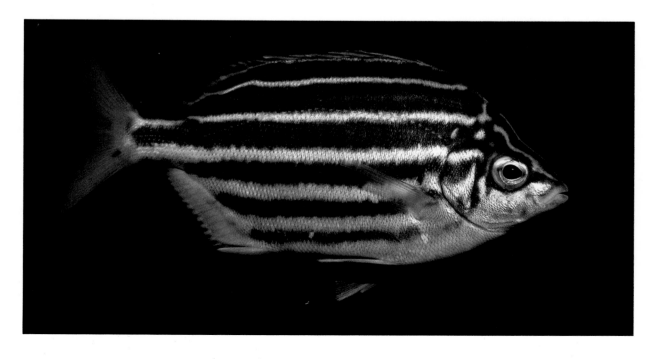

The mau-mau (*Caprodon longimanus*) is clad in an iridescent pink that stands out against the surrounding dark water.

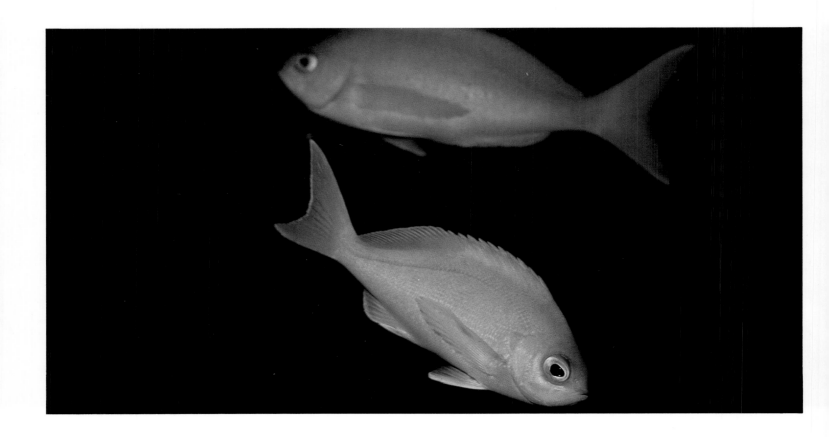

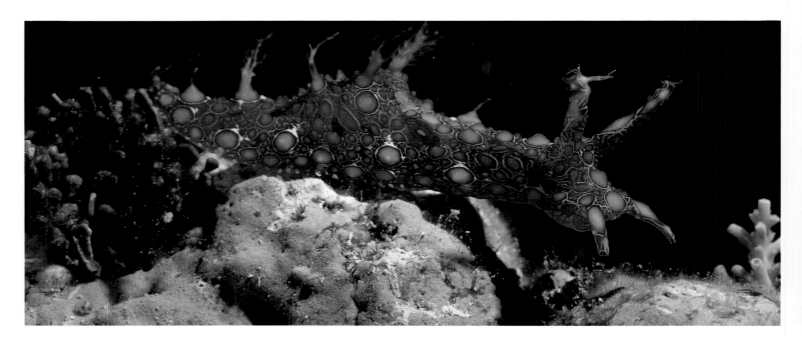

This is the Angas sea hare (*Dactylomela angasi*), a bizarre-looking nudibranch that browses on algae.

A golden soft coral (*Dendronephthya*) adorns the reef wall of Gadji Pass.

A spectacular golden finger coral on which individual polyps are clearly visible.

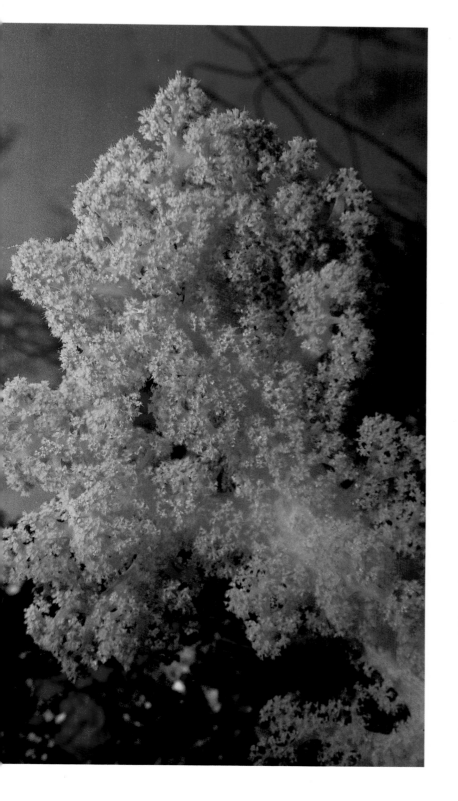

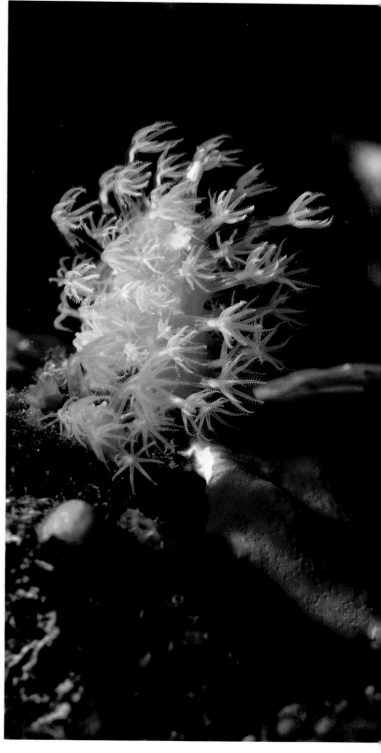

New Caledonia

Named by Captain Cook for the similar hills of his native Scotland in 1774, New Caledonia is one of the most favored islands of the Pacific. Its high central mountains are rich in cobalt, nickel, iron, manganese, and chrome, and the yacht basin in Noumea ("The Paris of the Pacific") is filled with the impressive luxury boats of the "nickel millionaires." There is a certain air in Noumea of studied elegance and grandness, which understandably led to this sun-bright city's nickname. The western slopes of the central range are a series of nobly rounded hills and valleys carpeted with a white-barked gum tree called *niaouli*. Sometimes in the half-light of late afternoon the trees resemble a population of ghosts with upraised hands, perhaps the restless spirits of the thousands of Melanesians who perished in the harsh years following the French annexation of the island. For the French this island paradise was a useful mining outpost and penal colony, which became noted for its repressive brutality.

From these mountains and from the air, we see that the entire coast is bordered with a broad reef mass reaching from one to five miles out to sea. The relatively young mountains of the reefs have undergone little subsidence as yet, and the broad lagoons of the far future have not yet formed. The proximity of the mountainous land with its associated rain runoff makes the water around this main fringing reef very turbid, and much of the coral has been snuffed out. For this reason divers seek out better conditions on smaller islands and reefs some distance from New Caledonia proper.

Thirty miles southeast of the main island ridge lies the tiny island of Kunie, also known as Ile des Pins, or the Isle of Pines. The pines in question are ramrod-straight spires of green, jutting regally from the tropical shrubbery that carpets the island. The larger pines, evolved from a species imported long ago from Australia, reach heights of 150 feet or more. Immediately off the shores of the island the diving is rather weak: broad, rolling shallows of current-carved stone with sparse coral cover. Those visitors who visit the lone hotel are often taken by small speedboat to these local reefs, and their impression of New Caledonia's diving suffers as a result.

It is unfortunately true that not all reefs are good reefs. Any locale may have nearby reefs both splendid and dreadful. Many visitors say, "Ah, but if I go out diving with a local I'll get to see the best reefs." Not necessarily. For several reasons, visiting divers anywhere in the world often miss the best diving of their chosen destinations. I know islands where the local guides simply have been too busy to go out and explore for better areas, and so for years have routinely taken visitors to mediocre reefs known chiefly for their convenient location near the hotels.

In other cases, the local guides know precisely where the great reefs are, but don't want to spend the time—or the fuel—to take visitors to them. The Isle of Pines is such a place; the really good diving is perhaps an hour-and-a-half boat trip from the hotel. Consequently, few visitors ever get to see it.

These great reefs are those of the remote, massive Gadji

Pass. Gadji is the main access for tidal water flowing into the huge shallow lagoon surrounding the island. Countless millions of gallons of water roar through the pass four times each day. As in such places as Tahiti and the Maldives, much of the vertical wall lining the pass is scoured clean of life. There is a difference here, however. Seismic activity has created immense cracks in the wall slicing far into the limestone reef mass. Marine life that cannot establish a foothold on the barren, turbulence-carved walls of the pass flourishes in the eerie calm of the crevices. I have struggled hand over hand in a raging current to reach a crack, then enjoyed a completely relaxed, easy dive in that still, protected water.

In the crevices huge orange gorgonians reach out to feed, while soft corals scatter pinks and yellows on the irregular stone surface. Discreet tropical fish slip gracefully from one protective coral overhang to another, telling the human visitor that he or she is not the only large predator to have prowled into this preternatural stillness. Indeed, if one goes to the open end of the crevice and looks out into the dark, clear torrent in the pass, shadowy sharks can be seen on every side.

Looking upward to the surface, we can see debris being swept by. When we return to the shallow coral gardens above, this racing water sweeps us to our dive boat with no exertion at all. Indeed, if we're not careful it will sweep us right past, and onward into the lagoon.

As spectacular as this experience is, the most unusual dive of the island lies inland from these sun-splashed coral reefs in the forest of the Isle of Pines. In a tall, quiet glade we will

Upon accidentally encountering each other during their slow feeding process, these flatworms shared what was an obviously procreational interlude. This swaying dance of courtship was pursued for an hour, at the end of which I was so cold I no longer cared whether their *amour* was blessed with success or not.

dive one hundred feet under the floor of this greenery in a vast underground cave. After parking the van and donning our dive gear we clamber through a hole beneath a tall tree; inside, the opening widens dramatically into the upper reaches of an enormous cavern. Its massive, dark emptiness is stabbed by huge white stalactites and stalagmites, and we only reach the floor by a narrow, winding, ramplike path around the perimeter.

Ninety feet beneath the trees, we turn on our lights, enter a shallow pool of crystal water, and swim through a hole in the wall barely large enough to pass a diver. Suddenly our lights stab out into utter darkness, and we are momentarily disoriented. Then, as in the outer cavern, the ghostly stalactites and stalagmites appear, like some engulfed petrified forest. For an enchanted half-hour we wander among this vale of sunken statuary, whose closest parallel is Chandelier Cave in Palau. Both experiences draw on deeply etched legends and fears and shake our sun-shaped complacency. And both involve real risk, it is important to note. The floors of these caverns are deeply overlain with fine silt. The incautious or clumsy diver who kicks up this murk does so at his or her very real peril, for in turbid conditions one may never find the tiny exit passage.

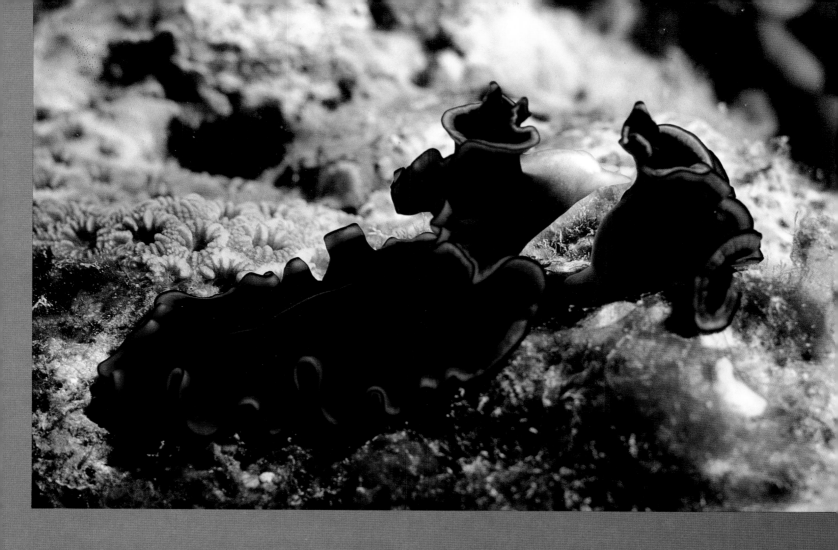

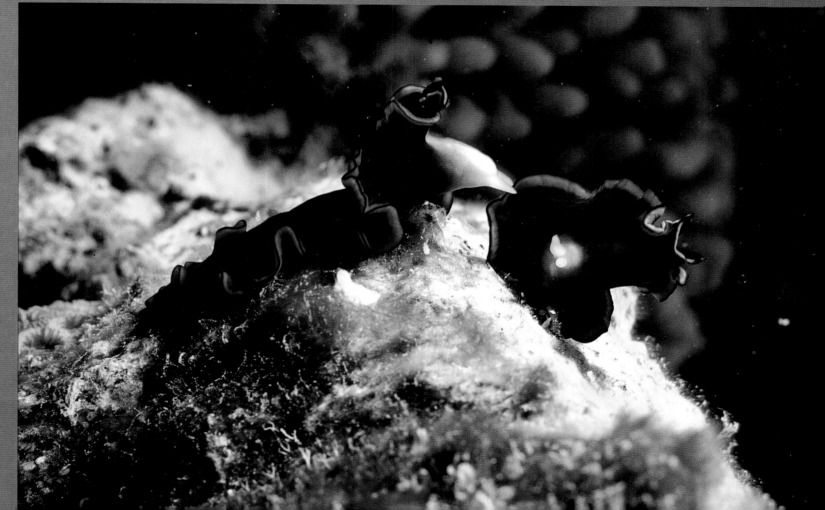

Vanuatu

Northeast of New Caledonia lie the "Islands of Coral and Ashes," the former New Hebrides, now known in their independence as Vanuatu. These are geologically young volcanoes, five of which are still active. In this strongly charged tectonic zone, earthquakes are frequent, often occurring several times each day. They are so common an event that no one here even looks up curiously when the power lines hum from the earth's vibrations. The blue waters around the greenery-dappled coral islands are often streaked with wind-blown volcanic pumice, slashes of gray-white that raise pure hell with the propellers of a dive boat.

Sharing a long, turbulent, blood-drenched history with so many other island groups, these peaceful outposts have seen much of the worst that civilization has to offer. The Spanish explorer Pedro de Queirós led the first wave of settlement in 1606, searching for the legendary "southern continent." His settlement was crushed by illness and disputes with the natives, beginning a long hiatus without European contact, which ended when Bougainville rediscovered the islands and claimed them for France in 1768.

In 1825 an Irishman discovered sandalwood (whose oil is used to make perfume) on the islands. Soon, escaped felons, pirates, and smugglers overran the populace in a destructive rush to procure the wood for the European market. Later, missionaries brought an epidemic of measles, which brought death to thousands of Melanesians; the islanders rose up in wrath and slew their erstwhile leaders.

"Blackbirding"—slavery—took many natives in bondage to distant plantations and made further inroads in the native population. Only in 1886 (and later made formal by treaty in 1906) did a joint French-British rule bring reasonable stability and an end to these horrors.

During the Second World War the New Hebrides island of Espíritu Santo became one of the largest and most important American bases in the Pacific. Warplanes and ships from Espíritu Santo were crucial to turning back the Japanese forces in the Solomons and New Guinea, foiling a planned invasion of Australia.

Today, in the green waters of the harbor near Luganville, two great reminders of the war allow divers a brief glimpse into those closed chapters of history. One is an undersea avalanche of military equipment—trucks, jeeps, bulldozers, and other machinery. They were purposely run off the beach and into the water when, at war's end, the British and French bid nothing for them thinking the Americans would leave them anyway. The American commander left what is a glorious monument to greed and its proper reward, now covered with crinoids and corals.

A mile or so closer to town, there used to be a permanent oil slick rising from the grave of the SS *President Coolidge*. The *Coolidge*, a grand relic of the glory days of pre-war society, had been converted for use as a troopship in 1942; in December of that year she hit two mines in the Luganville Channel. What really caused the *Coolidge* to go astray into our own minefield is shrouded in secrecy. It is known that four thousand marines and two thousand sailors scrambled down her listing sides to safety after the captain purposely rammed the sinking ship onto the reef outside town. The reef held her afloat long enough for the torrent of humanity to reach safety; then the great liner slowly slipped backward off the reef into the deep channel.

There she remains today, a ghostly leviathan from a lost age. Her bow rests at a depth of eighty feet, her stern more than 350 feet from the rippled surface of the green water. The effect is epic, tragic and chilling.

The *Coolidge* lies on her port side, the gaping eyes of her empty bridge staring sightlessly forward. Behind the bridge, great gun turrets yawn, guns at awkward, dead angles. Her davits are overgrown with *Dendrophyllia*, the somber-hued green tree coral, and patches of burnt-orange encrusted sponge.

In 1978 salvagers managed to recover ten thousand gallons of fuel oil from the ship's tanks, and a modern cruise ship spent some days at sea consuming this ghostly fuel. Did its passengers know that their voyage was a gift from the sea, that part of the ill-fated *Coolidge* had risen again?

For me this gloomy sunken colossus will always echo to the long-dead music of her prewar passengers, the pampered and beautiful who neither knew nor would particularly care that the platform for their revelry became a drowned victim.

The bow gun of the SS *President Coolidge* points forever out into the darkness of an empty sea.

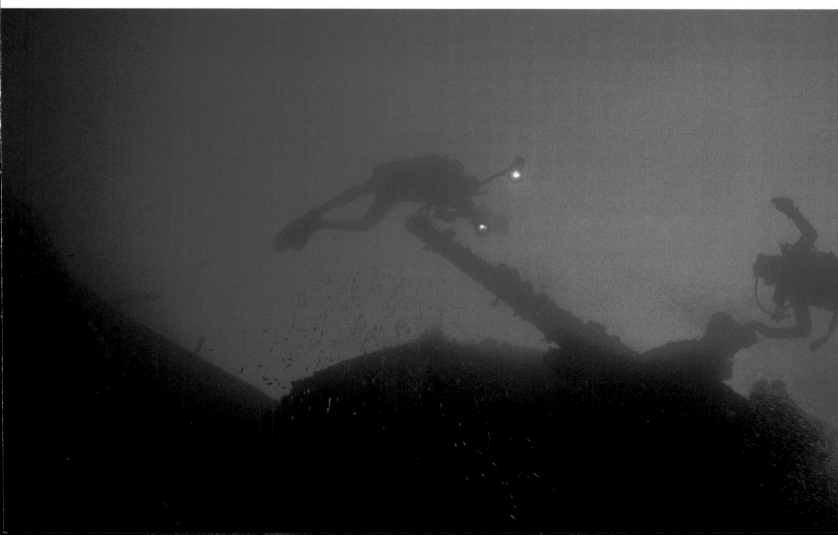

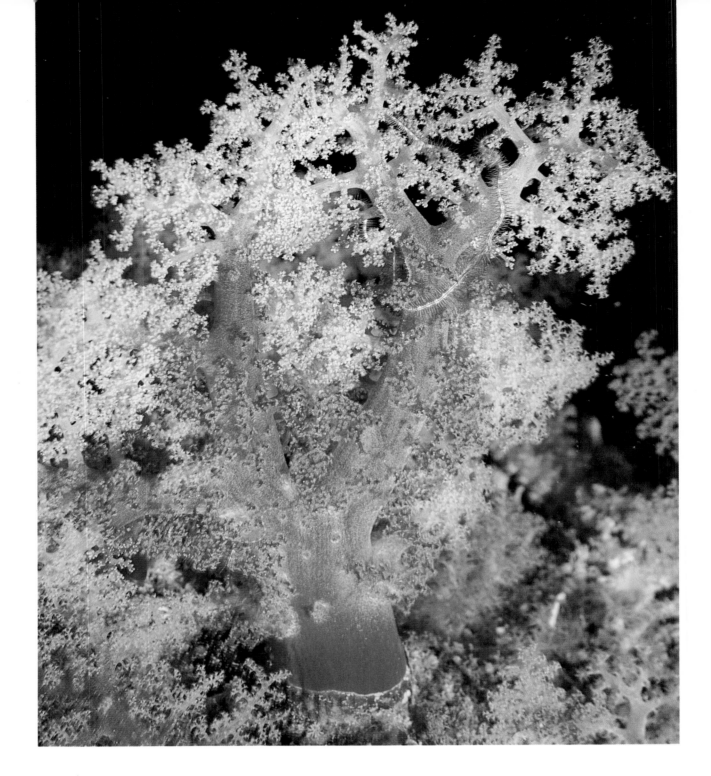

In the eerie darkness our hand lights vaguely illuminate metal that once gleamed in the sunlight. What once impressed the crowds now is ignored even by passing fish—of which there are many.

An active marine community has covered the ship with a living skin. Small anemones and coral colonies, soft corals, nudibranchs, crabs, and lobsters are everywhere, scattered about her generally algae-green surface. In the stillness of her dank holds, groupers, lionfish, and a hundred other stealthy hunters drift from darkness to darkness.

This special mood of the *Coolidge* is as fresh in my mind as the day I first dived her. Like a castle in a childhood legend, she is somehow intensely moving to me. Unlike coral reefs, which after some years tend to merge in one's mind, the memory of the *Coolidge* is so vivid that it will rerun in my mind's eye forever. When her great silhouette rose above me and blotted out the light, it left an impression I will never forget.

▲ A brittle starfish entwines itself among the branches of a soft coral colony.

The Great White Sharks of South Australia

In midsummer the restlessly churning waters of the Roaring Forties south of the Australian continent become briefly still. It is a time when the chill of morning dissipates by nine, and the toughened crews of the tuna fleet peel off their shirts and look skyward while the big tuna clippers thunder toward the sea through fluttering fleets of sailboats.

It was along this coast in 1802 that Captain Matthew Flinders reported the waters filled with great numbers of a terrifying gray-and-white shark. These sharks had claimed one of Flinders's longboats and its entire crew, men whose names now grace scattered offshore islands here.

The cold green waters of South Australia offer the perfect environment for the form of secret hunt particular to the great white sharks. A great white shark (*Carcharodon carcharias*) is one of the stealthiest stalkers in the entire animal kingdom. For all its massive size, it has the uncanny ability to be upon you before you know it is there, even when your every sense is attuned to detecting its approach.

The particulars of its life demonstrate the value of its stealth, for this secretive animal hunts such alert and swift prey as sea lions, porpoises, rays, whales, and turtles. For this massive animal—a hunting white shark is ten to twenty-five feet in length and weighs one to five tons—to be a master of the ambush is astonishing; its lethal skills are honed in ways that make the hair rise on the nape of one's neck. Even though all of the animals the white shark preys on are shy and move quickly away at the first hint of danger, the great fish are very successful predators. Recent research in California has shown that as many as half of the male elephant seals and weaned pups in a rookery are killed or wounded in a single season by the sharks, making them the limiting factor in population growth among these pinnipeds.

Having experienced a personal version of this lethal hunt, I have the greatest awe and respect for the unique talents of the majestic shark known as the White Death. In the chilled, murky water off Dangerous Reef (about fifteen miles from Port Lincoln) I've shivered in shark cages, waiting for the shadowy sharks to appear. No matter how hard I've strained to see them, the sharks always managed to come in on me unseen, from behind. Their great, looping passes were completely random and unpredictable; they seemed never to repeat the same maneuver. Sometimes they would sweep in just beneath the surface, other times appear abruptly directly beneath my feet.

It is their ability to hunt in turbid water that distinguishes the great whites as threats to divers. The other sharks we see are adapted to hunting disabled prey in clear water and are no threat, but the great whites take healthy prey of human or larger size in waters whose murkiness cloaks the predators' approach.

On a recent expedition we were working a particularly sassy eleven-footer. He had already eaten several twenty-pound chunks of bait when I finally slipped into a floating cage through its entry right at the surface. As I quickly turned to have one of the boat crew hand me my camera, the crewman yelled, "Watch out!" Instinctively, I grabbed the camera and ducked down into the enclosure. At that moment the shark's bulk rammed right over the top of the cage, where I had been an instant before. Its huge body pushed the cage down and slammed the entry hatch. The shark gave me a good thrashing before it dislodged itself and swam away.

On another occasion a large white shark managed to get its long, torpedo nose through the viewing window we use to shoot our pictures. The next thing I knew, the shark's nose was pushing my camera into my chest and pinning me against the back wall of the cage. Fortunately for me the viewing ports are framed with angle iron rather than the wire mesh of the cage body, or the bait might not have been the only thing consumed that day.

After a few such incidents, one develops an extraordinary respect for this unique predator. When it soars past your cage, you feel the intense scrutiny of those flat black discs of eyes; when two divers are in the cage, each will swear that the shark looked only at him or her.

On one expedition I became interested in getting a shark's reaction to the sight of a diver separated from a cage, even though diving without a cage in these waters would be pure madness. We had come to the conclusion that the sharks perceive the cages and their occupants as a monolithic mass; while they appeared very curious about us, they never charged the cage to get in. Instead, they would bump the

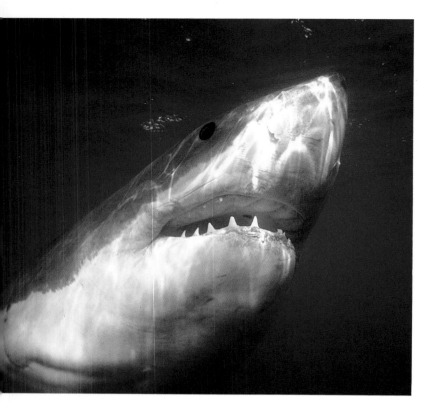

With supreme self-confidence a white shark swims within touching distance.

A fifteen-foot great white shark approaches the cage. At moments like this the cage seems very fragile indeed.

cage with their noses or nibble on its corners. During my interlude with the hyperactive eleven-footer, I took several opportunities to open the large side door of the cage so that the shark could discern me as an individual. On each occasion, the shark immediately turned and made directly for me. It left no question in my mind that outside the cage I would have instantly been attacked. Yet inside the cage we were perceived by that tiny brain as merely an indecipherable oddness in the huge cube and never became a focus of its lethal intentions.

During my most recent expedition we encountered two very patient great whites that stayed with us for twelve hours. Time after time they would engulf the bait, poke their noses into the viewing ports of our cages, and lash the water into white foam when a roped chunk of meat resisted their efforts.

These extraordinarily efficient predators, these stealthy shadows in the sea, have been the stuff of sailors' nightmares throughout history. Yet they are among the most savagely beautiful of all sea creatures. Awe, terror, sinister grace, and ineffable beauty are all elements of their effect on us. In our feeling for these predators, we share in a real way the fear and respect that the sharks' natural prey must experience on some level. It is a tie between humans and marine animals unlike any other I know.

Today in the cold green waters off South Australia, just as in Flinders's time two centuries ago, there is a steel-gray monarch with deadly black discs for eyes that maintains its ultimate rule of the sea. I can't wait until the next time we meet.

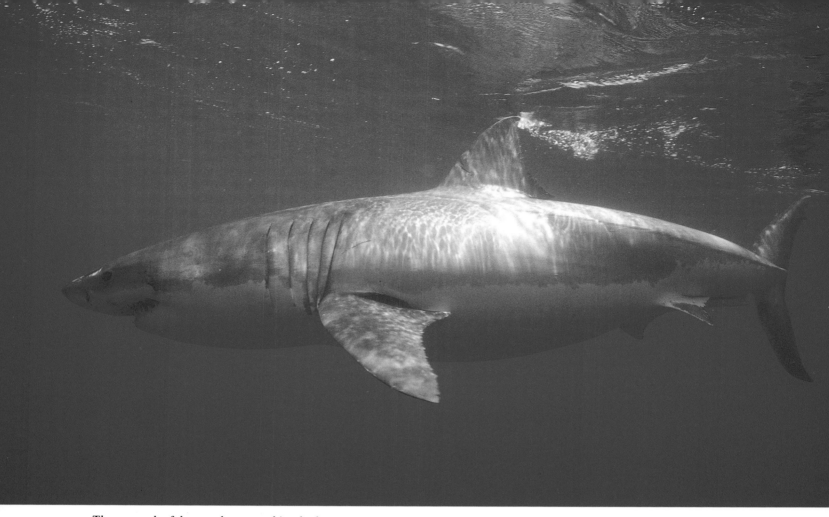

The monarch of the sea, the great white shark.

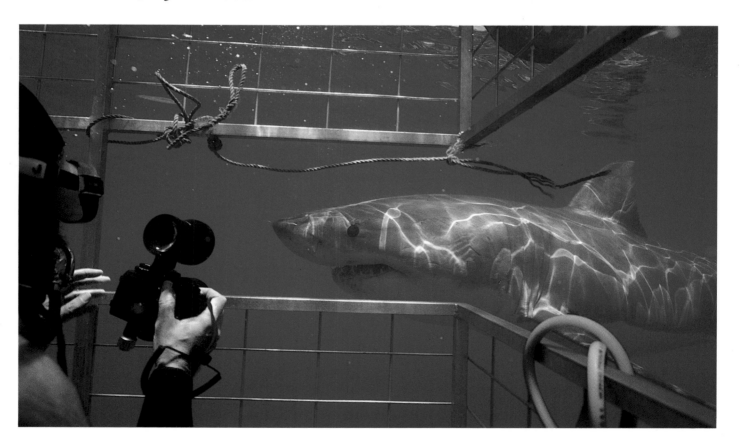

No creature in the sea possesses the awe-
some power and single-minded ferocity
of an aroused great white shark.

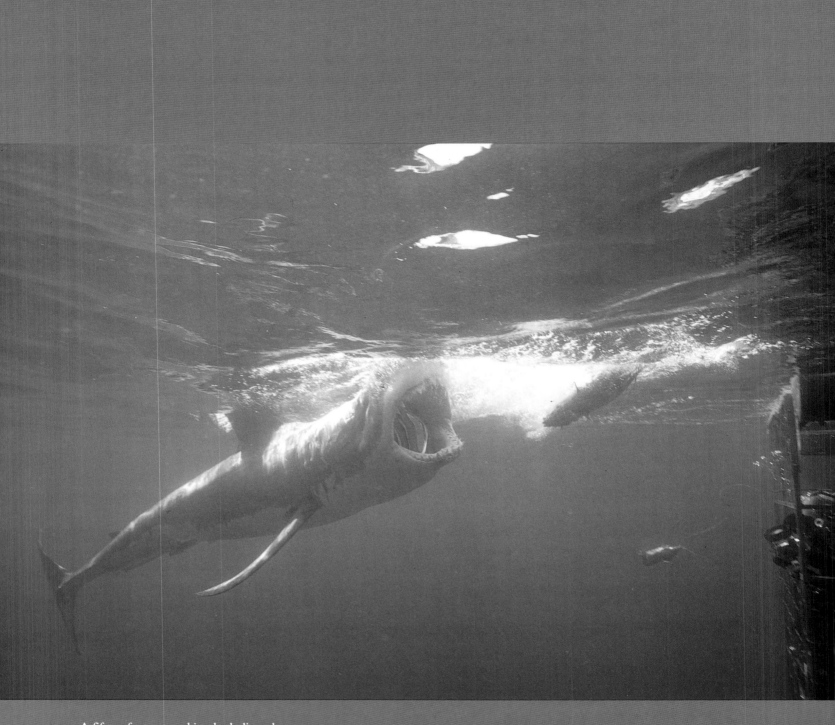

A fifteen-foot great white shark distends
its body until we can see right through its
gills. That maw can engulf an entire sea
lion (Dangerous Reef, South Australia).

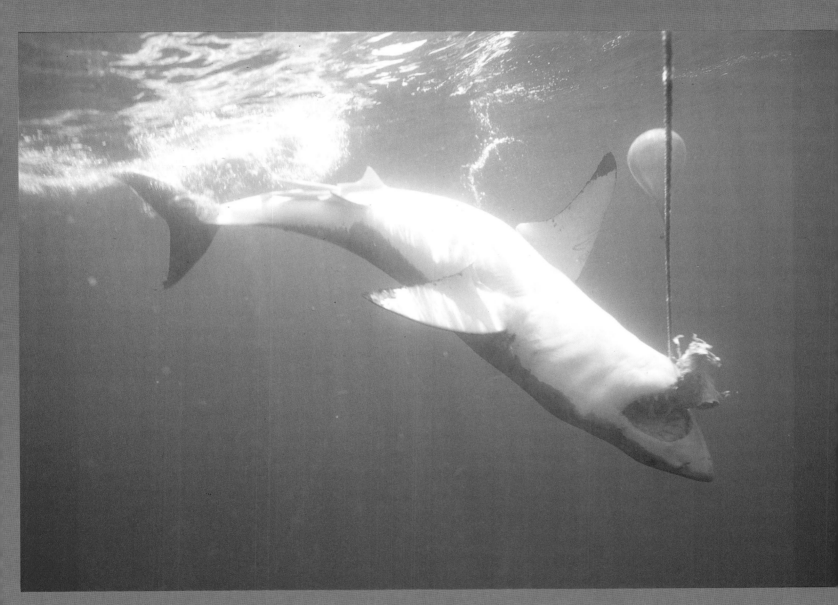

In the frenzy of feeding, a great white shark will attack from any angle (Dangerous Reef, South Australia).

Australia's Tropical Coral Sea

There is hardly a contrast in all the coral kingdoms to rival that between the white shark's domain and the starkly clear waters of the Coral Sea off Australia's northeastern coast. Where the waters off South Australia are chilled by the West Wind Drift, the sea off Queensland is bathed in tropical warmth by the electric-blue water from the South Equatorial Current.

There is a great deal of confusion about the diving of the Great Barrier Reef and that of the Coral Sea. Many divers have been misled by the long-published fame of the Great Barrier Reef and have an image of crystal-clear water and exquisite reefs just off the coast. The truth is rather different. To begin with the Great Barrier Reef system is a honeycomb of islands and reefs up to a hundred miles wide on an underlying platform less than one hundred feet beneath the surface. This extraordinarily complicated system acts as an intricate baffle through which tidal water restlessly churns. The fact is this reef is actually immersed in moving waters filled with stirred-up silt and larvae, with lateral visibility often restricted to fifty to seventy feet.

To make matters worse, many of the coral structures of the Great Barrier Reef are so mature that they lie at or so near the surface that the water above them reaches elevated temperatures that often inhibit further growth. Many areas are filled with rather drab limestone skeletons overlain with algae, only occasionally punctuated with colorful, still-living corals.

I've taken pains to describe the situation on the Great Barrier Reef because its reputation has caused an unfortunate confusion among divers. Many think that if they climb on an airplane and fly to Australia they are guaranteed to see the world's best diving. Given the costs involved in that trek, it is only fair that this point be made: some of the world's best diving lies in the open Coral Sea one hundred miles beyond the outer limits of the Great Barrier Reef.

When I take people to the Coral Sea's oceanic reefs, we pass through the Great Barrier Reef, but often do not even pause to dive there. If we do stop it is at one of the only two Great Barrier Reef sites I have ever found worth diving.

The *Yongala* wreck off Townsville features great masses of marine life gathered together in peace, as at an African watering hole. Big groupers, sharks, rays, turtles, and snappers swim together in an unforgettable assemblage. Two hundred miles north, off Cairns, the Cod Hole can be found. It is particularly interesting as an assembly point for fifteen large groupers (*Epinephelus tauvina*) that divers can feed by hand. Other than these two sites, however, I've always found the Great Barrier Reef to be terribly disappointing.

So where are Australia's legendary reefs? Up to two hundred and fifty miles off the Queensland coast, in the form of seamounts and atolls rising from the depths of the open Coral Sea. Here, in the shimmering absolute clarity of tropical ocean water, pinnacles of pristine coral grope, gleaming, toward the sun. I have witnessed lateral visibility in excess of two hundred and fifty feet in these waters, which makes our diving more like the free soaring of eagles. I've sat on the bridge of a dive boat and watched the radar scan a fifty-mile-wide area of these incredibly remote reefs. Day after day, in all those hundreds of miles of sea and scattered reef, no trace of other humans could be spied.

This solitude and emptiness is another important factor in the richness of these Coral Sea reefs. Their distance from shore has offered protection from all but the most adventurous and lavishly equipped of fishermen. Consequently, one may sight Napoleon wrasses (*Cheilinus undulatus*) up to seven feet in length, or huge two-hundred-and-fifty-pound groupers (*Epinephelus tauvina*), which the Australians call "potato cod." There are wandering sharks of all kinds—grays (*Carcharhinus amblyrhynchos*), tigers (*Galeocerdo cuvieri*), nurse (*Nebrius concolor*), and the sleek silvertip (*Carcharhinus falciformis*).

The Coral Sea experience is one of amazing spaciousness, both above and beneath the achingly clear water. This particular quality is extremely difficult to render in photographs, precisely because of its dimension and scale. For example, as we approach Dart Reef, or one of the pinnacles at Flinders or Marion Reef, a vault of blue sky often untouched by cloud fills the universe above us. The sea, often glassy calm, stretches from empty horizon to empty horizon. Beneath the surface, as if in some Disney epic, a vast, not-quite-real city of gleaming coral towers gropes upward from the

Epinephelus tauvina, known locally as potato cod, fed from our hands within ten minutes of encountering divers for the very first time.

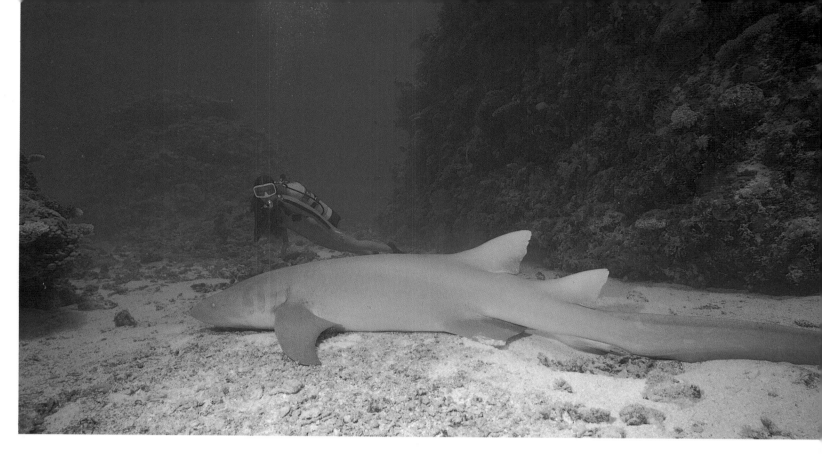

In a hidden valley we discovered a huge
nurse shark enjoying a nap.

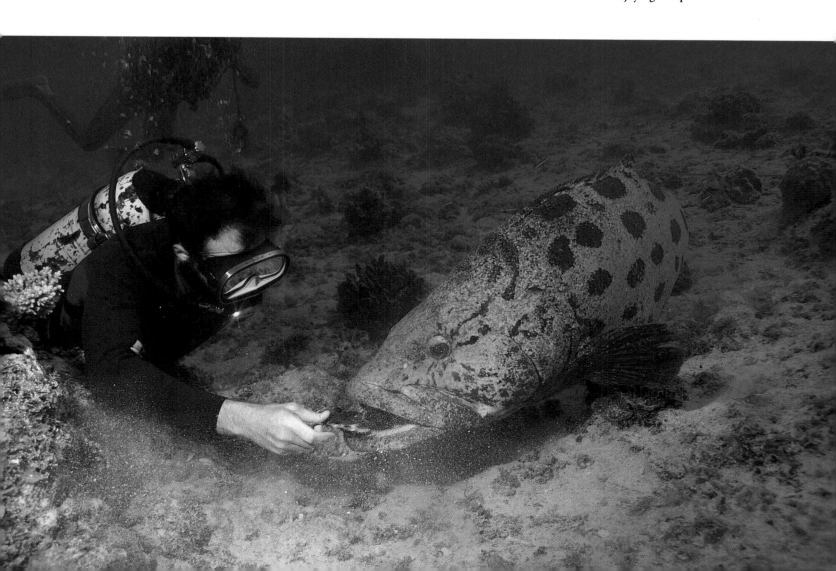

Sea lions are a staple of the white shark's diet. As many as half of the males and weaned pups may become victims of the stealthy sharks in a single season.

This cat shark (*Stegastoma tigrinum*) rose from its nap at the diver's approach and swept off into the blue.

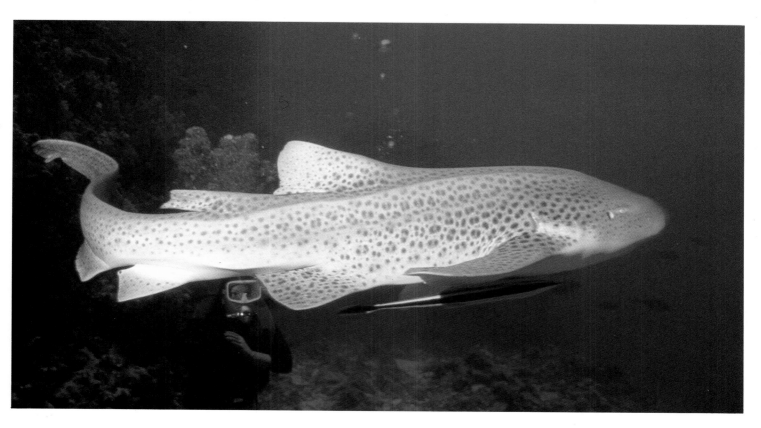

The swift gray sharks (*Carcharhinus amblyrhynchos*) of Action Point.

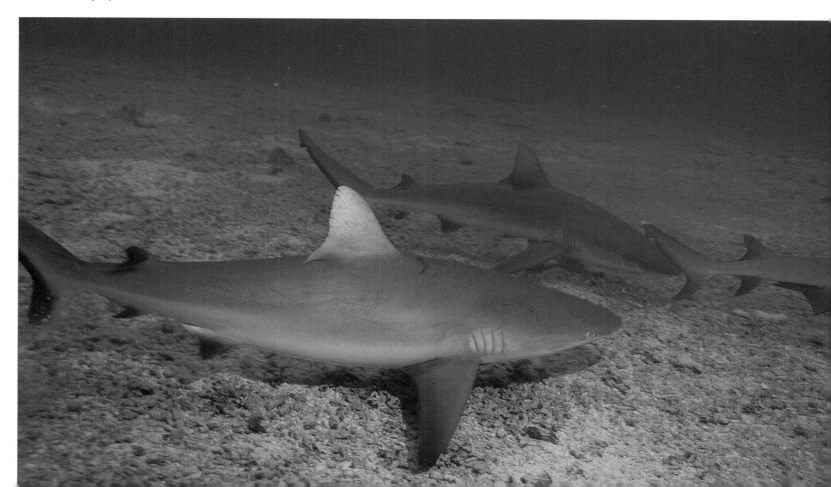

blue depths. The surface of these towers is a sculptured treasury of corals, many of which exhibit a canary-yellow coloration that shimmers brilliantly in the sunlight. Here and there amid the corals rests an immense anemone with purple-tipped tentacles, and curious, ever-fluttering clownfish dart from one part of the tentacle thicket to another.

Since the summits of these coral metropolises lie a mere ten feet beneath the surface, they are revealed in every exquisite glittering detail. The small nudibranchs, crabs, octopuses, and other browsing feeders can be quickly spotted, while the brightly colored tropical reef fish seem to etch themselves into the intense blue of the surrounding water. There are thin-plumed Moorish idols (*Zanclus canescens*), a plentiful variety of lushly decorated butterflyfish such as *Chaetodon ulietensis*, *C. ephippium*, *C. plebius*, and several others. Several species of angelfish, grunts, snappers, triggerfish, and wrasses crowd the reef tops, while damselfish and anchovies hover in schools above the coral ramparts.

One family of delicate and colorful reef-dwellers, the crinoids—feather starfish—reaches its fullest development here on these Coral Sea pinnacles. Sometimes occurring in colonies of hundreds, these intricate creatures display a rainbow of colors from scarlet to brown to green to canary yellow that all seem particularly vivid in the clear, sunlit waters.

Occasionally one will have a truly surprising encounter. One day I was photographing a clownfish and was stunned to hear it "barking" at me like a sub-miniature schnauzer. To experience this sort of oddity is a combination of luck in finding the special animal, combined with a certain alertness to its quirks of behavior. Such an observation is what makes every trip I take to the coral reef a wonderland of discovery.

If these scenes and these creatures were all one saw here, it would be spectacular diving, but these coral complexes with their cornucopia of life also attract some of the most dramatic of the open-water citizens from the surrounding sea. One will be photographing a soft coral or fish on the pinnacle and suddenly spy a majestic solitary tuna soaring in from the open blue. I've had these big bullets sweep within a few feet of me, their saucer eyes registering my presence with royal disdain.

Often the visitor from the deeps isn't a tuna, but rather a sleek shark. These clear waters are undoubtedly the world's finest arena for sharks and divers to meet. There is a very prolific carcharhinid population in the Coral Sea; I can't remember ever making a dive there without spying at least one of these graceful predators. On many dives we will encounter as many as five to ten, making their endless rounds on the reef.

In waters that are this clear, shark encounters are exhilarating rather than frightening. The sharks are easily seen and their intentions measured at a reasonable distance. Indeed, my most common complaint is that I can't entice them in close enough for photographs—in the clear water they can assess me from what *they* obviously consider a proper relative position.

In order to get close-up pictures I am thus driven to feed the sharks to bring them in. There is one area known fondly as Action Point at Marion Reef where I've fed the resident population several times; on the most notable occasion (which I described in *The Underwater Wilderness*), the feeding almost led to my demise in a pack of aroused gray sharks.

In that incident I fed the sharks in the morning and, assuming that by mid-afternoon they would have calmed down, I re-entered the water. To my horror I was quickly greeted by an inverted funnel of twenty-five gray sharks with Roessler-steaks on the menu. I spent several anxious minutes bashing noses with my large camera rigs before I could reach the reef mass. It was one of the few times I've been happy that my underwater camera housings weigh thirty pounds.

The primary lesson I learned in that nearly final encounter was that a feeding ends any further diving in the area that day. While it is reasonably routine to take ten divers into the water at Action Point to demonstrate feeding, once we've finished we move the boat to another site several miles away. It was re-entering the water after a luncheon break that precipitated the attack in 1974.

On a recent shark-feeding we were treated to a vivid demonstration of the slashing competitiveness of the shark pack during a meal. The boat captain and I were standing on a sandy bottom at seventy feet, with several divers behind us on a rocky platform. First we got the sharks interested with some tidbits from a bag of fish scraps we had brought from the boat. After a few bites the sharks were making fairly fast passes, and we decided it was time for the pièce de résistance, some live bait.

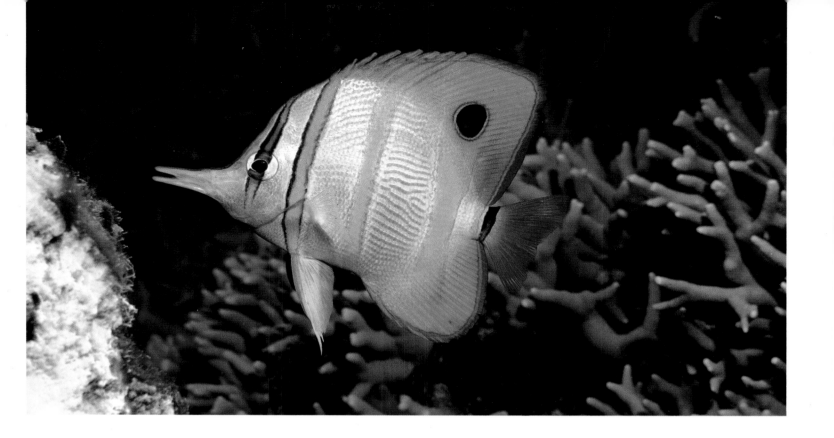

An octopus preens atop a shallow reef top (Marion Reef, Coral Sea).

Many soft corals in the Coral Sea feature this extraordinary canary-yellow coloration.

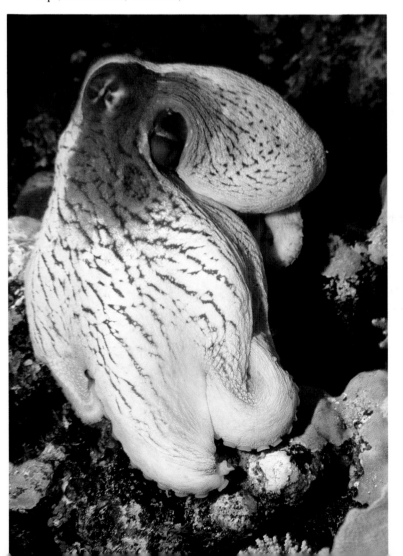

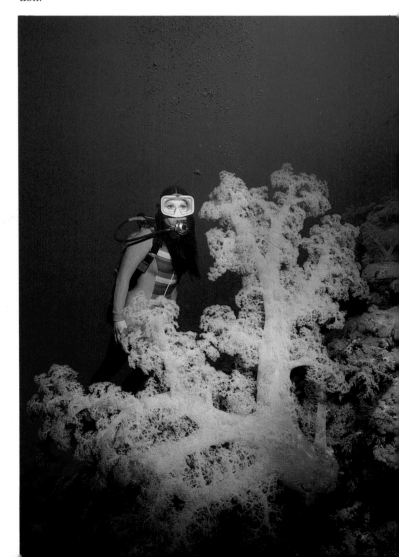

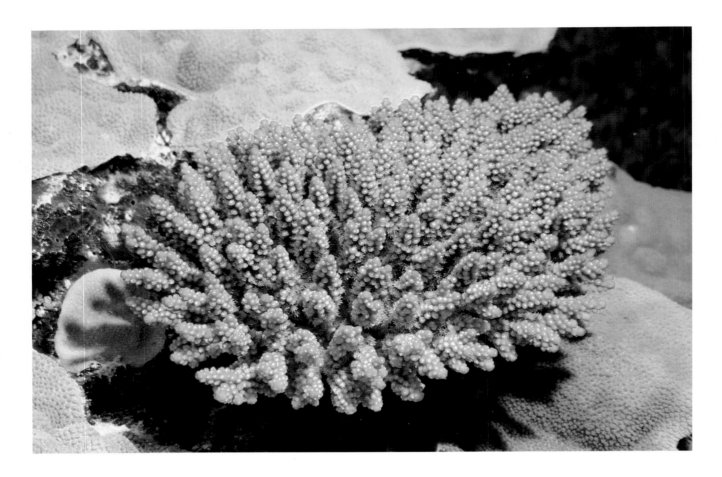

▲ At Marion Reef even the stony corals adopt bright colors, pink and yellow being quite common. Individual coral polyps can be clearly seen.

A pair of beaded nudibranchs (*Phyllidia bourguini*) on the delicate pink coral *Acropora*. ▼

The poison-armed tentacles of this *Stoichactis* anemone leech the color from the skin of a captured grouper. The touch of the anemone means swift death to the fish. ▶

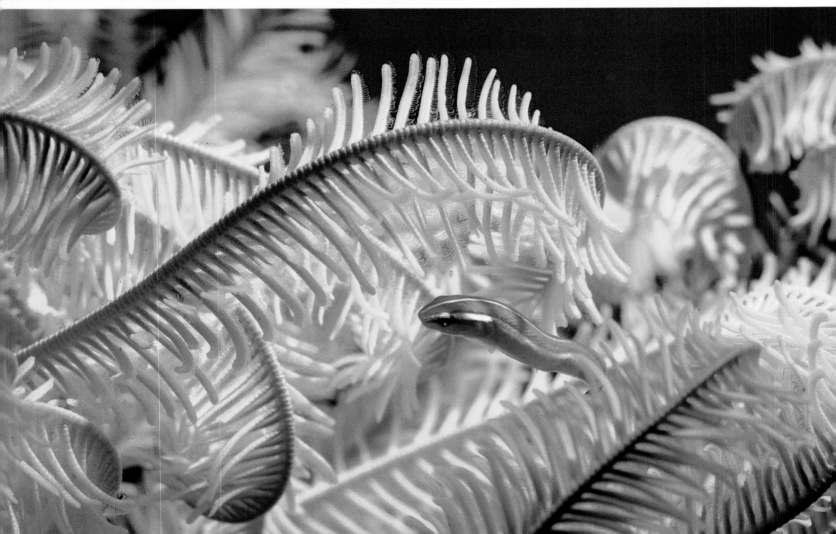

This aggressive but extremely suspicious clown triggerfish (*Balistoides conspicillum*) is one of the most gaudily decorated of all reef fish.

Most divers never realize that hosts of tiny symbionts live within the sheltering arms of crinoids. Clingfish (*Lepadichthys lineatus*) are the only fish in the sea with necks, having specially adapted vertebrae that enable them to raise, lower, and turn their heads from side to side. Clingfish take on the color of their host crinoids.

An elegantly designed Moorish idol (*Zanclus cornutus*) sweeps across a reef top (Coral Sea, Australia).

A sweetlip wandered up, and with regret we speared it. At the sound of the speargun firing, the sharks began rocketing in all directions looking for the meal they knew it promised. We held the fish up for them to see.

From separate directions three sharks bulleted in to take the fish. They attacked simultaneously, wrenching the fish free of the spear. None would relinquish its hold on the fish, so we were treated to a whirling dervish of sharks thrashing about, each trying to wrest the prize from its competitors. For a few seconds the action was furious; then two sharks bit great chunks free and swam off, leaving the third to disappear into the distance with the mauled carcass in its mouth. This type of incident has two very different effects on the observer. One, as might be expected, is to instill a very healthy respect for the predatory skills that have gone unchallenged for hundreds of millions of years. The second, however, is that once you've seen a shark frenzy for yourself, it somehow loses some of its terrifying aura.

Most of our divers have returned from these Coral Sea fastnesses with just a bit less mindless fear of sharks, and at the same time they tend to be properly appreciative of the terrible gray beauty of these masterful creatures.

By no coincidence, a similar process takes place with the sea snakes. Seeing these paddle-tailed wraiths of certain Coral Sea reefs is one of the unique thrills of diving these remote waters. There are several species, ranging from the rather delicate dark-blue *Aipysurus duboisii*, to the plentiful olive sea snake (*Aipysurus laevis*), to the rare and beautiful beaded sea snake (*Astrotia stokesii*). These marine cousins of terrestrial cobras range in length from perhaps two to more than six feet. In the particular locales where they are found at all they occur in extraordinary numbers.

The snakes have a fearsome reputation because their venom is in many cases far more potent than that of their terrestrial relatives. After the venom is injected into prey (usually a small fish sleeping in a crevice), the snake withdraws its slender, fragile jaws until the poison stops the victim's struggles. The prey is subsequently swallowed whole and digested in part by the powerful venom.

Most of our divers have heard of the snakes the same way they learned of sex in the schoolyard—lots of distortion and half-truth leading to deeply ingrained fear. This is never so clear as on the occasions when we arrive at our first dive site after a pleasant evening of cruising. Everyone races out from the breakfast table as we drop anchor; the pristine morning air is filled with shouts about who's going to be first into the water. Then the snakes, perhaps half a dozen, disturbed by the noisy anchor chain, pop to the surface and look around at us.

Abruptly, everyone decides that another cup of coffee (or two or three) is really what they want.

All this terror is unnecessary. These graceful air-breathers are under normal circumstances completely harmless to the diver. To begin with they generally hunt by night and lie about in languid sleep during the day. Their normal prey is tiny fish, and they only bite if cornered or pinioned by the fearsome bulk of a diver. Most will actually allow themselves to be picked up and handled, though after a few minutes they may lose interest and swim away.

There are, however, a sizable number that are wildly curious about divers and their equipment. We have come to understand that many of these snakes are totally fascinated with the gleaming clear glass of camera ports or face masks and also enjoy playing in the wash of the divers' swim fins. Their curiosity sometimes completely undoes the object of their interest, the diver making his or her first Coral Sea dive. Having these sinuous bodies wrap around your legs or tongue the faceplate of your mask is usually not fun, at least not the first time. But after a week, the divers' fear has invariably dwindled to utter boredom, and they totally ignore the snakes that so terrorized them only days earlier. *Sic transit gloria.*

In leaving this most pristine and healthy of all the coral kingdoms, we have reached a fitting climax to our world-wide travels. As the sun sets over the Australian mainland far below our horizon, or, as we cruise beneath a night sky filled with the splendor of a thousand mighty stars, we are treated to the most wonderfully private of sensations.

No matter that tomorrow a Taiwanese fishing boat may wander past, lonely derelict of a hungry world. In these moments in the stillness of twilight or midnight on glass-calm, virgin waters, the soul exults: *This sea is mine*.

On a sunset-seared horizon a tiny freighter plods its way across the South China Sea.

Conclusion

After a journey such as ours to the most distant and isolated of coral kingdoms, it would be comforting to draw up a set of coherent inferences concerning their future. It would be particularly satisfying if our observations could lead us to a uniformly hopeful outlook for the future of these tropical enclaves.

Yet the real message, like that from a battleground, is difficult to interpret. There are contradictory bulletins alternating between hope and despair. My own peregrinations of twenty years have seen the fall (and possible hint of rebirth) of Cozumel; oily wastes smother the reef life of Curaçao; the effects of dynamiting on the reefs of Colombia and the Philippines; Taiwanese and Koreans stealthily poaching *Tridacna* clams from Australia's Great Barrier Reef; a tropics-wide hunt for jewelry-quality black and red corals; and Jamaican fishtraps unselectively capturing the reef's most colorful denizens. Many other divers could duplicate or add to my endless litany of individual, corporate, and governmental havoc on the reefs.

Try to realize the threat of snuffing out the coral kingdoms by leafing back through these pages. Try to visualize coral reefs without the gentle butterflyfish, the clever octopus, the sassy triggerfish and damselfish, without even the exotic soft corals like jewels of iridescent rose, pink, or yellow.

For me the threat to the seas is a personal matter because their inhabitants are my friends, acquired over many years of close encounters. If my pictures and narrative of them at work and play will rouse those with the power to save them, I will have performed an invaluable service; if not, works such as this will be their cenotaph.

The longshoreman-philosopher Eric Hoffer once observed that we may judge a civilization by its capacity for maintenance. My travels in the Third World have often reminded me of that insight. But there is another measure by which our civilization may be judged: the final test may be how we conserve our planet's finite resources, of which our reefs and seas are a crucial component.

The world's coral kingdoms are triumphs of nature's cosmic design, the products of a process of selection through eons of the fittest, strongest, and most adaptive of marine species. These are the hardiest of history's oceanic experiments, yet they may not survive. One need only review the history of the Mediterranean Sea over the past half-century to realize just how quickly the wounds to an ocean become deadly. This oldest of the world's settled seas is also one of its smallest. The feeding, bathing, and industrializing of the dense urban populations along its northern and eastern coasts have swept it nearly clean of fish and left many coastal bays uninviting, if not dangerous, to swimmers. Ironically, it was the first sea to lure scuba divers, yet I could not include it in this book because its diving areas have been rendered wastelands. No one wanted the Mediterranean to die, but the damage it has sustained has proven fatal.

It is very difficult for the casual observer to detect the dying of an ocean or a coral reef. Indeed, I have observed in many of the coral kingdoms that coral reefs are self-repairing and wonderfully self-renewing. Given the slightest respite after sustaining damage, they will restore themselves to health and balance. The process of dying is a long, losing struggle to repair individual wounds—a sewer outfall here, a polluted river there, an oil spill, a sunken chemical barge, a fleet of boats with nets sweeping away the baitfish. It's like observing a dam that is springing small leaks; no single hole looks dangerous, yet one day the dam, weakened in so many areas, simply collapses.

As I have tried through the years to discover who is to blame for the damages to the seas, I've noted an amazing diffusion of responsibility. You cannot go out and find anyone who is intent upon destroying the sea. You can hardly even find anyone who considers him- or herself part of the problem. Fishing boat captain, industrialist, spearfisherman, tropical island official—they all feel what they do is no threat to the reefs. How can this be? The damage is obviously being done, someone out there is doing it. Who *are* the villains?

Nature's bounty flourishes where man does not destroy.

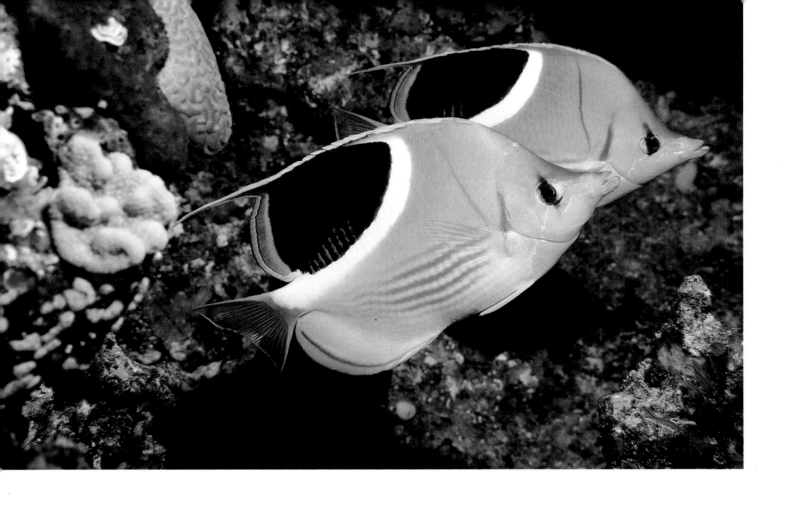

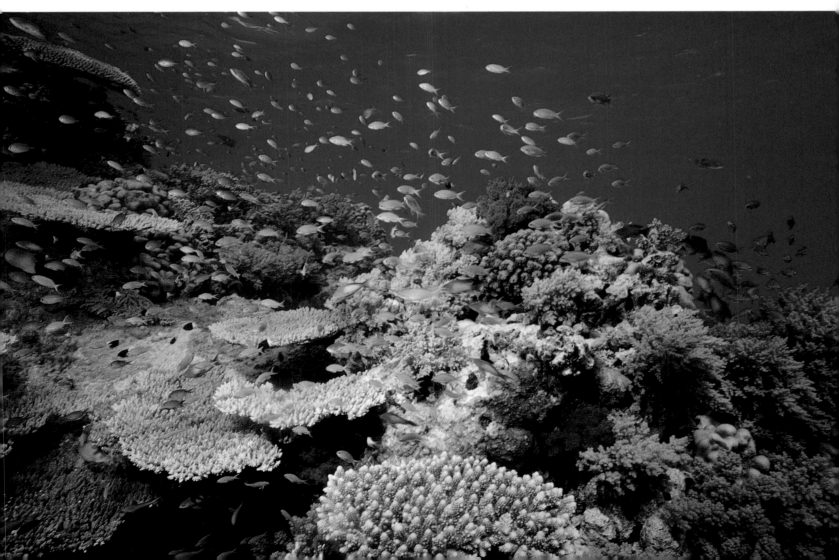

As I pondered the question at the heart of the reefs' destiny, I chanced upon the work of a biologist named Garrett Hardin. For the first time I saw an intriguing theoretical framework that squared with the facts as I had seen them all over the world. For me Hardin's insights and perceptions were like a sudden light in a long-closed room. Unfortunately, his theories are steeped in controversy because they lead to some politically unpalatable conclusions.

The fundamental insight central to his essay "Tragedy of the Commons" (1968) is a Rosetta stone in translating what I have seen. If the problem is to identify the villains when it seems that no one is purposely doing harm, the solution is to identify a behavioral or philosophical system that makes this paradox inevitable. Hardin has done just this, building upon concepts first formulated by the nineteenth-century mathematician William Lloyd.

Hardin's provocative thesis revolves around herdsmen grazing their cattle on a hypothetical village commons. This commons has a carrying capacity of one hundred cattle, and in our example ten herdsmen each graze ten cows upon it.

Now, one is offered the opportunity to acquire an eleventh cow, increasing his personal wealth by 10 percent. As it is clearly in his personal immediate interest to add that cow to his holdings, despite the fact that it will slightly overload the commons, he makes the purchase. The same logic leads each herdsman using the commons to add another cow, and eventually even more. The final, predictable result is the total destruction of the limited grass of the commons by overgrazing, the death of all the cows, and the inevitable impoverishment of their owners.

Although each individual herder acted rationally, the consequence of all their actions taken together is the destruction of the commons. Hardin calls this situation the "tragedy of the commons" and goes on to a crucial proposition: in a crowded world, private property is superior to commons. Thus—considering the reverse of our example—if each herdsman personally owned a parcel of pastureland, overgrazing would be in direct conflict with his own interests, and so he would decide not to acquire the extra cow. In a town of privately owned pastureland, each herder would act responsibly, because if he made the wrong decision, he himself would suffer for it. By contrast—and this is in the very nature of any commons—in the original story no individual feels any responsibility for the land. Indeed, each prospers (at least briefly) by abusing it.

The obvious outgrowth of this thinking is that we consider the oceans of the world to be a commons and treat them accordingly. Most of us at one time or another have been guilty of the very actions we deplore: collecting some black coral for jewelry, spearing a fish, bringing home a prize cowrie or Triton trumpet shell for our coffee table. And so the waters of many of the coral kingdoms are routinely abused.

In recent years there have been repeated alarums sounded as prized fishing areas off Iceland, Ecuador, Canada, the United States, and northern Europe abruptly showed declining catches. The general response has been to improve the technology of the hunt, a response analogous to putting more cows on the commons. If the pressure on the commons is not reduced and it is not allowed to recover from these abuses, the system will collapse. This is as relevant to a village green as to the open ocean, the crowded shores of the Mediterranean, or a tropical reef.

But the situation is not uniformly grim. There is the occasional flicker of awareness, the move to save the sea before the momentum of destruction is irreversible. I take heart at seeing the new local (as well as national) marine preserves in the Philippines and numerous newly designated parks in America and Australia. I've been pleased to see the United States and other countries enforce prohibitions on the import of products made from sea turtles and other endangered species, and I've watched with hope as a new generation of American divers shoots fish with cameras rather than spearguns. I've been delighted to hear that new fishing techniques have spared the porpoises that would have been swept to their deaths in tuna nets a few years ago.

These positive signs are important because they offer renewed hope that a long history of neglect and thoughtless exploitation may be ending. It may be a bit premature, however, to rejoice at these developments, for there are immense new shadows on the horizon that could dwarf any threat the seas have ever known.

Embodying many facets of these new threats to the seas is the marathon series of negotiations leading to the Law of the

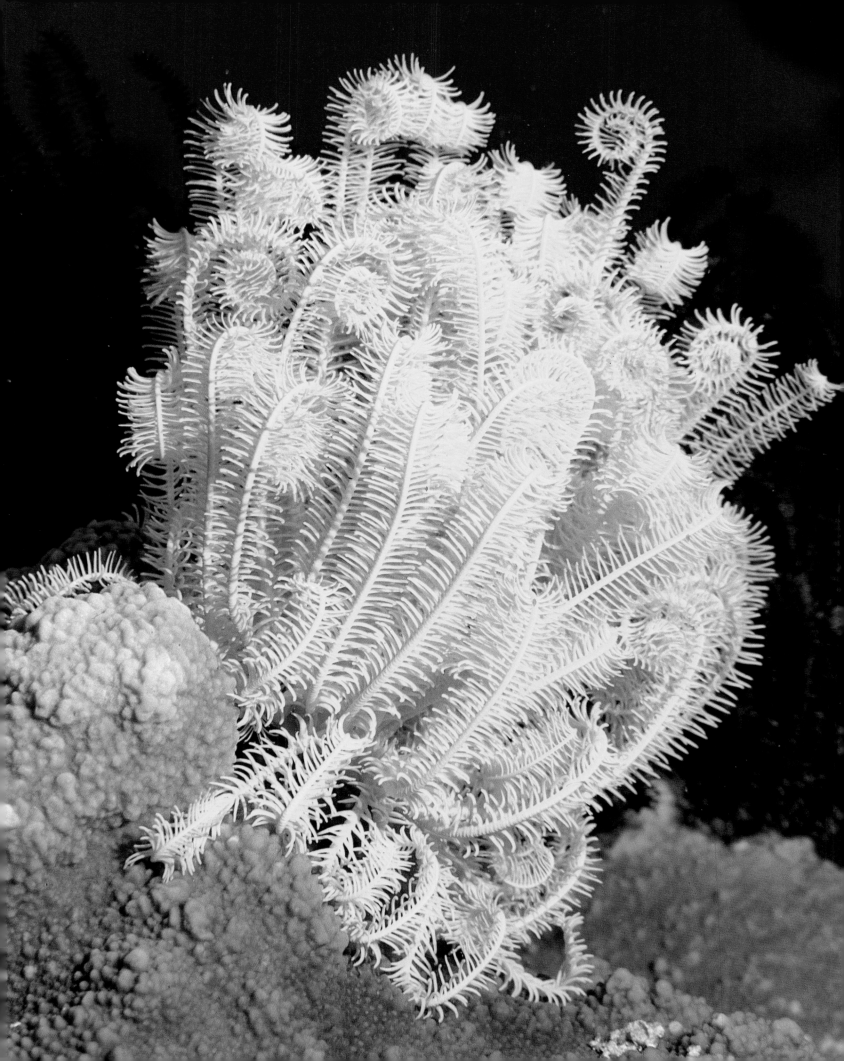

Sea treaty. The United States and other western nations are being asked to explore and develop the fish and mineral riches of the seas, so that in the future they can give the proceeds away to a throng of smaller, hungry nations—many of whom have not a mile of seacoast—*on the grounds that the oceans are a commons.*

The danger inherent in this theory is obvious. National greed is the engine that will drive the commons to destruction—the more nations that (at least initially) benefit from overzealous exploitation, the more certain is eventual depletion. Imagine the pressure generated by an entire congress of nations clamoring for the sea's wealth to feed their exploding populations. Such an environment will not foster conservative and responsible development. I have long believed that this negotiation is misguided and was pleased when the Reagan administration refused to sign such a flawed treaty.

I prefer to think that over the long term a system of vastly expanded national territorial waters will be developed, each jealously guarded against encroachment. That is to say, we should carve up the commons into separate areas for which each nation is individually responsible. If any nation exhausts its marine resources it will suffer the consequences just as it would if it exhausted its farmland. By the same token if a nation hasn't the ability to protect or develop its marine resources it could license the territorial protection and development to other countries for a return in money, fish, minerals, or all three.

The current drive toward a bureaucratic commons threatens to create a monster whose birth we shall surely live to regret. Instead, using Garrett Hardin's analogy, let's have all herders cherish and protect their own private sector of the former commons. Knowing the consequences of profligacy, nations as much as individuals may more carefully conserve the world's marine resources to the benefit of all.

The final hope of this volume is that the coral kingdoms have not already seen their greatest flowering. Will the very generation that was the first to see the beauty beneath the coral seas be the only generation to enjoy it? Not if individual and national senses of responsibility are heightened by abandoning the bankrupt and dangerous idea of the coral kingdoms as a commons.

Will these ideas be heard and accepted? Centuries from now will the coral kingdoms flash and swirl with living color for the generations that are to follow?

As in so many critical issues of our time, each of our voices will count.

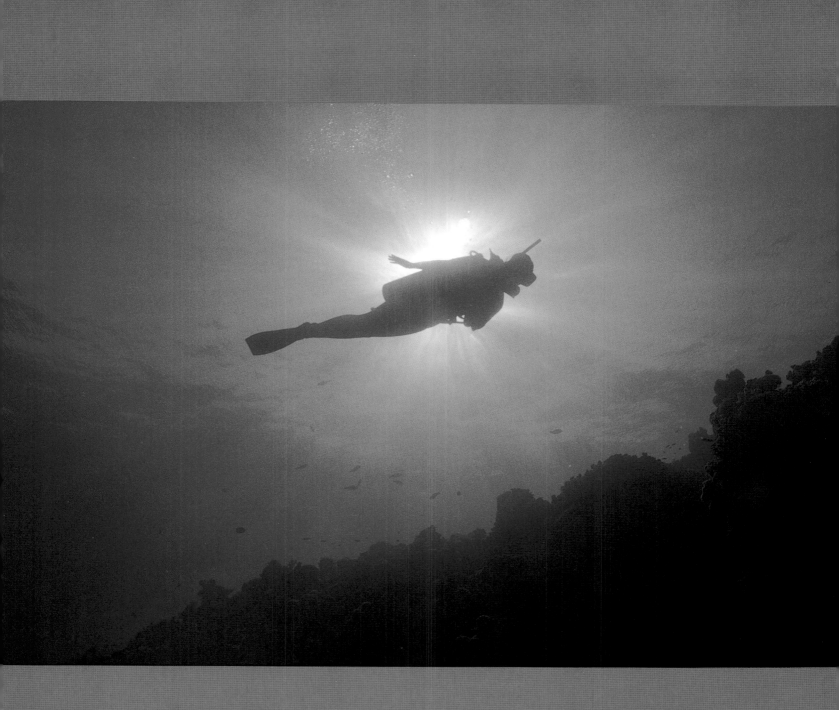

A marine farewell.

Index